W9-ACA-919

E. H. GOMBRICH

THE HERITAGE
OF APELLES

STUDIES IN THE ART OF
THE RENAISSANCE
III

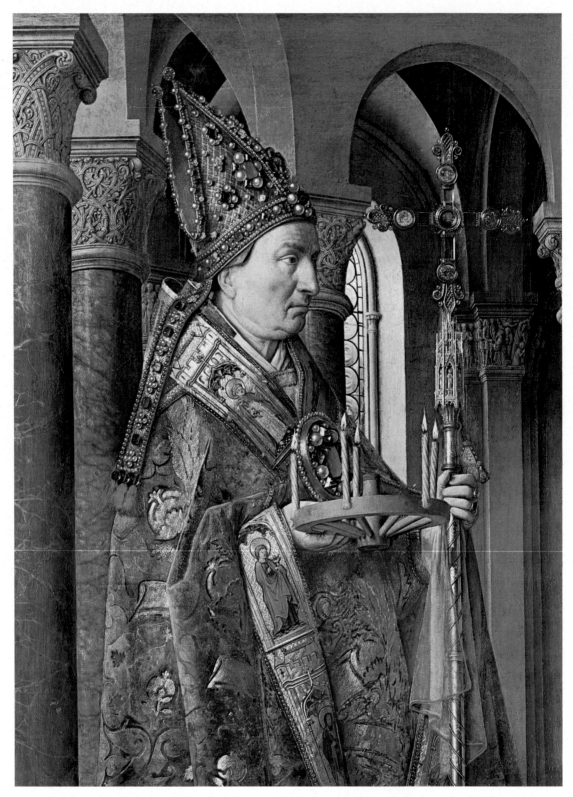

I. Jan van Eyck: St. Donatian. Detail from *Madonna and Child with St. Donatian, St. George and Canon van der Paele* (Fig. 51)

The Heritage of Apelles

Studies in the art of the Renaissance

by E. H. Gombrich

Cornell University Press

Ithaca, New York

This edition © 1976 by Phaidon Press Limited, Oxford

Except for brief quotations in a review, this book,
or parts thereof, must not be reproduced in any form
without permission from the publisher. For information address
Cornell University Press, 124 Roberts Place, Ithaca, New York 14850

First published in volume form 1976 by Cornell University Press

International Standard Book Number 0-8014-1012-6
Library of Congress Catalog Card Number 76-3080

Printed in Great Britain by R. & R. Clark Limited, Edinburgh

CONTENTS

TO THE MEMORY
OF MY DEAR FRIEND
OTTO KURZ

PREFACE

THIS volume is the third in the series of *Studies in the Art of the Renaissance* after *Norm and Form* (1966) and *Symbolic Images* (1972). The first centred on the traditional question of style and its relation with the outlook of the age; the second on those problems of symbolic interpretation often associated with the work of the Warburg Institute, with which I have been connected for so long. Here I am concerned with another aspect of the Institute's programme of research, the role of the classical tradition in Western art. It was the conviction of Aby Warburg that the triumphs and perils of our civilization can only be understood if they are seen against the background of our Mediterranean heritage. Our art no less than our science derives from the Greeks. The title of this collection alludes to one aspect of this heritage. The fame of Apelles, the court painter of Alexander the Great, continued to haunt the memory of art lovers and critics long after his works had fallen prey to time. The Roman encyclopedist Pliny the Elder had hailed him as 'the master who surpassed all painters who preceded and who followed him' and posterity was ready to accept this verdict on trust. Pliny's account of his life and work helped to establish the ideal of an art that combined supreme skill in the imitation of nature with the realization of surpassing sensuous beauty. The tradition of this twin ideal forms the connecting thread of these studies.

The successive artistic revolutions extending from Romanticism to our own time have given this tradition a bad name, and this in turn has led to a certain neglect of its theoretical implications. It is for this very reason that the historian who wants to understand these implications must concern himself with the heritage of Apelles.

In *Art and Illusion* (1960) I attempted to probe the process the Greeks called *mimesis*, the creation of a faithful representation. This line of research led me inevitably to the psychology of vision. I found the results and debates of contemporary perceptual psychology quite absorbing, but I was sometimes plagued by the worry whether I was not playing truant from my assignment at the Warburg Institute, where I hold the title of a Professor of the History of the Classical Tradition. It was with relief, therefore, that I discovered that these preoccupations also helped me to see the classical tradition in a fresh light and to pose questions which more specialized art historians had failed to ask. Indeed I venture to hope that the title essay of this volume offers interpretations of Pliny's text which might be of interest to classical scholars.

The inclusion of this interpretation in a volume devoted to the art of the Renaissance will not be found to be arbitrary, for the pictorial devices on which it turns remained essential to the craft of painting throughout the Middle Ages and beyond. Most of the other studies in this collection also take their starting point from the problem area of *Art and Illusion*. I was in fact tempted to entitle it 'Art and Illusion in the Renaissance', but I feared that this would lead to bibliographical confusions. In any case, what is central to this volume is the problem of the objectivity of standards in the rendering

of the visible world. The standards in question are not, of course, based on artistic but on scientific criteria. The findings of optics are as relevant to the rendering of light and lustre, discussed in the first two chapters, as they are to perspective; its importance as a touchstone of Renaissance art theory is illustrated in the last section. Two studies are concerned with the greatest of all scientific painters, Leonardo da Vinci, one with his investigation of waves and vortices, the other with his grotesque heads. These may form a bridge to a discussion of works by Bosch and Bruegel. My interpretation of Bosch's most famous work might have found a place in the volume on Symbolism, but it was in fact also sparked off by my interest in light effects.

Except for the title essay, which is based on a hitherto unpublished lecture, all the studies here assembled derive from papers previously printed elsewhere, which I have revised to a greater or lesser extent. Chapter Two has undergone the most radical transformation. Elsewhere I have been more conservative and have only added some paragraphs or even confined myself to the addition of a few footnotes referring the reader to relevant literature published since the first appearance of these studies. As in the previous volumes I have not aimed at a complete bibliographical coverage.

As in the previous volumes, also, I have translated quotations from foreign languages. I have given the original in the text or in the notes where the wording seemed to matter or where the reader might find the passage concerned difficult of access. Thus I have not quoted the Italian of Leonardo's *Treatise on Painting*, the Latin of Alberti's *De pictura* or the German of Dürer's writings because editions of these works are easily available. In nearly all cases I have given my own translation, because every translation is the result of choices which may be determined by the context.

One important aspect of my revisions must not go unmentioned. Thanks to the co-operation of the Phaidon Press I have been able to augment the illustrations of studies previously published with a bare minimum of visual support. This applies in particular to the study of Leonardo's grotesque heads, which now offers the first richly documented survey of these strange products of the master's imagination. I am grateful to my publishers for making these amplifications possible in a period of steeply rising costs.

My debt to my colleagues at the Warburg Institute is as great as ever. The sudden death of Otto Kurz in September 1975, a few weeks before his official retirement from the Institute, has made me doubly aware of how much I had come to depend on his miraculous erudition, his boundless generosity, and his cheering wisdom, wit and sense of fun, ever since we first met as students of Julius von Schlosser at Vienna University in the winter of 1928-9. It was he who made me change what was intended as a note on a story in Pliny into the title essay of this volume, of which he still accepted the dedication.

In conclusion I should like to thank Mrs. Mélanie Carr for her help with the preparation of the manuscript, Mrs. Marian Wenzel-Evans for her readiness as a painter to carry out the experiments illustrated on Plate III, and, of course, Dr. I. Grafe, whose eagle eye saved me once more from many sins of commission and omission.

London, January 1976 E.H.G.

LIGHT AND HIGHLIGHTS

The Heritage of Apelles

IN LIFE AND IN ART the distribution of light and shade helps us to perceive the shape of things. The presence or absence of reflections tells us about their surface texture. An old-fashioned text-book of line drawing explains this difference by means of two top hats (see below). The surface of the mat variety reveals the direction from which the light strikes the object, and the density of shading or 'hatching' therefore has the effect of modelling, that is of indicating form. We are shown an objective state of affairs which depends only on the position of the object in relation to the source of light. Even if nobody ever looked at this hat the light would still bleach the exposed side and leave the other one intact. The effect of lustre, which we see on the shiny silk hat, is of a very different kind. The highlights which the draughtsman has indicated by an abrupt step from black to white are reflections of the light source. They are composed of mirror images distorted by the threads and curvature of the tissue, and as with all mirror images the place where we see such highlights will depend not only on the incidence of the light rays, but also on our own position. Strictly speaking we do not even see highlights in the same place with both eyes. As mirror images they appear to lie behind the reflecting surface, and this often gives their lustre a strangely hovering quality.

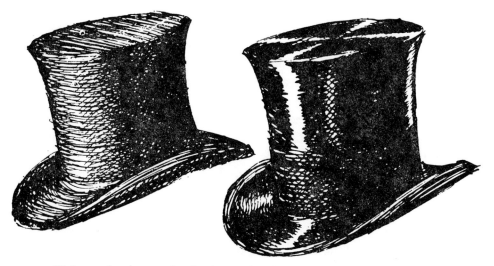

Light on absorbent and reflecting surfaces compared (after E. J. Sullivan)

The photographs of Figs. 1 and 2 show a hurricane lamp casting its light on variously textured objects and materials assembled around the replica of a glazed terracotta bust

This study is based on a lecture given as the Pilkington Lecture at the Whitworth Gallery of Art, Manchester, in May 1972, under the title 'The Lustre of Apelles'.

by Andrea della Robbia, which stands in front of a mirror. The cloth spread on the table shows how the gradations of light and shade visible on its absorbent coloured surface clarify the shape of the folds. On the dark bottle behind the bust and on the shaded side of the black glossy material near the lamp no shadows are visible, and all we see are the luminous mirror images of the lamp. The same absence of shadow characterizes the transparent glass jug and plastic sphere in front of the bust; they would be invisible but for the reflections. Yet the location and shape of the highlights also offer us clues about the form of the reflecting surface. Just as a curved mirror (such as the spoons in our picture), when seen from the appropriate distance, will collect the light rays and reflect a reduced mirror image (including that of the bust), so a curved surface will collect and reflect the images from a wider sweep of the surroundings. In thus gathering more of the light the more steeply curved surface (such as the rim of the earthenware cup) will also appear to intensify it. The strength of the highlight thus becomes an important indicator of the shape of the object as well as of its texture, for even a relatively mat surface will tend to throw back the intensified light of a concentrated reflection. Hence it is on the ridges or corners of objects that highlights appear most frequently—which is also the reason why ladies powder their noses to counteract this effect. It is an effect which is likely to persist despite movement, since the reduced mirror image on the steep curvature will shift only very little as our position, or that of the light, changes in relation to the object. The two photographs of Figs. 1 and 2 are taken from different angles to illustrate a fact which can be tested any moment in our environment. A flat mirror will hold a particular reflection only as long as we keep it and ourselves still. Move, and you will see the reflection move with you. The speed of this shift will decrease with the steepness of the curvature. In our photographs the reflection of the bust in the mirror is more affected by the shift of the camera than is the reflection in the spoons; the highlight on the tip of the nose is hardly changed at all.

But while 'stills' can thus demonstrate the degree of stability in the position of reflections, it is only motion that fully brings out the effect we call 'glitter'. The jeweller who wants the diamond to scintillate polishes its surface into many flat facets which catch the light differently at every twist and turn. The gleam on the rounded pearl, on the other hand, is likely to persist.

We need only open our eyes to observe these varied phenomena, which Goethe has described as *die Taten und Leiden des Lichts* (the actions and sufferings of light),[1] but art historians have paid little attention to their role in representations of the visible world. While there is a large body of literature on perspective and the rendering of space, the mastery of light has received much less detailed attention.[2]

Yet the complexities of the actions of light, which, of course, our brief analysis has far from exhausted, should be of interest to the historian of art not only for the challenge they presented to all styles which aimed at a faithful rendering of natural appearances. An awareness of these effects should also help us to trace connections and traditions precisely in styles where the formulae evolved by painters deviate from reality to a

larger or minor extent. I have argued in *Art and Illusion* that we could not study the history of art if every artist had been able to start from scratch and to arrive at an independent method of representing the world around him. Art has a history precisely because the methods of constructing an acceptable image have to be developed and have to be learnt. Innovations or reductions usually come gradually and allow us therefore to trace any stylistic convention to its source. It is the purpose of this chapter to attempt this in a particularly intriguing instance. It seeks no more and no less than the vanished art of the most famous painter of classical antiquity and the favourite painter of Alexander the Great, the great Apelles, whose name remained proverbial for a supreme master long after his works had all perished. I hope to show that many of the stories told about Apelles by Pliny can be better understood once we have sharpened our eyes to the problems in the rendering of light and to the traditions which spread from the ancient world not only through Europe, where they continued into the Renaissance, but even as far as India, China and Japan.

My evidence is partly stylistic, partly literary. The special value of literary testimonies for the historian often lies in their very simplifications, which help us to focus attention on certain extreme procedures they describe. There is such a text from late antiquity which has not received the attention it deserves though it was quoted in that precious compilation on *The Painting of the Ancients* by the seventeenth-century Dutch antiquarian Franciscus Junius.[3] He culled it from the commentary to Aristotle's *Meteorologica* by Philoponos (Johannes Grammaticus) of the fifth century A.D.

> If you put white and black upon the same surface and then look at it from a distance, the white will always seem much nearer and the black further off. Hence when painters want something to look hollow, such as a well, a cistern, a ditch or a cave, they colour it black or brown. But when they want something to look prominent, such as the breasts of a girl, an outstretched hand, or the legs of a horse, they lay black on the adjoining areas in order that these will seem to recede and the parts between them will seem to come forward.[4]

The same rule is also documented by an earlier author, the so-called Longinus who wrote the influential essay on *The Sublime* in the first or second century A.D. Comparing the effect of certain brilliant rhetorical devices with the effect of light in a painting he says:

> Though the colours of shadow and of light lie in the same plane, side by side, yet the light immediately leaps to the eye and appears not only to protrude, but actually to be much nearer.[5]

One is reminded of the debate on advancing and receding colours in the nineteenth century, not all of which was based on empirical evidence.[6]

The two passages which describe white as an advancing colour also help us to understand a remark by Cicero that painters see more than we ordinary people do 'in umbris et eminentia', in the shadows and the eminences or protrusions.[7] Shadow, darkness, is

here considered the opposite of the advancing form, the eminence. Like Philoponos, Cicero took it for granted that in pictures as in nature hollows are dark and ridges white.

Now it is certainly true that hollows will be more frequently in the shadow than ridges, but what is merely frequent is not always the case. The light can of course also shine directly into a recess. It is not mere pedantry to make this point. Rather it helps us to grasp the role which the assessment of likelihood plays in our visual reactions.

We have seen that the white streak on the ridge and the highlight on the silk hat are the result of reflections. They indicate the mirror images on the glossy convex curvatures. We have also mentioned why such shapes are the most likely to catch and maintain these reduced and blurred mirror images. However, it is clear that a concave mirror can catch the light and that hollow shapes as well will then show reflections. A glance at our two spoons will show that on the hollow side these will be inverted (Figs. 1, 2). However, we are rarely aware of this effect in ordinary life and many people may never have noticed it at all.

It is precisely the point that our perceptual system responds to these indications of probabilities without our being aware of their cause or of their weighting. The practice of ancient artists confirms the effectiveness of Philoponos' rule of thumb. Naturally caves or hollows are indicated by black colour in ancient mosaics. The rule that a white zone between darker ones comes forward is perfectly exemplified in a late antique mosaic of a fruit tree from Caesarea in Israel (Fig. 3). The white line on the trunk and the white spots on the fruit contribute to the three-dimensional effect. But we need only extend our scrutiny a little to see to what extent the rule of Philoponos presents an over-simplification. In our world the light normally shines from above and so the reflection of the sun or of the sky is generally located higher up on the upward curve of the solid body. A comparison between the schematic fruit on the Caesarea mosaic and one of the splendid still-lifes from Pompeii (Fig. 4) shows that the ancient painters were very well aware of this skyward shift of the highlight. Another (Fig. 5) shows their perfect mastery of the distinction between illumination and reflection, which was my starting point. Pliny says so explicitly where he introduces the two terms of *lumen* for light and *splendor* for gleam or lustre,[8] and even if we did not have this text, countless paintings and mosaics of the Hellenistic and post-Hellenistic periods amply prove the subtle powers of observation of these artists.

A mosaic from Pompeii of street musicians signed by Dioscorides of Samos (Plate II) illustrates the sophistication of the ancient masters in the rendering of both light and lustre. We see the cast shadows of the figures on the floor and against the wall, the light striking from the right. We also observe the modelling of the limbs and the drapery, with the hands and the arms of the castanet player clearly showing the distinction between illuminated and shadowed surfaces. But the artist proves himself equally aware of the gleam that indicates texture, notably on the curvature of the tambourine and the pink garment of its player. The hollow surface of the castanet in the player's left hand is clearly marked by the light on the left side, and the gleam of the cloth on the garment of

the dwarfish figure on the left completes this record of subtle observation.

It is a well-known fact of art history that these observations were embodied in the routine and indeed in the formulae for the rendering of the visible world which was passed on from antiquity both to the Byzantine and to the Western tradition of the Middle Ages. Long after painters had ceased to work from the motif, let alone from the figure, they used these indications of modelling and gleam. The little highlight on the cheekbone of Theseus (Fig. 6) in a mural from Herculaneum survived the development of more than a thousand years and can be seen on the schematic and solemn heads of twelfth-century frescoes from Eastern Europe (Fig. 7). But is it still a highlight here, conceived as a reflection, or is it now meant as modelling? It is likely that the question would no longer have been understood by the painter of the mural, who had ceased to refer to nature as his guide. There is perhaps less excuse for modern art historians to have neglected this simple difference. Yet the only book we have in our discipline on the treatment of light, Wolfgang Schoene's *Über das Licht in der Malerei*,[2] fails to make this distinction. Maybe this strange omission is due to the effect of two contradictory trends in the arts of the nineteenth and twentieth centuries which here, as always, influenced the observational bias of art historians. I am referring to Impressionism and Expressionism. It was the first of these liberating movements which notoriously influenced Franz Wickhoff in his seminal study of the *Vienna Genesis*, first published in 1895.[9] It was he who introduced the term 'illusionism' for the loose brushwork and the deft flicker of Roman decorative paintings, a technique which, as he proved, survived into a period previously considered decadent. He was less interested in an aspect of painting that he would rightly have regarded as part of the academic tradition, the close application to the study of modelling and highlights, and he bequeathed to art history this disregard. Expressionism of course had even less reason to return to these academic concerns. Remoteness from 'photographic' transcription of reality became, after all, a positive value, and it appeared to be merely philistine to compare the great creations of medieval art with observed natural effects. What mattered and still matters to the greatest of our authorities in this field is the expressive value of colour and line in these creations, and even where the continuity of traditions is investigated it is to these qualities that attention is drawn.

An important article by Professor Ernst Kitzinger on the Hellenistic heritage in painting is a case in point:

> Illusionism in Byzantine painting certainly was much more than a convenient idiom— let alone just a mechanically repeated technique. It was a positive artistic element, deeply tied to new spiritual values; . . . The web of highlights that ultimately emerges spins a subtle pattern over the surfaces of painting and mosaics far removed from anything the classical age had known.[10]

There is no doubt that Byzantine painting, and indeed medieval painting altogether, valued this characteristic of luminosity, to which Wolfgang Schoene also draws attention.

Beauty was almost identified with splendour, the sparkle of precious stones and the gleam of gold—and who is to decide how much of this preference was due to a primitive taste and how much to that identification of splendour with the spiritual values of divine light which Abbot Suger used in defence of his expenditure on precious treasures?[11] But I do not think we need ask what was intentional in this tendency and what unintentional. In artistic no less than in biological evolution there is such a thing as the survival of the fittest, evolutionary pressure. Certain practices and formulae in art survive because they create a desirable effect, others are no longer learnt because they have become irrelevant. From this point of view the distinction made by Professor Kitzinger between mechanically repeated techniques and positive artistic elements is perhaps less easy to draw. Every painting contains conventional elements which the artist has learnt from his master, and in the art of the Middle Ages this fact hardly needs demonstration. There are contexts in Byzantine art where the ancient method of rendering lustre was relevant and where it therefore survived intact—witness for instance the modelling of the pitchers on the splendid mosaic of the Marriage of Cana from the Kariye Djami (Fig. 8). There are other examples where highlights appear indeed to be intensified and multiplied in the way Professor Kitzinger describes (Fig. 9), though whether this is invariably due to a striving for greater spirituality may still be open to doubt. We find something of the exaggerating and coarsening of the effects of light and of gleam precisely among the cruder paintings and mosaics of antiquity which used the short-cut methods that led to the rule of Philoponos (Fig. 10). Some of these paintings make indeed a somewhat overheated or overglowing impression, which at that time was certainly not yet associated with spiritual values. Even so it may be granted that these means of conveying *splendor* acquired a new meaning for the Middle Ages as the formula was translated from white into gold, thereby losing something of the differentiation in favour of a general effect of splendour. The enthroned *Madonna and Child* probably painted in Constantinople around A.D. 1200 (Plate IV) illustrates this transformation as well as the residual distinctions between illumination and gleam. The treatment of the drapery still preserves something of the awareness of the fall of light and of the skyward shift of the highlights as on the knees and on the sleeves of the Virgin. Not only the gold represents lustre and radiance, there is some also on the hair and the nose of the Christ child. It is on the modelling of the throne, however, that we can best study the formulas employed. The fall of light on the top register seems clear enough, as it illuminates the left-hand side of the window-like recesses. It is equally clear, however, that the artist no longer knew or cared how to unify the fall of light, for on the lowest register he preferred symmetry to consistency. The light falling from the left, on the left-hand side, is consistent with the modelling of the Virgin's figure; but that from the right on the opposite side matches the topmost register.

I believe we need a much more detailed and systematic analysis of these conventions and rules, a kind of etymological dictionary of visual formulae or schemata before we can turn to the interpretation of their emotional meaning. It cannot be the purpose of

this chapter to provide such a dictionary but some samples may here be offered to indicate what I have in mind.

The motif of the set-in panel from the throne of the Madonna provides as good an occasion as any for such an exercise. It shows the use of light and shadow for the articulation of architectural features which may well be ultimately derived from the methods of ancient scene painters, whose illusionistic architectural backgrounds were produced by what was known as *skiagraphia*, shadow painting.[12]

The use for this purpose of lateral illumination, or 'grazing light', which is exemplified by the Madonna's throne, can certainly be traced back to the formulae of Pompeian decorators. One of their simplest and most effective tricks consisted in conjuring up the impression of a recessed or a protruding panel with no more than three tones of colour (Fig. 11). When two sides of the rectangle, the left and the top, are drawn with a dark outline and the two opposite sides in a lighter tone, the feature recedes because it looks as if the light striking from the top left were shadowing the rim. Any amount of variations could be played with this simple effect, such as the appearance of a protruding frame around sunken panels (Fig. 12).

Tricks of this kind had their obvious use even beyond the confines of illusionist decoration, for they could aid in the representation of any stereometrical forms on buildings or furnishings. Thus we find this device employed in the fifth century in the rendering of the cupboard doors in the St. Lawrence mosaic of the Mausoleum of Galla Placidia in Ravenna (Fig. 13) and some three centuries later in those of the Codex Amiatinus (Fig. 14). It was still used by Duccio (see Fig. 64).

This method of using grazing light for the indication of structure frequently survived within styles which had discarded or forgotten similar realistic uses of modelling in the rendering of the human figure. In the Gospel of Charlemagne, of the late eighth century (Fig. 15), the figure is quite flat while the architectural background preserves the formula of the ancient stage, the *scenae frons*; the pinnacles and the stones are neatly modelled. It is true that the decorative panels are somewhat insecurely placed but they, too, reflect the repertoire of the illusionistic tradition. The architectural composition in the ninth-century Gospel from St.-Médard, (Fig. 16) suggests the same derivation from scene painting. Here we find niches and windows marked by light falling diagonally from above and leaving deep shadows. This, too, is a formula which had been used in narrative art, witness the rendering of a city in the sixth-century *Vienna Genesis*, where the diagonal shadow of the tower falls across walls (Fig. 17). It is used with less rational justification in the building at the back of Hannah's Prayer in the tenth-century *Paris Psalter* (Fig. 18).

Sometimes this formula of a diagonal shadow becomes combined with that of grazing light. In consequence the building stones of houses look as if they were shaped (which may have been the original intention), as in the fifth-century mosaic of S. Maria Maggiore (Fig. 19). An echo of this formula survives for instance in an Ottonian miniature now in Pommersfelden (Fig. 20). The translation of these models into the medium of pen

drawing did not lead to the abandonment of the schema. Its traces are still visible in English eleventh-century drawings such as the famous Easter tables at the British Museum (Fig. 21), and once our eyes are sharpened to this tradition we may notice that the diagonal stroke marking the window in the rendering of a Church from the same period still derives from *skiagraphia* (Fig. 22).

It is most unlikely that the medieval craftsmen were normally aware of the rationale behind these workshop traditions. More often than not they make the light fall from various directions (Fig. 23), but it would still be rash to conclude that the meaning of the formula was not always there to be re-discovered. In the Ottonian miniature of a Sacramentary from Minden (Fig. 24) we find clear indications that the light was conceived as emanating from the central radiance, and though the effect is not quite consistent with the actual direction of the rays it still conveys the impression of divine illumination.

The minature is an exception in more than one respect. In representing the source of light it avoids a problem which is otherwise inseparable from the representation of modelling by grazing light; I mean the problem of ambiguity leading to apparent reversal. Light can only be a revealer of form if we know, or can assume, where it comes from. Change this assumption and what appeared hollow will look solid and what appeared solid will now look hollow. It is an effect frequently illustrated in text-books of psychology[13] but its compelling nature remains startling however often one may have observed it. Take any of the forms illustrated here (Figs. 12–14, 64) and turn the book round: the reversal will seem inescapable.

There is every reason to think that the ancient 'shadow-painters' knew of this instability, for Plato mentions it as an example of the fallibility of human senses.[14] Ancient decorators used it playfully on the walls and floors of buildings, and medieval craftsmen inherited these visual games (Fig. 25). But while ambiguity can be amusing in ornamental contexts, it must have presented a most unwelcome flaw in representational scenes. The very inconsistencies of illumination inevitably lead to the possibility that the windows or doors of a building might also be seen as bulging apses (Fig. 26). Maybe art historians have deliberately refrained from drawing attention to such possible misreadings of medieval stage props, but it is unlikely that the ambiguity did not pose a problem to the artists themselves. How was it to be avoided?

It is here, I believe, that the rule of Philoponos assumed real importance. The gleam on the ridge, we remember, makes it come forward and stand out. True, we have seen that even this effect rests on our visual reaction to probabilities, but we also know that there is a much greater likelihood of reflection or lustre guiding our interpretation correctly than there is in the case of the fall of light.[15] We can again see ancient painters and their medieval heirs exploring and exploiting this added device in decorative contexts such as the plastic meander. In the *Villa dei Misteri*, for instance, the meander running on top of the murals is simply revealed by grazing light, with the consequent effect of reversal on looking at it from the other side (Fig. 27). In another Pompeian

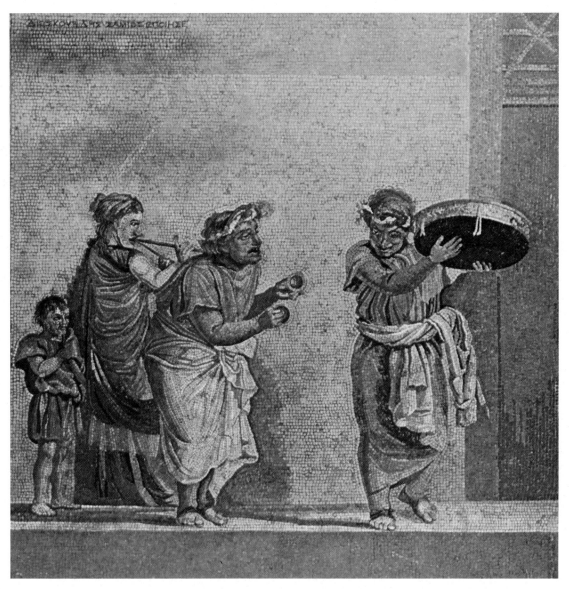

II. Dioscorides of Samos: *Street musicians* (scene from a comedy). Mosaic, first century B.C.(?). Naples, Museo Nazionale

mural, Achilles releasing Briseis (Fig. 28), the bordering meander is marked by a thin white line, which effectively counteracts any reversal though the lighting is far from consistent.

This method of anchoring a shape in the foreground by what we might call the white line of Philoponos also became part of the decorative repertory of ancient and medieval art. We find it applied to the magnificent meanders framing Ravenna mosaics (Fig. 29) or—nearly 500 years later—the Halberstadt tapestry of St. Michael (Fig. 30) which once more illustrates the relative independence of illusionist decoration and narrative styles. It is true that medieval examples are not always equally consistent. In their enjoyment of complexity they sometimes appear to jumble the cues like cubist painters (Fig. 31), though it is hard to tell in any particular instance whether the spatial inconsistencies are introduced intentionally or not. What is clear, however, is that even where the consistency of lighting breaks down the white line remains visually on top.

Here as before such decorative traditions can also serve as pointers for the better understanding of certain representational methods which the Middle Ages inherited from antiquity. For a glance back at the architectural features discussed above will convince us that indications of gleam were sometimes added to the modelling effects of grazing lights. We find them on the knobs and similar pieces of turnery on the Madonna's throne (Plate IV) and we may also interpret the golden outlines of the band of vegetative scrolls as lustre rather than light. Maybe the same somewhat uncertain appearance lies behind the convention so frequently followed in the rendering of roof tiles each of which is lit up near the lower edge (Figs. 19, 20, 26). Given a position of the sun somewhere behind the house, this appearance might be interpreted as due to grazing light, the upper tile always casting a shadow on the next lower one. But this is precisely one of the instances where the formula does not differentiate between light and lustre. The bright edge becomes a gleam as if the roof were glistening under Southern skies.

It might seem pedantic to subject a shorthand formula to this kind of scrutiny, but such an analysis may help to account for one of the most tenacious and most enigmatic conventions of medieval art—the layered rock formations which so often stand for landscape features and which had also reached their typical expression in the mosaics of Ravenna (Fig. 32). In its developed form this convention departs from the method of tonal modelling; it never shows the upper platform of the steps in even light. There always is a crescendo of brightness as the step comes closer to us, till the upper edge appears to gleam with a rather unnatural lustre.

Considering the distribution and the longevity of this motif, these gleaming rocks seem to have attracted surprisingly little attention. Towards the beginning of the century Wolfgang Kallab[16] devoted a few pages to the origin of these stage props in ancient art, but he was only interested in their shapes, not in their lustre.

It is easy to observe that these rocky steps are often used to mark the foreground edge of a pictorial landscape stage, like the setting of the *Good Shepherd* at the Mausoleum of

Galla Placidia in Ravenna (Fig. 34), where the white line marks the edge of the zigzag escarpment. It is also clear that this simplified and stylized form is derived from the more naturalistic renderings of rocky landscapes current in the Hellenistic tradition (Figs. 33, 35), but this observation only shifts the problem of the visual meaning of this convention without really solving it.

Perhaps another ancient text about the practice of painters may prove of some help. It comes from Ptolemy's *Optics*, only partially preserved in a Latin translation, of which only a single manuscript exists.

> . . . of two things in one place the one which has greater lustre appears to be nearer—for this reason the mural painters make the colours of things they want to appear distant veiled by air.[17]

We know the first part of this doctrine, the quality of lustre or gleam to come forward. We now learn something of the context in which the rule of Philoponos originally stood. Lustre and strong contrasts generally belong to the foreground, the background must be 'veiled by air' to appear to recede; it is the first adumbration of the principle which Leonardo da Vinci was to describe as the 'Perspective of disappearance'[18] and which we call 'aerial perspective'.

Casting our minds back to the examples previously scrutinized, we discover that they were predominantly foreground features. The contrasts created by grazing light were probably derived from the stage wall, the *scenae frons*, which lacked depth or distance. The gleam of figures and objects, too, applied to features near the observer. Ancient painters were certainly intent on observing the division into foreground, middle-ground and background that remained a stock in trade of the Western tradition, and once we focus on this zonal method we also notice the care with which tonal contrasts are stepped down in each of the successive zones (Fig. 36).

It should not be surprising, therefore, that ancient painters reserved the strongest contrast between light and shade for the zone nearest to the observer and narrowed the gap between these extremes progressively with increasing distance. The mosaic of S. Apollinare in Classe neatly shows how this rule of progressively muting the highlight was codified and observed in early Christian art (Fig. 37). It continued to exert its effect on the more sophisticated of Byzantine illuminators though it was not always fully understood (Fig. 39).

What remained was a formula for mountains which increasingly lost contact with observation. In Byzantine mosaics (Fig. 38) the gleaming slopes sometimes suggest snow rather than light, and in some icons (Fig. 40) the white stripes on rocks are purely conventional. Maybe, however, the persistence of the convention is not simply due to thoughtless copying. Remembering the rule of Philoponos and the degree to which the highlight on the ridge will counteract the ambiguity inherent in the rendering of lateral illumination, we can see the advantage of the 'gleaming ledge'. For once an art-historical hypothesis might be subjected to an experimental test. I have asked an artist to paint

such rocks with and without gleam (Plate III bottom) and to her own surprise my pre-
diction was borne out. The rocks painted on a purely tonal scale exhibit the same am-
biguity as do the cubes of Fig. 25, though it may take a little patience and practice to see
the effect. As with Fig. 12, the switch is most easily achieved by turning the book upside
down. Start with what thus becomes the highest step and try to see the illuminated
strip once more as the platform on which to step, and if you succeed the rest of the con-
figuration will conform to this reading. Alternatively the shaded parts may become plat-
forms of steps seen steeply from above. Once we are aware of these alternatives, we can
see them even in the normal orientation. The version on the right, with the gleaming
ledges, will, however, resist these transformations, for the reasons discussed above.

It is altogether unlikely that the survival up to that moment of these and similar
schemata for the rendering of light and lustre can have been due merely to inertia or to
sheer accident. They survived because they were easily learned and proved useful terms
in the language of painting. Some of these devices spread far beyond the confines of
Christian European art as far, at least, as the Buddhist murals of Ajanta in India. We
there find the serrated angular ledge at the rim of the pictorial space (Fig. 41) which
looks like a variant of the forms found in the mosaic of the Mausoleum of Galla Placidia
(Fig. 34).[19] We might at first hesitate to admit a connection between works so far apart,
but the spatial meander with the white ridge on one of the ceilings of Ajanta (Fig. 42)
makes such a connection with the Hellenistic tradition almost certain. Once this
possibility is conceded it would seem to me all the more likely that the methods of
modelling found in the figure style of these beautiful murals (Fig. 43) also go back to
the same Greek tradition.

Professor Otto Kurz has drawn my attention to a class of evidence which makes such
a spread of Western schemata Eastwards not only likely but practically certain. He has
collected motifs from the murals of Central Asia and Mongolia (Fig. 44) which clearly
betray their Western origin both in their shape and in the method of their illumination.[20]
These detailed observations raise a question of much greater magnitude to which I can
only allude—I mean the tangled problem of Hellenistic influences on Chinese painting
and of the routes by which these influences might have reached the Far East. Buddhist
painting in China and Japan, of course, derives its iconography from India, but the
extent of stylistic derivations is less easy to gauge. Both the practice of modelling in light
and shade—when it occurs in China—as well as individual conventions for rendering
crags have been traced to Indian painting,[21] but these observations do not prepare us for
the kinship between Hellenistic rock landscapes such as Fig. 35 and the setting of a
Japanese painting dating from the eleventh or twelfth century (Fig. 45). I would not
have ventured to broach this question were it not for a piece of textual evidence which
is germane to my subject. It occurs in a passage from the writings of the eleventh-century
painter Sung Ti which I have quoted in *Art and Illusion* for its similarity with Leonardo
da Vinci's advice that the painter should look at crumbling walls for inspiration. My
reason for returning to it here, of course, lies elsewhere.

Choose a tumbledown wall and throw over it a piece of white silk. Gaze at it morning and evening, until you can see the wall through the silk, its prominences, its levels, its zigzags, and its cleavages. . . . Make the prominences your mountains, the lower part your water, the hollow your ravines, the cracks your streams, the lighter parts your nearest points, the darker parts your more distant points.[22]

I was puzzled at first when I read that the whiter parts were to be the nearer points and the darker ones the distant points. Should it not rather be the other way round in a landscape? But of course the advice makes perfect sense when we remember the rule of Philoponos and the importance of the gleaming ridge. Mountains rarely exhibit such gleaming ridges, but in the Chinese conventions they are often marked by a white area, which marks their forward extension.

Now here as always it is the departure from strict visual truth, the simplification that goes with the distilling of manifold observations into a handy schema, that must arouse the interest of the historian. Here is a visual language that spread in various dialects over half the globe and endured over more than two thousand years. It is tempting to speculate who originated or consolidated this long-lived and powerful visual idiom, the language of light and lustre. My candidate for this role is none other than the most famous of all painters, the painter Apelles, who lived at the time of Alexander the Great at the end of the fourth century B.C.

Since no painting by Apelles has been preserved this speculation must look somewhat idle. But I think there is literary evidence at least that Apelles was credited in antiquity with something like the perfection of the rendering of lustre, the power of suggesting a gleam that brings the shape forward. The device makes its appearance on decorative motifs of Greek vases from the approximate period of Apelles, the second half of the fourth century (Fig. 47) and can henceforward be exemplified from many of the best paintings derived from the Hellenistic tradition.

My evidence inevitably comes from the chapter in Pliny's *Natural History* in which we find a compilation of notices and anecdotes about the famous Greek master. One of these anecdotes has been quoted and commented upon through the centuries. It runs roughly as follows:

The famous painter Protogenes lived on the island of Rhodes. When Apelles came there on a journey, he was most eager to see the works of a master of whom he had heard so much, and thus he immediately went to his workshop. He did not find Protogenes at home, but he saw a large panel on the easel, ready to be painted. An old woman, who acted as the housekeeper of Protogenes, asked the visitor who he was. 'Just show your master this', said Apelles, took a brush and drew an extremely thin line across the panel.

When Protogenes came home he saw the panel and immediately got the message. The visitor must have been Apelles, for nobody else was capable of such perfection. He then took another colour and traced an even thinner line on top of the one drawn

by Apelles, telling his housekeeper: 'If the visitor returns, just show him this.' When Apelles came again he blushed at the thought of having been outstripped, and cut the line with a third colour, leaving no place for a more subtle one. Protogenes admitted defeat, rushed to the harbour to embrace the visitor and the panel was preserved. It was later displayed in Rome in the palace of the Caesars until it perished in a fire. It was highly prized though it showed nothing but lines *visum effugientes*, that is literally 'escaping the eye'.[23]

A few years ago Hans van de Waal, whose untimely death was such a loss to scholarship, made this puzzling anecdote the subject of a learned article, in which he counted no less than thirty different interpretations.[24] Lorenzo Ghiberti remarked in the fifteenth century that it seemed a rather silly competition for artists to vie with each other as to who could draw a thinner line and he therefore proposed to amend the story in conformity with his own interest. He thought the two masters were competing with each other about a problem of perspective.

I have not found any among the thirty interpretations which seemed to me quite convincing and so I venture to come forward with a thirty-first, which might allow us actually to reconstruct the appearance of the panel exhibited in Rome. Needless to say, my hypothesis is based on the formulas for light and lustre developed in ancient art. Indeed it may be that the anecdote is basically a parable of this invention.

If Apelles found the prepared panel and drew a thin line across it as a token of his unrivalled manual skill, Protogenes, on returning to his studio, could have trumped him by adding a brighter line to give the appearance of modelling through grazing light and make the line stand out somewhat. But Apelles returning once more would have bisected it by an even thinner line that suggested gleam or splendour, and to this nothing could be added now without spoiling the appearance of the line, which would have begun to stand out from the panel as by magic. I have mentioned Pliny's account of the panel in Rome which showed lines *visum effugientes*. This is usually rendered as 'almost invisible lines' but maybe my interpretation yields a first bonus here, for could it not mean lines which appear to recede from sight?

There is more literary evidence that this was thought to be a striking effect of a painting by Apelles. He was said to have painted Alexander the Great holding a thunderbolt in such a way that 'the fingers seemed to protrude and the lightning to stand outside the painting—and [Pliny adds] let the reader remember that all this was done with only four colours'.[25]

The claim that in the good old days painters needed no more than four colours to achieve their marvellous effects while later artists were corrupted by too many technical inventions is also familiar from other sources. It does not contradict the interpretation of Pliny's anecdote I propose. I have asked my artist to paint another schematic demonstration, showing the successive stages in a sequence of lines sufficiently wide to permit reproduction (Plate III top). If the prepared panel in Protogenes' studio was grounded with the first colour, say blue, Apelles could have drawn his exquisite line with a second,

say brown. Protogenes, superimposing a thinner line with another colour (*alio colore tenuiorem liniam in ipsa illa duxisse*), might have used a third, say ochre, to produce the effect of illumination; the third coloured line, with which Apelles 'cut the lines, leaving no further place for more subtlety' (*tertio colore lineas secuit nullum relinquens amplius suptilitati locum*), would have been done with the fourth pigment, the trumping line of a gleaming white.

We have no original masterpiece of Hellenistic painting, but looking at such works of craftsmanship as have come down to us from the fourth century or at the copies which are said to derive from works of that period, this reconstruction does not seem to me too wild. We have vases which use plastic effects for meanders and tendrils that match my interpretation of the anecdote about as closely as anyone might hope (Fig. 47). They display precisely that four-tone method that supplements modelling in light and shade by the line of Philoponos, which I postulate to be the line of Apelles. Nor is it unrewarding in this context to analyse the way ancient painters achieved the appearance of such objects as flutes, rods or spears which are expected to 'stand out' and to look rounded (Plate II, Figs. 28, 48). In most cases we find that combination of modelling and reflection I postulate, though of course the method is less tidy than is implied in our anecdote.

We shall never know whether Apelles was literally the 'inventor' of the highlight—it is unlikely that he or anyone was;[26] but may he not have been its acknowledged master? I can see nothing in Pliny's rather schematic story of the successive achievements of Greek painters to contradict this hypothesis, but we have further indications that this is really how the epic of conquest was seen in Pliny's sources. We may assume that *skiagraphia*, modelling through illumination, was perfected in Plato's time, that is in the first half of the 4th century B.C. The great painter Nicias of Athens who probably lived in that period is praised by Pliny for his 'care over light and shade aiming at the appearance of relief'.[27] More interesting and also more suggestive is another somewhat garbled account in Pliny telling of the painter Pausias who is described as a fellow student of Apelles under Pamphilus. Pausias, we hear,[28] was also concerned with *eminentia*, the protrusion of figures from the panel, and he introduced an innovation to achieve this effect more perfectly. Having to paint a sacrifice of oxen and wanting to show the length of the animal, he painted it foreshortened rather than in profile and so made one fully understand its bulk. All other artists who aimed at the effect of relief (eminentia) started with bright tones which they modified with black, while he painted the ox in dark tones and derived the body of the shadow from this—presumably painting the light on top, which earned him more praise from Pliny for his art in achieving the appearance of solidity.

If there is any truth in this somewhat confused story, Apelles' fellow-pupil came close to the highlight in that he worked from dark to light rather than from light to dark. But there is nothing here to suggest that he mastered the elusive effects of lustre, glitter and gleam. Yet it is this precisely for which Apelles is praised by Pliny in a passage that

echoed through the centuries: 'He painted what cannot be painted, thunder, flashes and lightning'.[29]

There is another report in Pliny which confirms that the new mastery of Apelles in representing lustre was felt to be almost too dazzling for ordinary eyes. It so happens that I have had much occasion to quote this testimony for the bearing it may have on the controversy about stripping old paintings of their varnish.[30] It is the passage in which Pliny claims that one invention of Apelles proved quite inimitable:

> He used to give his paintings when finished a dark coating—*atramentum*—so thinly spread that by reflecting it enhanced the brilliance of the colour while, at the same time, it afforded protection from dust ... one main purpose was to prevent the brilliance of colours from offending the eye, since it gave the impression as if the beholder were seeing them through a window of talc, giving, from the distance, an imperceptible touch of severity to excessively rich colours.[31]

I have never claimed that I know what is behind this strange story—though I am sure that the report, however confused, must have had its effect on later experiments with dark varnishes.[32] What matters in the present context is rather the bearing the story may have on the hypothesis about the historical position of Apelles. Could it not be related to the very *splendor* of Apelles which, in hyperbolic language, had been claimed to be so dazzling that one could only look at his pictures through dark glasses, as it were? Or could it have been invented to account for the difference between the claims made by the critics for the dazzle which the master could achieve, and the more muted impression the actual pictures were found to make? There may be such elements of rationalization in the story, but we cannot exclude that it contains a grain of truth. If Apelles really worked in a four-colour system, the need to tone down excessive contrasts might indeed have arisen, particularly for objects he did not want to stand out from the panel in a spectacular way. After all, it is generally among the cruder paintings and mosaics that we find most of the gleam or what I have called 'overglow', while the more subtle ones show a very sparing use of highlights, to counteract, not, perhaps, the dazzle, but the disruption of the composition.

There is one report about Apelles which was never forgotten. He painted the famous picture of Aphrodite Anadyomene, Venus rising from the sea. Among the many poetic tributes to that lost masterpiece few omit to mention that the goddess was shown squeezing water out of her wet hair.[33] It is hard to imagine how this could have been painted without the device of *splendor*, or sparkling highlights on the falling drops.

Maybe this cue permits us to put one further piece of the jigsaw puzzle into place. It is another anecdote concerning Apelles and Protogenes. Noting the immense labour and anxious care the latter bestowed on his paintings, Apelles is said to have remarked that in this alone he felt superior to his rival—that he knew when to stop.[34] It is a remark which might well be attributed to a master whose sparkling highlights suggest a spirited touch.

The subtlety and virtuosity required for these effects certainly eluded codification and was therefore lost in medieval practice. I hope to show, however, that the new visual explorations of the phenomena of light and of lustre in the art of the fifteenth century still took their starting point from a tradition that may have been launched by the great Apelles.

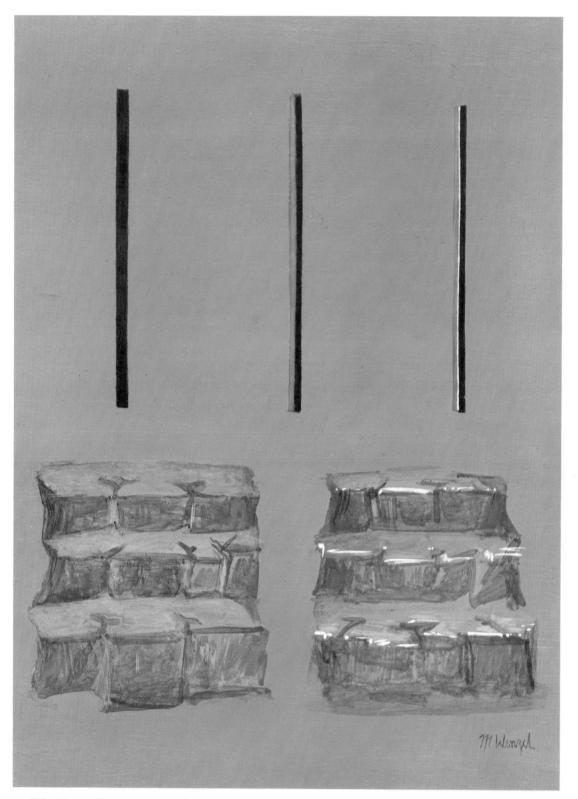

III. Above: Reconstruction of the 'line of Apelles'. Below: left, stepped rocks; right, stepped rocks with gleaming ledges. Paintings by Marian Wenzel

Light, Form and Texture in Fifteenth-Century Painting North and South of the Alps

THE BASIC FACTS of optics which were the starting point of the preceding chapter were of course familiar to that great explorer of visual reality, Leonardo da Vinci. His notes on the subject, which Richter has arranged under the heading of 'Six Books on Light and Shade',[1] show how he had mastered the heritage of ancient and medieval optics and had applied it in countless observations. With that superhuman patience that contrasts so mysteriously with his propensity for switching his interests, Leonardo would draw the different gradations of light on a sphere placed near a window, or study the shape of the cast shadow and what he called 'derived' shadow. He understood the theory of reflection and the range of phenomena connected with it. Thus he had no difficulty in distinguishing the nature of the 'highlight' as a little mirror image from the effect of direct illumination.

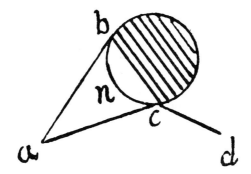

Of the highest lights (colmi de lumi) which turn and change according to the change of the beholder's eye: Suppose that the object in question is that round shape drawn here and that the light be positioned at the point a. In that case the illuminated part of the object will extend from b to c. . . . My proposition is that the lustre is everywhere and (potentially) present in every part. Thus, if you stand at point d, the lustre will appear at c. And as much as the eye will move from d to a the lustre will shift from c to n.[2]

Thus he arrives at the important distinction between *lume* (illumination) and *lustro* (lustre or gleam)[3], and notes that 'opaque bodies with a hard and rough surface never generate lustre at any illuminated part'.[4]

During Leonardo's lifetime these observations had certainly become common

This is a much revised version of the Fred Cook Memorial Lecture given at the Royal Society of Arts and published in the Society's *Journal* of October 1964.

knowledge among Italian painters and craftsmen. Yet it had not been in Italy that the first steps were made in the rendering of surface texture. We all associate Florentine art with the development of central perspective, and thus with the mathematical method of revealing form in ambient light. The other aspect of optical theory, the reaction of light to various surfaces, was first explored in modern times by painters North of the Alps. It was there that the mastery of lustre, sparkle and glitter was first achieved, permitting the artist to convey the peculiar character of materials. Indeed, for a time, during the first decades of the fifteenth century, the two schools of painting appeared thus to have divided the kingdom of appearances between them.

Take two altar paintings of the Virgin and Child with Saints painted within the same decade: the first in Bruges, the second in Florence. No illustration can hope to convey that miracle of subtlety, Jan van Eyck's *Madonna with the Canon van der Paele* of 1436 in the Bruges Museum (Fig. 51), but even an inadequate image gives some idea of the range and richness of van Eyck's rendering of texture. The sparkle of the jewels on the Virgin's garments (facing 26), the stiff brocade of St. Donatian's vestments (Plate I), the polish of the armour of St. George, the soft carpet with its woolly texture, the feel of the leaded glass and of the shiny marble columns—one could go on enumerating these magic evocations of any kind of substance and surface by means of Jan van Eyck's miraculous and mysterious technique. In a sense it is true to say that it is all done with mirrors, for Jan van Eyck is supremely aware of the fact that sparkle is composed of mirror images. In the original we can actually see the reflections of the red cloak of the Virgin at various points in the armour of St. George. Compared with this miraculous fidelity in the rendering of shifting reflections, van Eyck's rendering of forms in space is less secure. He is not in possession of the art of perspective construction, and so the floor seems slightly to slope and the spatial relationships between the figures and the building are not completely convincing.

We become aware of this when we look at a painting done in Florence about ten years later, Domenico Veneziano's *Madonna and Child with Saints* in the Uffizi (Fig. 52). In this masterpiece the figures stand clearly and firmly on the patterned floor, which is constructed according to the rules of projective geometry. We feel that solidity of form which Berenson described as 'tactile values'. This impression of solidity and spatial clarity does not only depend on the linear construction of the picture but even more on the treatment of light. Not only is every form consistently modelled in light and shade, we see the sunlight streaming into the open courtyard and imparting to the whole scene that radiant serenity so characteristic of that great artist, the master of Piero della Francesca. The light Domenico Veneziano represents is an objective state of affairs. If we imagine our standpoint to shift, the overlap of the columns would change, but the light would not. It is illumination, not lustre. This difference of emphasis becomes particularly clear at points of greatest similarity, as in the two mitred heads of the Bishops (Plate I; Figs. 49, 50). In the language of photographers, Domenico's would be called mat, van Eyck's glossy.

Technique certainly has something to do with this contrast. The artists used different media, which accounts for a different appearance of the picture surfaces. As Vasari would have put it, Domenico worked in tempera, Jan van Eyck in oil. It so happens that this contrast of media plays a part in Vasari's romantic story of Domenico's life, for he claims that the master had come into possession of the secret of oil painting and was therefore murdered by the envious Castagno (whom in actual fact he survived).

We are less sure today than Vasari was that the secret of van Eyck's technique depended mainly on the use of oil, but the surface of van Eyck's painting with its layers of transparent glazes certainly suggests something of the fattiness of oil.

And yet I hope to have shown that it is not so much the contrast of techniques or media that accounts for the different appearance of these paintings as their divergent approach to visible phenomena. It is the attention to the appearance of solid forms modelled in light and shade that gives the Florentine painting its sculptural quality. When we come from Jan van Eyck, who so convincingly conveys the softness of the child's body and the sheen of the Madonna's hair, Domenico's figures look almost like the rendering of a sculptured group, made of solid inert material.

Given the vital importance of reflections, of highlights for the impression of texture, it is surprising that no historian of Renaissance art has devoted a monographic study to the development of this effect. Here, as elsewhere, the question of space seems to have monopolized the attention of the great pioneers of stylistic analysis. It is worthwhile to visit any of the major galleries chasing after the first genuine highlight—a rendering of sparkle rather than illumination—for in the course of this search we shall also discover why the question is so baffling. It turns out that before the fifteenth century the distinction was not so much ignored as evaded. Wherever we come across the representation of an object that should really shine and sparkle, a piece of jewelry or a golden chalice, we are as likely as not confronted with real gold paint or even the imitation of the jewels in solid coloured paste.

It was precisely this manifestation of the love of gold and splendour which was censured by Leone Battista Alberti at the time when our paintings took shape:

There are some who make immoderate use of gold, because they think that gold lends a certain majesty to the representation. I myself do not praise them at all. Even if I wanted to paint Virgil's Dido with her quiver of gold, her hair tied up in gold, her gown fastened with a golden clasp, driving her chariot with golden reins, and everything else resplendent with gold, I would still rather strive to render this wealth of golden rays which dazzle the eyes of the beholder from all sides with colour rather than with gold. For quite apart from the fact that more admiration and praise is due to the artist's use of colours, it can also be seen that, when gold is applied to a flat panel, many surfaces which should have been represented as bright and sparkling look dark to the beholder, while others that should have been more shaded may appear brighter.[5]

No doubt Alberti was right when he attributed the lavish use of gold in medieval painting to the desire of imparting 'majesty' to images. It was this impression of awe and splendour that mattered in such works as the Byzantine *Madonna* (Plate IV) of around 1200 discussed in the previous chapter. In analysing its rendering of illumination and reflection we also noticed that the distinction between the phenomena is no longer clearly observed. The link with natural appearances had been broken.

But we have also seen that this severance did not lead to an abrupt abandonment of those methods and devices developed in Hellenistic painting for the rendering of light. The language of Apelles may have become garbled and somewhat corrupt, but just as Greek was still spoken in Byzantium, so the vocabulary of ancient art was still used in what Vasari called the 'Greek Manner'. Compare a funeral portrait from Fayum in hellenized Egypt (Fig. 53) with an icon-like panel from thirteenth-century Tuscany (Fig. 54). The humble craftsman who painted the former knew how to render the highlights in the eyes and the sheen of pearls and jewelry. In the latter the eyes have assumed a solemn blank stare, but the jewels are still marked with round white patches, though they no longer suggest real sparkle.

This panel is a coarse provincial work, but a closer look at one of the most refined masterpieces of the 'Greek Manner' in Tuscany will confirm the demise of the true highlight. Looking at one of the panels from Duccio's *Maestà* in the London National Gallery (Fig. 55) we can admire the painter's skill in suggesting the fall of light on the buildings in the background, with their windows and shutters lit from the side and the precise gradations of white clarifying the shape and orientation of the walls. His figures cast no shadows, but even the blind man's stick shows an illuminated and a shaded side, and the draped figures are modelled with assurance. But are the draperies silk or are they wool? In other words, should we imagine them to be mat or shiny? The more insistently we ask this kind of question, the more we come to realize that Duccio would not have wanted us to interpret his tonal effects in such a precise way. No more, in fact, than he would have wanted us to ask how far and how high the buildings in the background are, or whether the Apostles standing further back are taller or standing on higher ground. The normal reaction to this kind of question is to say that all medieval art operates with conceptual or conventional symbols which tell the sacred story without direct reference to visual reality. But like all simple answers, this contrast between a symbolic and a realistic mode of representation also begs a number of questions which are left unexamined. I have tried to argue in *Art and Illusion* that in a sense all art operates with conventional or conceptual symbols and schemata, though the character and the amount of information various styles are able to encode and convey may differ radically.

The fact that the medieval tradition had lost the desire and the capacity of conveying the distinction between illumination and reflection can best be confirmed by textual evidence. One such text, written at the very end of the period and close to the threshold of the new age, concerns us particularly: Cennino Cennini's *Libro dell'arte*, which is separated from Alberti's treatise and from our two altar paintings by only a few years.[6]

Nobody who studies this document, which aroused the admiration of Renoir,[7] will tend to underrate the role which the mastery of conventions used to play in painting.

In *Art and Illusion* I have condensed this observation into the formula that making comes before matching. It is with the making of images that Cennini is concerned, and there is no clear distinction in his mind between recipes for the grinding and mixing of pigments and prescriptions for the painting of folds.

Having decided, we read in Chapter LXXI, whether the drapery is to be white, yellow, green, red or any other hue, the painter must take three dishes to represent the three gradations of tone. If he decides for red, for instance, he must put into the first dish cinnabrese with a little white, well mixed with water. In another dish he should mix a lighter red by using much more white. Having established these extremes he can always find the required mean by mixing the two in his middle dish. He then begins laying in the darkest parts with the darkest of the three tones, taking care not to go beyond the middle of the thickness of the figure. (I take this to mean that the figures are on the whole envisaged to be lit from in front and to recede into the shade.) Then he lays in the middle tone from one dark tract to the next, blending them well in. Then comes the third and lightest of the tones with which he is to colour the protruding parts (*il rilievo*), arranging the folds with good design, feeling and practice. Having gone over these several times in order to blend them well, he should take another dish with a colour that is lighter even than the lightest of the three and pick out and whiten the ridges of the folds. Then he takes pure white and picks out precisely all the places which protrude. And finally, he takes pure cinnabrese and goes through the darkest parts and some of the outlines. 'Watching this work,' Cennini adds rather disarmingly, 'you will understand it rather better than reading this.' Note that he says watching it being done, he does not say looking at real drapery. Making comes before matching.

For though the results of this method are certainly convincing (Fig. 56), there is very little reference to natural appearances in this tradition. In this respect, by the way, the excellent translation of Cennini's Handbook by Daniel Thompson is a little misleading. For Thompson always makes Cennini say 'put on lights' where the original merely speaks of *biancheggiare*, whitening. 'The lights' sounds as if Cennini had thought of reflections, but his expression *bianchetto* (whiteness), which marks the utmost relief, is much more neutral. Clearly in all Cennini's precepts, whether for drawings, fresco or tempera, the implication is that ridges of any surface in lit areas should be marked with white.

This is still the procedure laid down in what I called the rule of Philoponos (p. 5) of late antiquity, the rule that light between dark will come forward. The term highlight, which we use, may still carry with it the implication not only of the highest, that is the brightest light, but also of the effect of *eminentia*, of relief; the term *rehauts* used in French and the German *weiss gehöht* (heightened with white) used in the description of tonal drawings (Fig. 57) point in the same direction.

There is no need to repeat the optical reasons for this impression of relief that can be

achieved by marking, in Cennini's terms, the *rilievuzzi* by *bianchetti*. We have seen that we have good reasons on grounds of probability to interpret a strongly illuminated part as a protrusion, but we have also seen that there is still a considerable gap between the simplified convention accepted by Cennini and the many possibilities realized in the visible world.

There is no awareness in Cennini that different materials should receive more or less white on the ridges according to their tendency of reflecting or absorbing light. His silence about texture in this context is all the more telling as he does have advice to offer elsewhere to painters who may want to imitate the texture of velvet, wool or silk. He recommends to imitate these textures directly on the wall or panel just as gold brocade in his time was still imitated with a surface of stencilled gold. If the painter wants to achieve the exact appearance of woollen cloth in a lining or dress, Cennini advises him to roughen up the surface of the wall with a wooden block to give it the appearance of woollen texture (Chapter CXL). The idea is the same as with the imitation of gold—you try to copy or duplicate the actual texture and material character of the stuff rather than its characteristic reaction to light.

Knowing, as we do, Jan van Eyck's astonishing success with this latter method, Cennini's advice inevitably strikes us as rather naïve. Yet his concern with real texture is a sign that the medieval tradition was breaking up and that he meant what he said when, in a famous passage, he speaks of the 'triumphal arch of drawing from nature', a guide that is superior to all exemplars (Chapter XXVIII).

In fact I oversimplified matters when I represented Cennini as a source for our knowledge of medieval conventionalism. It is true that his advice on painting draperies and his remarks on the distribution of tones are generally in accord with procedures that can be traced back through the centuries as far as classical antiquity. But there are passages where the conventional term *bianchetti*, whiteness, gives way to the term *lumi*, lights, and there is that astonishing chapter in which the artist is advised to pay heed to the fall of light and the position of the windows in a given chapel where he works. 'You must', he writes, 'grasp and follow it with the required understanding, for else your work would show no relief whatever and would turn out a crude thing of little skill' (Chapter IX).

It was Cennini's special pride that the skill and method he taught was in the tradition he had received in direct line of succession from none other than Giotto, the master of the master of Cennini's master Agnolo Gaddi. 'It was Giotto who transferred the art of painting from Greek into Latin and made it new.' ('Giotto rimutò l'arte del dipignere di grecho in latino, e ridusse al moderno.') (Chapter LI). How much we would give to be able to ask Cennini what exactly he meant by this remark. Unfortunately there is only one other passage where Cennini comes back to Giotto's achievement and the procedures he started, and that, too, is not easy to interpret. It seems, however, that it has a direct bearing on our subject, for in this important chapter LXVII Cennini contrasts Giotto's methods of modelling a head in fresco with two other traditions he con-

siders inferior. Basically, I think, the contrast is one between crude and slapdash methods and the care and finish demanded by Giotto's heirs. What all methods he discusses have in common is the preliminary work on the plaster, the *sinopie*, of which we now know many examples revealed by restorers (Fig. 58).[8] Cennini gives advice about the mixtures of ochre to be used at this stage, where he wants the painter to use a fine pointed brush 'to indicate the face which you wish to do, remembering to divide the face into three parts, that is the forehead, the nose, and the chin counting the mouth'. He then advises him to use a succession of greenish media for modelling the face, 'shading under the chin and mostly on the side where the face is to be darkest; and go on by shaping up the underside of the mouth and the sides of the mouth; under the nose and on the side under the eyebrows ... then take a pointed minever brush, and crisp up neatly all the outlines, nose, eyes, lips and ears with this *verdaccio* (green medium)'.

It is at this stage, when the underpainting is complete, that Cennini presents a choice of three methods.

There are some masters who, at this point, when the face is in this stage, take a little lime-white, thinned with water; and very systematically pick out the prominencies and reliefs of the countenance; then they put a little pink on the lips, and some 'little apples' on the cheeks. Next they go over it with a little wash of thin flesh colour; and it is all painted, except for touching in the reliefs afterwards with a little white. It is a good system.

Some begin by laying in the face with flesh colour; then they shape it out with a little *verdaccio* and flesh colour, touching it in with a little white (*alchuno bianchetto*) and it is all done. This is the method of those who know little about the profession.

But you follow this method in everything which I shall teach you about painting: for Giotto, the great master, followed it. He had Taddeo Gaddi of Florence as his pupil for twenty-four years; and he was his godson. Taddeo had Agnolo, his son. Agnolo had me for twelve years; and so he started me on this method, by means of which Agnolo used colours much more beautifully and freshly than his father Taddeo ever did.

Cennini suggests that, after the face had been indicated with the green medium, a little pink should be used to touch in the lips and the 'apples' of the cheeks. His master had put these apples closer to the ear than to the nose, for this helps to give relief to the face. Having softened these apples at the edges, preparation should be made for the actual colouring. As in the case of the painting of draperies, he advises to take three dishes containing three shades of pink as flesh colour.

Now take the little dish of the lightest one; and with a very soft, rather blunt, bristle brush take some of this flesh colour ... and shape up all the reliefs of the face; then take ... the intermediate flesh colour, and ... pick out all the half tones of the face

... then the third flesh colour and start into the extremities of the shadows, but taking care that here the green does not lose its effect. And in this way go over it various times to make a smooth transition between one flesh colour and another until it is well laid in as nature shows ... having applied your flesh colours, make another much lighter one, almost white; and go over the eyebrows with it, over the relief of the nose, the top of the chin and the eyelid. Then take a sharp minever brush; and do the whites of the eyes with pure white, and the tip of the nose, and the tiny bit on the side of the mouth; and touch in all such slight reliefs. Then take a little black in another little dish, and with the same brush mark out the outline of the eyes over the pupils of the eyes; and do the nostrils in the nose, and the opening in the ears. Then take a little dark sinoper (red earth) in a little dish; mark out under the eyes, and around the nose, the eyebrows, the mouth; and do a little shading under the upper lip, for that wants to come out a little bit darker than the under lip.

Cennini then goes on to discuss the treatment of the hair with similar care. Leaving the details aside, it is clear, I think, that the procedure he recommends concentrates on modelling, on modelling moreover from light to shade, for this is the sequence in which the three flesh tones are applied. It is surely not fanciful to connect this procedure with that impression of solidity we associate with Giotto and his tradition. For in this careful tonal method with its meticulous application and blending of three flesh tones the conventional lights are devalued in their function. The method condemned by Cennini depended largely on the darks and lights superimposed on the uniform flesh tone to indicate form. In what he describes as Giotto's way these accents become subordinate to the establishment of structure from the very beginning.

I believe that the visual evidence supports this interpretation. What Vasari called the Greek manner—including the painting we attribute to Cimabue or Duccio—still relied much more on those effects of undifferentiated light which could be read as either highlights or illumination. They are clearly visible in the head of an angel attributed to Cimabue in Assisi (Fig. 59), which contrasts so markedly with Giotto's head of the Virgin from the Arena chapel in Padua (Fig. 60). Any visitor to the Uffizi must be struck by the incomparable clarity and majesty of Giotto's *Ognissanti Madonna* (Fig. 62) seen side by side with the monumental panels of the Byzantine tradition shown nearby. As always there is both gain and loss in this revolution. Compare the head of the Christ child from Duccio's *Rucellai Madonna* (Fig. 61), with its charming highlight on the tip of the nose, with Giotto's heavy modelling (Fig. 62) and the smooth transitions into the shadows so well described by Cennini. It is clear from these and other details how far Giotto had moved away from the Byzantine, undifferentiated convention of painting light and had concentrated on the function of illumination as a revelation of form. It is not for nothing that it was he who painted the first monumental grisailles imitating sculpture in the Arena chapel in Padua. Maybe this is what Cennini meant when he said that Giotto transferred the art of painting from Greek into Latin and made it new.

Jan van Eyck: Madonna and Child. Detail from *Madonna and Child with St. Donatian, St. George and Canon van der Paele* (Fig. 51)

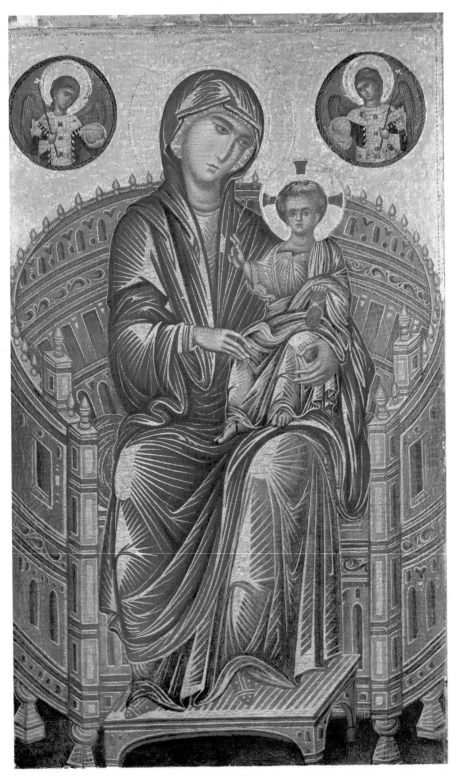

IV. *Enthroned Madonna and Child.* Probably painted in Constantinople about 1200.
Washington, D. C., National Gallery of Art (Mellon Collection)

What I suggest, therefore, is that Giotto's innovation parallels the one attributed by Pliny to Pausias, but in the opposite direction. Before Pausias, we read in the passage from Pliny discussed in the preceding chapter (p. 16), painters started with bright tones, which they subsequently modified with black, while he proceeded the other way round, thus—as I postulated—paving the way for the discoveries of Apelles. If Giotto principally worked from light to dark using highlights only sparingly this would help to explain that kinship of his art with the spirit of classical, pre-Hellenistic Greek painting which is more easily felt than defined.

There is some support for this interpretation in Giotto's treatment of that motif we have followed from Hellenistic art into late Byzantine and Slavonic painting—the conventional stage props of rocks with their schematic steps (pp. 11–13) and what I described as 'gleaming ledges'. The basic shape and function of these rocks has not changed much in Giotto's landscape settings, exemplified in the background of the *Flight into Egypt* from the Arena cycle (Fig. 63). There can be no question of this being a portrait from nature. Indeed, Giotto's tonal method for suggesting distance or depth can still be linked with the rule of Philoponos. It is recorded in Cennini's Handbook where we read that 'the farther away you have to make the mountains look, the darker you make your colour; and the nearer you are making them seem, the lighter you make the colours' (Chapter LXXXV). Giotto follows this method but he has discarded the appearance of unnatural gleam, which still marks Duccio's landscape features (Fig. 64).

It is probably this emancipation from the Greek formula that explains another famous passage in Cennini, which some commentators have found naïve—his advice to study the appearance of rocks or mountains from reality.

> If you want to acquire a good style for mountains and to have them look natural, take some large stones, rugged and not cleaned, and copy them from nature, applying the lights and the darks (*lumi e schuro*) as reason requires.

What reason would have shown the painter is precisely that a stone which had not been cleaned or polished would not exhibit reflections. It would lead him to that appearance of solidity that marks Giotto's rocks.

It would go far outside the scope of this chapter to test and to qualify this interpretation of Giotto's new approach through a detailed examination of Florentine Trecento painting. The excellent reproductions available in the illustrated edition of Berenson's lists[9] and in Eve Borsook's invaluable book on the *Mural Painters of Tuscany*[10] would not, at any rate, seem to contradict this reading. Indeed, it fits in well with this interpretation that the Sienese tradition remained relatively unaffected by what I take to be Giotto's reform, and continued instead to develop that detailed attention to minor articulations that is consistent with individual strokes of white.

Which of these two methods should be described as a greater advance towards realism? There is no simple answer to this simple question. Every tradition develops an idiom or (to use contemporary jargon) a code in which certain features of visual reality can be

recorded or encoded. Once the attention of the artist and of the public has become focused on a certain method of suggesting reality the painter is likely to watch out for those effects he can best express in his system. That mnemonic formula that 'making comes before matching' is meant to suggest that such schematic methods as Cennini had learnt from Giotto's tradition were not so much based on first-hand observation as they led to fresh observation. I believe, for instance, that it was this emphasis on model-ling in firm planes that necessitated increasing attention on the imagined fall of light and the effect of tonal gradations.

In a fresco in Santa Croce dating from about 1390, Agnolo Gaddi, in whose work-shop Cennini was trained for twelve years, conceived the figure of St. Mark in a unified light which is indicated by contrasting planes (Fig. 65). Once these effects were noticed and studied, the way was open for a genius such as Masaccio to use these contrasts for the suggestion of sunlight (Fig. 66a). In one sense this involved the sacrifice of Giotto's method of smooth transitions, and yet it is hard to see how this realistic innovation could have emerged directly out of the convention of the Greek Manner. For Masaccio knows how contrasts in small areas create the impression of strong light and shade. It was this discovery also that enabled him to include in his scenes from the Life of St. Peter the miracle of the Saint healing cripples with the shadow of his body (Fig. 66b).

It is surely no accident that Masaccio's methods of clarifying the position of forms in unified illumination coincide with the first application of scientific perspective, the clarification of spatial relationships by geometrical means. It was Masaccio, of course, who completed the effect of sculptural solidity and firmness that we still associate with the central tradition of Tuscan art from Giotto to Michelangelo. Its glory remains the clarification of structure not of texture, for the flickering highlights that shift with our position have no place in this objectivized world. This achievement demanded a supreme act of concentration which made the old rule of Philoponos obsolete or at least irrelevant.

There is one medium in particular which demonstrates the gain to be derived from this renunciation. I refer to the art of marquetry, which achieves an astonishing impression of tangible solidity merely through the juxtaposition of variously coloured woods in correct perspective setting (Fig. 67). How proud the Florentines were of this recent invention can be seen from the *Zibaldone* of Giovanni Rucellai, who lists it prior to painting among the glories of his city and his age: 'And from the time of the ancients until now there have been no similar masters of woodwork, intarsia and marquetry, of such skill in perspective that one could not do better with the brush.'[10a]

Most of the surviving examples of this skill come from places outside Florence and date from the second half of the fifteenth century, but we know that around 1440 cupboards in this technique were made for the Sacristy of the Florentine Cathedral. It so happens that Masaccio's brother Scheggia is listed among the craftsmen engaged there.[10b]

This, I believe, is the background against which we must read the memorable pages of Alberti's *De Pictura* in which the treatment of light and colour is discussed. Like Philo-ponos he is concerned with the effect of relief, the apparent protrusion of the painting

from the panel, but to him this means that the heads in a painting should stand out from the plane as if they were sculpted. Painters who aim at this much-lauded effect should first carefully observe light and shade (lumina et umbrae)

> and note that on the surface on which the rays of light fall the colour is clearer and brighter, and that the colour becomes darker where the force of light gradually diminishes. It should also be noted in what way shadows always contrast with the light, so that there is no object of which the surface is illuminated by light on which you will not find the opposite surfaces darkened by shadows.
> But as far as the imitation of light with white (*albo*) and that of shadow with black (*nigro*) is concerned, I urge you to devote particular study to the recognition of those surfaces which are touched by light or by shadows. This you can learn best from nature and from the motif. Once you have well understood this, you may modify the colour with a little white as sparingly as possible in the right place within the outlines, while adding in the opposite place the same amount of black. For with this balancing of black and white, as one might say, a rising prominence becomes more striking. Go on with the same parsimony making additions till you feel you have done enough.[11]

The best exemplification of Alberti's method I know is a predella panel by Fra Angelico painted in 1437 (Fig. 68), two years after Alberti's treatise. Here we find that careful balancing of lit and shadowed halves Alberti recommends, particularly in the figure seen from the back and in the crags of the landscape features from which all gleam is eliminated in favour of illumination. Alberti's claim that this procedure will be confirmed by a study of nature must of course be qualified. In nature not every object shows us an equal portion of its lit and its shadowed side. But to Alberti this idea of an exact balance is so vital that he even suggests marking the pivot or dividing line with a very faint brushstroke to aid in these calculations. It is clear that this procedure excludes the ancient and medieval convention of marking the foremost ridge with white. Giotto's reform is here carried to its logical conclusion.

It is quite consistent, therefore, for Alberti to inveigh against an excessive use of white, much in the same way as he warns against the use of real gold. Modifying a remark Vitruvius had made about minium red, he says that he wishes white pigments were as expensive to buy as the most precious jewels, for then painters would use them sparingly. The context of this admonition is of particular relevance to our theme, for here Alberti comes to speak of the problem of gleam or glitter. He knows—and he may have been the first student of painting to know this—that 'the painter has nothing else but white pigment (*album colorem*) with which to imitate the flash (*fulgorem*) of the most polished surfaces, just as he has nothing but black to render the uttermost darkness of night'. In other words, the painter should not normally exhaust the range of his brightness or darkness, but rely here as always on a study of the right relationships, 'for this juxtaposition of white and black has such force that by the use of skill and method it can convey the most brilliant surfaces of gold, silver and glass in a painting'.[12]

The passage remains admirable despite the fact that Alberti here slightly mixes up two different things, light intensities on the one hand and reflections on the other. It was an understandable confusion, for the brightest flash of a polished surface[13] would indeed be a mirror image of the sun and would thus come close to its intensity. But we also see texture and the sparkle of gold on a darkish day when the highlights may be darker than the painter's most intense light. It is indeed *only* what Alberti calls the correct juxtaposition of black and white, the gradients or steps between the tones, that results in this impression of sparkle.

Even so, Alberti was right in urging that the painter will have more scope for light-effects the darker he keeps the general tone of the picture. He must sacrifice his enjoyment of bright colours if he is to suggest brightness. The development of painting from Leonardo to Caravaggio and Rembrandt has tended to confirm this analysis.

Was Alberti aided in his astonishing diagnosis by acquaintance with Flemish paintings? He had been north of the Alps between 1428 and 1431, at the very time the new art took shape there, in fact he probably knew it before he returned to Florence from his family's exile. But this is guesswork, and not very important in my present context. What matters is that in the period that was my starting point, the period of Domenico Veneziano and Jan van Eyck, the problem of white and light was the subject of this searching discussion.

Giotto had started to reduce the conventional whites of the *Maniera Greca*, which broke up and disturbed the clarity of structure that could only be achieved by balanced modelling in light and shade. My hypothesis is precisely that this reform had never affected the tradition of Northern painting to the same degree, and that it was therefore easier for the North to rediscover the potentiality of these conventional whites to give the effect of reflections.

This hypothesis must look redundant to those who see the Renaissance both north and south of the Alps exclusively in terms of a break with the past and a fresh discovery of nature. The historian so minded will be less interested in the chain of traditions. For him Jan van Eyck painted highlights because he observed them, just as Masaccio painted clear forms modelled in light because he knew how to use his eyes. But in a sense the very difference between Masaccio and Jan van Eyck would suffice to put this explanation out of court. What we observe in nature depends on our interests and on our attention. To the Florentine painters the criss-cross of flitting reflections on the surface of things appeared like a random noise, which they disregarded in their search for form. Some artists in the north who also looked at nature became fascinated by the unexpected power of these lights to reveal and suggest texture. I am not a specialist in Gothic painting, but some of the stages in the rise of the new realism have by now been so well mapped out by those who are, that we know roughly in what territory to look for the first signs of the new skill.[14] Examining the paintings of the so-called International Gothic style around 1400, we find that its realism of minute details does not yet imply a clear awareness of *lustro*, but we also observe that, despite the incorporation of many Italian (especially Sienese and North Italian) motifs, this idiom embodies the ambiguities

of the medieval tradition, which favoured the picking out of bright ridges and luminous points in gold and white. Study the panels of Bohemian masters from the last decades of the fourteenth century[15] or of Meister Francke of Hamburg from the early fifteenth[16] and note their use of the scattered conventional lights on narrow folds, on hair and on the tip of the nose; pursue these tell-tale details into the Burgundian *ambiente*[17] of Melchior Broederlam (Fig. 69), and the contrast between these refinements of an old tradition and the methods practised in contemporary Tuscany will become apparent. The rendering of *splendor* as practised in antiquity lies dormant but ready to be revived. In the *Scenes from the Life of the Virgin* (Fig. 70)[18] painted in the Northern Netherlands around 1400 these white ridges on the drapery, on still life objects and particularly on the organ pipes, can be interpreted as real highlights, but there is no consistency yet in the distinction between light and lustre.

I hope these few examples indicate what I have in mind when I say that the new interest in illusionist effects may have led to the discovery that these lights could be made to suggest sparkle and texture, provided, as Alberti knew, they are sparingly used. For the real discovery of Flemish illusionism is not completed with the new use of these *bianchetti*. It lies in the introduction of a new differentiation, a new gamut of textures from sparkling jewels to mat velvet, that can be expressed by the distribution of lights. Again this magic makes use of a psychological fact of no mean importance. In grasping a system of notation, be it of a language, of a game or of an art, we become alert to what are called distinctive features—it is their presence or absence that matters. One convincing highlight placed correctly on a pearl or a jewel or on the pupil of an eye will also, by force of contrast, help to impart on to the surrounding surfaces the effect of a mat, absorbent texture. It is likely that Van Eyck found this method in the making when he set out on his career. It is certainly adumbrated in the work of the so-called Master of Flémalle, who is probably identical with Robert Campin.

There is more of Giottesque modelling than of real sparkle in the *Madonna of the Firescreen* in the National Gallery (Fig. 71), but the subtle lights are placed on such strategic points as the chalice, the eyes of the Christ Child and on the drop of milk that comes out of the Virgin's breast.

But the full potentiality of *lustro* to reveal not only sparkle but sheen is a discovery that will always remain connected with the art of the Van Eycks. This however, need not deter the historian from exploring the links of Van Eyck's technique not only with that of Robert Campin or the brothers Limbourg but with the earlier traditions. The way Jan van Eyck picks out the lights on brocade (Plate I, Fig. 72)[19] can perhaps be seen as an infinite refinement of those networks of gold that were conventional in Byzantine art (Plate IV). These networks could be seen as light, as reflection or as that elusive and fascinating effect of shot silk that also gained its place in the repertory of painting, requiring the most careful grading of transitions through hatching or stippling. Nobody, to my knowledge, has yet analysed in any detail how Jan van Eyck combined these effects with those of lustre. Maybe art historians shied away from this task because the

admiration of illusionistic effects is considered a hallmark of the untutored and philistine. Maybe also they overrated the explanatory force of a phrase such as 'the meticulous observation of nature'. One would like to see a more technical analysis of the making as well as the matching. What one can even see on any large enough reproduction is the way Jan van Eyck systematically increases the density and brightness of the highlights on the gold threads to conform with the sheen of reflections. This description may make this wizardry sound too easy, but up to a point the trick was picked up by most Flemish artists of the fifteenth century.

Nowhere did the new method of rendering texture lead to a greater advance than in the representation of landscape settings. The Southern orientation towards the study of modelling through incident light had led to the isolation of individual forms, of which the predella by Fra Angelico (Fig. 68) shows an instructive extreme. The Northern tradition had always set its pride in the accumulation of fine detail, picking out the flowers of a meadow or the leaves of a tree. But only the mastery of texture that springs from the new attention to reflections and highlights could lead the Van Eycks to their transformation of landscape detail into a microcosm of the visible world (Fig. 73). For where the detail becomes too small to elude even the magic brush of the master, the changing character of various surfaces can still be rendered with astounding fidelity; lawns and leafy crowns, the surface of rivers and the changing light on distant hills were suddenly evoked by these means.

It is interesting to note in our context that in this process of transformation the Northern masters did not simply discard those stage props of steep rocks which we have been following from antiquity into Byzantine art and down to Giotto and Fra Angelico. In the panels of Melchior Broederlam around 1400 (Fig. 74) the stereotype is still in evidence, though comparison with similar rocks in Giotto's fresco (Fig. 63) confirms again that their surface is less harshly modelled and more richly articulated with small dabs of light. In the landscape backgrounds of Van Eyck this richness of articulation has been transformed into a convincing rendering of a stony surface. There is full awareness of the fall of light on the individual crags and protrusions, but at the same time we also feel that the rocks reflect the light where they are more smooth or perhaps humid.

How does Van Eyck deal with the formula I have described as 'the gleaming ledge'? Interestingly enough he appears to have evaded the issue. In his paintings and in the work of many of his followers the terraces or level expanses of the mountainous features, which had been singled out for this treatment of uneven lighting, are now covered with vegetation.

There certainly is an element of direct observation in this new convention. The only place where the Netherlanders could see rocks were the valleys and gorges of rivers such as the Meuse which had dug a deep bed flanked by walls of rock (Fig. 75). One of the consequences of this new contact with nature is that the rocks have changed their apparent scale. They no longer stand for mountains of indefinite height, but rather for

elevations of modest proportions. Thus they can now be more easily fitted into a naturalistic setting, though their potentiality for the composition of fantastic scenery survives in the art of Bosch, Patenier and Bruegel.[20]

In thus stressing the importance of the systematic modification and refinement of traditions, therefore, I did not want to underrate the role which the observation of nature can play in the development of art. But if looking alone had made it possible to observe and to paint any aspect of the visible world, the discoveries and achievements of the Northern painters would not have made such an impression on the Italians, who surely knew as well as anyone how to use their eyes.

At the outset of this chapter I referred to Leonardo da Vinci as the greatest explorer of natural appearances, and reading the Treatise on Painting with its minute examination of natural effects will confirm this estimate. But how far did these observations affect the structure and motifs of Leonardo's art? By the time of his apprenticeship with Verrocchio, the achievements of the Netherlanders had largely penetrated across the Alps. Just as Dierk Bouts around 1464 had applied the Florentine invention of central perspective in his representation of the Last Supper, so the rendering of highlights, sheen and glitter had become a trick of the trade in the workshops of the more sophisticated Tuscan masters. Even so, of course, the two principal schools of European painting never lost their identity. Like two languages which exchange loan words while each retains its separate structure and vocabulary, the traditions of Italian and of Northern art never merged to the point of extinction. And just as Northern artists made a point, for centuries to come, of making their pilgrimage across the Alps in order to absorb something of the secrets of the classical tradition in the rendering of form, so the Italians studied masterpieces of Northern painting which eager collectors had bought or commissioned in the Low Countries for what they could learn from them.

I believe there is a good deal of evidence in Leonardo's early works that he, too, was a keen student of Northern painting. The loving care with which he picks out the sheen of Ginevra de' Benci's locks (Fig. 76) is an early example of this pride in the rendering of surface texture, which he shared with Jan van Eyck (facing p. 26; Fig. 72).

It seems to me that this aspect of Leonardo's style would merit a special study. In any case I should like to propose here that he studied that particular domain of the Northerners, their mastery of landscape setting, with more attention than has hitherto been allowed. His earliest dated drawing, of 1473 (Fig. 77), has been generally described as the outcome of a sketching expedition in the environs of Florence.[21] It seems to me that it should be regarded as a study after a Netherlandish painting. There is the tell-tale rocky wall of a watercourse in the foreground, with its vegetation on top, which recalls not only the background of the Ghent Altar but also the stage props of Jan van Eyck's *St. Francis* (Fig. 78). As in this painting, the rocky ledge in Leonardo's drawing serves as a repoussoir for a distant view, which opens in a gap left by high ground on the opposite side. But what is more relevant than these similarities in structure is the fact that the drawing shares with the Northern painting certain obscurities in the spatial

relationship of the individual features represented. Indeed I would go so far as to claim that Leonardo's drawing cannot, for that reason, represent a real scenery. At least it seems to me impossible to reconstruct from the drawing even the roughest sketchmap of the landscape in which he is supposed to have sat. Judging by the height of the trees in the foreground and on the ledge, the bank of rocks must be very close to the viewer and cannot be much higher than three to four times the height of these trees. Yet the waterfall that descends from this rock out of an implausible river-course into a deep pool suggests a very different scale. Trying to follow the water, which presumably descends down another ledge into the plane, presents new problems, and once we are thus alerted we shall also be at a loss to account for the foreground and its curving into the depth on the left. That sizeable country seat with its walls and turrets must surely be more distant than the structure of the land suggests, and the relation of the promontory on which it stands to the lake or flooded fields below remains puzzling. I grant that even photographs of a real view may sometimes present similar posers, but if we return from the drawing to the setting of Van Eyck's *St. Francis*, the basic kinship of the lay-out offers the easiest explanation of these inconsistencies. Not that Leonardo's drawing need be a copy of this or indeed any particular Northern landscape background, but it is from these that the basic schema is derived. The same applies to another of Leonardo's early drawings of a steep rocky river bank (Fig. 79). Judging by the size of the waterbirds, it can again not be a very high one. Its surface structure is quite close to the rocky ledges on the Ghent Altarpiece (Fig. 73). The derivation of the motif, I think, cannot be in doubt, but whether Leonardo simply copied it from a painting or went out to an appropriate river to match it against a real site, much as Cennini studied the rendering of mountains from stones in his studio, is a different matter.

In any case nobody is likely to claim that the landscape settings of Leonardo's paintings are renderings of real scenery. The derivation of his extraordinary vocabulary of rocks and crags from what Kenneth Clark has called the 'landscape of symbols' has frequently been discussed. What must interest us in looking at the *Madonna of the Rocks* (Fig. 81) is again the way these fantastic formations respond to the ambient light. We shall find that the complexity of the cave with its various openings gives the artist much scope for showing a variety of light effects suggesting both illumination and lustre, and we may discover to our surprise that these include an almost traditional gleaming ledge placed in the foreground of the composition. It is the same motif we observed in its schematic form on the *Good Shepherd* mosaic of the Mausoleum of Galla Placidia (Fig. 34), dating from some one-thousand years earlier, but Leonardo has 'rationalized' the device by turning it into the edge of a pool; the gentle support given by the angel to the Christ child to prevent it falling into the water gives an additional feeling of actuality to this device.

A closer analysis of the landscapes of the *Mona Lisa* and the Louvre *St. Anne* would bring out more of these elements of continuity, which only enhance the magic trans-

formation they have undergone through Leonardo's handling of light and of atmospheric effects.

If evidence were needed that Leonardo studied and observed these effects in nature, the *Treatise on Painting* would provide it on almost every page. But for the painter observation needs a focus, a frame of reference, and this is derived from the tradition he has absorbed in his youth. Leonardo said as much himself when he set out what he considered the proper sequence of study for a young apprentice:

> The youth should first study perspective, then the proportion of all things, then the handiwork of good masters to get used to fine features, *then nature, in order to confirm for himself the reasons of what he has learnt* (my italics). Then he should look for a time at the work of various masters, after which he should get the habit of applying his knowledge and practising his art.[22]

Some of the wonderful landscape drawings in Leonardo's oeuvre certainly represent Alpine ranges he had seen and observed to study the effects of atmosphere and distance (Fig. 80). But in selecting motifs for this exercise he was still guided, however unconsciously, by the ideas he had inherited.[23]

We art historians might do worse than follow Leonardo's advice and turn to nature in order to confirm for ourselves the reasons of what the artist had learned. We have concentrated so long on the morphology of different styles and visual idioms that we neglected to probe their descriptive potentialities for matching the visible world. It is true that the variety of styles which we encounter in the history of art confirms the idea that nature can be described in many different languages, but it happens to be wrong to infer from this premise that these descriptions cannot be either good or bad, true or false.

LEONARDO DA VINCI'S METHOD
OF ANALYSIS AND PERMUTATION

The Form of Movement in Water and Air

AN APOLOGY may be needed from an art historian proposing to approach a subject, however tentatively, that extends far into the history of science. One would have to be Leonardo to discuss anything in Leonardo—and if one were, one would probably never come to an end. I do not wish to dwell on the commonplace of Leonardo's universality. The problem is rather the unity of his thought. Every subject he approaches seems to absorb him completely and yet so expands under his gaze that we gain the impression that nothing else could have mattered to him throughout his life and that even his art should best be approached from this angle. This surely applies equally to his incessant studies of optics and of light and shade, to his studies of the geometry of equal areas in segments of circles, to his anatomical studies, or to his fascination with the balancing of weights. But none of these subjects, I believe, recurs with greater persistence than the subject of movement in water and air. The sheer bulk of his writings on that subject testifies to the key position it held in his mind. It was the only topic, apart from that of painting, for which a systematic search was made in Leonardo's notes, resulting in the seventeenth-century compilation entitled *Del Moto e Misura dell'Acqua*,[1] which unites Leonardo's observations and diagrams in nine books totalling 566 paragraphs. The only modern collection of Leonardo's writings on water by Nando de Toni is confined to the MSS. A to M in the Institut de France and even this selection comes to 990 notes.[2] The many more pages devoted to the subject in the Codex Leicester,[3] in the Codex Atlanticus, and among the Windsor drawings as well as a few others substantiate my claim that this subject was central to Leonardo's thought.[4] It concerned him as an engineer, as a physicist, as a cosmologist, and as a painter, and here as always it would be utterly artificial to divide up his mind into these modern compartments.

Take two of his most famous drawings in Windsor which have often been compared and rightly so. The one (Fig. 83) belongs to the visions of the Deluge and of the End of the World which so preoccupied Leonardo's mind towards the end of his life[5] and which still exert such a fascination on twentieth-century artists and critics; the other (Fig. 82) is a scientific study of the impact of water on water.[6] However different the two are in the scale of the phenomena they illustrate, they both share the interest in swirling movements and vortices that is so characteristic of Leonardo. Note that in the Deluge drawing it is the descending waters that appear to curl back in these spiralling movements, while in the scientific drawing the water is shown to well up and to form these complex curls and eddies round the rising rings of bubbles, which surround the minor whirlpools.

This was a contribution to an International Symposium on Leonardo at the University of California, Los Angeles, and was published in C. D. O'Malley (ed.), *Leonardo's Legacy* (Berkeley and Los Angeles, 1969).

It is obvious even to the casual observer that this drawing represents no mere impression of a particular sight that happened to take Leonardo's fancy. In fact, it belongs to a very large class of drawings concerned with the same problem of the effect of falling water on the pool below. Such drawings with their accompanying explanation occur as early as MS. A, from the early 1490's (Fig. 84),[7] and recur persistently at least to the second Milanese period when Leonardo attempted to assemble his notes on water (Fig. 85).[8]

What prompted me to take up the study of these astonishing drawings was the relation between seeing and knowing or more accurately between thought and perception, to which I have devoted my book, *Art and Illusion.*[9] There can be no more important witness for the student of this problem than Leonardo. He represents a test case for those of us who are interested in the interaction of theory and observation and are convinced that the correct representation of nature rests on intellectual understanding as much as on good eyesight. To Leonardo, this would have been a commonplace. He would not have written the *Treatise on Painting* with all its scientific observations if he had not been convinced that a painter must be more than 'merely an eye'. In fact, it is clear that he had to defend his position against his fellow-painters who resented this intellectualism no less than some of their successors do today.

> At this point [we read in the *Trattato*] the opponent says that he does not want so much *scienza*, that practice is enough for him in order to draw the things in nature. The answer to this is that there is nothing that deceives us more easily than our confidence in our judgment, divorced from reasoning, as experience shows, which is the enemy of the alchemists, the necromancers, and other simple minds.[10]

Leonardo's point is here surely that these charlatans also appeal to sense perception and make simpletons see ghosts or gold because they fail to combine their judgement with reason. It would hardly be necessary to stress Leonardo's intellectual bias were it not for the fact that in the history of science he has been represented for a long time as a person who simply looked and therefore knew more than all his contemporaries. It must be admitted that he sometimes talked as if this were the case. Exasperated as he was by the pride and ignorance of the bookish professors, he hammered it home that experience (*sperientia*) was his only mistress and guide. No wonder that the conception of science that saw in him a forerunner of Francis Bacon and inductivism stressed this observational bias of his writing in order to exalt his modernity. I need scarcely say that this interpretation is obsolete. It is obsolete in the methodology of science, where it is increasingly recognized that science does not progress by looking, but by taking thought, by the testing of theories and not by the collection of random observations.[11] It is obsolete also in Leonardo-studies where we have learnt increasingly to see and understand this element of continuity in the master's work, that thrilling progress of his understanding that starts, like that of every human being, from the accumulated ideas of past generations but proceeds to check and criticize ideas in the light of

sperientia.[12] This is surely as true of his studies of water as it is of his anatomical work. But while historians of science have provided us art historians with an admirable key to the understanding of Leonardo's anatomical drawings, no historian of hydraulics has as yet obliged us with a similarly detailed study of his drawings of water. In the absence of such a study art historians have sometimes fallen back on the reflex movement of praising Leonardo's unfailing powers of observation and intuitive vision. A glance at our illustration (Fig. 82) shows the insufficiency of such a comment. It is clear that it is not a snap-shot of water falling upon water but a very elaborate diagram of his ideas on the subject. No waterfall or whirlpool permits us to see the lines of flow with similar clarity, nor do bubbles in turbulent water ever distribute themselves so tidily. Even those who are not used to watching these effects must surely agree with L. H. Heydenreich that this beautiful drawing is an abstract, stylized representation,[13] a visualization of forces, not a record of individual observations. There are innumerable such diagrams in Leonardo's notes about water, ranging from little pictures on the margin to a slight visual indication of the content of a note. Some of these are mere pictographs repeating the information of the text,[14] many others support the description like an illustration in the tradition of geometrical or optical treatises, referring the reader to the letter symbols in the drawing. 'The water m, n, descends in b, and strikes under the rock b, and rebounds c, and hence it rises up turning in q, and the things hurled in f, by the water struck by rock b, rebound at equal angles. . . .'[15] The advantage of this method of description is clearly that it allows Leonardo to record the sequence of movements as in the following note, 'Here the water close to the surface performs as you see, rebounding upwards and backwards in the impact, and the water that rebounds backwards and falls above the angle of the current goes under and does as you see above in a, b, c, d, e, f' (Fig. 86).[16]

Leonardo certainly visualized his Treatise on Water as illustrated by countless such diagrams. Already some of the pages in MS. C of 1490 (Fig. 87) show the form which such a book might ideally have taken. He returns to it particularly in MSS. A and F (Figs. 88 and 89) and in some pages of the Codex Leicester. Some openings of Carusi's and Favaro's edition of the Codice Barberiniano, *Del Moto e Misura dell'Acqua*, give perhaps a fairer idea of the place Leonardo wished to assign to these diagrams than any selection made on the ground of their visual merit.

Yet, if anything is striking in these studies and notes about water, it is the predominance of the word and the role assigned to language. Whether he knew it or not, in the *paragone* (rivalry) between word and image the word was here very often in the lead.

There is much talk in contemporary art criticism and art teaching about the alleged difference between 'verbal types' and 'image types'. The artist is said to be an 'image type' and concern is frequently expressed lest his mind be corrupted by too much contact with the discipline of language. Nobody who has read through Leonardo's notes can doubt the importance that linguistic articulation held for him. His notes on

water in particular show his striving for mastery of this medium: he quite systematically builds up a vocabulary of words and concepts with which to catch and evoke the fleeting variety of phenomena and fix them in his mind.

The patience with which he lists, divides, and subdivides these phenomena may well outlast the patience of the modern student of these notes. Indeed, no less an admirer of Leonardo than A. E. Popham pronounced them to be almost unreadable.[17] And yet if one tries to work though this mass of notes, they acquire a singular fascination. Somehow the manner and the matter appear to fuse. Like the elusive phenomena they seek to describe and to capture, the stream of language meanders leisurely around obstacles only to rush headlong into abysses of metaphysical speculations where it turns and remains on the spot, seemingly caught in an impossible position from which there is no escape. Suddenly a fresh thought shoots up from the depths and the ideas flow again in eddies and waves seeking the central ocean of Leonardo's view of the universe and of the role that the elements are destined to play in its life and its death.

I shall not and cannot submit the reader to this ordeal by description and repetition, but it is essential to my theme that I give at least an idea of this astonishing effort on the part of Leonardo to make his language sufficiently pliable to describe and to analyse the movement of water. There is a note in MS. I, dating, it is believed, from *circa* 1497–9, which simply lists an incredible numbers of words that may be used in the description of water flow: *Risaltazione, circolazione, revoluzione, ravvoltamento, raggiramento, sommergimento, surgimento,* and so on through sixty-seven concepts, such as *veemenzia, furiosità, impetuosità, concorso, declinazione, commistamento.*[18]

Thus when Leonardo penned his famous descriptions of the Deluge he could draw on this rich thesaurus of words and phrases he had collected himself.

But it is not the words that matter here, but their power of creating distinctions and establishing categories. Throughout his life, I believe, Leonardo followed a method of systematic analysis and permutation. Far from starting from observation, he asked himself what variables could be identified in a given phenomenon and what combinations and permutations were possible *a priori*, as it were. We shall see this method at work in the chapter on his grotesque heads. The variety of vortices offered an even greater challenge.[19] MS. F, dating from some ten years later, is particularly rich in attempts to map the full range of possibilities for waves, currents or whirlpools.

Of the vortices on the surface and of those created at various depths of the water, and of those which take up the whole of that depth and of the mobile and of the stable ones, of the oblong and the round ones, of those which do not change and those which divide, and of those which convert into those where they join up, and of those which are mixed with falling and reflecting water and turn that water around. What kind of vortices turn light objects on the surface without submerging them, what kind are those that do submerge them and turn them at the bottom and then leave them there, what kind are those that detach things from the bottom and throw them up to the

surface of the water, what are oblique vortices and what upright ones and what level ones.[20]

What makes these paragraphs even more awe-inspiring is that their form and context reveal them as plans for more detailed chapters which Leonardo called 'books'. Sometimes we find page after page covered with these chapter headings which in their totality are to form a complete encyclopedia of the forms of water and of currents.[21] There is little doubt that in these schemes Leonardo was influenced by the Aristotelian concept of science as a systematic inventory of the world. He wants to classify vortices as a zoologist classifies the species of animals.

I think I am right in saying that such a classification of whirlpools or of waves would mean little to a modern scientist. He would probably say that the distinction between vortices that carry objects up and those that drag them to the bottom is not valid because the same vortex that spirals down also throws water up. Moreover the concept of turbulence, which he uses to describe the state when normal flow is upset, operates with the idea of randomization where the path of an individual particle becomes quite unpredictable.[22] Not that he does not also study the forms taken by waves and vortices, but what interests him is that these are mathematical relationships of a complexity that often causes him to admit defeat.

Leonardo is frequently quoted for his beautiful saying that mechanics is 'the paradise of mathematics'.[23] A glance into the most elementary text-book of fluid mechanics will convince most of us that this branch is the hell of mathematics. The arithmetical and geometrical tools at Leonardo's disposal were utterly far removed from those he would have needed to fulfil the wildly optimistic hope with which he started out—the hope of completely mapping out and explaining any contingency in a field of physics that still eludes such rigid treatment.

The *History of Hydraulics* by Hunter Rouse and Simon Ince (Iowa, 1957), devotes only a few pages to Leonardo before turning to the mathematical achievements of Bernoulli in the seventeenth century and of d'Alembert in the eighteenth. But the authors grant that Leonardo should be credited with the formulation of one basic law which is now known as the principle of continuity. It says that 'a river in each part of its length in equal time gives passage to an equal quantity of water, whatever the width, the depth, the slope, or the tortuosity'. It follows from this principle that (as Leonardo puts it in MS. A of 1492) 'a river of uniform depth will have a more rapid flow at the narrower section than at the wider, to the extent that the greater width surpasses the lesser'.[24]

This correlation is a matter of thought rather than of sight; it is something that Leonardo reasoned out, not something he can have observed and measured.[25] Once you assume that water cannot be compressed, this principle follows, for the narrower course must then speed up the flow to keep step, as it were, with the wider portions of the river.

Having learnt to speak with greater respect of deduction than did the historians of

science who were so strongly under the spell of Baconian inductivism, we can appreciate again Leonardo's original plan to make the science of water a deductive science starting from first principles like Euclid's Elements. These principles from which Leonardo started he found in the tradition of Aristotelian science, which dominated the thought of his age. According to this doctrine the sublunar world—the world under the moon—consisted of the four elements of earth, water, air and fire, each of which had its 'proper place' in the universe. Earth, as the heaviest, occupied the centre, after which came water, then air and then fire. There did not seem anything arbitrary in this account, for was it not a common experience that these substances tended to their allocated place when they were dislocated from it? Let go of a lump of earth and it will fall in the direction of the centre unless impeded by some obstacle. Water will naturally make up the second sphere, coming to rest in the ocean or in lakes above the solid earth. But release an air bubble in water and it will want to rise upward to its own home, the atmosphere, and when you, finally, light a fire in our atmosphere you will see it striving to rise higher still to its rightful place, directly below the fifth element or 'quintessence', the weightless ether, of which the stars are composed.

We find this orthodox Aristotelian account of what was called 'natural movement', the movement of an element towards its home, restated in Leonardo's MS. C, dating from 1490.

> All elements removed from their natural place desire to return to that place, most of all fire, water, and earth. And the more this return is effected along the shortest path, the straighter is that line and the more straight it is, the greater is the impact when it is opposed.[26]

Here was a first correlation that could easily be verified by observation, the difference between a winding and a straight river course, illustrated in the accompanying diagram. It was the exemplification of a cosmic law.

We know with what awe Leonardo looked upon the operation of these laws and with what fascination he sought to reason out the consequences that followed from their universal validity. Thus he devised in the same early note-book, folio 23*v*, what we would call an ideal experiment of a purely deductive character:

> If there were a lake of vast extent without entrance and exit and unruffled by wind, and you removed a minute fraction of the bank below its surface, all the water above that cut would pass through this cut without moving any of the water below.

Leonardo draws a vessel of water covered by a film of oil that can be drained off without making the water stir (Fig. 90). 'In such a case,' we read, 'Nature, constrained by the reasons of its law that lives implanted within her, effects that the surface of the water contained within the closed banks remains everywhere at equal distance from the centre of the earth.'[27]

Leonardo could not know the friction caused by the current thus created. But, this

very attempt to construct an ideal situation of what we would call an 'ideal fluid' testifies much more to his scientific genius than would the alleged accuracy of his eye.

There is a second general law that Leonardo applied in his discussion of movement—the law of reflection or rebound which he drew upon in MS. A of 1492:

> It is clearly seen and it is known that the waters that strike against the banks of rivers move like balls thrown against the wall which are reflected at similar angles to the angle of their impact and then hit the opposite walls (Fig. 91).[28]

Leonardo as a water engineer was particularly interested in this effect, which suggested to him the possibility of predicting the main points subject to erosion. He constantly returns to such situations in which the water is obstructed on one bank and through the consequent rebound damages the opposite bank[29] (Fig. 92). But as a theoretical physicist the comparison between the bounding ball and the reflection of water held an even greater promise for him. For this movement of the ball, so he thought, followed a strict law not only in its shape but also in the length of the path traversed. He was convinced, as we know from MS. A, that if you throw a ball obliquely to the ground its zigzag path between the bounces will be exactly as long, and take as much time for completion, as if you had thrown the ball horizontally through the air (Fig. 93).

Needless to say, this is one of Leonardo's *a priori* deductions which is refuted by experience: he had again failed to take into account the friction arising from any impact which would break the momentum of the throw. Owing to this friction, as we learn today, some of the energy of the throw is transformed into heat and dissipated. We, too, in other words, hold fast to the idea that there is a law governing the relation of these two events, and we, too, speak here of the law of the conservation of energy.

Though he had no knowledge of the complexity of these relationships Leonardo had a vision of the crucial importance of this postulated law:

> Oh, how miraculous is thy Justice, First Mover! Thou didst not want to deprive any force of the order and equality of its necessary effects![30]

Leonardo, in fact, had derived this general law from another of Aristotle's premises and it is this line of thought that ultimately helps to account for Leonardo's preoccupation with vortices:

> Quite generally—we read in the same early note-book—all things desire to maintain themselves in their nature. Hence the current of water desires to maintain its course according to the force that caused it, and when it finds an opposing obstacle, it completes the length of the initiated course by circular and whirling movements.[31]

These movements, too, 'will traverse the same length during the same time as if the path had been straight'.[32] Combine this law with the principle of continuity and you have the explanation of the vortices Leonardo was so fond of drawing, curling outward

when the course of the water widens. For this widening of the river-bed must slow the water down and thus create an obstacle for the water rushing in at greater speed, which has to be compensated for in turning movements[33] (Fig. 94).

These movements, we have seen, will be exactly proportionate to the impulse that creates them. A waterfall, therefore, will necessitate a much greater length of vortex movements—which would indeed be the case if much of its energy were not transformed into heat by friction.

I believe that Leonardo's diagrams of water become much clearer and even more beautiful if we read them, as they were intended to be read, as illustrations of this interlocking system of axioms. The extended corkscrew eddies in the Windsor drawing no. 12663r (Fig. 95) are a case in point. They are neither stylized nor observed; they are an indication of the strength of the water's impact which spends itself in these spiralling movements.

But the drawing also illustrates the complexity that Leonardo's thoughts had reached in the treatment of these laws. For it was clear that in almost every given case the various factors or principles he saw at work would combine in shaping the movement observed. The principle of continuity, the movement of the river following the tendency of the water to seek its place nearest to the centre of the earth, the reflections and eddies on meeting obstacles, and the extra impetus caused by a waterfall—all had to be taken into consideration in accounting for the actual movement.

One of Leonardo's most famous illustrated notes on water (Fig. 96) is designed to exemplify such a combination. It is the note accompanying Windsor 12579r:

> Observe the motion of the surface of water, which resembles that of hair, which has two motions, one of which depends on the weight of the hair, the other on the direction of the curls; thus the water forms turning eddies, one of which follows the impetus of the main course, while the other follows that of incidence and reflection.[34]

The point Leonardo here wishes to make is actually rather simple. He wants to remind us only of two factors, the spiralling movement of the vortex and the forward pull of the river.[35] Leonardo sometimes called the resulting formation a column-shaped wave.[36] The meeting and crossing of these waves and the resulting eddies were also to be systematized in the Treatise on Water (Fig. 89).

Once more I should like to mention the staggering boldness and optimism of this programme, to which Leonardo devoted so much time and effort. He knew that the phenomenon of the wave differed in principle from that of water flow. There is the famous passage in which Leonardo described and analysed the effect of throwing a stone into a stagnant pool with the ripples spreading outwards in ever widening circles,[37] adding that the movement of the waves did not shift the water masses, for he had observed the floating objects on the pond bobbing up and down on one spot. Leonardo's splendid intuition also grasped the comparison of this swaying motion with waves appearing to run over a cornfield without the individual stalks being shifted from their

place.[38] He also knew that this propagation of an impulse could be observed in moving water when the resulting circles would turn into elongated ovals,[39] and if I interpret another passage correctly, he saw that the two movements of water and impetus could cancel each other out, resulting in a standing wave.[40]

I have tried to consult eminent specialists in hydrodynamics about the way these forces interact in a turbulent river, but they only shook their heads or shrugged their shoulders. There are too many variables; the forces at work are quite beyond computation even with modern means. But Leonardo hoped originally to account for every eddy, and this despite the fact that he had to consider further complications arising from the interaction of water with the other elements. The earth of the river-bed and of the bank exerted friction that slowed down the movement of water in its vicinity,[41] as he was able to observe by watching the varying height of eddies caused by sticks placed at varying distance from the shore.[42] The earth carried in the turbulent water increased its weight and therefore its impact.[43]

There is, in addition, the element of air which gets caught in falling water and desires to return to its proper place. In the Windsor drawing that investigates the effect of this contrary movement on the eddies (Fig. 95) we find the characteristic heading *opera e materia nuova non più detta*, 'new work and matter not treated previously'. It concerns the idea that what impedes some of the water from following the course of the river downwards is the captured air in the form of foam. It is this air-cushion that prevents the vortices which turn in different directions from interfering with each other and cancelling each other out.[44]

I hope that even this selection of Leonardo's ideas[45] may enable us to return to our first example, Windsor 12660v (Fig. 82), with fresh eyes and also to appreciate the text:

The movements of the falling water after it has entered the pool are three in kind and to these must be added a fourth, which is the movement of the air that is drawn into the water by the water. And this is the first, and let it be the first to be defined; and let the second be that of the air drawn into water, and the third the movement of the reflected waters after they have yielded up the compressed air to the other air; when the water has risen in the shape of large bubbles it acquires weight in the air and hence falls back on to the surface of that water, penetrating it as far down as the bottom, hitting and eating away that bottom. The fourth is the swirling movement on the surface of the pool of the water that returns to the place of its impact since it lies at a lower level between the falling and the reflected water. There is to be added a fifth motion called the welling motion, which is the movement of the reflected water when it carries up the air to the surface that was submerged with it.

 I have seen in watching the impact of ships that the water below the surface observes its revolutions more completely than the one that lies open to the air, and the reason for this is because water has no weight within water but water has weight within air.

Hence water that moves within stagnant water has as much strength as has the impetus that is imparted to it by the moving object and this impetus consumes itself in the aforementioned revolutions.

That part of the impetuous water, however, that finds itself between the air and the other water cannot carry out so many [revolutions], because its weight impedes its agility and therefore it cannot complete the whole revolution.[46]

I have ventured to quote this long and, in every sense of the word, tortuous passage because it surely drives home the point that a drawing like this must be read as a diagram visualizing Leonardo's theoretical propositions rather than a kind of snap-shot achieved by a miraculous pair of eyes. Clearly some of these propositions are correct while others would not be accepted in this form by modern scientists.

Note, for instance, that despite the distinction that we saw Leonardo make between wave movement and flow he here seems to equate waves with incomplete vortices, that is, with a flow pattern. He was even partly right, in so far as the individual particle in a wave tends to move up and down in a wheel-like motion, but here Leonardo's partial insight sometimes misled him into drawing waves curling backwards, as if the undulation itself strove to complete the circle.[47]

To stress this 'deductive' and theoretical character of many of Leonardo's diagrams, however, does not necessarily mean that the formations he illustrated could not really occur in nature. Just as Ptolemy's system of astronomy was capable of 'saving the phenomena' observed in the night sky, so Leonardo's largely Aristotelian mechanics could frequently be moulded to accommodate what he saw. It is no criticism of his genius to say that the modern high-speed camera sees more and occasionally sees differently. Some of the forms of movement it frequently records cannot be matched from any of Leonardo's studies, but several can be. Many of Leonardo's drawings of vortices arising immediately behind an obstacle with the water or air curling round and back against the stream from both sides show a close resemblance to certain photographs made of similar patterns (Figs. 97 and 98). Whether it is necessary to attribute this similarity to Leonardo's rapid and acute vision is perhaps another matter.[48] Actually an ideal vortex can result in an almost static pattern and can be watched at leisure.[49] There are even more beautiful movements in water which Leonardo would have loved if he could have seen what the camera records (Fig. 99).

But we have seen that it would still be dangerous to infer that Leonardo looked upon these vortices in the same light as the modern scientist does. There is evidence that his interest in this whole phenomenon was sparked off by another legacy of Greek science which had occupied the mind of man for many centuries. It is the idea that nature abhors a vacuum and that any displacement occurring in a fluid which threatens to cause such a vacuum is therefore immediately compensated for by a contrary movement filling the vacant place. The first detailed description of this circular movement occurs in Plato's *Timaeus* where the consequence of breathing is discussed:

Inasmuch as no void exists into which any of the moving bodies could enter, while the breath from us moves outwards, what follows is plain to everyone, namely, that the breath does not enter a void but pushes the adjacent body from its seat; and the body thus displaced drives out in turn the next; and by this law of necessity every such body is driven round towards the seat from which the breath went out and enters therein, filling it up and following the breath; and all this takes place as one simultaneous process, like a revolving wheel, because of that no void exists.[50]

Plato connects this circular movement with the circulation of the elements in the universe. There is no proof that Leonardo knew this particular passage, but there is a famous critical reference to Plato's *Timaeus* in MS. F in connection with the geometrical theory of elements.[51] There are certainly many instances where this kind of reasoning influenced Leonardo's thought. He postulated in MS. A that the movement on the surface of the water must be compensated by a contrary movement along the bottom, attributing such a movement also to the depth of the sea.[52] Even his theory of the tides in which the attraction of the moon is rejected relies on this idea of a contrary motion due to the water of rivers pushing into the ocean[53] (Fig. 100).

But the most important role was reserved for this theory of reflow in Aristotle's physics where it became known as the theory of *antiperistasis*.[54] This much debated theory arose in answer to an obvious difficulty created by Aristotle's theory of motion. He believed that here on earth, or rather in the sublunar sphere, rest was the normal state for things in their proper place and that movement could only displace them contrary to their inherent tendency as long as they were pushed. Once contact with the pushing force was lost they should therefore return to their proper position. Unfortunately, this deduction could not be reconciled with the simple fact that a stone continues to fly upwards when it has left the throwing hand, and an arrow when it has left the string. To avoid a break-down, an explanation had to be sought in the behaviour of the medium through which the stone or arrow travelled. Each of the particles of the air which had received a push would push the next, and, as in Plato, the need to fill the resulting void would lead to a circular movement. Neither Aristotle himself—who had his qualms about this explanation—nor those of his medieval commentators who appeared to accept it were very explicit about the way *antiperistasis* solved the problem posed by 'enforced' movement. Did the resultant waves open a path to the projectile and carry it forward or did they close up behind it and thus push it along?

In any case, the Aristotelian idea that the medium was responsible for this movement was certainly accepted by Leonardo in his first Milanese period.[55] There is a detailed account of these phenomena in MS. A, where Leonardo described the 'circular movements' of the medium and compares the movement of a projectile with that of a boat through water: '. . . And since no place can be a vacuum, the place whence the boat leaves desires to close and creates a force like a cherry-stone pressed between the fingers, and creating this force it presses and catches the boat.'[56]

The comparison, added in the margin of the note, between the action of the medium and that of the fingers that makes a slippery cherry-stone shoot forward could not be more clear nor more plausible.

There is a similar account in the Codex Atlanticus intended to explain why fish move faster in water than birds in the air, though air being thinner one would expect the opposite. I am far from sure that Leonardo's observation was correct but his explanation again draws on Aristotelian physics:

> This occurs because water in itself is denser than air and hence heavier and for this reason it is faster in filling up again the vacuum that the fish leaves behind it. Also the water that it strikes in front is not compressed as is the air in front of the bird and creates a wave that by its movement prepares and augments the movement of the fish.[57]

Some of these ideas actually remained with Leonardo throughout his life. Thus we find in the late MS. G, which dates from after 1510, a famous comparison between the bodies of fishes and of well-built boats, which is sometimes quoted to show Leonardo's anticipation of the stream-line principle (Fig. 101). But this is only one side of the story. The text reads:

> These three ships of equal size, length, and depth below the water, moved by the same force will move at different speeds because that ship that directs its broad end forward is faster, for it is like the shape of birds and of fish. And such a ship divides in front and at the sides a large quantity of water which, with its revolutions, pushes the boat from two-thirds of its length behind. . . .[58]

Of course Leonardo was wrong in believing that the shape of the rear end would make the water push the boat forward, though he was right in so far as this shape prevents drag and facilitates the forward movement.

We know that by this time Leonardo had explicitly rejected the idea of *antiperistasis*, at least as far as the action of the air was concerned. There is a long discussion of the impossibility of this notion in the Codex Leicester which leaves no doubt on this score.[59] But a habit of mind is not so easily discarded, least of all after the age of fifty. The theory had focused his attention on phenomena which are both striking and widespread—the backward turning of fluids—and these movements continued to engage his interest to the end. Thus he explained the closing of the valves of the heart by the turning movement of the blood[60] and it has been suggested that he may well have been right with this surmise. In any case the application of his hydrodynamic ideas to his anatomical studies at this period brought him uncannily close to an understanding of the transformation of energies. He now considered the possibility of the eddies and frictions of the blood being the cause of the heating of the blood and notes for future reference: 'observe whether the churning of milk when butter is made causes heat'.[61]

There is no doubt, however, that for Leonardo these fresh insights and progressive revisions also involved an intellectual sacrifice. It was not easy to pick holes in Aristotle's

mechanics, because with all its manifest absurdities it had one supreme virtue which made it hard to abandon. That virtue was precisely its simplicity that allowed it to subsume the most disparate phenomena of nature under one unitary law. Today physicists are puzzled by the fact that two apparently independent forces of attraction can be discerned in nature, the force of gravity and the electro-magnetic forces which account for the cohesion of matter. Aristotle did not know of either of these forces but he had a convenient formula that seemed to go a long way in explaining observed movement. He taught that all things desire to maintain their nature. In ordinary life this desire manifests itself in what we call the elasticity of objects, though neither Aristotle nor Leonardo had a separate word for this important concept, which was only coined and named in the seventeenth century by Robert Boyle. The bow or the spring which bounces back when deformed is the most obvious illustration of this law. As an engineer Leonardo could not but be constantly concerned with this method of preserving and transmitting energy. Winding up a clockwork we store up the energy that will be released as the spring unwinds. Apart from the natural sources of energy such as the currents of water and air Leonardo's age had few other methods of producing 'force' and thus Leonardo devoted a good deal of attention to springs or twisted ropes as motive powers (Fig. 102). True, their energy was soon spent, and it is interesting to see how he attempted to prolong their effect by coupling a series of springs, thus ensuring a continuous movement.[62]

Once more we are struck by the unity of Leonardo's thought when we find him explaining to his fellow artists the form of draperies (Fig. 103) by Aristotle's version of this law of elasticity:

> Everything by nature desires to maintain its being. Drapery being of equal density and thickness on both sides desires to remain level; hence when it is constrained by some fold or plait to depart from that flatness, you can observe the nature of that force in that part where it is most constrained. . . .[63]

I believe that in the light of these observations Leonardo's much quoted notes about 'force' dating from the first Milanese period fall into place. They sound less mystical if we assume that in writing and rewriting these drafts Leonardo was thinking of the uncoiling of a spring or the release of a catapult:

> Force is complete and whole throughout itself and in every part of it. Force is a non-material (*spirituale*) power, an invisible potency which is imparted by accidental violence from without to all bodies out of their natural inclination . . . by animated bodies to inanimate bodies, giving to these the semblance of life . . . it speeds in fury to its undoing, retardation strengthens and speed weakens it. It lives by violence and dies through liberty . . . great power gives it great desire for death. It drives away in its fury everything that stands in the way of its ruin . . . it inhabits the bodies placed outside their natural course and usage . . . nothing moves without it . . . no sound or voice is heard without it.[64]

What inspired Leonardo to grope for these solemn utterances must have been the realization that, given the physics of Aristotle, all force in this sublunar world is ultimately due to 'accidental' dislocation. Without 'violence' applied from outside the elements would all be at rest in their 'proper place' and it is their desire to achieve this natural state which accounts for all observed movement. This applies specifically to the theory of projectiles, which, in modern terms, is a theory about the elasticity of the medium. The medium through which the body moves has to give way only to bounce back and in doing so it carries or thrusts the projectile forward. Air or water thus can be seen to wind or unwind not unlike a coiled spring and it is like coiled springs that Leonardo often draws their movement.

We have seen, moreover, that according to Aristotle what is called 'natural' (as distinct from 'enforced') movement originates in the same fundamental law that all things desire to maintain their natural place and form. To lift a stone and let it fall or to release an air bubble in water is no different in principle from stretching a rubber band and letting it snap back.

Looked upon in this way, the universe is like an enormous wound-up clock; the forces we observe in it are due to previous violent actions that create movement. There would be no water course or rain in our world if heat had not previously drawn it up;[65] its force and fury in rushing downwards is the result of its desire of returning to its proper place.[66]

What goes for the 'macrocosm' Leonardo assumed also to be true of the 'microcosm', the human organism. In his early notes on the physiology of the senses, at any rate, he conceived of 'impressions' as due to percussion.[67] And in one of his most poetic notes Leonardo equates the hopes and desires of the soul with a desire for its own undoing, the release of the spring.

> Now look at the hope and the desire to seek the home and to return to the primal chaos, which acts like the moth to the light, and man, who with constant longing always joyfully waits for the new spring, the new summer, always the next months and the next years—it seeming to him that when the things he longs for arrive they come too late; and he does not see that he desires his own undoing. But this desire inheres in that quintessence, the spirit of the elements, which finding itself shut up as the soul of the human body desires always to return to him who sent it there; and I want you to know that this same desire is that quintessence, companion of nature, and man is a model of the world.[68]

Students of Leonardo have become aware of a gradual change that affected his philosophical outlook in his later years. Detailed observation and criticism increasingly compelled him to revise and qualify his unified theory. We have seen that he had come to reject the Aristotelian tradition, but there was nothing to take its place. We detect a note of scepticism and disillusion in some of the notes that date from this last period; thus we read in MS. K dating from *c.* 1507:

The water that moves through the river is either called, or chased, or it moves by itself. If it is called or rather commanded, what commands it? If it is chased, what chases it? If it moves of itself, it shows itself to be endowed with reason, but bodies which continuously change shape cannot possibly be so endowed, for in such bodies there is no judgement.[69]

Even where these changing shapes are concerned there is a new awareness in MS. G, the latest of the note-books, of the immense variety and unpredictability of the 'infinite number of movements' in water currents, with a marvellous description of a floating object carried along by the jostling waves:

... which movement is sometimes fast and sometimes slow, and sometimes it turns right and sometimes left, now up and now down, revolving and turning around itself now this way and now the other, obeying all its movers and in the battle arising between these movers it always falls prey to the victor.[70]

There is a similar awareness of the limits of human knowledge in the note on one of the Windsor drawings concerned with whirling water:

Navigation is not a science that has perfection, for if it had it would save (us) from all peril, as birds are able to do in storms of rushing air and fish in storms at sea and in flooding rivers where they do not perish.[71]

Had Leonardo renounced his ambition to map out all the forms of movement in water and air? Had he given up building the 'bird'? We know that in these very years he also abandoned the analogy between macrocosm and microcosm which had guided his thought about the circulation of water and of blood. But though these unifying ideas had broken in his hands, he still used their fragments as he had to if he was not to give up the search altogether. In his studies of the air and wind, though he had given up the notion of *antiperistasis*, he continued to assign a great deal of importance to the elasticity of the medium. It is precisely this reliance on the compressibility of air that separates Leonardo's studies of flight from modern aerodynamics, where this characteristic is neglected in speeds lower than that of sound.[72] Leonardo remained convinced that it was the compression of the air under the flapping wings of the bird that provided the spring-like lift in seeking to regain its normal density (Fig. 104). He also much overrated the degree to which the air in front of a moving body was condensed and that in its wake rarefied. It was to this fact that he attributed the turning movements of an object falling through the air. The falling panel compresses the air which therefore pushes it towards the rarefied air and causes it to turn[73] (Fig. 105).

I believe it is this theory which accounts for the most striking feature in Leonardo's so-called Deluge drawings, the way the falling waters curl back as if they formed vortices in the air. The unwinding of the universe is not a simple collapse; it results in fresh vortices that spend their fury in the air, causing winds and tornadoes.

I hope it is apparent that Leonardo's preoccupation with these swirling and spiralling movements was not entirely a matter of aesthetic preference. Not that his artistic sense did not respond to the beauty of such forms. We need not speculate here, for he said so. In all Leonardo's meticulous descriptions of natural phenomena there are only very few where he allows himself an expression of delight. There is at least one in his notes on water, from his second Milanese period, where he discusses that interpenetration of the elements which is caused by heat. He suggests an experiment with boiling water to which a few grains of millet can be added:

> Through the movement of these grains you can quickly know the movement of the water which carries them, and by means of this experiment you can investigate many beautiful movements which occur when one element penetrates the other.[74]

Imagine the delight that Leonardo with his love of intricacy and interlace must have felt at the crossing and recrossing of waves.

I have spoken at the outset of the unity of Leonardo's thought, and I am convinced that the conception he had formed of the working of impulse and recoil that together create the variegated shapes of water also had its echoes in Leonardo's compositions.

What else is the *Last Supper* but such a study of the impact a word is seen to make on a group recoiling and returning (Fig. 106)? I know that this sounds far-fetched, but this metaphor would not have surprised Leonardo. On the last page of the Codex Leicester he quotes the beautiful image from Dante's Paradiso (XIV, 1–3) illustrating the effect of the words of St. Thomas, who stands outside the circle, on Beatrice in the centre, and then back from her to the circumference:

> Dal centro al cerchio, e sì dal cerchio al centro
> Movesi l'acqua in un ritondo vaso
> Secondo ch'è percossa fuori o dentro.

(From centre to circumference and again from circumference to centre moves the water in a round vessel according to whether it is knocked outside or inside.)

We may link this image with one of the more mysterious of Leonardo's notes on the propagation of impulses:

> On the Soul: The movement of earth against earth in collision results in little movement on impact. Water hit by water creates circles around the point of impact. The voice in the air creates the same along a greater distance; even larger ones in fire, and longer still the mind in the universe, but since the universe is finite the impulse does not extend to the infinite.[75]

I do not pretend quite to understand this mysterious speculation but I think it justifies our thinking of the actions of rational beings as compelled by similar dynamic laws as those governing the course of water and air.

Once we are on this tack we may also compare the central group of the *Battle of*

Anghiari with the clash of forces interpenetrating in a whirlpool. I would not insist on these comparisons for they are not needed to prove the effortless transition in Leonardo's *oeuvre* between the studies of water and his artistic creations. As we have seen, the descriptions and drawings of the End of the World cannot be isolated from Leonardo's scientific diagrams and notes (Fig. 107).

These astounding creations have found such a vivid response in the doom-laden atmosphere of the twentieth century[76] that I could not add much to what has been written about them. There is only one point that I should like to make and that is a highly speculative one. It is usually assumed that these drawings represent the private meditations of the ageing artist. There is indeed in these sketches an element of that perpetual monologue on which we seem to eavesdrop whenever we try to penetrate into the master's universe. And yet I do not see why this should apply more to the drawings of the Deluge and of Doomsday than to others of his notes and plans. Might he not have planned such a work, a work that would embody his insights into the workings of the elements and the phenomena of nature down to the minutest effect?

Though these are mere speculations, it would not be out of keeping with Leonardo's character if one related the crystallization of that project to his rivalry with Michelangelo. Arriving in Rome in December 1513 and staying there off and on till 1516, he cannot but have seen the Sistine Ceiling, where he would have found that his erstwhile competitor had progressed even further in the rendering of the human body but that he had re-treated even further from the rendering of all the atmospheric effects that for Leonardo constituted the glory of painting. A glance at Michelangelo's rendering of the Deluge (Fig. 108) in particular would have convinced Leonardo that the master was not *universale*, no more than 'our Botticelli' had been, who made most wretched landscapes.[77]

Leonardo could still beat him there. Gantner has noticed the distant similarity between Michelangelo's Deluge composition and Leonardo's Windsor drawing 12376 (Fig. 109) but, more cautious than I, he did not draw any conclusions from this.[78] Might not Leonardo have set to work to demonstrate the rendering of the Deluge or of Doomsday as a vast cosmic catastrophe? Might he not even have dreamt of such a commission?

I certainly cannot prove or even make likely the hypothesis that Leonardo hoped to crown his studies of the movement of water and air by a work in Rome that would challenge the great Michelangelo and present a cosmic diagram of the unwinding of the universe. But maybe we can still catch the last reverberations of such a plan, the circles left by the impact of his mind on the mind of others.

We remember that where Vasari speaks of the effect that the art of Michelangelo had on Raphael he attributes to the younger master motives like those I have attributed to Leonardo. He makes him deliberately avoid a direct competition with Michelangelo's mastery of the nude and rather concentrate on those compartments of painting his rival had neglected, including 'fires, turbulent and serene air, clouds, rain, lightning'.[79]

Vasari may, of course, have made up this interpretation, as he made up others. He

may simply have rationalized the contrast he saw between Raphael's second stanza and his first. But it is also possible that his story contains an important grain of truth. After all he had a very good source: he still knew Raphael's favourite pupil Giulio Romano and had been his guest in Mantua some twenty years after the master's death.

I have always felt that the elusive presence of Leonardo in Raphael's work is so strong that we should assume a personal contact between the two, perhaps both in Florence and in Rome. This is a wide field, but we need not explore it to admit at least the possibility that Giulio Romano still knew something of Leonardo's talk and even of his plans to outclass Michelangelo. For this would explain that it was Giulio Romano who both preserved and traduced such a project in that sensational virtuoso piece, the *Sala dei Giganti* (Fig. 110), which Kenneth Clark has so surprisingly and yet so rightly linked with Leonardo's conception of art.[80] One hesitates to place the two side by side, but Leonardo's sketches not only contain the blowing wind-gods and the falling mountains, his description even includes the motif of those who 'not satisfied with closing their eyes with their own hands, placed one over the other and covered them so as not to see the cruel slaughter of the human race by the wrath of God.'[81]

But if there was such a lingering memory of Leonardo's project, it was finally blotted out by his surviving rival. Michelangelo's *Last Judgement* makes us doubt whether even a Leonardo could have evoked a more shattering image of the 'day of wrath' (Fig. 226). By the time it was painted science and art had begun to go each its own way.

The Grotesque Heads

THE grotesque heads, which Leonardo liked to draw in such profusion, represent perhaps the least studied facet of his infinitely varied mind.[1] Yet they were once among his most popular inventions. At a time when the rest of his miraculous drawings were inaccessible to artists and art lovers they were eagerly copied, collected and disseminated in series of prints, of which the twenty-six etchings by Wenzel Hollar of 1645 were the first.[2] The title *variae figurae monstruosae* (various monstrous figures), given by Jacobo Sandrart to his series of 1654,[3] is characteristic of the taste to which they appealed and which continued well into the eighteenth century.[4] In what might be called the pre-humanitarian age such monstrosities and malformations—the dwarf, the cripple and the bizarre physiognomy—belonged to the category of 'curiosities' to be gaped at in a mixture of sensationalism, low humour and scientific detachment.[5] Images of strange fish, strange races or strange oafs could be sure to be popular on the printseller's stand at the fair and might even be given a place in the portfolio of the virtuoso's cabinet. Leonardo's bizarre inventions could thus easily be fitted into an existing genre of imagery, the popular series of human monstrosities, people with enormous noses, or satirical prints of ugliness dressed up in finery, of crabbed age derided by youth. Leonardo, of course, did not create this interest—it had found its expression already in ancient terracottas and medieval drolleries—but since he added to the rather limited store of forms carried by this tradition, his inventions, once discovered, were as sure of attention and repetition as were those of Jerome Bosch in his period and of Callot a century later. Moreover there is certainly some genuine affinity between this popular tradition and some of Leonardo's drawings. There is evidence that Leonardo had a taste for this category of robust satire. During his youth he must have seen such adaptations of Northern humour as the grotesque Morescas with their absurdly dressed-up May Queen[6] or the showy dress of the decrepit pair on one of the Otto Prints (Fig. 111) with the contemporary inscription *dammi conforto* (comfort me).[7] The exaggerations of fashion, that perennial topic of popular ridicule, also aroused his sense of fun. He warns against representing figures in contemporary dress 'so that we may be spared being laughed at by our successors on account of the crazy inventions people go in for' (*Trattato*, McMahon, 574) and gives a humorous description of changing fashions he witnessed in his lifetime. He is well within this type of satire against folly and vanity when he draws his ridiculous couples at Windsor (Figs. 112, 113), and we can detect a similar mood in the Codex Forster where he accompanies the quotation from Petrarch '*Cosa bella mortal passa e non dura*' (a beautiful mortal thing passes away and lasts not) with

This study is based on a lecture given at the Royal Academy on occasion of the fifth centenary of Leonardo's birth in 1952 and published in Achille Marazza (ed.), *Leonardo, Saggi e Ricerche* (Rome, 1954).

a scribble of an ugly old woman (Fig. 114) or when his parody of Petrarch's love of *lauro* in the Codice Trivulziano fol. 1v. leads him on to an assembly of ugly faces (Fig. 115).

This affinity may explain the speed with which Leonardo's grotesques were absorbed by popular satire North and South of the Alps,[8] but it does not account for the place of honour accorded to these so-called caricatures within Leonardo's oeuvre by refined eighteenth-century connoisseurs such as Mariette.[9] This rather connects with the picture of Leonardo's genius which was prevalent before the nineteenth century—a picture which owed most to Vasari and Lomazzo. It was Vasari, above all, who represented Leonardo as the bizarre, incalculable genius, fond of playing practical jokes on his visitors and frittering away his art with no better purpose than that of scaring a poor peasant with the sight of a Medusa's head. It fits in well with these *'infinite pazzie'* (infinite follies) recounted by Vasari when he tells us in a famous passage that Leonardo was so pleased when he saw *'certe teste bizarre, o con barbe o con capegli degli uomini naturali'* (certain bizarre heads, either with the beards or the growth of hair of wild men), that he was capable of shadowing such a person for a whole day to impress these features on his mind and then to draw them from memory. Vasari himself obviously considered these products particularly worthy of collecting and thus set the pattern for his successors.

> One encounters many drawings of this kind of male and female heads and I possess several of them drawn by his hand with the pen in that book of drawings to which I have so often referred, such as was that of Amerigo Vespucci which is a most beautiful head of an old man, drawn in charcoal; likewise that of Scaramuccia, the captain of the gipsies.[10]

The Scaramuccia has sometimes been identified with the large grotesque profile in Oxford[11] (Fig. 116) but Vasari's context does not allow us to say whether the Captain of the Gipsies had a bizarre face, an interesting growth of beard or hair, or simply a fine head like Amerigo Vespucci, nor even whether the 'likewise' implies that this head, too, was drawn in charcoal or merely that it, too, was in Vasari's collection. The evidence is quite insufficient for identification. In one respect, however, Vasari's account is borne out by a study of Leonardo's notebooks: An entry in the Codex Forster (II, fol. 3r) *'Giovannina viso fantasticho, sta a Sca chaterina all'ospedale'* (Giovannina—fantastic face—in the hospital of St. Catherine's) testifies to Leonardo's interest in human freaks.

It is in the nature of things that we can never know whether, among the grotesques that have come down to us, there are portraits from a model, such as Giovannina. Taken in isolation, many of them may well occur in real life. In fact anyone who studies these drawings for any length of time will tend to see them suddenly spring to life among the crowds of our cities. The reason must be that we are too much disposed to call a 'monstrosity' in art what is rather commonplace ugliness in reality. Those of us who are not professional painters, at any rate, are easily inclined to think of the typical human face in terms of the traditional 'conceptual' image and not to notice the frequent deviations,

such as asymmetry and distortions, unless we meet with them unexpectedly within the context of art. This is only another way of saying that many of Leonardo's so-called 'caricatures' need not be distortions of reality—in fact there is no evidence that he ever practised the game of mock-distortion we call 'caricaturing'[12]. Maybe what strikes us as fantastic and grotesque in them is less their occurrence as such than their appearance among the drawings of a Renaissance artist whose very name, for us, is connected with visions of beauty.

II

As long as Vasari's picture of Leonardo prevailed, these strange productions could be accepted as just another instance of the master's whimsicality. But as soon as this odd and wayward wizard gave way to the Leonardo of the nineteenth century the breach was felt to be intolerable. For with the rediscovery and decipherment of Leonardo's manuscripts Vasari's picture became suspect. The biographer had obviously misunderstood the high purpose of Leonardo's activities and seen mere whim and folly where there was deep thought and method. As a scientist the Leonardo of the nineteenth century was in constant search of secure knowledge based on experiment and observation, as an artist he was engaged in a ceaseless quest for beauty—there was so much evidence for this interpretation to be found in the manuscripts and drawings which gradually emerged into daylight that a few ugly profiles or strange monstrosities could hardly tell against it. If they did not quite fit the picture they were bound to suffer an eclipse of interest or, better still, to be thrust aside as inauthentic.

This is what actually happened during the period of the most intensive Leonardo research, from about 1880 to 1930. Müller–Walde gave the signal in 1889 when he denied that there was a single genuine drawing by Leonardo which could repel the beholder by an expression of meanness and fatuity, unrelieved by some quality that would secure our sympathy.[13] He had no hesitation in dismissing all drawings that contravened this canon as weak concoctions of stupid imitators. This extreme position could hardly be maintained, but there was a safer method of bringing the undeniably authentic grotesques into harmony with the idealized picture of the nineteenth-century superman. They could be classed as manifestations of his scientific interest in organic form. Here it was Eugene Müntz who set the key for subsequent decades in 1899: 'The term caricature has been applied to these studies—a great mistake . . . for they are the fragments, gigantic fragments, of a Treatise on Physiognomics. Leonardo had far too exalted a mind to linger over frivolous comparisons aiming at no more than provoking laughter. This type of joke was altogether unknown to the Italians of the Renaissance, but they were passionately interested in the laws which govern the aberrations of the human species.'[14]

True to the main preoccupations of his century, Müntz proceeds to explain that in these studies Leonardo proves himself a precursor of Darwin.[15] The general direction

of his interpretation was taken up by many subsequent writers. H. Klaiber elaborated it in a careful study on Leonardo's position in the history of physiognomics.[16] A. Venturi remarked that in these drawings 'the scientist takes precedence over the painter'[17] E. Hildebrandt regarded them as studies of the laws governing the structure of deformed organisms,[18] Suida thought that their theme is the outward expression of human character[19] and L. H. Heydenreich emphasized their connection with Leonardo's planned treatise on anatomy. He believed them to be related to a projected chapter on human expression but also to serve as demonstrations of such different scientific problems as the effect of deviations from the canon of proportion, the effect of muscular movements and the systematic observation of human physiognomy.[20]

This new interpretation certainly revealed aspects of Leonardo's grotesques which deserve more detailed discussion. Leonardo was really interested in the morphology of the human face and in the physiological factors that make for beauty and ugliness, character and expression. The *Trattato* tells us a good deal about Leonardo's views on these matters but these views, it seems, explain only some but not all the aspects of the grotesque heads.

> I shall not dwell upon the misleading methods of Physiognomics and Cheiromancy, for there is no truth in them; and this is evident because such chimeras lack all scientific foundation. It is true enough that some of these signs of the human face show the nature of their owners, their vices and their humours. The marks which in a face separate the cheeks from the lips, and the nostrils from the eye sockets, clearly show whether these are cheerful people who frequently laugh; while those who have few such traces are men who concentrate on their thoughts; those whose features are bestial and irascible; and those who have strong horizontal lines across the forehead are people tending to silent or loud lamentations; and the same may be said of many such features. (*Trattato*, McMahon, 425).

The distinction made by Leonardo between 'false' and 'true' physiognomics was destined to become of great importance in the eighteenth century. At that time the school of Lavater had started the craze of reading character out of the structure of the head, the shape of the nose, the height of the forehead. This *Physiognomik* was opposed by Lichtenberg who, following observations made by Hogarth, which in their turn are based on Leonardo's views, emphasized that what makes us see a 'character' in the face is not the bony structure but the muscular traces of frequent expression. He termed the study of expression and of its lasting effect on the face *Pathognomik*, which alone he considered a rational pursuit. It is clear in this context that 'pathognomics' is also what Leonardo advocates. The man who smiles often will have the smile fixed on his face. The structure of the bones of the skull, on the other hand, has nothing to do with it.[21]

It must be this reliance on the skeleton structure which Leonardo dismissed as the 'fallacious' and 'chimeric' method of physiognomics. We can infer what he meant by

looking into the contemporary treatise *De sculptura* by Pomponius Gauricus. Gauricus revived the ancient pseudo-Aristotelian physiognomic doctrine which judges faces by their resemblance to animals.[22] The man with an aquiline nose must be noble like the eagle, the man with a leonine mane courageous like a lion, and so on. Leonardo found no 'scientific' foundations in this doctrine and abandoned it for 'pathognomics'. But did he not himself compare human heads with those of animals in the famous sketch for the battle of Anghiari where a shouting warrior's head is shown side by side with the heads of a horse and of a lion? (Fig. 117). There is no contradiction here. For on that sheet Leonardo is again out to study, not structure as a sign of character, but the symptoms of expression common to animal and man. The fury of war, '*pazzia bestialissima*' (a most bestial madness), manifests itself similarly in man and beast. Here, as so often in his scientific studies, Leonardo is seen groping for a visual formula which would allow him to develop furious heads from one common centre.

It is an easy matter for anyone to acquire universality in this, because all terrestrial animals have a similar structure, that is similar muscles, nerves and bones, and their only variation is in their length or thickness as will be demonstrated in the Anatomy. The only exception is the aquatic creatures, of which there are a great variety. I shall not try to persuade the painter to make up a rule for them, for they are of almost infinite variety; and the same applies to insects. (Richter, No. 505.)

To Leonardo comparative anatomy and, we may infer, comparative 'pathognomics' were a search for that 'regola' which allowed the painter to grasp the underlying structure and then to individualize at will. Far from believing that there were 'lion men' and 'horse men', Leonardo was out to demonstrate that essential unity of all expression in vertebrates. There is, indeed, a similarity with Darwin here, but the aim is not to establish any law of evolution but rather the search for some underlying principle such as Goethe was after when, in his botanical studies, he looked for the 'archetypal plant' (*die Urpflanze*).

But if we turn from this unique study of expression to the grotesque heads we find that here, strangely enough, emphasis is more on changes in bone structure than on muscular pulls.[23] These monstrous excrescences of enormous chins, these pitiful snub noses and deformed jawbones cannot all be meant as permanent traces of frequent facial expressions. There are only comparatively few which might be interpreted as illustrations of Leonardo's pathognomic theories. The famous head in Venice (Fig. 118) might perhaps pass as a demonstration of the tenet that those people whose individual features stand out in great relief and with deep recessions are apt to be brutish, irascible and stupid. We may interpret it as a face showing each separate muscle standing out because it is marked by uncontrollable passion and evil contortions. But this is the point where, to Leonardo, the laws of expression seem to merge with considerations of beauty. For these separate muscles are mentioned in the passage in the *Trattato*[23a] which contains the very quintessence of his ideal of physiognomic beauty:

> Do not represent muscles with harsh lines, but let the sweet lights fade imperceptibly into pleasant and delightful shadows; this produces grace and beauty. (*Trattato*, McMahon, 412.)

From this angle some of the grotesque heads with their harshly articulated features may be seen as anti-types of beauty, and it accords well with this interpretation that Leonardo liked to play on these contrasts, as if to try out another aesthetic law formulated in the *Trattato*: 'Beautiful and ugly features are mutually enhancing'. (McMahon, 277). Several compositions known from copies and variants produced by Leonardo's pupils look like demonstrations of this law, notably the type of Salome whose seductive beauty is effectively 'enhanced' by the monstrous profiles of executioners, which recall the repertory of grotesque heads (Fig. 119).

<p style="text-align:center">III</p>

I have used the term 'repertory' advisedly, because it would seem that one of Leonardo's principal concerns in his studies of facial types was not so much a treatise on physiognomics as envisaged by Müntz, but an extension of his repertory of forms. The need for such an extension is rooted in the artistic situation of the *quattrocento*.

A certain uniformity of types is common to many painters of Leonardo's generation, be it Botticelli, Filippino Lippi or Perugino, whom Giovio criticized for this fault.[24] Even in the first half of the century Leone Battista Alberti had evidently noticed the tendency of artists to remain satisfied with a few facial stereotypes and had urged them to profit from the variety of nature.

> You will see people with a protruding humped nose, others have nostrils like monkeys splayed open and turned up, others again have hanging lips, while others are graced with puny meagre lips and in this way let the painter examine everything. . . .[25]

Alberti's text reads almost like a description of some of Leonardo's monstrosities and the passage may well have been in Leonardo's mind when he launched on these studies. But here, as always he went beyond the demand for simple observation. If the artist's range of types was to be effectively widened he must be made aware of the possibilities that exist in nature. Without such awareness, in fact, he would find it hard even to remember a physiognomy. Pliny tells of Apelles that he could so accurately draw from memory the portrait of an offender that he was immediately identified by the King.[26] Leonardo may, or may not, have remembered this anecdote when he incorporated in his Treatise on Painting a paragraph on 'How to make a human portrait in profile after one single glance'.

> For that purpose you must keep in mind the variations of the four different divisions of the profile that is: nose, mouth, chin and forehead.
>
> To start with the nose: there are three shapes—(A) straight, (B) concave and (C) convex. Among the straight there are only four varieties, that is (A 1) long, or (A 2)

short, and (A 3) at a sharp angle or (A 4) at a wide angle. The (B) concave noses are of three kinds of which some (B 1) have the dip in the upper part, some (B 2) in the middle, and others (B 3) below. The (C) convex noses again show three varieties: some (C 1) have the hump high up, others (C 2) in the middle and others (C 3) at the lower end. (*Trattato*, McMahon, 416.)

I have added letter symbols to Leonardo's account which should help to elucidate the illustrations which accompany it in the *Codex Urbinas* (see below). The first three represent the first subdivision into A, B, C, the middle the variety of concave noses, B 1, B 2, B 3, the third the convex ones, C 1, C 2, C 3. Evidently Leonardo was not yet satisfied with these categories and he (or Melzi) added at the bottom of the page three varieties of the context in which the central hump may be seen, that is between straight lines, convex lines or concave lines.

| A | B | C | Bɪ | B2 | B3 | Cɪ | C2 | C3 |

We have seen in the previous chapter how Leonardo's attempts to arrive by analysis and permutation at an inventory of all possible vortices led him to complexities which threatened to exhaust even his own patience. The same occurred here.

The middle parts of the nose, which form the bridge, can differ in eight ways: they can be (1) equally straight, equally concave or equally convex, or (2) unequally straight, concave or convex, (3) straight on the upper and concave on the lower part; (4) straight above and convex below; (5) concave above and straight below; (6) concave above and convex below; (7) convex above and straight below; (8) convex above and concave below.

The transition from the nose to the forehead is of two kinds: it is either concave or straight. The forehead has three varieties: flat, concave or bulging. Flat foreheads are divided into four kinds: (1) convex above, (2) convex below, or (3) convex above and below, or (4) flat above and below. (*Trattato*, McMahon, 417.)

He lists eleven kinds of noses when seen from in front, which are:

(1) even, (2) thick in the middle, (3) thin in the middle, (4) with a thick tip and thin in the beginning (5) a thin tip and thick at the beginning, (6) with large nostrils and (7) with narrow ones, (8) high ones, (9) low ones, (10) with exposed nostrils, (11) with the nostrils covered by the tip. (*Trattato*, McMahon, 415.)

Leonardo did not lose sight of the essentially mnemonic purpose of this exercise, which comes very close to the Identikit or photofit method used by the police today.

The artist should have a little book by him containing these varieties of features and whenever he wished to record the appearance of a person he should simply tick the appropriate diagram and compose these features into a portrait at his leisure. Characteristically he concludes this advice in the *Trattato* with the remark 'Of monstrous faces I do not speak, since these are remembered without difficulty'. [*Trattato*, McMahon, 415.]

The remark confirms once more that we may expect to find such 'monstrous faces' drawn from memory among Leonardo's grotesque heads, but it is equally likely that many of them manifest that urge to experiment with permutations and combinations which pervades Leonardo's notes on so many subjects. It is indeed rewarding to try out Leonardo's Linnaean system of facial varieties by applying it to his own creations— rewarding but also frustrating.

Some can certainly be caught in the net of his categories of foreheads, noses or chins, but like the system itself they fail to reflect the variety we find in human types. On the contrary, the more one studies these heads the more one is struck by a strange uniformity, even monotony, behind the surface of extreme variations. To account for this obsession with a limited repertory of stereotypes the nineteenth-century picture of Leonardo the dispassionate observer and recorder of nature is insufficient. It was at this point in the history of Leonardo studies that an important new stimulus came from psychology.

IV

The first impulse for this new approach to the image of Leonardo came from Freud's study.[27] Though this study is probably wrong in its assessment of the historical evidence[28] it taught a new generation to see Leonardo's writings, drawings and paintings not only as an incredible encyclopedia of science and the arts, but as the manifestations of one extraordinary human being. The decisive step in the integration of this approach with the historical evidence was taken by Kenneth Clark. It was in his catalogue of the Windsor drawings that he first drew attention to the psychological riddle of Leonardo's profiles and caricatures.[29] 'The mind throws up fragments of weeds and dirt which float about on its surface and betray us into tuneless humming or stupid reiterated words: and such, it seems to me, was the origin of most of Leonardo's caricatures ... it is astonishing how little, in the course of his life, Leonardo's unconscious mind changed.' The author refers to two profiles of boys drawn by Leonardo at a distance of some thirty-five years (Fig. 120, dateable *c.* 1478, and Fig. 121, from *c.* 1513) to illustrate this tenacity of Leonardo's types.

In his monograph on Leonardo of 1939, Kenneth Clark followed up these remarks with a characterization of these heads in words of such precision that it could only be spoilt by paraphrase. He acknowledged that Leonardo's 'immediate successors were right in recognizing the caricatures as essential to his genius' and emphasizes that they cannot be separated from Leonardo's 'ideal types'. He writes:

'His caricatures, in their expression of passionate energy, merge imperceptibly into the heroic.

Most typical of such creations is the bald, clean-shaven man with formidable frown, nut-cracker nose and chin, who appears sometimes in the form of a caricature, more often as an ideal. His strongly accentuated features seem to have typified for Leonardo vigour and resolution, and so he becomes the counterpart of that other profile which came with equal facility from Leonardo's pen—the epicene youth. These are, in fact, the two hieroglyphs of Leonardo's unconscious mind, the two images his hand created when his attention was wandering . . . both types go back to his earliest Florentine years, were indeed taken from Verrocchio, the elegant youth from such a head as the David [Fig. 122], the warrior from the lost Darius relief . . . these two images reflect deep and fixed necessities in Leonardo's nature. Even in his most conscious creations, even in his Last Supper they remain, as it were, the armature round which his types are created.'[30]

This masterly analysis was completed by Popham, who stressed the frequent juxta-position in Leonardo's oeuvre of the stern warrior (Fig. 124, akin to Verrocchio's Colleoni, Fig. 123) and the pretty youth (Fig. 125) (who gradually assumed the features of Salai).

'Perhaps he thought of himself in the character of Caesar, laying a conquered world at the feet of his lover, the beautiful youth.' Popham described how this profile 'becomes the connecting link between the normal and the abnormal, between the sublime and the ridiculous, as if Leonardo were mockingly distorting the unattained ideal of his youth'.[31]

More explicitly even than Kenneth Clark, he saw these caricatures as the outcome of an inner tension, the release of some conflict troubling Leonardo's mind.[32] This is the point where the historian should really hand over to the psychologist. But perhaps it may be permitted to the historian to gather such concrete evidence as there may be found in Leonardo's writings and in the drawings themselves.

V

To look through a series of Leonardo's grotesque heads with the interpretation of Kenneth Clark and A. E. Popham in mind means to see them in a fresh light. The very difficulties which have so far frightened away connoisseurs now fall into place. For if these heads grew out of semi-automatic penplays, of what nowadays is called 'doodles', the usual criteria of authenticity and artistic quality can hardly be expected to apply. We know that Leonardo harnessed the 'doodle', the half-conscious scribble, to his working procedure with no less deliberation and psychological intuition than he advocated the contemplation of crumbling walls to rouse the imagination. I have discussed elsewhere what revolutionary importance attaches to his advocacy of the *componimento inculto* (untidy sketch)[33] (McMahon, 267).

Here lies one of the root causes of the difficulty in the attribution and chronology of the grotesques. In the 'doodle' control may be deliberately relaxed—in fact this relaxation is part of its psychological function, and so we cannot approach it with the standards abstracted from deliberate drawings. Luckily for us there are a fair number of such 'doodles' in Leonardo's manuscripts which we must accept as by his hand for purely external reasons. A typical instance is the head on the margin of the *Quaderni di Anatomia* (Fig. 127) or the profile on the fringe of an architectural drawing in the Codex Arundel (Fig. 128). Other instances might be quoted from the Codice Atlantico[34] (Figs. 130–3, 135), Codex Ashburnham (Fig. 134), from Windsor (Figs. 129, 138), or finally from the Trivulziano (Fig. 115). Some of these scribbles, including the last one mentioned, show a strangely hesitant stroke. If we met them in isolation we might well doubt whether they could be authentic. Unfortunately a good many of them were in fact isolated in this way. Many of the small fragments and snippets at Windsor Castle[35] were also scribbled on similar sheets in a like mood and were cut out by an admirer who had no use or understanding for the remaining matter on the page.[36]

Given this type of origin, it is understandable that other collectors were not content with cutting out these heads. They were tempted to ink them in or retrace them, particularly if they had originally been drawn in fading charcoal. From here it is but a step to the copying of such drawings, either in facsimile or, again, rounding them off and completing their hints. Carlo Pedretti has shown that this is in fact what happened in the case of one type (Fig. 135), which was 'completed' in a rather feeble drawing now in Amsterdam (Fig. 136).[37]

As interest in these heads was great, one may well imagine an eager pupil systematically going through the master's notebooks to copy and neatly arrange these fruits of his fancy on single sheets or in series. Sometime, perhaps, we possess figures in several stages. The profile with the high hat in Windsor (Fig. 139) is certainly from Leonardo's hand. The similar profile (Fig. 140) may serve, according to Kenneth Clark, as an instance of a re-worked original, and so may the type in the Albertina (Fig. 141). A head in Lille,[38] on the other hand, is probably too neat to pass for an original, but the preceding examples give a fair idea of what it may have looked like. Thus we can imagine the steps by which the Trivulzio sheet (Fig. 115) was turned into an arrangement like the three heads on a sheet from the Vallardi Collection (Fig. 142).

But are all these later stages really the work of copyists? Here, so it seems, lies one of the most interesting problems still awaiting solution. For there are indications that Leonardo himself may have joined in the game of completing, arranging and copying his original 'doodles'. A comparison between the head from the *Quaderni* (Fig. 127) and the profile in the British Museum (Fig. 143) shows, if nothing else, at least how closely he could come to repeating and elaborating the same type. More striking is the re-use of the extremely distorted profile which he began drawing on the right hand margin of the Trivulzio page (Fig. 115). Though it looks like a free improvisation we find it used again, in reverse, for the profile of a grotesque bust of an old woman on a

sheet with five heads in Venice (Fig. 144). The sheet belongs to a series of which there are other examples in Venice, at the Louvre, the British Museum, and at Windsor Castle (Fig. 145), all of which are copies, almost certainly by another hand. They must be very close facsimiles, however, as we can judge from some of these types which also exist in the original or in faithful copies like those in London (Figs. 148–9) or the head in Hamburg (Fig. 146), repeated in the Ambrosiana (Fig. 147). It seems to follow that the prototype of the coiffured head of Fig. 144 was also by Leonardo's hand. He must have used his scrawl from the Trivulzio page (Fig. 115) and elaborated it. Whatever his procedure in this particular case, there can be no doubt that he sometimes spent infinite pains on the elaboration and shading of one of these creatures of whim. At least one such case has been preserved in its setting, the 'nut-cracker' type in the centre of Windsor 12283r (Fig. 150). It may have started like the profile bust in Windsor (Fig. 151), but so fascinated Leonardo that he gave it a minute finish. The same type of finish distinguishes the group of grotesque busts of which the above mentioned collective sheets and, we may assume, the prototypes of many etchings by Caylus, were copies. Of this group the series in Chatsworth has the best claim to be considered authentic, and a comparison of one of these types (Fig. 152) with the Windsor bust (Fig. 150) should show, at any rate, that high finish and polish need not be a cause for suspicion. The Windsor sheet being dated by Kenneth Clark into the first Milanese period, we may tentatively suggest a similar date for most of the grotesque heads of this type.

To pursue these problems of authenticity further, a real stemma of types and copies would have to be drawn up. Only after these had been classified and analysed could the question of which of them are originals be approached with any chance of success. But whatever the answer to this question may turn out to be—and it may well be more positive than is usually suggested—even an incomplete survey shows that these drawings must reflect the master's intention sufficiently faithfully to be worthy of serious attention. And so we are back at the problem of what this intention may have been.

The answer must certainly take account of a strange tension in Leonardo's mind and work, a tension illuminated by Kenneth Clark's observation that the same stereotypes appear so persistently among Leonardo's profiles. For this tendency to repetition stands in the strictest contrast to Leonardo's own formulated conviction and advice. There is hardly a maxim on which he insists more frequently than the reminder: 'vary as much as you can'. We have seen him developing a system of permutations of facial elements precisely to record this variety of nature, but we also notice that to some extent even this system failed to yield the desired result. The master's variations on the theme of the human head remind one of musical variations in which the presence of the theme is always felt behind the harmonic and rhythmical elaborations imposed by the composer.

The theme, in this case, is the type Kenneth Clark calls the 'nutcracker head'. It is the type represented early in Leonardo's oeuvre by the profile of a warrior in the British Museum (Fig. 124) and its many relations among the profiles[39] (Figs. 153–5). Using Leonardo's own system we may classify it as having the forehead 'bulging above and

below'—that is 'deeply incised in the middle'—the nose 'convex with the hump above', and a 'hanging tip', the mouth with protruding under-lip and the chin well marked. Where this profile is exaggerated into a grotesque the hanging nose shows not only the 'nostrils covered by the tip', but the tip actually touching the protruding lower lip, a rather repulsive monstrosity which can hardly be matched in nature but which fairly obsessed Leonardo (Figs. 156–60).

If this basic type is regarded as Leonardo's theme or 'signature tune' we can relate most of the other grotesques to it by repetition or negation. The search for contrast and variation is most evident in those drawings in which two profiles are facing each other, either old and young, as in the combination mentioned by Popham (Fig. 125), or as extreme permutations of the features singled out in Leonardo's system. In Fig. 161 the exaggerated 'nut-cracker head' with the high bulging forehead 'incised in the middle', the convex nose with the bulge high up and an enormous chin confronts a profile with receding forehead, a straight nose and hardly any chin. In Fig. 162 not only the noses are contrasted, but the familiar mouth with a protruding lower lip is reversed in a grotesque way we shall meet again. The tendency is the same in the 'doodles' of Fig. 163 and Fig. 164, where a straight nose and protruding chin is faced by a huge nose and receding chin, and a large scrawl in Milan (Fig. 165) continues the game.

Many of the individual grotesques can also be seen as such 'mirror images' of the standard profile. The normal high brow is turned into a receding forehead or sometimes hidden under a low cap or hanging hair such as in Fig. 166. The negation of the aquiline nose is once more exemplified in Figs. 167, 112, 144, the extended and monstrous upper lip in Figs. 168 and 169.[40] One of Leonardo's most famous grotesque inventions (Fig. 170), taken up by Quentin Massys[41] and made popular by Tenniel in his illustrations to *Alice in Wonderland* (Fig. 171), combines the standard forehead and chin with the negations of the nose and mouth.

The female monster of the drawings in Venice (Fig. 144) and in the British Museum (Fig. 148) combines all 'negations' of the four standard features and thus looks a particularly characteristic specimen. The 'doodles' in the Codice Trivulziano (Fig. 115) confirm the authenticity of these variations. In one case, for instance, we see Leonardo beginning with the double-humped forehead of the 'standard profile' and then checking himself and introducing the variation of the small nose and the grotesque, beaklike upper lip as if he wanted deliberately to avoid drawing once more his typical nose and mouth. Perhaps it is this element of 'negation' even in many of the most bizarre heads which accounts for the curious paradox of these types. Passing them in review one cannot get rid of the feeling *plus ça change, plus c'est la même chose*. Far from being free improvisations the grotesque heads look like frantic avoiding actions, almost desperate struggles to get away from the compulsion of once more repeating the features of the 'nut-cracker head'.[42]

What insistent impulse can thus have prompted Leonardo to 'doodle' the same type and again, to struggle against its repetition ? Once more there are passages in Leonardo's

own writing which suggest an answer. The need to vary is all the greater, he tells us, because there is a natural tendency in any artist always to repeat his own type. Leonardo had developed a metaphysical theory to account for this alleged propensity.

> Having frequently pondered the reasons for this shortcoming, I have come to the conclusion that we must believe that the same soul that rules and governs every body is also the one that fashions our judgement even before it becomes explicitly our own judgement. Now that soul has developed the whole body of that man in the way it considers best, be it with a long, a short or a flat nose; and in the same way it has established its height and type. And this underlying judgement is of such power that it also moves the arm of the painter and makes him replicate himself, since it appears to that soul that this is indeed the true way of representing a man and that anyone who departs from this is mistaken. And if that soul finds any body which resembles the one which it has put together, it likes it and frequently falls in love with it. This is the reason why many fall in love and take wives who are like them and frequently the children born from these are like their parents. (*Trattato*, McMahon, 861.)

The passage is all the more fascinating from the psychological point of view, as some of Leonardo's observations can hardly apply as generally as he thought.[43] It must to some extent be based on his own experience. Only introspection can have led him to discover what we call the 'unconscious', and what he described as *quella anima . . . che fa il nostro giuditio inanti sia il proprio giuditio nostro* ('the soul that fashions our judgement even before it becomes explicitly our own judgement'). Only experience could make him attribute to this force 'so much power . . . that it moves the arm of the painter', and to equate the emergence of these unpremeditated images with the physical generation of children.

Moreover, the fact preoccupied Leonardo, for the passage recurs in many versions, and his insistence that this tendency to self-representation must be fought by the artist is clearly charged with emotion.

> Once he has noticed this (failing) the painter must make every effort to remedy it, so that the figure he creates shall not exhibit his own shortcomings. And remember that you must fight extremely hard against this vicious inclination. (*Trattato*, McMahon, 87.)

These words must mean that Leonardo himself had struggled hard against the innate tendency to repeat what he took to be his own type in art. The profile which 'his arm' drew automatically and which his caricatures enhance, distort or deny, might therefore be expected to be his own. At first this may seem an absurd conclusion. We know from Kenneth Clark's and from A. E. Popham's observation that Leonardo took over this formula from Verrocchio and that it is pre-figured in the Colleoni (Fig. 123) and the Darius. It is therefore obviously not a portrait of Leonardo's profile if we take the word portrait in our sense. But how far does this modern sense apply to Leonardo? The *Mona Lisa* passes as a portrait and is at the same time a type that recurs in Leonardo's

vocabulary, a type, we may assume, applied to an individual. Now this idea of portrayal may not be as far removed from the general practice of the quattrocento as we are inclined to believe. Portrayal is the selection of the appropriate type. The very head with the imperial profile which we know from Leonardo and from Verrocchio had done service as a 'portrait' earlier in the quattrocento; it forms the basis of Cosimo de' Medici's posthumous medal.[44]

Taking the word 'portrait' in this wider, non-photographic sense, there would be nothing paradoxical in Leonardo having conceived his own head in terms of the traditional 'Roman profile'. He was famed for his beautiful head, and Planiscig has suggested that later in life he deliberately modelled himself on the image of Aristotle.[45] May he not earlier have liked to think of himself as a Roman warrior? We have seen that this is in fact the intuition derived from these profiles by Popham, who suggests that Leonardo may have thought of himself as a conquering Caesar. That the 'standard head' lends itself easily to the representation of a Roman Emperor is certain. There is a scribble on one of the sheets in Windsor (Fig. 172), in which it is used to 'portray' a coin of the Galba type (Fig. 173), just as there is another on which the 'Salai' type is used to recall or record a coin of Nero (Figs. 174–5).[46] But the same standard head, normalized into beauty, forms also the basis of these models of proportion in which Beltrami years ago thought to discover Leonardo's own features (Fig. 176).[47] He was violently contradicted by Möller,[48] but Nicodemi has since gone even further in the same direction.[49] The question of what Leonardo 'really looked like' may never be solved, but surely it is true that the profile of these heads has much in common with those alleged portraits which have the strongest claim to represent Leonardo's features. The Turin drawing (Fig. 177), most of all, embodies all the features we enumerated as characteristic of Leonardo's stereotype—the bulging, incised forehead, the eagle nose with the hanging tip, the mouth with protruding under-lip, and, as far as one can see, the marked chin. Admittedly we are in danger of moving in a circle. The Turin head need not be a self-portrait, it may be another embodiment of Leonardo's favourite type—perhaps so, but the sixteenth-century person who called it Leonardo may well have had reasons for doing so. The least one can claim for the Turin head is that it must have resembled Leonardo's type, and that is all we need for the present argument.

Something similar has often been felt in front of the Windsor drawing of the old man with the head resting on his hand (Fig. 178). It has been called an 'ideal self-portrait'[50] and it clearly repeats the traits just enumerated. Castelfranco has noted the similarity between this profile and the grotesque head of the old man (Fig. 179) in which Berenson saw something like a self-caricature.[51] He has seen that this hypothesis leads one to suggest a similar meaning for the other bearded old heads in Windsor (Fig. 180).[52] But from here it is only a small step to such beardless types as the head of the warrior in Venice (Popham, 196) and thence to the standard profiles among the Apostle studies (Figs. 181–2). It should be possible to arrange nearly all Leonardo's male heads on a screen and watch their slow transition from one type to the next—

with the Turin self-portrait somewhere in the centre. For this is the conclusion we are driven to—that the head that came first into Leonardo's pen, in the way Kenneth Clark describes, was the type he considered his own, and that the variation he insisted upon when introducing types into his compositions were still variations of this formula. If he really considered this a vice to be struggled against, the compulsion must have been strong indeed. What wonder that he sometimes mocked at his head in grotesque exaggerations as if he wanted to search out and demonstrate to himself its essential ugliness, while at other times he searched for negative variations in the manner described?

Dangerous as it is to indulge in psychological speculations one is tempted to see here another instance of Leonardo's solipsism, of his loneliness and of the ambivalence with which he looked upon his own self. Berenson calls the bearded Windsor profile (Fig. 179) an ironical and half-pitying self-portrait. Others of the standard profiles deserve a similar characterization. And it seems that only from this angle can we arrive at a satisfactory interpretation of the most famous of Leonardo's 'caricatures', the so-called 'five grotesque heads' in Windsor (Fig. 183). Are there really five grotesque heads? In earlier times, when the 'scientific' interpretation prevailed, there seemed to be no doubt. Richter reports the opinion of an alienist who saw in these heads a classification of five types of mental disease. Suida was perhaps the first to see the essentially classical character of the central head crowned with oak leaves, but he saw the remaining four heads as illustrations of the four temperaments.[53] O. H. Giglioli rightly calls the central head 'the traditional classical type of Leonardo's'[54] and Castelfranco recognized in the central figure the old man familiar from the drawings of Leonardo's youth.[55] Is it a caricature? We need only cover up the other heads and isolate the central profile to see that it can hardly be meant as a comic type. Its affinity to Leonardo's formula for imperial dignity is striking. True, the head shows the ravages of age and an expression of bitterness, but this could well be interpreted as grief and defiance in the face of the four mocking fiends. As soon as we see the sheet in this light as 'four grotesque heads' surrounding a profile of tragic dignity, the essential unity of Leonardo's oeuvre becomes once more apparent.[56] For this conception of the lonely head surrounded by uncomprehending faces also gained shape in other compositions of Leonardo. It crystallized in the *Christ in the Temple*—known to us from the reflection in Luini's (Fig. 184) and Dürer's compositions[57]—and, in the last analysis, even in the basic scheme of the *Last Supper*. Its effect beyond the Alps remains to be investigated. There is much to suggest that it was known to Jerome Bosch, whose many compositions of Christ among his tormentors (Fig. 185) seem to derive their inspiration from some such composition of Leonardo[58]—perhaps from a copy of the very drawing under discussion, which was certainly known in the Netherlands in Quentin Massys' time.[59] It is a point which only becomes apparent if we cease to read the composition as 'five grotesque heads'.

Moreover, with this interpretation, the drawing finds its place among the compositions which grew out of Leonardo's favourite 'doodle' as described by Popham—the confronting profiles embodying some contrast and, as on the Trivulzio page (Fig. 115),

even intense hostility. Once more, in these Windsor 'Five Heads', Leonardo indulges his love of the variation and inversion of a favourite formula. Usually the imperial head is confronted by a beautiful youth, now its ugliness is overtopped by worse ugliness and meanness. And yet—may we not feel that here, too, Popham's interpretation still holds good? That this Caesar is something of a self-image?

The reverse of the drawing carries a cryptic text which has often been felt to correspond, at least in its mood, with the drawing on the *recto*. It is an invocation of the 'spirit' from an unknown context, ending in the outcry:

> And should any be found among them who has any good in them, they will not be treated any differently from the way I was treated by other men. This is the final conclusion to which I come; that it is bad to have them as enemies and worse to have them as friends. (Windsor 12495*v*.)[60]

Are the grimacing faces surrounding the wreathed figure the bad enemies and the worse friends? One would like to think so, though we may never know if the text really relates to the drawing or, indeed, if it strikes a personal note. Yet another text of Leonardo's may throw some light on this constellation of heads. It occurs in the plan for the work on Anatomy which Leonardo intended to conclude with four illustrations of typical affects:[61]

> Then represent in four scenes four general conditions of man, i.e. joy, with various forms of laughter, and also represent the cause of their laughter. (Windsor 19037*v*.)

It would fit the pessimistic mood of the reverse if the wreathed head, the bald-headed Caesar, were to be considered the 'cause of laughter', which is here conceived as derision ranging from the sly smile to uncontrolled braying. Did Leonardo see himself as the victim of such fiendish incomprehension, isolated but undefeated?

Such an interpretation may sound unduly romantic and should certainly not be pressed too far. But Leonardo's capacity of gliding from playful humour to savage denunciations of mankind is well documented in his writings, notably in the 'Prophecies'.[62] These strange products of Leonardo's whim share many aspects with the grotesques. They have the same surface of conventional humour, the same dream-like quality, the same mixture of high spirits and an almost pedantic heaviness which makes Leonardo think up more and more of these inverted trivialities.

> (a) Finally the earth will turn red after many days of conflagration and the stones will be transformed into ashes.
>
> Of kilns for bricks and lime.

> (b) And the high walls at the great cities will be beheld below their moats.
>
> Of the reflection of city walls in the moat water.

> (c) What a filthy thing, that the tongue of one animal will be seen in the guts of another.
>
> Of the tongues of pigs and calves in sausage skin.

Such jokes are harmless enough, even if some of them are sailing rather close to the wind in their mock-solemn descriptions of Church matters. And yet, the more one reads in them the more one has the feeling that they, like the 'caricatures', are not merely some marginal eddies on the fringe of Leonardo's personality but reveal a capacity which is characteristic of his whole mind—a capacity one might describe as that of 'dissociation'. More even than other men of genius he could look at things from the outside, as it were, and thus turn the familiar and homely into the unfamiliar, wonderful or threatening. There is something of Swift's precision and objectivity in this outlook and, as with Swift, it could lead Leonardo to a horror of the brutish aspects of man.

> Animals will be seen on the earth who will always be fighting each other with the greatest suffering and frequent death on both sides. And there will be no limit to their viciousness. Thanks to their strong bodies, the major part of the trees of the larger forests of this world will be seen to be laid low. And when they have eaten their fill they will feed their desires by inflicting death, grief, exhaustion, fear and flight on every living thing. And because of their limitless pride, they will strive to rise towards heaven; but the excessive weight of their bodies will hold them down. There will be nothing on the surface of the earth, or beneath the earth or water which will not be persecuted or despoiled; and those of one country carried off to another country; and the bodies of these creatures will be made the tomb and passage-way of all the living bodies they put to death. O Earth, how is it that you do not open and hurl them into the deep cracks of your vast abysses and caverns, so as to let heaven no longer see so cruel and merciless a monster.
>
> Of the cruelty of man (Richter, Vol. II, p. 302, No. 1296)

Can this still be satire? Can this reference to the frustrated flight towards heaven be a mere mock prophecy? And do we not know that Leonardo accepted the consequences of his disgust of man, the beast of prey, and turned vegetarian? Is this not finally the same Leonardo who revelled in descriptions of disasters bringing death and destruction to the 'monster' that is man and who spent years of his life thinking out engines of destruction?

We can hardly hope to understand the grotesques without taking account of this side of Leonardo's being, his spasmodic disgust with mankind, with the physical functions, with decay, and the tension between cruelty and extreme gentleness.[63] To a mind in which such conflicts were warring, existence was perhaps only bearable because of the power that art gave him over it. For 'art' clearly meant something entirely different to Leonardo than it meant even to the most gifted master-painters of his time. Where they repeated or varied time-hallowed formulae in attempts to illustrate the sacred or the classical story, Leonardo saw the painter as the rival of the creative poet, ready to project his inner visions into the outside world.

> In what way the painter is the lord of all varieties of man and of all things; if a painter desires to see beautiful women who make him fall in love, he has the power to create

them; and if he desires to see monstrous things which frighten or are clownish, laughable, or really arouse compassion, he is their Lord and God. (*Trattato*, McMahon, 35.)

It cannot be without significance that here, where Leonardo issues the manifesto of the new conception of art, of art as creation to satisfy the creator, he dwells on the artist's wish not only to see beauties to fall in love with (like Pygmalion), but 'monstrosities' to frighten, to entertain or to arouse his pity. Can we wonder that we find it hard to decide whether the grotesques are meant as jokes or as monsters? Leonardo himself left the question open. His mind was so wide, that he even foresaw the possibility of feeling pity for the creations of his own cruel whim. Here, perhaps, we approach from afar the answer to the riddle of why Leonardo found it a relaxation to 'doodle' these faces. For his new conception of art as creation rather than illustration the doodle could become the instrument and token of the freely creative imagination.[64] As he watched these profiles taking shape under his hand, he felt his 'arm being guided' by that creative 'judgement before judgement' that had given shape to his very body. Then, taking the reins as *dio e signore* he could try out distortions and variations and watch the outcome— see the oddest creatures emerge into existence through a mere pressure and twist of the pen. Moreover these weird monsters were less exacting than the 'little worlds' his pictures should embody. They acquired a presence, an individuality of their own without that endless toil for knowledge and perfection that threatened the fulfilment of his wishes in painting. And yet, these children of fancy somehow partook of the essence of art, of its power. They were capable of arousing fear, laughter or pity.

To Leonardo the power of art to compel the passions was the token of its divinity, second in importance only to its sheer creativity.[65] He did not think a painting could make one weep, but it could make one laugh and so prove its hold over the passion.

The painter can move to laughter but not to tears, because weeping is a stronger reaction than laughter. A painter made a picture which caused everyone immediately to yawn who looked at it. And this reaction was repeated as long as the painting was looked at which depicted yawning. (McMahon, 33.)

If he showed the grotesque heads round he could have the satisfaction of watching their power, their effect, in the faces of the beholders. Seen in this light they do, in fact, reveal the same aspect of his personality as some of Vasari's anecdotes. For what are these if not so many attempts to test the 'power of art', taking the word *art* in its widest sense? To frighten a peasant, to create a dragon out of a lizard with which to scare visitors to the 'Belvedere', to blow up balloons till they fill a room, are all, perhaps, worth while to a lonely genius who wants to study 'effects'. Could Leonardo have endured his position as a wizard engineer at the court of the mighty, providing for festivals, designing automata and promising panic among the enemies, if he had not taken 'effect' seriously? Does not the *Trattato* testify at many places to the importance Leonardo

attached to the power of his art to stun, to overwhelm and to make the flesh creep?
His descriptions of the deluge are not free from this 'sensationalism', taking the word
in its literal meaning. To be sure, much more of Leonardo's personality is engaged and
revealed in these visions of a swirling chaos, but from one point of view they too may
be described as 'grotesques'. The word may sound shocking in this context, and yet I
concluded in the previous chapter that Kenneth Clark must have been right when he
discerned the way that leads from these apocalyptic disasters to such frank and uninhibited
demonstrations of the power of art as Giulio Romano's *Sala dei Giganti*.[66]

There was something of Prospero in Leonardo which made him enjoy his power to
conjure up storms and to lord it over Caliban. If this is true, past centuries were right
in recognizing in Leonardo's most repulsive grotesque no less authentic a creation of
his mind than in the haunting beauty of his smiling angels.

JEROME BOSCH'S
'GARDEN OF EARTHLY DELIGHTS'

The Earliest Description of the Triptych

THE description to which I wish to draw attention occurs in the travel diary of Antonio de Beatis, who accompanied Cardinal Luigi d'Aragona on his journey through Germany, the Netherlands, France and Italy in 1517–18.[1] The diary is familiar to art historians for its references to Raphael's tapestries and the Ghent altar-piece,[2] and most of all for its account of the Cardinal's meeting with Leonardo da Vinci at Amboise.[3] On 30 July 1517 the party was at Brussels, where they visited, among other sights, the palace of Henry III of Nassau, the Regent of the Netherlands.

> We also saw the castle of the Lord of Nassau, which lies in a mountainous tract, though close to the plain where the castle of the Catholic King is situated. The said castle is rather large and fine, in the German manner. ... Inside there are most beautiful paintings, among others a 'Hercules and Deianeira', nude and with fine bodies, and a 'Story of Paris' with the three goddesses most perfectly rendered. Then there are various panels with diverse fancies where there are represented seas, skies, woods and fields with many other things; some who come out of a seashell, others who defecate cranes, men and women, both white and black in various actions and positions, birds and animals of every kind and with much truth to nature, things so pleasing and fantastic that it is quite impossible to describe them to those who have not seen them.[4]

One may well believe the writer when he tells us that he found it impossible to describe these bizarre and fantastic inventions clearly to people who had not seen these panels. But surely we have. The combination of landscape vistas, 'of seas, skies, woods and fields with many other things' including 'men and women, both white and black in various actions and positions' not only suggests the general subject matter of Bosch, but fits one particular work, the so-called 'Garden of Earthly Delights'[5] (Fig. 186) of which indeed the central panel shows men and women, both black and white disporting themselves in the strangest ways (Fig. 188). Moreover there is no other work of Bosch extant of which it could be said with equal justification that it shows 'birds and animals of every kind and with much truth to nature'. In the 'Garden of Earthly Delights' the birds are of course particularly conspicuous (Fig. 189), but the variety of animals represented in the circular procession in the background is equally shown with much truth to nature (*con molta naturalità*). Near the foreground there is also a conspicuous group with a seashell from which two pairs of legs are sticking out (Fig. 190), a motif that may well be described as 'some who come out of a seashell'. The most puzzling passage in Antonio de Beatis's description which remains to be accounted for is *altri che cacano*

This was published as a Note in the *Journal of the Warburg and Courtauld Institutes*, 1967.

grue, literally 'others who defecate cranes'. If the description had referred to the work of another artist one would be tempted to amend the reading and to replace *cacano* by *cacciano* (chase). But with Bosch we cannot be sure. True, there is no such motif to be found on the Triptych, if we insist on the exact zoological description of the species of birds, but the strange 'anal fantasy' has at least its parallel on the side wing. There we see the group, possibly inspired by the *Vision of Tundal,*[6] of a demon on his stool devouring the damned and eliminating them into a pit. Birds are flying out of the rectum of the body whose head is just being bitten off (Fig. 192). They are not cranes, but de Beatis, writing from memory, might well have confused them with the many cranes appearing elsewhere in the painting. Of course we cannot exclude the possibility that the various panels included more than the three of the triptych. A similar motif occurs on a drawing by Bosch in the Albertina[7] (Fig. 193) showing a man creeping into a basket or beehive and about to be hit on his bare bottom by a man with a lute. Here the emerging birds (not cranes) are actually chased and caught by small children.

Since Otto Kurz has found independent evidence making it likely that the 'Garden of Earthly Delights' was confiscated by the Spaniards in the Palace of William of Orange[8] the identification is confirmed, for William was the heir of Henry of Nassau.

The possibility of tracing back this famous work to the Palace of Henry III, where it was seen in 1517, only one year after the artist's death, confirms once more Bosch's popularity among noble collectors. We know that Philip le Beau commissioned a large triptych of the Last Judgement from the painter in 1504.[9] It is even less surprising to find the Counts of Nassau among his patrons, for their domains were largely in North Brabant, and their favourite residence was Breda, not far from s'Hertogenbosch.[10]

Quite apart from thus extending the pedigree of the painting, the passage in Antonio de Beatis's travel-diary may show us how soon Bosch's paintings were appreciated by the international aristocracy who also enjoyed the well-turned-out nudes of mythological paintings the visitor singled out for mention. The 'Hercules and Deianeira' he describes is very probably the painting by Mabuse now in the Barber Institute in Birmingham (Fig. 197). Dated 1517, it was probably one of the latest aquisitions then on view.[11]

Henry III was altogether known for his interest in this kind of art. Frederick of Saxony later made him a present of a 'Lucretia' by his court painter Lucas Cranach.[12] Like most Northern princes, however, he was certainly not a man of refined taste. Our visitors also saw and admired in his castle a huge bed on to which the Count used to have his guests thrown when he had made them dead drunk.[13] If this was how he treated his friends, the treatment he meted out to his enemies made even the nineteenth-century German historian of his house avert his eyes 'as from a disgusting painting of brutal slaughter'.[14]

It is perhaps well to remember this background of cruelty and coarse humour if we are to see Bosch as his patrons saw him. For the visitors from Italy, at any rate, Bosch's gruesome inventions were noteworthy as so pleasing and fantastic things (*cose tanto piacevoli et fantastiche*), amusing grotesques which they greatly enjoyed. Antonio de

Beatis looked at some of the bizarre details, but does not seem to have searched for a meaning of the whole. The tone of his description suggests entertainment rather than horror or anxiety. He was not alone in this reaction, which represents a frequent attitude to Bosch, who was called inventor of comic monsters (*grillorum inventor*)[15] in the sixteenth century, and more surprisingly even *der Lustige* (the humorous) in the early nineteenth.[16] Perhaps it does the twentieth century credit that it has found it harder to find Bosch's imaginings funny. In the difficult search for the key to his inventions, however, this element of satirical humour should certainly not be disregarded. Now that we know the 'Haywain' to be a satirical sermon against the vain chase after 'hay', after dust, ashes, vanity,[17] we may be a little better placed to see this element also in the 'Garden of Earthly Delights' which was interpreted in a similar way by de Sigüença in the seventeenth century.[18] Perhaps recent interpretations have concentrated too much on the sexual element and too little on the other theme that appears to pervade this enigmatic panel, the theme of instability and impermanence.

Whatever else the strange tower-like structures in the background may be meant to signify, one thing is clear, they are most precariously balanced. The central structure is a shattered globe floating on water and topped by columns resting on a rounded base (Fig. 195). Everywhere this theme of hair-raising instability is emphasized. Let any person perched on the structure make a movement, let one of the birds fly off and the whole fountain will topple over. The same applies in various ways to the other structures visibly made of impermanent stuff, possibly of clouds or foam. Once our attention is drawn to this feature we find it in many variations, the many figures balancing things on their head, the acrobatic rider in the circling throng who balances on one leg on the back of a horse, the fragile bubbles, lobster shells, glass tubes and eggs. Even the central creature in the figure of hell, the mysterious treeman, rests on two ramshackle boats which offer no safety (Fig. 194).

There is at least one pictorial representation dating from Bosch's lifetime which alludes to this contrast between the fugitive gifts of Fortune and the safety of well-grounded virtue, though only in the form of a conventional emblematic illustration: the titlepage of Bovillus, *Liber de Sapiente*, 1510 (Fig. 196).[19] It shows Wisdom with the mirror of Prudence, seated on a firm throne with the inscription *Sedes Virtutis quadrata* (the seat of Virtue is square), confronting Fortuna with her wheel, seated on a globe which is precariously balanced on a see-saw with a narrow ridge. The sphere is inscribed *Sedes Fortune rotunda* (the seat of Fortune is round). Over Fortuna is the medallion of the *insipiens*, the fool, who says '*Te facimus Fortuna, deam, celoque locamus*' ('Fortune, we make you a goddess and place you in heaven'), while the *sapiens*, the wise man, retorts, '*Fidete virtuti: Fortuna fugatior undis*', 'Trust in virtue, Fortune is less stable than water'.

These commonplaces from a Renaissance allegory certainly do not offer a key to the whole meaning of Bosch's triptych. The title by which it is known today does not go sufficiently far back in time to offer any further clue; but if the composition of the central panel was in fact intended to depict 'earthly delights' Bosch must also have wanted to

remind us of their impermanence. There is one small but significant detail which confirms this expectation and rules out the optimistic interpretation made popular by W. Fraenger, who considered the triptych to have served in the orgiastic rites of millenarian heretics—the huge bunch of grapes carried by a monk close to the left-hand corner of the central panel is, at least partly, composed of human heads[20] (Fig. 191). I believe that all these images of instability and impermanence find their natural context within the interpretation proposed in the next chapter.

'As it was in the Days of Noe'

NONE of Bosch's paintings has contributed more to the aura of mystery surrounding his subject-matter than the large triptych in Madrid which has become known as 'The Garden of Earthly Delights'.[1] Sigüença, who described it in 1605, saw in the central panel (Fig. 188) a symbolic representation of the vanity of worldly pleasures signified by the strawberries, a fruit whose fragrance 'one can hardly smell ere it passes'.[2] However much later interpretations may have differed, they have all taken it for granted that the key to this enigmatic representation must be found in a knowledge of Bosch's symbolism. The real or imaginary symbolic codes of alchemy, astrology, folk-lore, dream books, esoteric heresies and the unconscious have each been claimed, in isolation or combination, to provide the solution. Erwin Panofsky accepted the general premise, though he expressed the conviction that none of the keys proposed really fitted.[3] When I first approached the triptych I shared Panofsky's scepticism, but I also remained convinced that Sigüença's interpretation must be basically right and therefore concentrated on the symbols of transience which can be identified in the central panel.

It was not altogether easy, however, to fit the outside of the triptych (Fig. 187) fully into this reading. This large grisaille shows a picture of the earth as a flat disc surrounded by water and God the Father appearing above in the left-hand corner. It is inscribed with a quotation from the 33rd Psalm *Ipse dixit et facta sunt; Ipse mandavit et creata sunt,* which is rendered in the Authorized Version 'For He spake, and it was done; He commanded, and it stood fast'. The inscription no less than the whole representation has generally been taken to refer to the Creation of the World, with the earth being surrounded by a crystal sphere. Support was found for this reading in representations of the orb held by Christ, which is often pictured in Netherlandish paintings as a shining sphere.[4] It is a plausible interpretation, and yet I do not think that it is tenable. The more closely one examines the bright curved streaks under the thunder-cloud on the left wing, the less does their appearance accord with what we know about reflections in an enclosed surface such as the transparent sphere next to the ashtray in the foreground of our photographic still life (Figs. 1 and 2).

Convex curvatures, as we remember from mirrors, reduce the image, concave surfaces also reverse it.[5] The Netherlandish masters were well aware of these facts of optics, since their interest in sheen and sparkle—the subject of an earlier chapter of this book—made them observe reflections with particular care. Bosch is no exception. In fact our triptych offers a striking instance of this mixture of naturalism and fantasy. The cauldron which the demon on his stool in the Hell wing (Fig. 192) wears on his head shows the

This section was first published in the *Journal of the Warburg and Courtauld Institutes,* 1969 under the title: 'Bosch's "Garden of Earthly Delight": A progress report'.

reflection of the window in Bosch's workshop—a device sometimes encountered in the art of the period. It was in fact my interest in these phenomena which first attracted me to the problem of the triptych's outer wings. I doubted whether it would ever be possible to observe this particular configuration of reflections in a transparent sphere, and so I cast round for an alternative interpretation. Could these streaks not represent the rainbow instead? If this obvious question has never been asked, the reason can only lie in the fact that it seems somewhat perverse to think of a rainbow painted in grisaille. Yet it turned out that in pursuing this clue an entirely different approach to the meaning of the triptych was opened up.

The rainbow, of course, is the token of the covenant which God made with Noah after the Flood:

> I do set my bow in the cloud, and it shall be for a token of a covenant between me and the earth. And it shall come to pass, when I bring a cloud over the earth, that the bow shall be seen in the cloud: And I will remember my covenant, which is between me and you and every living creature of all flesh; and the water shall no more become a flood to destroy all flesh. (Genesis ix, 13–15)

In the picture, God is seen pointing at the pages of a book as if he were speaking of the covenant. If that is so, the painting cannot represent the creation of the earth. It must show the earth after the Flood, when the waters were receding and it is indeed clear that the disc of earth is still surrounded by water. On closer scrutiny it also becomes clear that the painting cannot possibly represent the moment of the creation of the world, because there are quite a number of castles and other buildings in the landscape.

The reader is not asked to accept this reading of the outer wings on the strength of these details alone. It can only be made convincing by showing the bearing it has on the central panel covered by these wings. For if the theme of the triptych is the Flood, then the central panel (Fig. 188) might represent the world before the Flood. The love-making and the greed would not have a vague symbolic reference to the wickedness of man but would rather illustrate the actual scenes on earth that prompted God to destroy the world.

The Biblical account of the events which led up to the Flood is tantalizingly laconic and enigmatic:

> And it came to pass, when men began to multiply on the face of the earth, and daughters were born unto them, that the sons of God saw the daughters of men that they were fair; and they took them wives of all which they chose. And the Lord said, My spirit shall not always strive with man, for that he also is flesh: yet his days shall be an hundred and twenty years. There were giants in the earth in those days; and also after that, when the sons of God came in unto the daughters of men, and they bare children to them, the same became mighty men which were of old, men of renown. And God saw that the wickedness of man was great in the earth, and that every

imagination of the thoughts of his heart was only evil continually. And it repented the Lord that he had made man on the earth, and it grieved him at his heart. And the Lord said, I will destroy man whom I have created from the face of the earth; both man, and beast, and the creeping thing, and the fowls of the air; for it repenteth me that I have made them. But Noah found grace in the eyes of the Lord. (Genesis vi, 1–8.)

The earth also was corrupt before God, and the earth was filled with violence. And God looked upon the earth, and, behold, it was corrupt; for all flesh had corrupted his way upon the earth. And God said unto Noah, The end of all flesh is come before me; for the earth is filled with violence through them; and, behold, I will destroy them with the earth. (Genesis vi, 11–13.)

It is in the commentaries to this last passage that the clue to the most enigmatic feature of the painting can be found—the explanation of the strawberries and other gigantic fruit which play such a conspicuous part in the composition. For not unnaturally God's words to Noah that he would 'destroy the earth' raised a problem of exegesis. The earth was not destroyed in the Flood. One explanation became standard in the glosses and paraphrases, from the *Glossa Ordinaria* of the ninth century[6] to Petrus Comestor's *Historia Scholastica* of the twelfth, a book which enjoyed such a popularity in the late Middle Ages that it almost eclipsed the Bible itself: what God had meant was that He would destroy the *fertility* of the earth. 'The vigour and fecundity of the soil is said to be much inferior after the Flood than it was before, and it is for this reason that man was given permission to eat meat, while before he lived on the fruits of the earth.'[7]

This is the aspect of antediluvian life on earth on which the imagination of the painter fastened when he filled his picture with people eagerly feeding on gigantic fruits. There are too many of them to enumerate, but I may draw attention to the group in the central foreground where a man whose head is covered by a huge blossom buries his teeth in a gigantic strawberry (Fig. 198); to the circle of people in the water all feasting on a supergrape (Fig. 190) and the crowd in the background on the left surrounding an even larger strawberry (Fig. 199). A closer scrutiny also shows the many apples and berries enjoyed by the men and women who carry them on their heads or feast on them while they are making love.

That the principal sin that brought about the destruction of mankind was unchastity had always been taken for granted. The Biblical account of the beginning of this corruption through 'the sons of God who saw that the daughters of man were fair' has presented a famous crux to commentators. The possibility was always mooted that these were the fallen angels or demons and that the giants who are mentioned in this passage were the offspring of this sinful union.[8] There may be an echo of this interpretation in the two large winged figures carrying a berry and a fish through the air (Fig. 200). But the presence of many black people, most of whom are women, suggests that Bosch

mainly relied on another interpretation of the passage, which is stressed by St. Augustine in the *City of God* and found its way into the commentaries from there. According to this reading the 'sons of God' are to be understood as the offspring of Seth, the son of Adam, Noah's ancestor and a good man, while 'the daughters of man' represent the tribe of Cain.[9] The belief that this tribe could be identified with negroes[10] and that their blackness was in fact the mark of Cain mentioned in the Bible was to play an unfortunate part in the arguments for the retention of slavery in subsequent centuries.[11]

There was little else Bosch could learn about antediluvian man, but he let his imagination play around these few indications. Clearly in those days of vegetarianism animals had no fear of man. To us this proximity of man and beast may look more like a remnant of a paradisical state than a sign of particular depravity, but it may be well to remind ourselves that even in our language it is not a compliment to say that man has sunk to the level of beasts. The way in which these naked men and women give free rein to their animal instincts is in accord with their evident feeling of companionship with beasts both clean and unclean. They accept food from the gigantic birds which must have grown to this size because of the abundance of the earth.[12] One accepts the visit of a rat, and the majority disport themselves on all kinds of animals in the mad circular procession that fills the centre of the picture.

Lust had indeed driven man to madness in the period before the Flood. So, at least, we read again in the *Historia Scholastica*, which here refers to the visions of Methodius for a chronological account of the deterioration of mankind leading from abomination to perdition:

> In the year five hundred from the year one thousand, that is after the first millennium, the sons of Cain abused the wives of their brothers with excessive fornication; but in the six hundredth year the women turned even more mad and abused the men. When Adam died, Seth separated his relatives from the family of Cain, which returned to its native country. For while the father was alive he had prohibited them from intermingling, and Seth lived on some mountain close to Paradise. Cain lived in the plain where he had killed his brother. In the five hundredth year of the second millennium men caught fire having intercourse with each other. In the seven hundredth year of the second millennium the sons of Seth lusted after the daughters of Cain and hence the giants were born. And when the third millennium began the Flood set in.[13]

Given this description, Bosch's picture looks indeed remarkably restrained. It is not so much the wickedness of man's actions that is stressed as the complete self-abandon with which they are performed. There is another Biblical text which fully explains this aspect and which permits us to clinch the interpretation here proposed by means of an important document which has been known for some time to students of Bosch,[14] but which has not been brought into connexion with the Madrid triptych.

The inventory of the purchases of Archduke Ernest at Brussels shows that a triptych

by Bosch was bought for him by Grameye in 1595 which was described as 'a history with naked people, *sicut erat in diebus Noe*'. It was suggested more than sixty years ago that this item was the same as the painting described in the inventory of the Prague *Kunst und Schatzkammer* of 1621 under the title 'the unchaste life before the Flood'. In this inventory, by the way, the item is followed by 'two altar wings how the world was created'.[15] There can be no doubt that this was a copy or a replica of the Madrid Triptych.

But more is gained from this identification than the knowledge that the meaning of the central panel (though not of the wings) was still understood more than a hundred years after Bosch's death. The title itself not only confirms the interpretation, it also helps to make it more precise.

Sicut erat in diebus Noe is a quotation from the Gospel of St. Matthew, where Christ speaks of the coming Day of Judgement:

> But of that day and hour knoweth no man, no, not the angels of heaven, but my Father only. But as the days of Noe were, so shall also the coming of the Son of man be. For as in the days that were before the flood they were eating and drinking, marrying and giving in marriage, until the day that Noe entered into the ark, And knew not until the flood came, and took them all away; so shall also the coming of the Son of man be. (Matthew xxiv, 36–39.)

Here, as in the painting, what is stressed is not so much the wickedness of man before the Flood, as his unconcern. Thus the document about the original title of the Madrid triptych also provides an invaluable key to the true mood of the work. It becomes indeed intelligible that Fraenger could make so many converts to his fantastic reading of the panel as a glorification rather than as a condemnation of sexual pleasures.[16] For however wild his hypothesis about the presence of a nudist sect among the members of the Confraternity of Our Lady of s'Hertogenbosch may have been, he did discern something essential when he commented on the sense of joy rather than revulsion that pervaded the painting. True, the joy is not that of the painter or the ideal beholder but rather that of the *dramatis personae*. But the passage from the gospel which was probably inscribed on the painting makes it clear that what constituted the real sin of man before the flood was the absence of a sense of sin. People indulged in 'eating, drinking, marrying and giving in marriage' without a thought of the judgement that awaited the indulgent in that Hell where the very instruments of pleasure are turned into tools of torture (Fig. 186). As Nicholas de Lyra comments on the passage: '*Erant enim tunc comedentes et bibentes in securitate: diluvium non timentes*' (For they were eating and drinking at that time and not fearing a deluge),[17] while Rabanus Maurus is particularly anxious to combat the heretical interpretation that the Lord was here condemning eating and marriage as such. 'They perished in water and fire not because they did these things, but because they wholly gave themselves up to them and despised the judgement of God.'[18] Returning to the picture from this text one can only admire

the imagination with which Bosch evoked and envisaged this total absorption in eating, lovemaking and revelling.

Bosch's version, of course, is unique, but the subject is not without parallel in Netherlandisch Renaissance art. There exists an engraving by Sadeler after D. Barendz inscribed *Sicut autem erat in Diebus Noe* and showing naked people feasting in a landscape (Fig. 203),[19] but the artist appears not to have known about vegetarianism before the Flood and furnished them with a well-cooked fowl.

The parallel certainly takes Bosch's composition out of its complete isolation. With all its strangeness the triptych does conform to the tradition of Biblical illustration rather than to a genre of symbolic fantasies. It can be more easily imagined in a chapel or church even than the triptych with the 'Hay-Wain'.

As in the case of the Madrid 'Epiphany', which I have discussed elsewhere,[20] it seems to me that we are much more likely to make further progress in the 'decoding' of Bosch by reading the Bible and its commentaries than by studying the kind of esoteric lore that has attracted so many of Bosch's interpreters. This does not mean that the picture should necessarily be regarded as a pure illustration without any recourse to symbolism. The possibility certainly exists that the metaphors and allusions to sexual activities which Bax traced in what he called the *Tuin der Onkuisheid*[21] were in fact intended by the artist to convey this message. The same applies to the images of instability and transience I described in the preceding section. The Biblical theme itself does not exclude the presence of such symbols though several of the most obtrusive ones still await explanation. Maybe a tentative solution can still be proposed for some of these puzzling features. One concerns the curious motif of glass implements, many of which look like test-tubes. Was chemistry practised by the antediluvians? Actually it was, though the records take a rather confused and puzzling form. According to Josephus[22] the 'children of Seth' knew that Adam had foretold the destruction of the world. They therefore made two pillars; one of stone, one of brick, to withstand both the forces of water and fire, and inscribed on them all knowledge they wished to preserve for mankind after the flood.[23] The story of these pillars and of the care taken with their material spread from the *Historia Scholastica* to other accounts of the history of the world.

Sometimes the craftsman is said to have been Tubal Cain, sometimes it is Jubal.[24] But at least in one medieval world chronicle, that of Rudolf von Ems, the authorship of the columns is attributed in more general terms to the sinful people before the Flood whose skill and cunning in contriving a resistant material 'harder than glass' is stressed:

Now there began, more and more, the increase of people; there were so many, all the time and ever, late and early, their number grew mightily. Sin and a sinful mind also began to increase; and with the power of their cunning skill there also increased their mastery of many skills and arts. Now Adam had foretold them that the world would have to perish through water, and come to an end in fire. Against this peril their skill artfully wrought two columns; one was of brick, the other of marble,

harder than glass. Whatever art had been discovered by them they inscribed onto these columns. . . .[25]

There is something very much like a pillar in the right-hand corner of the central panel, and behind it a pointing man who may be the only one who is dressed. Could he be Noah? (Fig. 198).

There are test-tubes even in Paradise; they can be discerned sticking out of the slag-heap that supports the fountain with its four jets reminiscent of the four rivers of Paradise (Fig. 201). The flesh colour of the fountain prompts the speculation whether Bosch may have known one of the most basic texts on the Flood, the *Liber de Noe et Arca* by St. Ambrosius, where the passage 'all flesh had corrupted his way upon the earth' is commented upon at some length. 'It is out of the flesh that the rivers of concupiscence and other evils burst forth as from a fountain'.[26] However that may be, the creeping creatures which crawl out of that pond, no less than some of the other apparitions which disturb the beauty of Paradise, make it visually more intelligible than it could ever be intellectually that the Lord repented of the Creation. In Bosch's Paradise, corruption has already set in.

The giant trees with their fantastic shapes, which are the result of the fertility of the antediluvian soil, line the horizon here and on the central panel, but the swarm of black birds which spiral through and around them augurs nothing good. It is these trees, of course, which are shown withered and dying in the waters of the Flood on the outer wing (Fig. 187), to which we can return in conclusion. The verse from Psalm xxxiii we read across this scene of divine wrath and consoling promise is not in contradiction to its subject.[27]

By the word of the Lord were the heavens made; and all the host of them by the breath of his mouth. He gathereth the waters of the sea together as an heap: he layeth up the depth in storehouses. Let all the earth fear the Lord: let all the inhabitants of the world stand in awe of him. *For he spake, and it was done; he commanded, and it stood fast.* The Lord bringeth the counsel of the heathen to nought: he maketh the devices of the people of none effect. . . . The Lord looketh from heaven; he beholdeth all the sons of men. From the place of his habitation he looketh upon all the inhabitants of the earth. He fashioneth their hearts alike; he considereth all their works. There is no king saved by the multitude of an host: a mighty man is not delivered by much strength. An horse is a vain thing for safety: neither shall he deliver any by his great strength. Behold, the eye of the Lord is upon them that fear him, upon them that hope in his mercy: To deliver their soul from death, and to keep them alive in famine. . . . (Psalm xxxiii, 6–19.)

Thus the message of the triptych is not one of unredeemed gloom. The rainbow in the storm-cloud contains the promise that no second deluge will destroy the whole of mankind, and the salvation of Noah is a reminder that the good will not perish with the wicked.

This last mentioned motif is, of course, of such crucial importance in the interpretation of the Flood, that one must ask whether Bosch can really have omitted a representation of the ark when he painted the world emerging from the destructive waters. The question is all the more legitimate, as there exists a wing of an altar in Rotterdam (Fig. 202) by Bosch or by his workshop which shows the unusual scene of the ark having come to rest and the animals emerging into a desolate landscape littered with the corpses of men and beasts drowned in the Flood.[28] The scale of the earth on the Madrid wings almost excludes the possibility of a similar representation, but whether or not the ark itself may have been visible in the centre is another matter. It is certain that all the pictures have been trimmed. This can be demonstrated through a comparison with the sixteenth-century tapestry based on them.[29] Moreover, we can safely assume that in this, as in countless other cases, Bosch enclosed the painted field of the outer wing in a complete circle. In the present mounting (Fig. 187) the circle is maintained,[30] but bisected by the double frame which may not be original.[31] A central strip about one-sixth of the total widths would thus be available for our imagination to play with. It corresponds to some 32 cm out of a total width of some 194. The width of the Rotterdam wing is no more than 38 cm. Could it possibly represent an echo or an elaboration of the centre of the closed Triptych? But whatever fresh evidence about these and other aspects of Bosch's masterpiece the future may reveal, we can safely discard the awkward title of 'The Garden of Earthly Delights'. Its Christian name is *Sicut erat in Diebus Noe,* or, perhaps more briefly, 'The Lesson of the Flood'.[32]

CLASSICAL RULES AND RATIONAL STANDARDS

From the Revival of Letters to the Reform of the Arts: Niccolò Niccoli and Filippo Brunelleschi

CULTURAL HISTORY is passing through a crisis, the crisis engendered by the slow demise of Hegelian 'historicism'. Its repercussions have been felt with particular force in Renaissance studies because it is here that the link between developments in art and in other fields has proved to modern research to be so much more complex and problematic than it appeared to the philosopher of progress. It was Hegel even more than Burckhardt who had first projected a unifying vision of the Renaissance as a forward surge of the spirit, a phase that expressed itself with equal authenticity in the revival of learning, the flourishing of the arts and the geographical discoveries, three facts representing for him the 'dawn that precedes the sunrise of the Reformation'.[1]

However little Hegel's optimistic metaphysics may have appealed to individual historians, the need for a unifying principle made it hard to forgo this conception of a new age without being left with unrelated fragments of an unintelligible past.

Rudolf Wittkower is one of the students of the period who has shown that this dilemma is unreal. Boldly challenging the traditional view that the Renaissance predilection for centralized church buildings is the expression of a new paganizing aestheticism he has also refused to withdraw into a positivist collection of dates and groundplans.[2] He could thus show that in one particular area a bridge exists between ideas and forms without falling back on generalizations about the new age and the new man.

It is the purpose of this chapter to follow up this success by facing Hegel's questions once more, to look for an answer not in the metaphysics of history but in the social psychology of fashions and movements. Maybe the solution it tries to offer is premature. It is certainly one-sided. But it will have served its end if it shows once more that, if we follow Wittkower in concentrating our attention on living people in concrete situations, we are more likely even to find texts and cues that explain the interaction of changes in various fields than if we are satisfied with the pseudo-explanation of a 'spirit'.

The Renaissance is the work of the humanists. But to us this term no longer denotes the heralds of a new 'discovery of man' but rather the *umanisti*, scholars, that is, who are neither theologians nor physicians but rather concentrate on the 'humanities', principally the *trivium* of grammar, dialectic and rhetoric.[3] How was it, we must ask, that these preoccupations could lead to a revolution not only in classical studies but also in art and ultimately even in science? What started the landslide that transformed Europe?

Any movement that thus conquers society must have something to offer that establishes

This was a contribution to the *Essays in the History of Art presented to Rudolf Wittkower* (London, 1967).

its superiority in the eyes of potential converts. Where what is offered is a useful invention the historian need hardly puzzle his head why it was accepted. We know only too well why gunpowder was quickly taken up in Europe, which it had reached from the East, and we are not surprised that spectacles were a success when they were first invented about 1300 in Pisa.[4] What 'movements' offer their new adherents, however, is generally something a little less tangible but psychologically more important. They offer them a feeling of superiority over others, a new kind of prestige, a new weapon in that most important fight for self-assertion which the English humorist Stephen Potter has so aptly described as the game of 'one-up-manship'. The early humanists evidently had both to offer, real inventions or at least discoveries which established their superiority in some respects over more old-fashioned scholars, but also a new emphasis on that superiority, a new glamour and self-confidence that carried everything before it, even though it was based at first on precariously narrow foundations. The humanists, as Ruskin once put it, 'discovered suddenly that the world for ten centuries had been living in a ungrammatical manner, and they made it forthwith the end of human existence to be grammatical. . . .'[5]

To be sure this interpretation has been increasingly challenged in recent years. Many students of the period have come to emphasize the importance of 'civic humanism'[6] in the outlook of such great humanists as Coluccio Salutati and Leonardo Bruni Aretino, who certainly cared for many things besides grammar. The question is only whether it was these virtues which secured humanism its ascendancy and ultimate triumph. The time may have come to focus attention once more on those representatives of the movement who are nowadays sometimes censured for their exclusive concentration on classical studies. Of these, by common consent, the most outstanding and the most extreme example is Niccolò Niccoli, 1367–1437, a Florentine merchant of a well-to-do family.[7]

Every student of the period knows the charming portrait of the aged Niccoli, which Burckhardt quoted from Vespasiano da Bisticci's biography: 'always dressed in the most beautiful red cloth, which reached to the ground . . . he was the neatest of men . . . at table he ate from the finest of antique dishes . . . his drinking cup was of crystal . . . to see him at the table like this, looking like a figure from the ancient world, was a noble sight indeed.[8]

Every line of Vespasiano's beautiful biography breathes his veneration for a man he is proud still to have known, and whom he describes as a central figure in that great circle of enthusiasts who experienced the exhilarating tide of new texts and new information. We can confirm from the correspondence of Poggio Bracciolini, Ambrogio Traversari, Bruni, Aurispa and others that in this respect Vespasiano had not exaggerated. Niccolò Niccoli was the man to whom discoveries were reported from abroad and who passed on information and codices. His library, which went to San Marco, testifies to his industry and his devotion to the cause of classical studies.

Many decades after his death, when Vespasiano looked back, Niccolò Niccoli's role

as one of the originators of the humanist movement was no longer a point of contention. 'It may be said that he was the reviver of Greek and Latin letters in Florence . . . although Petrarch, Dante and Boccaccio had done something to rehabilitate them, they had not reached the height which they attained through Niccolò.'[9] In all its deceptive simplicity the sentence still sums up the theme of Niccoli's life, his ambivalence towards the three great luminaries of Florentine literature who had to be surpassed if the recovery of Greek and Latin standards was to be attempted in earnest. It was his respect for these standards, we learn from Vespasiano, that accounts for the fact that Niccolò himself never published anything. His taste was so fastidious that he never satisfied himself.

Even in this idealized portrait it is possible to discern the type of pioneer to which Niccolò Niccoli belongs. They may be called the catalysts, men who effect a change through their mere presence, through conversation and argument, but who would be unknown to posterity if others had not left records of their encounters. Socrates is the most exalted example (save for religious leaders). Like Socrates, Niccoli is known to us mainly in the dual reflection of hostile satire and pious evocation. He was singled out for scurrilous diatribes and as an interlocutor in many a humanist dialogue that tried to evoke the atmosphere of discussions in Florence during its most creative period.[10]

The most telling of these dialogues was composed at a time when Niccoli was in his middle thirties; it is the first of Leonardo Bruni's famous *Dialogi ad Petrum Histrum*[11] which is often quoted for Niccoli's unbridled attack on Dante, Petrarch and Boccaccio in which it culminates.

> What are these Dantes, these Petrarchs, these Boccaccios you remind me of? Do you expect me to judge by the opinion of the vulgar and to approve and disapprove of the same as does the crowd? . . . I have always suspected the crowd, and not without reason.

Quite apart from Dante's anachronisms and mistakes he was devoid of Latinity. Niccoli had recently read some of Dante's letters:

> By Jove, nobody is so uneducated that he would not feel ashamed to have written so badly. . . . I would exclude that poet of yours from the company of literate men and leave him to the woolworkers. . . .[12]

After similar tirades against Petrarch and Boccaccio Niccoli exclaims that he rates 'a single letter by Cicero and a single poem by Vergil far higher than all the scribblings of these men taken together'.[13]

It is hard to understand, let alone forgive, this sensational blasphemy unless one reads it in the context of the dialogue. For Bruni is careful both in the setting and in the argument to prepare the reader for this denunciation of Florence's proudest tradition. In the opening section Coluccio Salutati, the chancellor, a sage as well as a scholar, is found politely reproaching the young men, Bruni, Roberto Rossi and Niccolò Niccoli

because they neglected discussion or disputations of philosophical matters. Niccolò agrees that such exercises would be beneficial but it is not his fault but the fault of the times in which they live that they are not worth pursuing.

> I cannot see how one can pursue the mastery of disputations in such wretched times and with such a shortage of books. For what worthy skill, what knowledge can be found in these times that is not either dislocated or totally degraded? . . . How do you think we can learn philosophy these days when large parts of the books have perished and those that survive are so corrupt that they are as good as lost? True enough, there are plenty of teachers of philosophy who promise to teach it. How splendid these philosophers of our age must be if they teach what they do not know themselves.[14]

They defer to Aristotle's authority, but those harsh, hard and dissonant words they quote as Aristotle cannot be by the same man of whom Cicero writes that he wrote with incredible sweetness. And as with philosophy so it is with all the Liberal Arts. It is not that there are no talents nowadays, or no wish to learn, but without knowledge, without teachers, without books it cannot be done. 'Where are Varro's writings, where Livy's histories, where Sallust's or Pliny's? A whole day would not suffice to enumerate all the lost works.'[15] It is here that Salutati interposes and asks his opponent not to exaggerate. They have works by Cicero and Seneca, for instance, and he reminds him of the three great Florentines, thus provoking the final outburst.

In the second dialogue this attack is withdrawn. Niccoli maintains that he had only said these outrageous things to provoke Salutati into a eulogy of the Florentine 'triumvirate'. Since it was not forthcoming it is he who shows that he can argue the other side and give due praise to the Great Three.

The contrast between these two speeches is so startling that Hans Baron has concluded that they cannot date from the same period and must be indicative of a change of heart, at least on the part of Bruni.[16] But quite apart from the fact that the marshalling of effective arguments on both sides is part of the rhetorical tradition, Niccoli's conversion is perhaps not as complete as it looks on the surface. Bruni slipped in a malicious joke that turns out to be a very backhanded retraction of the original remark about Vergil and Cicero: 'As to those who assert that they rate one poem of Vergil and one letter by Cicero more highly than all the works of Petrarch', Niccoli is now made to say, 'I frequently turn this round, and say that I prefer one speech by Petrarch to all Vergil's letters and that I rate Petrarch's poems much more highly than all Cicero's poems.'[17] Cicero's poems, of course, were notoriously wretched, and we do not possess Vergil's letters. The retraction, therefore, is quite in character.

There is no doubt that it was this sensational irreverence that attracted most attention among Niccoli's contemporaries; and in revolutions of this kind to have gained attention is half the battle. The baiting of authority, the cry 'burn the museums' belong to that ritual of 'father-killing' that we associate with new movements. But the first dialogue

shows us also that this attack was launched from a secure base. The humanists had probed the enemies' defences and found out their weakest spot. They were right in their complaint about the lack of good texts, right in their suspicion of the Aristotelian doctrine as it was taught in the universities, right in their demand that in such a situation first things must come first and that the greatest need was to find out what the ancients had in fact written and taught. Without these preliminaries there can be no valid disputations within a framework that relies on authorities. It is a temper that is not unfamiliar to those of us who have witnessed similar if less spectacular reactions in present-day scholarship against the grand generalizations of philosophical historians. The proper edition of texts and charters acquires an almost moral significance for those rebels who submit to a self-denying ordinance in order to atone for the vapid rhetoric of their elders.

It is against this background that both the hostility aroused by Niccoli's group and its ultimate European triumph become more intelligible. Documents of this hostility there are plenty. No less than five formal 'invectives' against Niccoli and his circle are known,[18] among them vicious attacks by the greatest of fellow humanists such as Guarino and Bruni himself. The burden of their complaint is always the same: irreverence towards the great Florentine poets, excessive arrogance backed by no creative achievement, a foolish pedantry concerned with finicky externals of manuscripts and of spelling instead of an interest in their meaning.

Thus Cino Rinuccini pretends in his invective written around 1400 that his 'sacred wrath' drove him from Florence to seek refuge and peace from the empty and stupid discussions of a gang of prattlers.

> To appear very erudite in the eyes of the vulgar they shout in the piazza how many diphthongs the ancients had and why today only two are in use . . . and how many feet the ancients used in their verses and why today only the anapaest is used . . . and with such extravagances they spend all their time . . . but the meaning, the distinction, the significance of words . . . they make no effort to learn. They say of logic that it is a sophistic science and not much use. . . .

And so through the whole gamut of the Liberal Arts, each of which the arrogant set is accused of dismissing and which the writer feels called upon to defend against these 'vagabonds'.[19] Rinuccini does not mention the offending party. Guarino's invective dated 1413 is much more personal; though he does not name his victim he must have been easy to identify. The letter exists in two versions.[20] Both of them contain the gravamen of the charge that Niccoli forgets that 'it is not the eagle but the spider who catches flies'.[21] One of them expands on this point at some length with heavy sarcasm describing Niccoli as a student of 'geometry'.

> Neglecting the other aspects of books as quite superfluous he expends his interest and acumen on the *points* (or dots) in the manuscript. As to the *lines*, how accurately,

how copiously, how elegantly he discusses them. ... You would think you hear
Diodorus or Ptolemy when he discusses with such precision that they should be
drawn rather with an iron stylus than with a leaden one. ... As to the paper, that is
the *surface,* his expertise is not to be dismissed and he displays his eloquence in
praising or disapproving of it. What a vacuous way to spend so many years if the
final fruit is a discussion of the shape of letters, the colour of paper and the varieties
of ink.[22]

Guarino had recently seen a little work by Niccoli, an Orthography compiled for the
education of small boys.

It shows that it is the author who is a small boy and is not ashamed, against all rules,
to spell syllables which are contracted by nature with diphthongs. ... This white-
haired man does not blush to adduce the testimony of bronze and silver coins, of
marbles and of Greek manuscripts in cases where the word offers no problems. ...
Let this Solon tell us, if he can, which living author of his age he does not find fault
with.[23]

Leonardo Bruni picked up these and other motifs when it was his turn to quarrel with
Niccoli around 1424.[24] He offers a vivid caricature of Niccoli strutting through the streets
looking left and right expecting to be hailed as a philosopher and a poet, as if he said:

Look at me and know how profoundly wise I am. I am the pillar of letters, I am the
shrine of knowledge, I am the standard of doctrine and wisdom. If those about him
should fail to notice he will complain about the ignorance of the age.[25]

It is Bruni now who confirms that Niccoli does not stop at abusing Dante, Petrarch
and Boccaccio, that he despises St. Thomas Aquinas and anyone else who lived during
the last thousand years.[26] Yet what has he done himself? He cannot put two Latin
words together, he is sixty now and all he knows is about books and the book trade, he
knows neither mathematics nor rhetoric, nor law. Allegedly he is interested in grammar,
a subject fit for boys. He ponders about diphthongs.[27]

Making allowance for the obvious distortions of these caricatures they still supple-
ment the picture of Niccoli in an important respect. If Bruni's Dialogue has shown us
the rebel who wants to break with the immediate past in order to restore the higher
standards of antiquity, the caricatures emphasize the weapon he was using in this fight.
The old men should go back to school, they cannot even properly spell or write.

It was easy to ridicule this concern as tiresome pedantry, but the very resentment it
caused betrays anxiety. For clearly Niccoli was often right. The spelling of Latin had
been corrupted in the Middle Ages. In itself this was no new discovery. Salutati was
also interested in orthography.[28] But for him this was certainly not the most important
issue. He could freely cultivate the heritage of Petrarch and pursue the study of the
classics without being totally diverted to such concentration on minutiae. He could
never contemplate a breach with tradition. As Ullman has brought out so well in his

book on Salutati's humanism, medievalizing and modern elements do not clash in the mental universe of the Florentine chancellor.[29] To the young rebels this must have looked like compromising with the devil. Their programme 'first things first' now started with spelling and writing.

At first sight such a programme does not look like a promising start for a fashion and movement that was to embrace the whole of the Western world. It is understandable therefore that in Hans Baron's book this pedantic classicism is mainly used as a foil to bring out the 'civic humanism' of Bruni.[30] The pedants stand condemned as men lacking in patriotism and glorying in their isolation. Not all of the few facts we know about Niccoli fit this image. Niccoli quite frequently held public office and some of the posts he occupied were not without importance.[31] But even if the picture of Niccoli's detachment were entirely correct this need not prove that he might not have influenced the course of events. It is rash to assume that a concern with spelling and similar issues cannot have more far-reaching consequences than the best-intentioned participation in local politics. We have seen in our own days that spelling reforms can become an issue of no less explosive a kind than the design of flags. It only depends in what contexts such questions are raised.

There are indications that the concern with these famous diphthongs was aroused in this circle by an outsider. Manuel Chrysoloras, the admired sage from Constantinople whom Salutati had called to Florence to teach the young scholars Greek, was interested in this question of orthography[32] which probably impinged on the correct transliteration of Greek names. It must have been startling to be told by a Greek that Latin had been corrupted in the Western world and to find confirmation of this in inscriptions on coins and tombstones. The spelling *etas* was clearly wrong, it should be *aetas*, and so with many similar forms. No wonder that these matters could become a symbol of the new emphasis on accuracy, a banner to be raised in the fight against the corruption of language.

Even now, as it happens, the question of diphthongs can make hackles rise. We need only watch the reaction of a proud English scholar who has to accept American spelling of such words as color or labor, though in this case etymology favours the transatlantic usage. But the dropping of that old-fashioned 'u' becomes identified in the mind of the conservative with 'false quantities' or even with that proverbial dropping of aitches which marks the uneducated Cockney on the stage and in real life. No wonder tempers could be frayed over matters of spelling. Salutati still clung to the medieval usage of *michi* and *nichil* and wanted to enforce this barbaric tradition against the 'stiffnecked' opposition of Poggio Bracciolini who called the spelling of *nichil* a 'crime and a blasphemy'.[33] He may have been joking but he surely felt strongly about the need to revert to the purity of ancient orthography.

It would be interesting to study in a wider context the importance which language has played in the formation of social groups. Bernard Shaw's Professor Higgins knew that language and accent are the passport to society. But language is more, it can create

a new allegiance. The purist who claims special insight into language and castigates current abuses will always attract attention and arouse both hostility and passionate allegiance among users of language. Karl Kraus in Austria was a case in point, a satirist to whom little else was sacrosanct beside the rules of correct German, which he saw threatened and corrupted by journalistic jargon. Healthy as was his campaign in many respects, the feeling of superiority he gave to those who had learned to spot certain common mistakes was a noteworthy by-product of his pamphleteering. It appears that it even spread to England through his admirer Ludwig Wittgenstein who, in his turn, wanted to reform the language of the tribe and succeeded mainly in raising the self-confidence of those who had learned to spot linguistic muddles in others.

We need not overwork this possible parallel to realize that the movement which Niccolò Niccoli represents may have owed some of its dynamism to what Potter calls 'one-up-manship'. The humanists were reformers of style and language and in this field they could show their demonstrable superiority over the old men who still betrayed their ignorance by spelling *nichil* instead of *nihil* or *autor* instead of *auctor*. It may well be true that this passion sometimes crowded out all other interests. Niccoli, at any rate, was not a rebellious spirit in metaphysical matters. There is no reason to doubt Vespasiano's words that he was *cristianissimo*[34] and that 'those who harboured doubts concerning the truth of the Christian faith incurred his strongest hatred'.[35]

In a sense that concentration on form rather than on content that so much aroused the wrath of Niccoli's enemies in his own time and in ours, facilitates this conservatism in religious and philosophical matters. Neither for him nor, a century later, for Erasmus was there any contradiction between this regard for philological accuracy and a respect for the Gospel.

Far from being a weakness therefore, this emphasis on form was an added asset for the success of the humanist movement. It established the superiority of those who adhered to it, but it did not cut at the root of their beliefs. From this point of view it is not surprising that it was in this circle and at that moment of time that the direct transfer occurred from a literary concern and attitude to a change in a visual style. We have heard from Guarino how much Niccoli worried about 'points, lines, and surface' in books. Another satire[36] is even more explicit. It complains once more about a group of irreverent men who fail to respect the three great Florentine poets but have never created anything of themselves. It is true,

one of them may claim to know very much about books. But I should reply, yes, perhaps, whether they are well bound, and that might make a good beadle or stationer. For this turns out to be the height of genius of that professional fault-finder, to want to see a beautiful ancient script, which he will not consider beautiful or good, if it is not of the ancient shape and well spelt with diphthongs, and no book, however good it may be, pleases him, nor would he deign to read it if it is not written in ancient characters (*lettera antica*).[37]

Here we know that what struck contemporaries as a fad and an affectation in one man was to affect the whole of the Western world. For it was this *lettera antica* that replaced the Gothic script first in Italy, whence it spread in the wake of humanism wherever the Latin alphabet is now used, including the printers of this volume.

The story of this first tangible innovation which we owe to the Florentine circle of humanists is exceptionally well documented. An art historian may well envy the palaeographer the precision with which he can here follow a stylistic change. It has been treated with masterly clarity and acumen by L. Ullman in his book on the *Origins and Developments of Humanistic Script*.[38] Thanks to Ullman we can see this development in terms of particular people expressing preferences and making a choice rather than in terms of those anonymous collective forces and trends which are the bane of history. Not unexpectedly the story begins with Petrarch, who still wrote a Gothic script but who had strong opinions about the quality of lettering he preferred. What he wants, he writes to a friend, are not fine luxuriating letters which delight the eye from afar but fatigue it in reading. In 1395 Petrarch's heir and disciple Salutati tries to procure a book from France and writes: 'If you could get one in antique lettering I would prefer it, since no letters are more welcome to my eye.'[39]

There is little doubt that what Salutati meant by antique lettering was the type of lettering used before the arrival of Gothic script, the type we now call Carolingian minuscule, which is indeed much more lucid and easier to read. Very likely Salutati, whose eyesight was deteriorating, preferred it for that reason; but he must also have noticed that the earlier manuscripts offer on the whole a better text. His expression 'antique lettering' even suggests that he may have wrongly believed the oldest codices of this kind to go back to the classical age. Salutati normally wrote in a Gothic hand (Fig. 204) but Ullman has shown that there exists at least one manuscript by Salutati himself, a codex of letters by Pliny, which the aged humanist and chancellor copied out for himself, and in which he experimented with an imitation of this earlier form of lettering. He did not sustain the attempt. The first dated manuscript known to Ullman written in the new script is a codex written by Salutati's pupil and subsequent successor in the chancellery, Poggio Bracciolini, dating from 1402 to 1403[40] (Fig. 205). It still shows traces of Gothic form but is written with the discipline and care of the professional scribe—for that is what Poggio apparently was in his youth.

It is interesting to follow Ullman here into an analysis of the spelling which reflects the very discussions in this circle which had attracted so much hostility and ridicule.[41] In the first part of the manuscript Poggio still writes *etas* but later *aetas*. On the whole Poggio is careful to employ the sacred diphthong, occasionally even too careful. As Ullman noticed he had some difficulty in not introducing it where it does not belong. Thus he once wrongly writes *fixae* for the adverb *fixe* and twice *accoeptus* for *acceptus*.

Poggio himself was not to become an extremist in matters of diphthongs. But what is important here is not so much the individual spelling as the emphasis on a standardized

orthography and a standardized script. We can trace the efforts by which Poggio spread the new form of lettering for we know from his letters that he had set himself the task of teaching it to the scribes who served the circle of the Florentine humanists.[42]

In a letter of June 1425 to Niccolò Niccoli he mentions a scribe who can write fast and 'in that script that savours of antiquity' (*litteris quae sapiunt antiquitatem*). By then he also had a French scribe at his disposal whom he had taught to write *litteris antiquis* (in antique lettering). In 1427 Poggio complains that for four months he had done nothing but to teach a blockhead of a scribe to write 'but the ass was too stupid'. Maybe he would learn in two years. By that time, of course, the manuscripts tell their own story; we can see the spread of the *littera antiqua* in manuscript after manuscript.

As far as we can tell, the amateur Niccolò Niccoli himself did not write in the same perfect hand—as little indeed as he wrote in a perfect Latin style. According to Ullman he had developed instead a more cursive utility version of the *littera antiqua* which must have served him well in his labours of copying ancient texts and which developed later into the type we know as italic.

And yet, if the picture painted by the satirists is any guide, the single-minded passion of this man must have had a share in that reform of letters that still affects us today. It was a reform in the true sense of the word: a turning back from a corrupt style and lettering to an earlier phase. Otto Pächt has shown how closely fifteenth-century manuscripts in Italy came to be modelled on twelfth-century exemplars both in their scripts and their initials.[43] He drew attention to the similarity between the Oxford Lactantius of 1458[44] (Fig. 206) and a Gregory manuscript of the twelfth century[45] (Fig. 207).

It is obvious therefore that there is a striking parallelism between this spread of the *littera antiqua*, which was really a twelfth-century form, and the momentous change in the style of architecture we connect with the name of Filippo Brunelleschi. Brunelleschi too rejected the Gothic mode of building current in Europe in his day in favour of a new style that became known as *all'antica* (the manner of the ancients). His reforms, like that of the humanist scribes, spread from Florence throughout the world and remained valid for at least five hundred years wherever the Renaissance style was adopted or modified. Throughout these centuries this style has been regarded as a revival of ancient Roman architecture, and that is what it effectively became at the time of Brunelleschi's successor, Alberti. But whatever Brunelleschi's own intentions may have been, modern research has revealed that, like the humanists, he derived his alternative to the Gothic style less from a study of Roman ruins than from pre-Gothic exemplars in Florence which we now know to be in a form of Romanesque but which he probably invested with greater antiquity and more authority.[46]

The order and magnitude of Brunelleschi's achievement is of course on a different level from that slight adjustment in letter-forms carried out by Salutati and his disciples. And yet that comparison would perhaps have sounded less extravagant to the fifteenth century than it sounds today. Lorenzo Ghiberti, who, whatever his relations were with Brunelleschi, was in constant touch with him for many years, makes the explicit com-

parison in his *Commentarii*. Discussing proportion as a key to beauty he switches from the example of the human body to that of writing:

> Similarly a script would not be beautiful unless the letters are proportionate in shape, size, position and order and in all other visible aspects in which the various parts can harmonize.[47]

Now it is this discovery of an underlying harmony that is stressed by Brunelleschi's first biographer as the true revelation that was granted to Brunelleschi in his contemplation of ancient statues and buildings where 'he seemed to recognize quite clearly a certain order in their members and bones . . . whence he wanted to rediscover . . . their musical proportions. . . .'[48]

It is unnecessary here to revive the discussion that has centred round the problem of Brunelleschi's Roman journey.[49] The story which Vasari took over from that same biography, which maintains that Brunelleschi left Florence for Rome because he was not awarded the commission of the Baptistry doors, so obviously bears the stamp of a pragmatic reconstruction that it need not be taken seriously. Of course this would not exclude any number of trips by Brunelleschi to Rome during which he may have studied ancient methods of vaulting and ancient forms of capitals.

But seen in the light of the palaeographic parallel such studies of detail may well have come after the main reform. Humanistic script also came to embody features, especially in majuscules, that were directly taken from Roman monuments, but the basic structure of the *bella lettera antica* was not Roman but Romanesque. Like the reform of script the reform of architecture was certainly due to the new and exclusive enthusiasm for antiquity, but its inspiration came mainly from monuments of the Florentine past that were venerated as Roman relics. In this respect there is evidence, not yet considered by art historians, that strongly suggests a link between these two reform movements, for once more the clues point to Niccolò Niccoli and to Coluccio Salutati.

Vespasiano actually tells us that Niccolò 'especially favoured Pippo di Ser Brunellesco, Donatello, Luca della Robbia and Lorenzo Ghiberti and was on intimate terms with them'.[50] But this testimonial is rather vague and late in date. More precious and more startling evidence is buried in Guarino's invective of 1413 against Niccolò Niccoli, a date that is a few years earlier than any of Brunelleschi's first efforts in the new style. This is what Guarino writes about Niccolò Niccoli:

> Who could help bursting with laughter when this man, in order to appear also to expound the laws of architecture, bares his arm and probes ancient buildings, surveys the walls, diligently explains the ruins and half-collapsed vaults of destroyed cities, how many steps there were in the ruined theatre, how many columns either lie dispersed in the square or still stand erect, how many feet the basis is wide, how high the point of the obelisque rises. In truth mortals are smitten with blindness. He thinks he will please the people while they everywhere make fun of him. . . .[51]

Here is a precious document therefore which shows Niccolò Niccoli as interested in the externals of ancient buildings as he was in ancient lettering and spelling. We can even infer what spurred this interest in Florence at this particular moment. The clue is found in a famous pamphlet by Salutati which strangely enough has also escaped the attention of architectural historians.

Once more we are in the context of polemics. Salutati, the Florentine chancellor, was out to defend and exalt the dignity of Florence against the attacks of the Milanese Loschi.[52] The background of this polemic has been illuminated in Hans Baron's book on *The Crisis of Humanism*.[53] Baron has emphasized how the civic pride of Florence was aroused by the moment of mortal danger from the north when the Visconti of Milan made ready to snuff out the last of the independent city states. It was in this patriotic propaganda that the legendary links between Florence and the Roman Empire loomed large and Salutati was out to prove this claim to be well founded. He proved it by art historical arguments:

> The fact that our city was founded by Romans can be inferred from the most compelling conjectures. There is a very old tradition obscured by the passage of years, that Florence was built by the Romans, there is in this city a Capitol and a Forum close by, . . . there is the former temple of Mars, whom the aristocracy believed to be the father of the Roman nation, a temple built neither in the Greek nor in the Etruscan manner, but plainly in the Roman one. Let me add another thing, though a matter of the past; there was another sign of our origin that existed up to the first third of the fourteenth century, . . . that is an equestrian statue of Mars on the Ponte Vecchio, which had been preserved by the populace in memory of the Romans. . . . We also still have the traces of the arches of the aqueduct built according to the custom of our ancestors . . . and there still exist the round towers, the fortifications of the gates now joined with the Bishop's Palace, which anyone who had seen Rome would not only see but swear to be Roman, not only because of their material and brickwork, but because of their shape.[54]

There is yet more literary evidence for this interest in the architectural style of the monuments we now assign to the Florentine 'proto-Renaissance'. Giovanni da Prato's *Paradiso degli Alberti* which Baron dates around 1425, the very years of Brunelleschi's reform, contains another discussion of the Roman origin of Florence which is probably dependent on Salutati but gives more details. Its description of the Baptistry (Figs. 208–10) as an ancient temple of Mars scarcely has a parallel in pre-Renaissance literature:

> This temple can be seen to be of singular beauty and in the most ancient form of building according to the custom and method of the Romans. On close inspection and reflection it will be judged by everyone not only in Italy but in all Christianity the most notable and singular work. Look at the columns in the interior which are all uniform carrying architraves of finest marble supporting with the greatest skill and

ingenuity that great weight of the vault that can be seen from below and makes the pavement appear more spacious and more graceful. Look at the piers with the walls supporting the vault above, with the galleries excellently fashioned between one vault and the other. Look at the interior and the exterior carefully and you will find it as architecture useful, delightful, lasting, solved and perfect in every glorious and happy century.[55]

While these lines were being written Brunelleschi was probably already at work to revive this form of building.

We do not know for certain to which building should go the honour of having been the first in which Brunelleschi ventured this deliberate break with current usage to become the *risuscitatore delle muraglie antiche alla romanescha* (the reviver of ancient building in the Roman manner) as he is called by Giovanni Rucellai.[56]

Brunelleschi's ascendancy in the Cathedral workshop coincides with the work on three important projects, the Ospedale degli Innocenti, the San Lorenzo Sacristy, and, if we can believe his early biographer, the Palazzo della Parte Guelfa.[57] That there was some give and take between two of these projects at least is indicated by the fact that a certain Antonio de Domenico *'capomaestro della parte Guelfa'* (Master in chief of the Parte Guelfa) was detailed in March 1421 to do some work on the building of the Innocenti.[58] If it could ever be shown that the Parte Guelfa was the first project in which the new reformed style was used, a certain link could perhaps be established between the interest of the 'civic humanists' in the Roman monuments of Florence and the revival of the style. For though the *Parte Guelfa* appears to have lost much of its power in the course of the fourteenth century it may still have been true, to use Gene A. Brucker's formulation, that it remained a 'visible symbol of the Guelf tradition. Most Florentines had come to accept the Parte's contention that it was the city's most vital link with her past and also the guardian of her destiny.'[59] Among their ceremonial rights and duties was the precedence given to the captains of the *Parte* to lead the annual procession to the Baptistry at the Feast of San Giovanni, the patron saint of Florence.[60] Would it not have been fitting to build their palace in the admired style of that ancient shrine? A new statute of the *Parte Guelfa* was approved in March 1420. It had been prepared by a commission whose members 'in this preparation could rely on the work and aid of Leonardo Bruni'.[61] It would certainly be tempting to connect the new building with this attempt at reviving the institution. According to Manetti, Brunelleschi was only called in when the building had already been begun. In the absence of further evidence we cannot tell whether this may have happened as early as 1418 as some have conjectured[62] or whether the Innocenti project which was started in 1419 has the priority. One thing is likely—Brunelleschi's departure from the traditional Gothic methods was at first confined to certain commissions.[63] In all probability he continued to use the earlier idiom for some of the private houses which he apparently built in the twenties.

This is evidently not the place to recapitulate the development of Brunelleschi's

style, which has been so frequently discussed. Suffice it to repeat that it was a reform rather than a revolution. It is well known, for instance, that for the interiors of San Lorenzo (Fig. 211) and of S. Spirito he adapted the scheme of the Romanesque basilica, exemplified in Florence by the eleventh-century church of SS. Apostoli (Fig. 212), but that he changed not only its proportions but also such details as the arches resting directly on the columns. The device he used of interposing an 'entablature block' between the capital of the column and the arch was also pre-figured in the arcaded orders of the exterior of the Baptistry (Fig. 208).

Even one of Brunelleschi's most perfect creations owes more to the Baptistry than to genuinely Roman architecture. I am referring to the (unfinished) façade of the Cappella Pazzi (Fig. 213). This time it is the basic scheme of the interior of the earlier building, with the arch cutting into the zone above the columns (Fig. 209) that Brunelleschi adapted for his graceful design. Yet in adopting this arrangement he also purified the detail (perhaps on the authority of the Pantheon in Rome; cf. Fig. 214). He did away with the solecism of the truncated pilasters which, in the Baptistry, are showing over the arch.

Thus it is clear that Brunelleschi's reform parallels the humanist reforms also in that respect that it is more concerned with the weeding out of corrupt practices than with an entirely fresh beginning. What strikes us, in the vocabulary of quattrocento architecture, is less its classical character than its link with the medieval past. The typical form of the palace window as we see it on Michelozzo's Medici palace is a case in point (Fig. 218). There is nothing here that matches Roman forms, but much that goes back directly to medieval practice as exemplified by the Gothic window of the Bargello (Fig. 219). All the Renaissance architect did was to remove the solecism of the pointed arch and so to make the general shape conform to the rules abstracted from Vitruvius and Roman buildings. The relation can be taken as typical. It is this type of continuity behind diversity which we so often find when we analyse the manifestations of the Renaissance. No wonder opinions differ so widely as to the degree of novelty we should attribute to the period. Would it not be correct to say that the novelty lies frequently in the avoidance of mistakes that would infringe the classical norm?[64] This avoidance in its turn springs from the new freedom to criticize the tradition and to reject anything that seems 'a crime and a sacrilege' in the eyes of ancient authority.

It is this after all that distinguishes the humanists from the more conformist scholastics. It is this which made Niccolò as their spokesman so unpopular and so startling. He arrogated to himself the right to feel superior over the greatest figures of the Florentine past because he knew certain things better—diphthongs for instance. Is it not possible that it was this same critical attitude that connects the humanist movement also with the second of Brunelleschi's momentous reforms, the introduction of scientific perspective into the vocabulary and the practice of painting?

The first great work of art, of course, in which Brunelleschi's style *all'antica* is combined with his achievement of mathematical perspective is the presentation of the

Christian mystery of the Trinity in Masaccio's fresco in Santa Maria Novella, painted about 1425.

Much, perhaps too much, has been written about perspective and the claim has been made in various forms that this new style reflects the new philosophy, the new *Weltanschauung*, centred on man and on a new rational conception of space. But cannot Occam's Razor be applied to these entities? Can it not be argued that perspective is precisely what it claims to be, a method of representing a building or any scene as it would be seen from a certain vantage point? If it does, Brunelleschi's perspective represents an objectively valid invention, no less valid than the invention of spectacles a century earlier. Nobody has as yet claimed that to look at the world through lenses to correct one's bad eyesight is due to a new *Weltanschauung*, though we may claim that it is due to inventiveness.

Maybe the invention of scientific perspective can be seen as a reform that originated from the same critical scrutiny of tradition as did the introduction of diphthongs. The Trecento tradition that had its origin in Giotto was as vulnerable from that point of view as was the poetry of Dante, Petrarch and Boccaccio. Boccaccio could claim of Giotto that he was able to deceive the sense of sight,[65] but looked upon with cool detachment and with the legendary fame of ancient painters in mind this claim could hardly be upheld. There are inconsistencies in the spatial construction of Trecento paintings which must have jarred increasingly on critical minds the more the narrative style demanded a convincing setting.[66] It fits well with this interpretation that in Bruni's first Dialogue of 1401 there is also a critical reference to painting put into the mouth of Niccolò Niccoli. The passage which has also escaped the attention of art historians occurs in the context of Niccoli's attack on Petrarch and the advance publicity he was accused of giving to his *Africa*.

What would you say of a painter who would claim to have such knowledge of his art that, when he started to paint a scene, people would believe that another Apelles or Zeuxis was born in their age, but when his paintings were revealed it would prove to be laughably painted with distorted outlines? Would he not deserve universal mockery?[67]

Whether or not Niccoli's darts are here directed against any particular artist, one thing is sure, at the time when they were published there was really nothing painters could do to rectify this strange impression of distorted outlines—indeed the closer they came to a naturalistic narrative, the more noticeable were such inconsistencies. Help had to come from outside, and looking at the matter *post factum* it is not at all surprising that it came from an architect.

The story of Brunelleschi's invention has been discussed and analysed by Panofsky, Krautheimer and John White.[68] According to Manetti the first perspective painting was a view of the Baptistry (Fig. 208) as seen through the door of the Cathedral. Looking at the painting, or rather its mirror reflection through a peephole, and looking at the

real scene, the startled beholder could see that the two images were identical. It may be no accident that Brunelleschi took the Baptistry for his demonstration piece. For this famous landmark of Florence which Dante calls '*il mio bel San Giovanni*' (my fair St. John's) had figured on many traditional views of the city in the Trecento. We can discern it well, both in the Biadaiuolo Codex on grain distribution (Fig. 217), and again on the fresco in the Bigallo of 1352 (Fig. 216). The examples show one of the difficulties in rendering this beautiful building without distorted lines; the representation must be consistently constructed if the patterns of the incrustation are not to get you into trouble. Even on that later Cassone (Fig. 215) which may well have been influenced by Brunelleschi's panel, this inconsistency is disturbing, once attention has been drawn to it.

How was it that it fell to an architect to find the remedy for this awkward distortion of lines? Maybe, because an architect is used to asking a different question from the painter. The painter is apt to ask 'What do things really look like?' while the architect is more often confronted with the more precise question of what can be seen from a given point. It is the answer to this simple question which must have given Brunelleschi the means to solve the painter's puzzle. For obviously, if Brunelleschi was asked, for example, during the work on the cupola of the Cathedral whether the lantern would be visible from the door of the Baptistry he would have replied that this could easily be found out by drawing a straight line from the one point to the other. If the line hits no obstacle the points must be visible. Even today, whenever the problem is raised whether a new building is likely to obscure or spoil a famous view the architect will be called upon to show exactly how much of his projected building will be visible from a given point and how its silhouette will relate to the city's skyline. Needless to say this is a question that allows of an exact answer. None of the arguments that have been customarily adduced to stress the conventional character of perspective materially affect its accuracy—neither the fact that we see with two eyes nor the fact that the retina is curved or that there is a conflict between the projection onto a plane and onto a sphere. The same objective laws secure of course an uncontrovertible answer to the question as to what part of a room can be seen from a given spot through a window. It all follows from the fact that visual lines are straight and that Euclidean geometry works, at least here on earth.[69]

It also did in 1420. What Brunelleschi had to demonstrate to his painter friends was precisely a view through an opening that corresponds to a window or frame. He chose the door for the Florentine Cathedral. What such a door offers is of course a frame of reference at a given distance against which the view out there can be plotted. If it has a gate in form of a grille, or if a net is placed in front, so much the better. With the help of this simple demonstration it can be shown that a perspective picture can be projected onto a plane. The geometrical problems of projection may not yet be solved by this simple answer, but at least they can thus be correctly posed.

Why is it, then, that this simple solution did not occur to anyone? Why is it even

asserted today by the most eminent students of the problem that there is a flaw in this argument? It is because it may be claimed in fact that we always *see* the world *linia-mentis distortis* (with distorted lines). We must not confuse this simple question of *what* we see from a given point with the similar-sounding question of how things appear to us from that point. Strictly speaking that second question allows of no objective answer. It will depend on many circumstances, a building will look small when 'dwarfed' by a neighbour, a room may look larger with one wall-paper than with another. Most of all, our knowledge and expectation will invariably transform the appearance of familiar objects or identical shapes receding in depth through what are technically known as the constancies, the stabilizing mechanism of perception that counteracts the objective fluctuations of the stimuli impinging on our retinas.

The paradox is only that this transformation does not justify the criticism that has been made of the validity of Brunelleschi's invention. For where perspective is applied convincingly it enables and even compels us to read a projection on a flat panel as a report of a three-dimensional configuration.[70] It can be shown and has been shown that in this reading the constancies come into their own and we again transform the appearance of the objects represented much as we would transform it in reality. This transformation must not be confused with the total illusion we call *trompe l'œil*. It even applies to schematic images of three-dimensional views. A few moments spent on architectural photographs such as Fig. 211 with a pair of dividers will demonstrate the degree to which we underrate the objective diminution of the distant door or columns as compared to features in the foreground.

These discussions may seem to lead far off the problem of this study. But we are unlikely to get a clear picture of any movement in history before we try to assess the advantages it offered its adherents. These advantages, we have seen, may be utilitarian, psychological, or both. They can spring from the feeling of superiority that follows even from a slight improvement that makes earlier methods look first old-fashioned and soon ridiculous. Even the early humanist reform of Latin orthography had this effect of superior knowledge backed up by genuine philological and archaeological training. The reform of lettering had the added advantage of greater clarity and beauty. Both were in fact a symptom, but not a symptom of a new philosophy so much as of an increasingly critical attitude towards tradition, a wish to eradicate mistakes that had crept in, of getting back to better texts and an unclouded view of the wisdom of the ancients. Brunelleschi's reforms went further, but in the same direction. We may call the success of his architectural innovations a mere fashion though for him the eradication of such solecisms as the Gothic arch unsanctioned by Vitruvius was certainly a genuine improvement, a return to the correct manner of building. In his reform of painting methods he could feel the assurance that he had really discovered, or re-discovered, the tool that had enabled the famous ancient masters Apelles or Zeuxis to deceive the sense of sight. Here was tangible progress and this progress, in its turn, reacted back on the self-confidence of his generation and those who followed.[71] From the preoccupation of

a small *brigata* of arrogant young men the Renaissance had become a European movement, irresistible in its appeal. But perhaps it is no mere paradox to assert that this movement had its origin not so much in the discovery of man as in the rediscovery of diphthongs.

The Leaven of Criticism in Renaissance Art:
Texts and Episodes

IF by the criticism of art we mean the detailed assessment of both the merits and the shortcomings of an individual work of art, the large bulk of writings on art bequeathed to us by the Renaissance will be found to be disappointingly poor in this respect.[1] The culture of the humanists was predominantly literary and rhetorical, and though they liked to congratulate themselves on the efflorescence of the arts their age had witnessed, they usually had to fall back on formulas culled from classical authors when they were confronted with a particular achievement.[2] In their poetic tributes they were generally satisfied to ring the changes on the conventions evolved by the ancient writers of epigrams which praise the lifelikeness of a figure that 'only lacks the voice'. Even the more technical writings on art rarely go beyond general topics derived from the rhetorical tradition, such as the question of the fitting, *decorum*, or the rivalry of the arts, the *paragone*. Later in the cinquecento the debate of the schools resulted in the discussion of the relative importance of drawing, *disegno*, and colour, *colore*, but though this antagonism afforded some opportunity for sniping at Michelangelo or Titian, even here the writers hardly came to grips with concrete problems of criticism.

THE NATURE OF THE EVIDENCE

But despite this largely negative evidence Renaissance artists behaved as if they were aware of the gadfly of criticism. There is a purposeful direction to be observed in the development of certain methods and problem solutions which clearly suggests the existence of rational standards by which works of painting and sculpture were judged. Only the existence of such standards and the awareness of failures as well as of successes can explain that spirit of rivalry and of experimentation that marks the 'rebirth of the arts'. Without a tendency to faultfinding there can be no such desire for the improvement of certain qualities.[3]

It is the purpose of this study to assemble a few texts to illustrate and test this interpretation. None of them is new to art historians, but perhaps they may still illuminate each other and confirm the role of that spirit of criticism which inspired the new conception of art. They may thus supplement and more closely define an argument I presented in an earlier paper on 'The Renaissance conception of artistic progress and its consequences'.[4]

In that paper I left the idea of progress rather undefined, taking it for granted that

First published as a contribution to Charles S. Singleton (ed.), *Art, Science and History in the Renaissance* (Baltimore, 1967).

standards of lifelikeness such as the Renaissance inherited from antiquity were shared and understood by all. But this assumption, in a way, begs an important question. Those conventional terms of praise to which I alluded above are not confined to the Renaissance. Byzantine poets used them in profusion for works which to us look anything but lifelike,[5] and the same may be said of Boccaccio's famous eulogy of Giotto.[6] The point is precisely that without an articulate formulation of what constitutes lifelikeness there are no easy grounds for a negative judgment. The illusion given by paintings and works of sculpture, after all, is always a relative matter. In some respects Sluter or Jan van Eyck cannot ever be surpassed in this direction. We do not usually call their style Renaissance.[7] Is there any evidence for a different approach which marks that new movement?

To find a full awareness of what the Renaissance was about, we often do well to approach it from outside. The historian of the Italian Renaissance may be baffled when faced with the notorious problem of 'periodization'. But as a Polish historian reminded his colleagues when this perennial question once more came up for debate during the Rome Congress of the Historical Sciences, there is no such difficulty in countries which took over Renaissance standards and values from Italy in a developed form.[8] In Poland the adherents of the new movement talked differently, even dressed differently; in short, they emphasized the gulf that separated them from the old-fashioned traditionalists. Had they been interested in art, they would no doubt have formulated their objections to Gothic images as the German humanists, for instance, formulated their contempt of medieval Latin. In going to the periphery we gain, as it were, a ringside seat for watching the contest between the old and the new standards.

DÜRER'S TESTIMONY

Albrecht Dürer saw himself both as a pupil of the Italian Renaissance and as its missionary. In the drafts and in the final formulations of his theoretical books he strove incessantly to explain to his German readers how the new conception of art differed from the one they had learned. Careful not to offend their susceptibilities, he still insisted that there were rational grounds on which the traditional methods of German Gothic painting could be criticized.

Up to now many able boys in our German lands were placed with a painter to learn the art, where, however, they were taught without any rational principle and solely according to current usage. And thus they grew up in ignorance, like a wild and un-pruned tree. True it is, that some of them acquired a ready hand by steady practice, so that their work was produced powerfully, but without forethought and simply as it pleased them. Whenever knowledgeable painters and true masters saw such un-considered work, they laughed at the blindness of these people, and not unfairly so, since nothing is less pleasing to a man of good sense than mistakes in painting, how-ever much diligence may have been employed in the work. But the fact that such

painters were pleased by their own errors is only due to their never having learned the skill of measurement, without which nobody can become a proper workman.[9]

Dürer's testimony here is precious for two reasons. It confirms that the painters of the older persuasion were 'blind' to the 'mistakes' they committed, and it insists nevertheless that those trained in the new standards are right in criticizing these mistakes as laughable. We could not wish for a better witness, for there is no doubt that Dürer here speaks from his own experience. Trained in the tradition of the Wolgemut workshop, he himself must have experienced the shock of discovering that there were so many mistakes in the paintings of this school. Once the power of perspective, of conjuring up a convincing interior, had been demonstrated to him, it was natural to ask how St. Luke could see the Madonna he was supposed to be painting on one of the panels of the Peringsdörffer Altar (Fig. 220). Once Mantegna's engravings had revealed to him the character of a correctly structured nude (Fig. 221), the conventions of German engravers (Fig. 222) must naturally have looked to him antiquated and simply wrong.

It was in fact in these two achievements that Dürer unreservedly acknowledged the superiority of the Renaissance. Asking a humanist friend to write a Preface for his Treatise on Measurement, he begs him to remember 'that I highly praise the Italians for their nudes and most of all for perspective'.[10] That 'measurement', mathematics, could serve to eliminate mistakes in perspective Dürer had no doubt (Fig. 224). The problem of the rendering of the nude was more elusive. For what was wanted was not just accuracy. The Italians seemed to possess another secret, the secret of beauty. Nothing is more moving in Dürer's writings than his struggle with this enigmatic problem (Fig. 223). Was beauty also a matter of measurement? In his youth he had believed it, when Jacopo Barbari first showed him a figure of a man and of a woman based on measurements:

> and at that time I would rather have seen what his opinion was than gained a new Kingdom . . . but I was still young at that time and had never heard of such things . . . and I well noticed that the aforementioned Jacopo did not want to explain his method to me clearly. But I took the matter upon myself and read Vitruvius, who writes a little about the limbs of a man.[11]

Dürer had no doubt that the secret he was searching for had in fact once been known and laid down in books. Indeed the decline of art was to him a result of the loss of these books:

> Many hundred years ago there were several great masters, mentioned in Pliny's writings, such as Apelles, Protogenes, Phidias, Praxiteles, Polycletus, Parrhasius and the others. Some of them wrote knowledgeable books on painting, but alas, alas, they are lost. For they are hidden from us, and we lack their great knowledge.
>
> Nor do I hear that any of the present masters are at work writing or publishing. I cannot think what causes this lack. And thus I want to put forward the little I have

learned, as best I can, so that a better man than I am may find the truth and correct me by proving the errors of my present work. In this I shall rejoice, since even so I shall have been the cause of the truth coming to light.[12]

The criticism which Dürer here invites with such touching modesty concerns of course the rational foundations of art. It was the loss of these foundations which caused the art to be 'extinct till it came to light again one century and a half ago'.[13]

In discussing the causes of this loss, Dürer makes it perfectly clear that what he speaks about are the means rather than the ends of art. Those who destroyed the books had confused the two. Art is a tool, and any tool, for instance a sword, can be used in a good cause or in a bad one.[14] He thus would have pleaded with the Fathers of the Church:

Oh my beloved holy Lords and Fathers! Do not, for the sake of the evil they can wreak, lamentably kill the noble inventions of art which have been gained by so much labour and sweat. . . . Because the same proportions the heathens assigned to their idol Apollo, we shall use for Christ the Lord, the fairest of them all, and just as they took Venus as the most beautiful woman, we shall chastely use the same figure for the purest of the purest Virgins, the Mother of God. . . .[15]

Clearly then, beauty too, like perspective, is a means of art, and one for which standards exist, however hard they may be to define and however much Dürer was aware of his own ignorance of the secret. And here, too, the only way to improvement lay in listening to criticism. For painters are too easily enamoured of their own products, as mothers are of their own children.[16] Let nobody, therefore, trust his own judgement in these matters. Even the unskilled will usually be able to spot a mistake, though they may not be able to tell how to correct it.[17] Faultfinders are again to be encouraged.

If this attitude could only prevail, art was sure to make progress far beyond the present. I know of no earlier account (and indeed of few later ones) in which this faith is more clearly expressed than in the following passage:

For I am certain that many worthy men will still come forward, all of whom will be better in writing about this art, and in teaching it, than I am. For I myself think very little of my art. For I know my own shortcomings. Hence may anyone undertake to improve my shortcomings as best he can. Would God it were possible for me to see now the works and the skill of those future great masters who are not yet born, for I believe that would improve me. Oh, how often do I see great art and good things in my sleep, of a kind that never comes to me while awake. But when I wake up, I lose the recollection. . . .[18]

Socrates claimed that he knew more than others, for at least he knew how ignorant he was. Dürer had a right to repeat this proud Socratic claim. The Gothic masters of his youth had been blind to their mistakes. The Renaissance movement had given the artist sight. He now knew that there were rational standards of which his work fell short.

Even where he felt he had improved the art, the road to perfection still lay before him and his successors. An acceptance of the Renaissance conception of art implied an acceptance of the notion of progress. Thus criticism implied a view of history, that view which Vasari, a generation after Dürer, enshrined in the first edition of the *Vite*.

VASARI'S *VITE*: THE POWER AND PERILS OF HINDSIGHT

To read Vasari with some of Dürer's formulation in mind is to see the task he faced in a new light. His ruling conception of art as a solution of certain problems certainly provided him with a principle of selection that alone enabled him to write history rather than a mere chronicle. It is well known that the history of the revival of art 'from Cimabue onwards' is for him a history of those contributions which advanced the arts toward his ideal. In a remarkable article S. Leontief Alpers has shown that Vasari made a distinction between the ends and the means of art.[19] We are likely to misread him if we fail to make this distinction, which we also found implied in Dürer. A passage not specifically adduced by Prof. Alpers defines this aim succinctly. It occurs in the Life of Barna da Siena where Vasari describes a fresco, now lost, of that Trecento painter, whom he much admired:

> There was a painting representing a young man being led to execution, as well done as can possibly be imagined, since one saw in his features the pallor and fear of death quite like the truth, which merited the highest praise. Beside that young man there was a monk to comfort him, very well conceived in his attitude, in short everything in that work was so vividly painted that it was clear that Barna had pictured to himself that most horrible episode as it must occur, full of the most bitter and harsh terror, and that therefore he portrayed it so well with his brush that the real event itself would not arouse more emotion.[20]

In thus describing a work which obviously lacked both correct perspective and a mastery of anatomy, Vasari showed that he was well able to enter into the mind of earlier periods which, in Dürer's words, were still 'blind' and could not see their own mistakes.

Admittedly where he discusses the development of means Vasari sometimes allows his hindsight to obtrude. There are passages where he attributes to earlier artists a dissatisfaction with their own technique which they could only have felt if they could have foreseen coming improvements. His account of the invention of oil painting in the Life of Antonello da Messina is a case in point which is all the more instructive since it deals with a technological problem Vasari considered part of art:

> When I reflect on the diverse character of benefits and useful inventions which many masters who adhered to the 'Second Style' have contributed to the art of painting, I am bound, in considering their efforts, to call them truly industrious and excellent, since they tried so much to raise painting to a higher level, regardless of difficulties or expense or of their private advantage. . . .

Adhering thus to the method of using no other medium but tempera on panels and canvases (a method initiated by Cimabue in 1250 when he worked with those Greeks, and then followed from Giotto onwards up to the time of which we are speaking), the same procedure was always followed. . . . Nevertheless the artists knew quite well that tempera paintings lack the effect of a certain softness and vividness, which, if it could have been achieved, would have imparted to these paintings more grace in design, more beauty in colouring and a greater facility in blending the colours, rather than always applying only the point of the brush. But however many had cudgelled their brains searching for such a thing, nobody had as yet found one which was good . . . a large number of artists had talked about these matters and had discussed them many times without results. The same desire was shared by many outstanding minds who practised painting outside Italy, such as the painters of France, Spain, Germany and other parts.[21]

Vasari's famous account of the accidental invention of oil painting by Jan van Eyck, which then follows, need not detain us here.[22] What matters is his readiness to project the present into the past, to assume that artists working in tempera were longing for a method they did not know. It is safe to say that this is unlikely. Why should a Fra Angelico have been dissatisfied with a medium that he could use with such mastery for his jewel-like panels? Surely a great artist works within the limitations of his means; in fact, these limitations present both a challenge and an inspiration. We can thus discard Vasari's picture of congresses for the overcoming of these limitations. Even so, it is characteristic of the period that collections of recipes were indeed circulating among artists. We may be sure that there were many eager to learn of new methods, including some which made use of oil (of which there were a good many before van Eyck).

The point is surely that once some improved method is claimed to exist any artist worth his salt will want to try it out, even if he had been quite happy with the older procedure before. And though hindsight distorts our view if we imagine Fra Angelico fretting because his medium lacked softness and vividness, hindsight shows its power if it makes us pay attention to the reasons which secured such a rapid victory of oil over tempera.

For however much Vasari may have simplified the story of this invention and its spread from Flanders to Italy, it remains demonstrably true that once oil paintings were known they were in demand.[23] We also know from the reliable pen of Vespasiano da Bisticci that that great patron Federigo da Montefeltre had painters come from the Netherlands because he wanted works in the new technique.[24]

By Vasari's time, of course, oil had been so triumphant that tempera had almost become forgotten, a fact which so characteristically prompted Vasari to try his hand at it.[25] What is apt to irk us in Vasari's account is merely the assumption that any improvement must have been striven for and that those who still lacked it felt its absence as a mark of inferiority. Dürer, to repeat, was wiser here, for he spoke from experience.

But though we must acknowledge these perils of hindsight, which have vitiated more recent histories than Vasari's and have tended to reduce the history of art to the story of how the past strove to become the present,[26] we must not allow our awareness of these limitations to dismiss Vasari's whole account as unhistorical.

Take his treatment of Signorelli, whose memory he revered as that of a kinsman who had encouraged him in his youth:

Luca Signorelli, an excellent painter, . . . was considered more famous in Italy in his time and his works were more highly praised than had happened to anyone at any period before, because in his paintings he demonstrated the way of representing nudes which, albeit with skill and difficulty, can be made to appear alive. He was the follower and disciple of Piero della Francesca and made a great effort in his youth to imitate and even to surpass his master. . . . In . . . Orvieto . . . he painted all the stories of the end of the world with bizarre and capricious inventions, angels, demons, ruins, earthquakes, miracles of the Antichrist and many other similar things; moreover nudes, foreshortened figures and very beautiful ones, imagining the terror of that last and tremendous day. Hence he aroused the mind of all those who came after him, who therefore found the difficulties of that style easy. I am therefore not surprised that the works of Luca [Signorelli] were always highly praised by Michelangelo, nor that some things in [Michelangelo's] Last Judgement were partly gently lifted out of Luca's inventions, for instance, angels, demons, the order of the heavens and other things in which Michelangelo imitated the procedure of Luca as everyone can see. . . .[27]

We may rebel against this typical assessment of an artist's achievement as merely a stepping stone toward Michelangelo's supreme creation (Fig. 226). We are right in wanting rather to forget *The Last Judgement* of the Sistine Chapel when visiting Orvieto (Fig. 225). But can we be quite sure that Signorelli himself did not acknowledge Michelangelo's superiority? Granted that he never saw *The Last Judgement*, we know that he did visit Michelangelo's studio in Rome and was, alas, treated less generously than Vasari's account would have made us hope.[28] The incident itself is irrelevant to our problem. What matters is that Signorelli's younger contemporary Dürer freely acknowledged that there was still much to be learned in the rendering of the beautiful nude and that greater masters would achieve in the future what he could only see in a fleeting vision in his dream. Did Signorelli also have such dreams? Did he find that Michelangelo realized what he had wanted to do? These are no doubt idle questions, but they allow us at least to do a little more justice to Vasari's picture of the Renaissance, which finds its culmination in the grandoise opening of his Life of Michelangelo:

While industrious and excellent minds, aided by the light afforded them by such renowned artists as Giotto and his followers, strove to give proof to the world of their value and of the talent which the favour of the stars and harmonious blending of the humours had given them, and while they were desiring to rival the greatness of

nature by the excellence of their skill so as to arrive as close as they could at that highest knowledge which many call a vision of truth, and while all of them laboured in vain, the Ruler of Heaven in His goodness graciously turned His eyes towards the earth and perceiving the infinite futility of all these strivings, the most ardent efforts which remained entirely fruitless, and the presumptuous opinion of men who were still further removed from the truth than light is from darkness, He resolved to liberate us from so many errors by sending down to earth a spirit, who would universally master every skill and every profession and demonstrate by himself alone what is perfection in the art of design. . . .[29]

Obviously we cannot take Vasari's view of history here at its face value. The idea of Fra Angelico trying in vain to paint like Michelangelo must again strike the modern reader as ludicrous. But is the idea of Fra Angelico wishing to master the rendering of the human body as perfectly as Michelangelo equally naïve? It is only naïve because in this form the question does not allow of an answer. To answer it, perhaps, would mean to decide to what extent he still belonged to the medieval tradition and to what extent to the Renaissance. I do not want to be misunderstood. I do not assert that medieval artists or craftsmen never experienced such 'sacred discontent'. We have Dante's word for it that every 'artista' must fall short of his ultimate aim (*Par. XXX. 31*), that matter resists the form (*Par. I. 127*), and that the hand trembles (*Par. XIII. 76*).[30] But we are less sure whether such dissatisfaction was necessarily caused by what Dürer was later to call 'mistakes' in painting. This notion obviously presupposes a definite conception of the problem art must solve in order to fulfil its aim of vivid evocation.

If it is true, as the evidence suggests, that the public, including the learned, was easily ready to accept the conventions of more hieratic styles as serving this aim, we are once more faced with the question of why this style ever changed in favour of greater visual truth. How was that leaven of criticism ever introduced, and who were its carriers? Vasari does not give a complete answer, but he certainly shows himself aware of the importance of the critical milieu. He is sure that it is only where many artists congregate and where rivalry is kindled that the atmosphere will favour the kind of progress he has in mind. It is in this way, for instance, that he accounts for Donatello's return from Padua to Florence:

Since he was considered a miracle there and praised by every knowledgeable person he decided he would return to Florence, for, as he said, if he had stayed longer he would have forgotten all he knew being so much praised by everyone; he willingly returned to his hometown to be constantly decried, for these strictures would make him work harder and thus acquire more glory.[31]

In the life of Perugino, Vasari is even more explicit about this secret of the Florentines: he puts the lesson into the mouth of Perugino's ambitious teacher, who tells his pupil

that it was in Florence rather than anywhere else that people became perfect in all the arts and specially in painting, since in that city people are spurred on by three things.

The first is the abuse which is dispensed so much by many, since the air there favours a natural freedom of the mind which is not generally satisfied with mere mediocrity, and is always more concerned with honouring the good and the beautiful than with respect for person. The second reason is that if one wants to live there, one must be industrious which means to say always use one's mind and judgement, and be ready and quick in one's work, and finally be good at earning money; Florence has no large countryside, abundant of products, which would enable one to live there for little, as happens where there is a surplus of goods. The third thing, possibly not less important than the other two, is a thirst for glory and honour, which is to a large extent aroused by the air in men of every calling and which does not allow anyone who has his wits together to let others be on his level, let alone to lag behind those whom they consider to be men like themselves, even though they acknowledge them to be masters. In fact the air frequently prompts them to desire their own greatness so much that, unless they are by nature kindhearted or wise, they will become evil-tongued, ungrateful and thankless. It is true that, once a man has learned enough there, and does not want to go on living from day to day like an animal, but wants to get rich, he must leave that city and sell the quality of his works and the reputation of that city abroad, as the Doctors do with the reputation of the Florentine University. For Florence treats its artists as Time treats its creations, making and unmaking them and using them up little by little. . . .[32]

To some extent, no doubt, this brilliant sociological analysis is also born from hindsight. It serves in its context to explain Perugino's career, his development into a great artist in the Florentine hothouse and his subsequent preference for less exacting surroundings which allowed him to repeat himself and to exploit the vein he had once developed. In fact Vasari goes on to relate toward the end of Perugino's Life how one of the master's paintings done in his old age for Florence 'was much abused by all the new artists' mainly because Perugino had there used figures he had employed before (Figs. 227–8). Even his friends accused him of not having taken trouble, but Perugino replied:

'I placed figures into this picture which you had praised at other times and which then pleased you enormously. If they now displease you and you do not praise them, what can I do about it?' But they continued to harass him with sonnets and public insults.[33]

The fact that Perugino was criticized in old age for repeating himself is confirmed by Paolo Giovio.[34] And yet the answer which Vasari puts into his mouth is a perfectly rational one. Judged by the explicit standards of Renaissance art such as they are formulated in Dürer's writings there is no reason why an excellent solution should not be repeated. After all, Perugino's altarpieces were not intended to be all seen side by side, and since they contained no mistakes and embodied much beauty, he may well have felt aggrieved when the critical Florentines suddenly produced an additional standard of excellence, that of originality.

Vasari also tells us, it will be remembered, who the people were who raised this criticism. It was the 'new artists', critics in other words, who were less concerned with the question of whether a particular altar painting served its purpose well in a particular setting, but who had a professional interest in problem solutions. Artists, we may supplement Vasari's account, did see many of Perugino's works, if not side by side at least in succession, because they were interested in art. Hence their dissatisfaction with a master who repeated himself. He had begun to bore them.

But if we can believe Vasari's simplified model situation, the new artists also carried the public with them. They had fresh and more convincing solutions to offer which made the earlier ones suddenly look inadequate. Even though Perugino's public, like Wolgemut's, had been 'blind' and had shared the artist's satisfaction with his fine style, the new masters had shown it up as less than perfect.

Describing the new sweetness and colour harmonies of Francesco Francia and Perugino, Vasari writes with his customary zest:

> Seeing it, people ran like mad to that new and more vivid beauty, since it seemed to them absolutely sure that it would never be possible to do better. But the error of those people was clearly shown up by the works of Leonardo da Vinci. . . . (*Preface to Part III.*)[35]

It fits in well that Leonardo is here singled out as the artist whose works revealed the limitations of Perugino's achievement. For it was Leonardo who wrote in the *Trattato della Pittura*:

> Painter, if you please the best painters you will produce good paintings, for these alone can really judge you; but if you want to please those who are not masters, your paintings will contain few foreshortenings and little relief or vivid movement. . . .[36]

THE SOLUTION AND CREATION OF
ARTISTIC PROBLEMS

It is here that the argument links up with the previous study on the Renaissance conception of artistic progress cited above, in which I also referred to Leonardo's remarks. The study was concerned with the idea of *dimostrazione*, the display of ingenuity characteristic of Renaissance art. But ingenuity itself may always have had its admirers, and there are few artistic traditions which do not pay tribute to a display of skill. In many societies, however, this skill lies in manual dexterity, in feats of patience and precision easily intelligible to the layman; we all know the intricate fretwork, the minute execution of detail, that leads the guide in the country house to say that it is all made by hand and every one motif is different from the other. Often the admiration of craftsmanship here merges with awe of the rarity of the material, the pearls, corals, or precious stones that characterize the curiosity cabinet. We can, if we choose, also speak of

problem solutions in such contexts—it is certainly a problem how to acquire a steady hand, and a greater one still how to acquire gold and ivory. But *dimostrazioni* which count as artistic progress are of a very different kind. They are admired by the connoisseur who can appreciate their difficulty and their relevance to the overriding problems of art. Problems, one might vary a famous adage, should not only be solved; they should be seen to be solved. Indeed some works of art derive their main interest and their main social function from their character of such demonstrations. Brunelleschi's lost panels demonstrating the laws of perspective (see p. 108) provide the most famous instance.[37] They may be described as an experiment in applied geometry designed to convince artists of the validity of Brunelleschi's method of construction. It is an open question whether or not we should describe these panels as works of art. But Dürer's testimony alone would suffice to show that this demonstration was felt to be relevant to art. Any problem solved, any difficulty overcome, lent interest to a work in the eyes of a public that watched the progress of the artist's skill in rendering nature as our contemporaries watch the progress of space travel.

To quote a text not adduced in the previous study: describing the competition for the first Baptistry Doors (Figs. 229–30), the anonymous biographer of Brunelleschi who wrote around 1470 takes it for granted that the jury was influenced by such considerations—or that at any rate it should have been when looking at his relief:

> They marvelled at the difficulties he had confronted, such as the attitude of Abraham with his finger under the chin, his energy, his drapery and the way the body of his son was treated and finished, and the same for the drapery and the posture of the angel, and how he seizes Abraham's hand, and the attitude and treatment and finish of the one who pulls a thorn from his foot, and the same of him who drinks bending down, and how many difficulties there are in these figures and how well they perform their roles so that there is not a single limb devoid of life and the same for the action and finish of the animals represented, and every other thing just as the whole of the narrative taken together.[38]

One wonders how far this particular assessment may reflect the intentions of Brunelleschi himself. That he wanted his figures to be lifelike and dramatic is certain. Whether he also wanted to display the difficulties he had overcome by introducing the figures of the 'thornpuller' and the drinking man is a very different question. Maybe the problem here lay in the narrative he had been asked to illustrate. On receiving the dreadful summons Abraham had 'saddled his ass and taken two young men with him, and Isaac his son'. Seeing the assigned place from afar on the third day he asked the two servants to stay with the ass while he proceeded to the sacrifice. They were therefore to be included in the story, but played no part in the action. The real difficulty was how to represent them within the quadrifoil without their appearing to be witnesses of the main event. Ghiberti's solution here is perhaps the better one, though it is also more traditional. He sets a stage prop between the servants and the main action and uses in

addition the device, so frequently found in Giotto, of two bystanders looking into each other's eyes as if to find out their companion's reactions. Brunelleschi apparently spurned this traditional device, and so he had to account for his figures not seeing the main scene, busying one of them with a thorn in his foot and making the other bend down to drink.

Be that as it may, Manetti's praise for the difficult postures chosen by his hero certainly reflects a critical standard that had emerged in the quattrocento. Its formulation, however, is not new. It derives from antiquity. It was Quintilian who passed on to the Renaissance the criterion of variety and difficulty in postures, while advising the orator on effective gesticulation.

> It is often useful to depart a little from established and traditional order, and it is also sometimes correct to do so, just as we see that in sculptures and paintings the dress, the face and the attitude is often varied. For there is very little grace in a straight upright body; neither should the face look straight in front, nor the arms hang by the side and the feet joined, to make the whole work appear stiff from top to bottom. A certain bending, I might almost say movement, gives the feeling of action and emotion. And so, neither the hands should all be modelled on one formula, and there should be a thousand different types of faces. Some run and are in violent movement, others sit or lie down; this one is naked, those are draped, some partly the one, partly the other. What can be more twisted and elaborate than that discobolus by Myron? (Fig. 231). Yet, if someone were to disapprove of it because it was not straight, would he not lack any understanding of an art in which this very novelty and difficulty is particularly praiseworthy?[39]

The criterion of the *distortum et elaboratum* ('twisted and elaborate') is more usually today associated with the period of Mannerism, and we shall see that this is not without justification. But it is all the more important to stress that even in Mannerism the critical standards of the Renaissance had not lost their force when it came to assess the validity of certain problem solutions. Novelty and difficulty, *novitas et difficultas*, were praiseworthy only when these paramount standards had been met. The most characteristic episode here is the story of Baccio Bandinelli's *Hercules and Cacus* (Fig. 232). It illustrates in all its aspects the spirit of ambition and the craving for fame that the Renaissance bequeathed to the sixteenth century.[40] Bandinelli's intrigues to get hold of a marble originally assigned to Michelangelo, his boast that in carrying out the group of *Hercules and Cacus* Michelangelo had planned he would surpass the *David*, his failure in devising a model that would fit the block, and the hostile reception the finished work was accorded by the Florentines when it was revealed in 1534, are well told by Vasari. It was Benvenuto Cellini, however, the sworn enemy of Bandinelli, who preserved for us in one of the showpieces of his autobiography the criticism levelled against this boastful group:

> This talented school says that if one were to shave the hair off Hercules, there would not remain noddle sufficient to contain his brain; and that as regards that face of his,

one would not know whether it was the countenance of a man or of a lion-ox: and that he is not paying any attention to what he is doing: and that it is badly attached to its neck, with so little skill and with so bad a grace, that one has never seen anything worse: and that those two ugly shoulders of his resemble the two pommels of an ass's packsaddle; and that his breast and the rest of his muscles are not copied from those of a man, but are drawn from an old sack full of melons, which has been set upright propped against a wall. Also the loins seem to be copied from a sack full of long gourds: one does not know by what method the two legs are attached to that ugly body; for one does not know upon which leg he is standing, or upon which he is making any display of pressure: still less does he appear to be resting upon both, (as it is customary sometimes for those masters who know something about the representation of figures). It is easy to see that he is falling forward more than a third of a *braccio*: for this alone is the greatest and most intolerable fault that those wretched masters of the common herd commit. Of the arms they say that they are both stretched downwards without any grace: nor is there any artistic sense to be perceived in them, as if you had never seen living nudes: and that the right leg of Hercules and that of Cacus make a mixture in the calves of their legs; so that if one of the two were removed from the other, not only one of them, but rather both would remain without calves at that point where they touch: and they say that one of the feet of Hercules is buried and the other appears to have fire under it.[41]

Our age, which has rediscovered Mannerism and demoted the standards of classical art, has questioned the justice of these strictures. It can be claimed, after all, that Bandinelli never aimed at presenting a naturalistic likeness of a muscular man and that popular criticism therefore missed the point of his work, as it was later to miss the point of Epstein or of Picasso. It is true that Bandinelli would have had a case against Cellini, whose famous diatribe is obviously malicious. And yet it is important from the point of view of methodology not to dismiss it too lightly. It is always tempting to argue that an artist did not want to do what he is found not to have done. For the problem he has failed to solve we can always invent one, by hindsight, which he might be said to have solved. If somebody misses the bull's-eye, we can always attribute to him the conscious or unconscious desire to miss it, and we may even be right. But the more sophisticated we become in this technique, the less will it yield in real insights. A sixteenth-century sculptor who aimed at surpassing Michelangelo certainly did not declare his indifference to the accurate rendering of the human body. In seeking an expression of superhuman power and energy at the expense of anatomical plausibility, Bandinelli could in fact be accused of not playing the game. However much the emphasis may have shifted in the appreciation of certain artistic qualities, correct design was still a standard to which the artist was expected to submit.

In this respect the interpretation of Mannerism as an 'anti-classical' style has tended sometimes to obscure the continuity of artistic standards which alone accounts for

Vasari's profound understanding of the Renaissance.

For Vasari the painter had actually been asked to display a solution of the central problem of the Renaissance at the very period when he put the final touches to the first edition of his literary masterpiece. The document that tells us of this challenge to the painter is worth quoting in full, despite its length, because it not only illustrates the artistic ideals of Vasari's circle but also confirms the importance of criticism as a spur, of which, as we remember, Vasari wrote so eloquently. He wrote from experience, for Annibale Caro makes it clear in his letter of 1548 that Vasari's recent work had created a mixed impression which he would do well to wipe out. The artist had just won fame and courted criticism by completing a series of frescoes in the *Cancellaria* in Rome in one hundred days.[42] The opening paragraph of Caro's letter alludes to this situation; the final remarks refer to the *Vite,* in which Caro had some share as a consultant and stylist:[43]

Annibale Caro from Rome to Giorgio Vasari in Florence, 10th May, 1548.

It is my desire to possess a notable work of your hand both for the sake of your reputation and for my own satisfaction; because I want to be able to show it to certain people who know you better as a quick painter than as an excellent one. I discussed this matter with Botto since I do not want to trouble you while you are encumbered with major commissions. But since you yourself have just offered to do it now, you can imagine how great my pleasure is. As to doing it quickly or slowly I leave that to you, because I think that it is also possible to do things quickly and well when the frenzy seizes you as happens in painting, which in this respect as in all others is very much like poetry. It is certainly true that the world believes that if you worked less quickly you would do better, but this is a probability rather than a certainty. It might even be said that it is the works which are strained and not finished and carried forward with the same fervour with which they were begun that turn out worse. Nor would I want you to think that my desire to possess one of your works was so lukewarm that I do not wait for it with impatience. Even so I would want you to know that I say 'take your time', use deliberation and application, but not too much application, as it is said among you of that other man who was unable to take his hand from the picture.[44] But here I console myself that even the slowest movement you make will be completed before the fastest movement of the others; I am sure that you will satisfy me by any method, for apart from the fact that you are you, I know well that you are well disposed towards me and I see with what zest you turn to this particular enterprise. From your readiness to do the work I have already come to expect the great perfection of the work, so that you should do it whenever and however it comes easily to you.

And as to the invention of the subject matter, I also leave this to you, remembering another similarity that painting has with poetry; all the more so since you are both a poet and a painter, and since in each of these pursuits one tends to express one's own

ideas and conceptions with more passion and zeal than those of any other person. Provided there are two nude figures, a male and a female (which are the most worthy subjects of your art) you can compose any story and any attitudes you like. Apart from these two protagonists I do not mind whether there are many other figures provided they are small and far away; for it seems to me that a good deal of landscape adds grace and creates a feeling of depth. Should you want to know my own inclination I would think that Adonis and Venus would form an arrangement of the two most beautiful bodies you could make, even though this has been done before. And as to this point it would be good if you kept as closely as possible to the description in Theocritus. But since all of the figures he mentions would result in too intricate a group (which, as I said before, would not please me) I would only do Adonis embraced and contemplated by Venus with that emotion with which we watch the death of the dearest; let him be placed on a purple garment, with a wound in his thigh with certain streaks of blood on his body with the implements of the hunt scattered about and with one or two beautiful dogs, provided this does not take up too much space. I would leave out the nymphs, the Fates and the Graces who in Theocritus weep over him, and also those love-gods attending him, washing him and making shade with their wings, and would only put in those other love-gods in the distance who drag the boar out of the wood, one of them striking him with the bow, the other pricking him with an arrow and the third pulling him by a cord to take him to Venus. And if possible I should indicate that out of this blood are born the roses and out of the tears the poppies. This or a similar invention I have in my mind because apart from the beauty it would need emotion, without which the figures lack life.

Should you not want to do more than one figure, the Leda, particularly the one by Michelangelo pleases me beyond measure. Also that Venus which that other worthy man painted as she rose from the sea[45] would, I imagine, be a beautiful sight. Even so (as I said before) I am satisfied to leave the choice to you. As to the material I want it to be a canvas, five palms wide and three palms high. About your other work I need not say anything more since you have decided that we should look through it together. Meanwhile complete it entirely as you think, for I am sure there will be little else to do but to praise it. Remain in good health.[46]

It may be argued that Annibale Caro's letter was sent to the wrong address and that he should have written to Titian rather than Vasari. Not only would the subject matter have been congenial to the great Venetian; even the distinction with which the letter opens, the discussion of the two modes of performance, one slow and detailed, one rapid and inspired, might have applied to Titian, whose change of manner became a topic of discussion. It has been suggested by Karl Frey that Caro may in fact have had Titian in mind.[47] But the point of his letter is of course precisely that he wants to arouse his friend Vasari to greater efforts by challenging him to create a work that would silence his critics and could be shown in the company of the greatest masterpieces embodying the

Renaissance ideal. The ideal itself is still the one adumbrated by Dürer—the representation of beautiful human bodies in a convincing setting. Of course Caro is less anxious than Dürer was about the possible exploitation of this ability for erotic effects. The power of art over the emotions can be as legitimately tested in the rendering of the alluring as in the evocation of tragedy.[48] Caro's principal suggestion, the death of Adonis, cunningly combines both elements, 'for apart from the beauty it would need emotion, without which the figures lack life'. He could be sure that there was common ground between him and Vasari if he asked him to strain his poetic faculty in following Theocritus' evocation of that episode. But he also knew that the painter cannot slavishly illustrate the poet. In fact he comes close to Lessing's *Laokoon* when he reminds the painter of the difference between poetic and pictorial narrative.

We do not know how far Vasari rose to the challenge. The painting of Venus and Adonis he painted for Caro had disappeared in France even by the time Vasari published his autobiography at the end of the second edition of the *Vite*.[49] It is unlikely that this is a very grievous loss. Vasari was not a great artist. Even so it may be argued that he has had rather a raw deal from the art historians. His autobiography, in particular, has suffered from the contrast with Benvenuto Cellini's and from the lack of zest with which Vasari turns from the biography of others to the account of his own career. And yet his own *vita* offers valuable testimonies about the way a highly intelligent and highly successful artist right in the centre of things looked upon his own art. A full analysis of this testimony lies beyond the scope of this study, but it is clear from the first that this arch-mannerist had meant to practise what he preached and that for him, too, the problem of dramatic evocation was paramount. To the modern observer the drawing for another lost painting by Vasari (Fig. 235), the *Martyrdom of St. Sigismund*, which he painted for a chapel of San Lorenzo in Florence, looks like the typical mannerist showpiece of contorted nudes. But it is clear from Vasari's own description that he saw himself pursuing the same aim he had attributed to Barna da Siena:

I painted a panel ten braccia wide and thirteen high, with the story or rather the martyrdom of St. Sigismund, the King, that is when he, his wife and two sons were thrown into a well by another King or rather tyrant, and I arranged it so that the decoration of the chapel which forms an apse should serve me as the frame of the *rustica* porch of a large palace through which one could see a square courtyard supported by pilasters and doric columns; and I made it appear that through this opening one could see an octagonal well in the centre, surrounded by steps, which servants were mounting with the two naked sons they were throwing into the well. And standing around under the arches I painted on one side people who stand and watch that horrible spectacle, and on the other, the left hand side, I painted a few armed men who, having fiercely seized the King's wife, carry her towards the well to kill her. And under the main gate I painted a group of soldiers tying up St. Sigismund who, by his yielding and patient attitude, shows that he willingly suffers this death and

martyrdom, and gazes at four angels in the air, who show him the palms and crowns of martyrdom for himself, his wife and his sons, which appears wholly to comfort and to console him. I tried equally to show the cruelty and fierceness of the vile tyrant, who stands on the upper storey of the courtyard to watch his revenge and the death of St. Sigismund.

In short I made every effort to ensure that all the figures should be animated as far as possible by the right affects and showed the appropriate attitudes, fierceness, and all that is required. Whether I succeeded or not, it is for others to say, but I am entitled to add that I put into this as much study, effort and industry as I was capable of.[50]

There is perhaps more in these repeated protestations than mere conventional modesty. Conventional modesty never imposed similar inhibitions on Benvenuto Cellini. Like Dürer, Vasari is supremely aware of the existence of objective standards, and he feels and says where he has fallen short of them. He knows his weakness and also his strength:

But since art is essentially difficult one must not expect any more from anyone than he can give. Yet I would say, for this I can say truthfully, that I always made my paintings, inventions and drawings of whatever kind if not with utmost speed, at least with incredible ease and without strain.[51]

Thinking of art as a means to an end, facility in invention and execution was certainly an asset. Of the dangers of this kind of productivity to which Annibale Caro had gently drawn his attention Vasari was certainly aware, but the courtier in him made him often yield to pressures in order to please his patrons.

Moreover Vasari was not conscious of having shirked the other requirement of Renaissance aesthetics, the search for 'novelty and difficulty'. He tells us that he thought out fresh problems which challenged his ingenuity as an artist. In his account of another lost work, also known only from a drawing (Fig. 236), his frescoes in Bologna, we read:

I painted the three angels (an idea that came to me I do not know how) in a heavenly light that can be shown to issue from them while the rays of the sun surround them in a cloud. Old Abraham adores one of these angels though he sees three, while Sarah stands laughingly thinking how their promise could possibly come true, and Hagar with Ismail in her arm leaves the house. The same light also illuminates the servants who are making ready, among them some who are unable to bear the splendour and shield their eyes with their hands; since strong shadow and bright lights impart strength to paintings, this variety of motifs gave it greater relief than the two preceding compositions and having varied the colour, made a very different effect. Had I only always known how to realize my ideas! For then, and later, I always went on with new inventions and imaginings, searching out the difficulties and obstacles of art.[52]

The emphasis on light effects as the problem Vasari had set himself is significant. It was a problem where much remained to be done. The paramount problems of art mentioned by Dürer, perspective and the rendering of the nude, had been solved. Nobody could surpass Michelangelo in the rendering of the human body. But Prof. Alpers has shown that we misread Vasari if we interpret his glorification of this victory as the feeling of an epigone who believes that nothing remains to be done any more. In one of his most famous critical discussions, inserted in the life of Raphael, Vasari is eager to remind artists that there are other problems which remain to be explored.[53] He mentions the rendering of light among them. No wonder therefore that in his auto-biography he frequently lingers on his attempts to render light effects. It was a problem that had interested him since the time when he had struggled pathetically with the rendering of the sheen on Alessandro de Medici's armour.[54] Perhaps his training and his gifts were really not sufficient for him to make this novel contribution which he seems to have envisaged for himself. Perhaps also the Florentine tradition, which saw in invention and design the main problems worthy of an artist's aspirations, weighed too heavily on him. Colour and light are less easily subject to rational standards and rational criticism, and hence progerss was much less measurable there than in the mastery of perspective and the nude.

Significantly it was an artist from the North who was provoked by the critical bias of the Florentines for problem solutions in this field to challenge them on their own ground. In the famous story of Giovanni da Bologna's response to criticism the theme of this study comes to its climax (Figs. 233, 234). It is a well documented story, since Raffaello Borghini's account in *Il Riposo* of 1584 was published less than two years after the event.

When Giambologna had produced many figures of bronze, both large and small and an infinite number of little models he had so well demonstrated his mastery of his art that even certain envious artists could no longer deny that he succeeded uncommonly well with things of this kind. They admitted he was very good in devising appealing figurines and statuettes in the most various attitudes which had a certain beauty. But they added that he would not have succeeded in the creation of large marble figures, which after all constituted the true task of sculpture. It was for this reason that Giambologna, pricked by the spur of ambition, resolved to show to the world that he knew not only how to make ordinary marble statues but also several together including the most difficult that could be made which would display all the skill in creating nude figures (showing the decline of old age, the strength of youth and the delicacy of womanhood). And thus he fashioned, for no other reason than to de-monstrate the excellence of his skill and without proposing to himself any particular subject matter, a group of a proud youth who snatched a most beautiful girl from a weak old man; and when he had nearly completed that marvellous work it was seen by His Highness Franceso de Medici, our Grand Duke, who so admired its beauty that he decided it should be placed where it is still to be seen. But to avoid the group

having to be shown without any title he urged Giambologna to find a subject. He was told, I do not know by whom, that it would be a good thing to link it up with Cellini's story of Perseus, to say that the raped girl was intended to be Andromeda, the wife of Perseus, the abductor Phineus, her uncle, and the old man Cepheus her father.

But one day Raffaello Borghini happened to find himself in Giambologna's studio, and having looked at this beautiful group of figures with much pleasure he showed surprise on hearing the story it was alleged to represent. On noticing this, Giambologna asked him urgently to tell him his views, and he made it clear that he should on no account give that name to those statues; the Rape of the Sabines would fit better and that story being judged suitable lent indeed a name to that work.[55]

Here, then, is a work of art which every visitor to Florence has seen, which owes its existence entirely to the desire of its maker to show that he could solve an artistic problem. The theme, as he himself put it in a letter, was chosen 'to give scope to the understanding and the mastery of art'.[56] The interest in problem solutions had ultimately led to a shift in the very aim of art. For Dürer, as we have seen, the aims of art were still unequivocally religious: the new means were to serve the elimination of mistakes; even Vasari still implied the primacy of the narrative function to which the means were subordinate. In Giambologna's group the display of virtuosity as such has gained priority over the subject matter. The dramatic story is selected (not without qualms) after the group is finished, though the artist then obliged and placed a relief of the *Rape of the Sabine Women* on the pedestal to serve as a label.

Seen through the eyes of hindsight, then, the development of the *dimostrazione*, the display of problem solutions in art, really falls into its place from the vantage point of Giambologna's challenge to his critics. We also know from Borghini's account who these critics were. Not, to be sure, the men of letters but his fellow artists who had sought to damage his reputation by insinuating that his skill, however appealing, was limited to small-scale work. It so happens that Vasari tells of a similar criticism and of a similar reaction in the Life of the painter Giovan Francesco Caroto:

It is true that either through envy or for some other reason he was labelled a painter who could only do small figures; in doing the painting for the chapel of the Madonna in S. Fermo . . . he therefore wanted to show that he had been groundlessly slandered and made the figures more than lifesize and so well that they were the best he had ever done . . . and truly this work is never considered anything but good by the artists. . . .[57]

But let us remember that Caroto's work was an altar painting; he had had to wait for his demonstration till he received a commission. The monks hardly worried about the size of the figures, which he enlarged to show his fellow artists what he could do. Giambologna's case was different here. He could embark on a large marble group of no specified subject or purpose, sure that it would attract admiration and find a buyer.

He could be sure because the setting of the event was Florence. In his native Boulogne such a gesture would have been as futile as it might have been even in Siena or Naples. But in Florence a public had grown up in the course of almost 300 years which would appreciate the point and hail the problem solution as a feat deserving of fame and support.

It would be tempting to end this survey with this triumphant manifestation of the creative power of criticism, but it would also be a little misleading. For what really mattered in this acceptance of rational standards was not the external display of virtuosity, but the internalization of these demands, that 'sacred discontent' that makes criticism creative.

Perhaps the most beautiful description of the workings of the artistic conscience is the report of Titian's working methods which the master's faithful pupil Palma il Giovine passed on to Marco Boschini, who tells how Titian would lay in his paintings rapidly with a few brushstrokes.

> Having laid these precious foundations he turned the paintings to the wall, and there he sometimes left them for several months without looking at them. And when he then wanted again to apply the brush, he scrutinized them with rigorous attention as if they had been his deadly enemies, to see if he could find a fault in them. And having discovered any feature that did not correspond to his sensitive understanding, he would, like a beneficent surgeon, treat the invalid, if necessary remove some excrescence or superfluity of flesh, or straighten an arm, if the shape was not adjusted to the bone structure; or if a foot had taken up an inconsistent attitude he set it right without paying heed to the pain, and so in all things of this kind.
>
> Thus shaping and revising the figures, he reduced them to the most perfect symmetry that could represent the Beauty of Nature and Art. . . .[58]

We do not usually connect Titian's art with this concern for correct representation, and it is quite possible that Palma-Boschini stressed this element to counter the criticism of Titian's *disegno* Vasari had attributed to Michelangelo.[59] But whatever Titian's main emphasis may have been in these revisions, we need not doubt that note of self-criticism that marks the great master, the hostile scrutiny of his own work, the awareness of his limitations and the wish to transcend them. Here our account may link up with its beginning and return in conclusion to the testimony of Albrecht Dürer.

Eighteen years after Dürer's death Philip Melanchthon recalled in a letter what Dürer had once said to him:

> When he was a young man he had loved florid paintings with a maximum of variety, and had admired his own work, being mightily pleased when he contemplated that variety in any of his own paintings. But when he had grown old, later, he had begun to see nature and had attempted to perceive her real face; then he had understood that this simplicity was the greatest ornament of art. Since he could not achieve this,

he said he no longer was an admirer of his own works as before, but often sighed when looking at his pictures and reflected on his weakness.[60]

When Melanchthon wrote down this memory, in 1546, German art had entered into a decline from which it was not to recover for centuries. It is usual to blame the Reformation for this loss of creative power, but the lack of ecclesiastical patronage did not have similar disastrous effects on the arts of the Netherlands. Somehow, in Germany the new standards had killed the vigour and enjoyment of art, the Gothic pleasure in richness and variety, without leading to a more than skin-deep adoption of the new critical tradition. Perhaps there was too much in this tradition that was implicit rather than explicit, and these implications were lost in teaching.

For obvious reasons this study has been concerned with the explicit and formulated standards that made it possible for a new critical attitude to emerge. But though these standards were rigorous in establishing priorities, they were only conceived as a framework, as certain specifications that a work of art had to fulfil if it was to be acceptable. What the Renaissance never formulated was the crucial experience that for every problem solved, a new one could be created,[61] that the mastery of perspective and the nude had destroyed certain assets of the medieval tradition which had to be compensated for in new solutions of calculated composition and conscious colour harmonies, in short in all those specifically artistic problem solutions which the modern art historian attempts to reconstruct from hindsight.[62] Among these potent but less articulate ideals, that of 'simplicity', which Melanchthon remembers Dürer to have mentioned, certainly stands out in what we call the 'classic' art of the Renaissance. The history of this ideal is not yet written. There is little doubt, though, that for Dürer the recognition of the profound simplicity of nature was the consequence of a grasp of her mathematical structure. It was the simplicity we admire in Piero della Francesca and in Mantegna, the mastery of essentials which stands in no need of the subsidiary values of richness and variety. It may be claimed that the generation of Vasari had lost sight of this ideal and had replaced it by its deceptive double, the ideal of ease of execution, which mattered so much to Vasari.[63]

The Pride of Apelles: Vives, Dürer and Bruegel

THERE exists a little dialogue by the Spanish humanist Johannes Ludovicus Vives[1] in which Dürer figures as a participant. Published a mere ten years after the artist's death, it has so far escaped the attention of Dürer specialists.[2]

The dialogue is one of 25 conversations included in the *Exercitatio Linguae Latinae* of 1538. This last work of the great Spaniard was an imitation of Erasmus' *Colloquia* and was also very successful as a Latin primer. No less than two hundred editions have been counted.[3] One of these exercises arranged to extend the student's vocabulary deals with the appearance of the human body (*corpus hominis exterius*), and centres on a painted portrait, which is discussed in great detail. It is for this purpose that Vives introduces Dürer, who has painted a picture of Scipio Africanus and argues with two learned pedants, Grynius and Velius, who find fault with every feature, but are soundly rebuffed by the proud master. There is no reason to assume that Vives ever wanted to embody any real traits of the historical Dürer in this exercise and even less to suggest that there really existed a portrait of Scipio by Dürer.[4] The point of interest is rather the tone in which Vives makes the artist speak to his comical tormentors. A few extracts from these exchanges will suffice to make this clear.[5]

Dürer Go away from here, for you will buy nothing as I know full well, and you only remain in the way, and this keeps buyers from coming nearer.

Grynius Nay, we wish to buy, only we wish you to leave the price to our judgement, and that you should state the limit of time for payment, or, on the other hand, let us settle the time and you the amount of payment.

Dürer A fine way of doing business! There is no need for me to have nonsense of this sort!

Grynius Whose portrait is this, and what price do you put on it?

Dürer It is the portrait of Scipio Africanus and I price it at four hundred sesterces, or not much less.

Grynius I pray you, before you favour us with a single word, let us examine the art of the picture. Velius here is half a physician, and very skilled in knowledge of the human body.

Dürer For some time I have perceived that I was in for being worried by you. Now whilst there are no buyers at hand, you may waste time as you will.

Grynius Do you call the practical knowledge of your art a waste of time? What would you call that of another's?

Velius First you have covered the top of his head with many and straight hairs

This was a contribution to the *Album Amicorum*, J. G. van Gelder (The Hague, 1973).

	when the top is called *vertex*, as if a vortex, from the curling round of the hair, as we see in rivers when the water rolls round and round (*convolvit*).
Dürer	Stupidly spoken; you don't reflect that it is badly combed, following the custom of his age.
Velius	His forehead is unevenly bent.
Dürer	As a soldier he had received a wound at the Trebia when he was saving his father.
Grynius	Where did you read that?
Dürer	In the lost decads of Livy.
Velius	The temples are too much swollen.
Dürer	Hollow temples would be the sign of madness!
Velius	I should like to be able to see the back part of the head.
Dürer	Then turn the panel round.

There is much more in the same vein and even Grynius is made to concede: 'You are not only a painter, but a rhetorician, well versed in turning off any criticism of your work'. Soon Dürer explodes: 'You are, beyond measure, chatterers and talkative cavillers. Get away with you. I won't let you have the opportunity of further criticizing the picture.' The others plead to let them go on while there are no other clients. Each of them would write a distich whereby the picture would be more easily sold. Dürer rejects this offer: 'My art has no need of your commendation. Skilled buyers who understand pictures do not buy verses but works of art.'

It is obvious that this Latin exercise must not be treated as an historical testimony. Vives probably did not know much more about the artist than that Erasmus had praised him as another Apelles. The pride and the pleasure in rebuffing ignorant critics are, of course, among the personal traits which Pliny reports of Apelles. He not only asks the critical cobbler 'to stick to his last' but even warned Alexander himself that the boys would laugh at his ignorance if he went on making a fool of himself.[6]

But though the dialogue yields no information about the historical Dürer it is worth noticing as a document of changing attitudes towards art and artists. Clearly Vives sides with the painter who makes his critics look foolish. Though his Latin primer is an exercise in language it also teaches the pupil incidentally how not to talk to artists. Such a lesson may have been less trivial in the Netherlands around 1538 than it would have been in Italy. The great master is shown to be not only the equal of the erudite humanists but to be by rights their superior.

Less than thirty years later Pieter Bruegel the Elder expressed a similar sentiment in a well-known drawing (Fig. 237) which was sufficiently famous in the sixteenth century to have been frequently copied.[7] The contrast between the self-assertive painter and the foolish and myopic buyer who fumbles in his purse is sufficiently obvious to recall the spirit of Vives' dialogue. The spirit, not the letter, because there is only one buyer and not two.

Could the dialogue have inspired Bruegel? It may never be possible to answer this question, but it may still be worth looking at the composition with this possibility in mind. The drawing has sometimes been interpreted as a self-portrait and its message certainly looks sufficiently personal to make this a tempting reading. But there is no reason to distrust the portrait of the master by Hieronymus Cock published a mere three years after his death. It shows no similarity whatever with the painter in the drawing. Could the painter then be the Dürer of Vives' dialogue? At first sight the suggestion must look outrageous. He certainly does not resemble the real Dürer, whom we know from self-portraits and from contemporary accounts, which stress his well groomed and even dandified appearance. But there exists an alternative portrait tradition which differs quite markedly from the master's self-portraits, one, moreover that would have been more easily accessible to Bruegel than the paintings and drawings we remember. It originates in a medal by Matthes Gebel of Nürnberg (Fig. 238), dated 1527,[8] which was subsequently copied and which also provided the model for a woodcut attributed to Erhard Schön (Fig. 239) that exists in its turn in several versions.[9] This type shows a much more fierce-looking Dürer than the one who lives in our imagination. His hair is not flowing over the shoulders, but cut to half-length, his beard looks much less well trimmed and bulges over the chin and lower lip. True, even the Dürer of this iconographic tradition has reasonably well brushed hair and a neat moustache, a feature which Bruegel's bristling Bohemian certainly lacks. There can be no question, therefore, of Bruegel having made an effort to portray the historical Dürer in this imaginary confrontation. But neither, as we have seen, did Vives. Even in its most risky form the hypothesis here put forward for discussion would amount to no more than that Bruegel may have been inspired by the dialogue to conjure up the ideal image of a modern Apelles and that, in doing so, he may have fed his imagination on the medal or the woodcut without aiming at an accurate portrait likeness.

Or would he have found this hypothesis worthy of the bespectacled pedant whom he drew peering over the artist's shoulder?

Notes

THE HERITAGE OF APELLES

1. Goethe, *Farbenlehre*, Vorwort, Didaktischer Teil.
2. Wolfgang Schöne, *Über das Licht in der Malerei* (Berlin, 1954); T. B. Hess and J. Ashbury, *Light: From Atom to Laser* (New York, 1969); P. Bertin *et al.*, *Ombre et Lumière* (Paris, 1961); M. Barasch, 'Licht und Farben in der italienischen Kunsttheorie des Cinquecento', *Rinascimento* II (Florence, 1960). For some further references see my *Art and Illusion* (New York and London, 1960), Notes to Chapter 1.
3. London, 1638.
4. *Commentaria in Aristotelem Graeca* (Berlin, 1900), XIV, i, pg. 73 (Aristotle p. 342 b14): καὶ γὰρ εἰ ἐν τῷ αὐτῷ ἐπιπέδῳ λευκὸν θείης καὶ μέλαν καὶ πόρρωθεν αὐτὰ θεωρήσειας, ἐγγύτερον εἶναι δόξει τὸ λευκόν, τὸ δὲ μέλαν πορρώτερον. τοῦτο καὶ οἱ γραφεῖς εἰδότες, ὅταν κοῖλον εἶναί τι δοκεῖν ἐθέλωσιν, οἷον πηγὴν ἢ δεξαμενὴν ἢ βόθυνον ἢ ἄντρον ἤ τι τοιοῦτον, μέλανι καταχρίουσι τοῦτο ἢ κυανῷ, καὶ τοὔμπαλιν ὅσα προπετῆ φαίνεσθαι βούλονται, οἱονεὶ μαζοὺς κόρης ἢ χεῖρα τεινομένην ἢ πόδα ἵππου, τὰ ἑκατέρωθεν τοῦ μορίου τούτου μελαίνουσιν, ἵνα τούτων κοίλων εἶναι δοκούντων τὸ μεταξὺ αὐτῶν γραφὲν ἐξέχειν νομίζηται.
5. XVII, 2; Loeb Classical Library, p. 186.
6. James B. Johnson, 'The Stained Glass Theory of Viollet le Duc', *Art Bulletin*, June 1963.
7. *Academica*, II, 20 and 86.
8. Pliny. *Naturalis Historia*, XXXV 29 K. Tex-Blake and E. Sellers, *The Elder Pliny's Chapters on the History of Art* (London, 1896), p. 96.
9. F. Wickhoff, *Die Wiener Genesis* (Vienna, 1895), Engl. translation by E. Strong as *Roman Art* (London, 1900).
10. E. Kitzinger, 'The Hellenistic Heritage in Byzantine Art', *Dunbarton Oaks Papers*, 1963, pp. 95–117.
11. E. Panofsky, *Abbot Suger on the Abbey Church of St. Denis* (Princeton, 1946).
12. On 'skiagraphia' cf. E. Pfuhl, *Malerei und Zeichnung der Griechen* (Munich 1923), pp. 674ff. But see now E. Keuls, 'Skiagraphia once again', *American Journal of Archaeology*, 79, I. 1975.
13. J. J. Gibson, *The Perception of the Visual World* (Boston, 1950), pp. 96 ff. Wolfgang Metzger,

Gesetze des Sehens (Frankfurt am Main, 1953), pp. 377 ff. See also my *Art and Illusion* (London and New York, 1960), Chapter VIII.
14. *Republic* X, 602 D.
15. William Hogarth, *The Analysis of Beauty* (1st edit. 1753), ed. Joseph Burke (Oxford, 1955), p. 117.
16. Wolfgang Kallab, 'Die toskanische Landschaftsmalerei im 14. und 15. Jahrhundert', *Jahrbuch der kunsthistorischen Sammlungen in Wien*, XXI, 1900.
17. A. Lejeune (ed.), *L'Optique de Claude Ptolémé* (Louvain, 1956), p. 74.
18. J. P. Richter, *The Literary Works of Leonardo da Vinci* (Oxford, 1939), I, pp. 210–9.
19. The similarity was noticed by J. Strzygowski, *Die Landschaft in der Nordischen Kunst* (Leipzig, 1922), though his conclusions were the opposite of mine. There is a detailed entry on Ajanta by Ghulam Jazdeni in the McGraw Hill *Encyclopedia of World Art*, New York, 1952. For a more recent appraisal see Herbert Härtel and Jeannine Auboyer, *Indien und Südostasien*, Propyläen Kunstgeschichte, Berlin, 1971.
20. A. Waley, *A Catalogue of Paintings recovered from Tun-Huang by Sir Aurel Stein* (London, 1931), no. 1, illustrated in Sir Aurel Stein, *One Thousand Buddhas, Ancient Buddhist paintings from Tun-Huang*, Introduction by Laurence Binyon (London, 1921), pl. VII; P. Pelliot, *Les grottes de Touen-Houang* (Paris, 1914), vol. I, pl. LX; Longton Warner, *Buddhist Wall Paintings* (Cambridge, Mass., 1938), pl. XLIIb; Mission Paul Pelliot, *Douldour-Aqoir et Soubachi* (Paris, 1967), vol. III, pl. LVII; A. Grünwedel, *Altbuddhistische Kultstätten in Chinesisch-Turkistan* (Berlin, 1912), pp. 64, 90, 146; M. I. Rostovzeff, Dura and the Problem of Parthian Art, *Yale Classical Studies*, V, 1935, pp. 155–304, figs. 71–3. I should also like to draw attention to the white highlights on blue beads clearly visible on the fragment from Tun Huang (British Museum, 1919–1–1–0132) reproduced in colour on the poster for the Exhibition of T'ang Buddhist Painting at the British Museum, June–October 1975.
21. For shading, cf. C. Sickman and A. Soper, *The Art and Architecture of China*, The Pelican

History of Art (Harmondsworth, 1956), pp. 64 and 81. For the 'Indian crag' cf. Michael Sullivan, *The Birth of Landscape Painting in China* (London, 1962), pp. 46 and 134–8.

22. Ch'ên Yung-Chih, quoted from H. A. Giles, *An Introduction to the History of Chinese Pictorial Art* (Shanghai and Leiden, 1905), p. 100, cf. *Art and Illusion*, Chapter VI.

23. Scitum est inter Protogenen et eum quod accidit. Ille Rhodi vivebat, quo cum Apelles adnavigasset avidus cognoscendi opera eius fama tantum sibi cogniti, continuo officinam petiit. Aberat ipse, sed tabulam amplae magnitudinis in machina aptatam picturae una custodiebat anus. Haec foris esse Protogenem respondit interrogavitque a quo quaesitum diceret. Ab hoc, inquit Apelles; adreptoque penicillo liniam ex colore duxit summae tenuitatis per tabulam; et reverso Protogeni quae gesta erant anus indicavit.

Ferunt artificem protinus contemplatum subtilitatem dixisse Apellem venisse, non cadere in alium tam absolutum opus; ipsumque alio colore tenuiorem liniam in ipsa illa duxisse abeuntemque praecepisse, si redisset ille, ostenderet adiceretque hunc esse quem quaereret. Atque ita evenit. Revertit enim Apelles et vinci erubescens tertio colore lineas secuit nullum relinquens amplius suptilitati locum.

At Protogenes victum se confessus in portum devolavit hospitem quaerens, placuitque sic eam tabulam posteris tradi omnium quidem, sed artificum praecipuo miraculo. Consumptam eam priore incendio Caesaris domus in Palatio audio, spectatam nobis ante, spatiose nihil aliud continentem quam linias visum effugientes, inter egregia multorum opera inani similem, et eo ipso allicientem, omnique opere nobiliorem. *Historia Naturalis*, XXXV, 81–3.

24. Hans van de Waal, 'The *Linea Summae Tenuitatis* of Apelles: Pliny's Phrase and its Interpreters', *Zeitschrift für Aesthetik und allgemeine Kunstwissenschaft*, XII/1, 1967, pp. 5–32.

25. *Historia Naturalis*, XXXV, 92.

26. Evidence from vases is naturally inconclusive on various counts, all the more as we are inevitably better informed about their relative than their absolute chronology, but it seems to be agreed that the so-called 'Ornate Apulian

style', to which the vase in Copenhagen (inv. 3408; Fig. 47) belongs, flourished in the second half of the fourth century, the period of Apelles. Cf. A. D. Trendall, *South Italian Vase Painting* (London, The British Museum, 1966). Dr. David Harvey of the University of Exeter has kindly drawn my attention to important discussions of the use of colour imagery in Greek literature which have a bearing on this question, notably S. A. Barlow, *The Imagery of Euripides* (London, 1971), pp. 8–15 and 69–70. Even more relevant is an article by G. Collard, 'On the Tragedian Chaeremon', *Journal of Hellenic Studies*, 90, 1970, pp. 22–34. It comments on a fragment from that fourth-century tragedian which describes a girl as 'giving the appearance of a living painting'.

27. 'lumen et umbras custodiit atque ut eminerent e tabulis picturae maxime curavit', *op. cit.*, XXXV, 131.

28. 'eam primus invenit picturam, quam postea imitati sunt multi, aequavit nemo. Ante omnia, cum longitudinem bovis ostendi vellet, adversum eum pinxit, non traversum, et abunde intelligitur amplitudo. Dein, cum omnes quae volunt eminentia videri candicanti faciant colore, quae condunt nigro, hic totum bovem atri coloris fecit umbraeque corpus ex ipsa dedit magna prorsus arte inaequo extantia ostendente et in confracto solida omnia.' *Op. cit*, XXXV, 126–7.

29. *Op. cit.*, XXXV, 96. It was applied to Bruegel by Ortelius, cf. F. Grossmann, *P. Bruegel* (London, 1955).

30. 'Dark Varnishes: Variations on a Theme from Pliny', *The Burlington Magazine*, CIV, February 1962, pp. 51–5.

31. *Op. cit.*, XXXV, 96.

32. What I merely postulated as likely in my article quoted above was in fact claimed by A. Félibien for his contemporary Le Brun in the eulogy of his painting *Les Reines de Perse au pieds d'Alexandre* (*Recueil de Descriptions de Peintures . . . faits pour le Roy* (Paris, 1689), p. 61), where we read that the painter deliberately deprived the colours 'de leur éclat et de leur vivacité naturelle'.

33. J. Overbeck, *Die antiken Schriftquellen* (Leipzig, 1868).

34. *Op. cit.*, XXXV, 80.

LIGHT, FORM AND TEXTURE IN FIFTEENTH-CENTURY PAINTING NORTH AND SOUTH OF THE ALPS

1. Jean Paul Richter, *The Literary Works of Leonardo da Vinci* (Oxford, 1939), I, pp. 164–207.

2. Richter, *ed. cit.*, no. 133 (Bibliothèque Nationale 2038, 32a); for parallel passages see Leonardo da Vinci, *Treatise on Painting*, ed. A. Philip

McMahon (Princeton, 1956), pp. 260–3, under the general heading 'Luster'.

3. Richter, *ed. cit.*, no. 135, section 1.

4. Richter, *ed. cit.*, no. 135, section 2.

5. Leon Battista Alberti, *On Painting and On Sculpture* (ed. C. Grayson) (London, 1972), II. 48, pp. 90–2.

6. Cennino Cennini, *Il Libro dell'Arte*, ed. and translated by Daniel V. Thompson (New Haven, 1932–3).

7. Renoir wrote a long letter to Cennini's early editor Mottez, first published in the *Journal de L'Occident*, Paris, June 1910. A German translation is to be found in H. Uhde Bernays, *Künstlerbriefe über Kunst* (Dresden, 1926), 294–303.

8. Ugo Procacci, *Sinopie e Affreschi* (Milan, 1961); and the catalogue of the Exhibition *The Great Age of Fresco* (New York and London, 1968), with an introduction by Millard Meiss.

9. Bernard Berenson, *Italian Pictures of the Renaissance, Florentine School* (London, 1963).

10. London, 1960.

10a. A. Perosa, *Giovanni Rucellai ed il suo Zibaldone* (London, 1960), p. 61.

10b. A. Chastel, 'Marqueterie et Perspective au XVe Siècle', *Revue des Arts*, Paris, Sept. 1953, pp. 141–54; and *The Golden Age of the Renaissance* (London, 1965), pp. 245–63.

11. *ed. cit.*, paragraph 46, pp. 89 ff.

12. *ed. cit.*, paragraph 47, p. 90.

13. The Italian text, ed. H. Janitschek (Vienna, 1877), p. 135, here speaks of the extreme lustre of a most polished sword, 'l'ultimo lustro d'una forbitissima spada'.

14. Erwin Panofsky, *Early Netherlandish Painting* (Cambridge, Mass., 1953).

15. Antonín Matějček and Jaroslav Pešina, *Czech Gothic Painting* (Prague, 1950).

16. Bella Martens, *Meister Francke* (Hamburg, 1929).

17. Grete Ring, *A Century of French Painting* (London, 1949).

18. Another scene is illustrated in Panofsky, *op. cit.*, fig. 112.

19. For a colour reproduction see R. Gregory and E. H. Gombrich (eds.), *Illusion in Nature and Art* (London, 1973), pl. 15.

20. See my paper 'The Renaissance Theory of Art and the Origins of Landscape Painting', *Norm and Form* (London, 1966), pp. 107–21.

21. Most recently in Carlo Pedretti, *Leonardo* (London, 1973).

22. Richter, *ed. cit.*, no. 483.

23. Naturally this applies less to the topographical drawings Leonardo made for military and engineering purposes, such as the ones found in the newly discovered notebooks in Madrid. Cf. Ladislao Reti, *The Madrid Codices* (New York, 1974), especially Cod. II, fol. 7*v* and 8*r*, dating from 1503.

LEONARDO: THE FORM OF MOVEMENT IN WATER AND AIR

1. First published by F. Cardinali in 1824 and again by Carusi-Favaro (Bologna, 1923).

2. N. de Toni, *L'Idraulica in Leonardo da Vinci* (*Frammenti Vinciani*, III–IX) (Brescia, 1934–5). Since this useful edition is not easily available, I have here reprinted in the original all the passages quoted.

3. Published by G. Calvi (Milan, 1909). For the source of a number of these notes see C. Pedretti, *Leonardo da Vinci on Painting: A Lost Book* (*Libro A*) (Berkeley and Los Angeles, 1964).

4. J. P. Richter, *The Literary Works of Leonardo da Vinci* (2nd ed. London, 1939), included only a very few of these notes in his influential anthology. The largest selection, in translation only, is in Theodor Lücke, ed., *Leonardo da Vinci, Tagebücher und Aufzeichnungen* (Zürich, 1952), covering 108 pages. Among general discussions of the subject that were accessible to me I should like to mention: A. Favaro, 'Leonardo da Vinci e le scienze delle acque,' *Emporium*, 1919, pp. 272–9; F. Arredi, 'Gli studi di Leonardo da Vinci sul moto delle acque,' *Annali dei Lavori Pubblici* (*già Giornale del Genio Civile*), 1939, 17 (fasc. 4), April, pp. 357–63; 'Le Origini dell'Idrostatica,' in *L'Acqua*, 1943, pp. 8–18; and A. M. Brizio, 'Delle Acque,' *Leonardo da Vinci, Saggi e Ricerche*, ed. A. Marazza (Rome, 1954), pp. 277–89, and recently Carlo Zammatio, 'The Mechanics of Water and Stone' in *The Unknown Leonardo*, ed. Ladislao Reti (London, 1974), pp. 191–207. The Madrid Codices (for which see note 23 above), which became only available after the completion of this study, contain relatively few notes about this topic, except for four entries about the motion of waves, dating from 1504 (Cod. II, 24*r*, 41*r*, 64*r* and 126*r*).

5. K. Clark and C. Pedretti, *A Catalogue of the Drawings of Leonardo da Vinci in the Collection of Her Majesty the Queen at Windsor Castle* (London, 1969), no. 12384, p. 54, dated by the authors *ca.* 1515.

6. Clark and Pedretti, *op. cit.*, no. 12660*v* dated by the authors *ca.* 1509.

7. MS. A is dated by Leonardo himself (fol. 114*v*)

July 10, 1492. Here and throughout I am relying on the chronology of Leonardo's manuscripts given in A. Marinoni, 'I Manoscritti di Leonardo da Vinci e le loro Edizioni,' *Leonardo, Saggi e Ricerche* (ed. cit.), Appendix I.

8. The Windsor drawings concerned date, according to Clark and Pedretti, from *ca.* 1509.

9. London and New York, 1960.

10. Cod. Urb., fol. *222r* (McMahon, 686). The passage refers to a problem of light.

11. K. R. Popper, *The Logic of Scientific Discovery* (New York and London, 1959).

12. K. D. Keele, *Leonardo da Vinci on Movement of the Heart and Blood* (London, 1952), offers many instructive examples of this process. See now also the important book by a great historian of science, V. P. Zubov, *Leonardo da Vinci* (Cambridge, Mass., 1968), which I reviewed in the *New York Review of Books*, 5 December 1968, pp. 4–8.

13. L. H. Heydenreich, *Leonardo da Vinci* (New York and Basel, 1954), note to plate 226.

14. E.g., the small scribbles accompanying the enumeration of water conduits, C.A., fol. *70v.*

15. C.A., fol. *37v, c:* 'L'acqua m. n. disciende in b, e percuote sotto il sasso b, e risalta in c, e di li si leva in alto, ragirandosi in q., e le cose sospinte in f. dall'acqua percossa nel sasso b., infra angoli equali, risaltan [per] sotto la medesima linia q. b., cioè per la linia b. c., e la cosa, che qui si trova, va ragirando più che quelle che percotano il sasso infra angoli disequali, imperò che queste, ancora che si vadino regirando, esse [ne] fuggano insieme col moto del fiume.' The accompanying diagram is unfortunately too faint to reproduce legibly.

16. 'Qui l'acqua vicina alla superfitie fa l'ufficio che vedi, risaltando in alto e indietro nel suo percotersi, e l'acqua che risalta indietro e cade sopra l'angolo della corrente, va sotto e fa come vedi di sopra in a, b, c, d, e, f' (MS. F, fol. *20r*).

17. *The Drawings of Leonardo da Vinci* (London, 1946), p. 164.

18. 'Sommergere, s'intende le cose ch'entrano sotto l'acque. Intersegazione d'acque, fia quando l'un fiume sega l'altro. Risaltazione, circolazione, revoluzione, ravvoltamento, raggiramento, sommergimento, surgimento, declinazione, elevazione, cavamento, consumamento, percussione, ruinamento, discenso, impetuità, retrosi, urtamenti, confregazioni, ondazioni, rigamenti, bollimenti, ricascamenti, ritardamenti, scatorire, versare, arriversciamenti, riattuffamenti, serpeggianti, rigore, mormorii, strepidi, ringorare, ricalcitrare, frusso e refrusso, ruine, conquassamenti, balatri, spelonche delle ripe, revertigine, precipizii, reversciamenti, tomulto,

confusioni, ruine tempestose, equazioni, egualità, arazione di pietre, urtamenti, bollori, sommergimenti dell'onde superficiali, retardamenti, rompimenti, dividimenti, aprimenti, celerità, veemenzia, furiosità, impetuosità, concorso, declinazione, commistamento, revoluzione, cascamento, sbalzamento, conrusione d'argine, confuscamenti' (MS. I, fols. *72r, 71v*).

19. 'Dell'oncia dell'acqua, e in quanti modi si può variare. L'acqua che versa per una medesima quantità di bocca, si può variare di quantità maggiore o minore per modi, de' quali il primo è da essere più alta o più bassa la superficie dell'acqua sopra la bocca donde versa; il 2°, da passare l'acqua con maggiore o minore velocità da quell'argine dove è fatto essa bocca; 3° da essere più o meno obbliqui i lati di sotto della grossezza della bocca dove l'acqua passa; 4° dalla varietà dell'obbliquità de' lati di tal bocca; 5° dalla grossezza del labbro d'essa bocca; 6° per la figura della bocca, cioè a essere o tonda o quadra, o triangolare, o lunga; 7° da essere posta essa bocca in maggiore o minore obbliquità d'argine per la sua lunghezza; 8° a essere posta tal bocca in maggiore o minore obbliquità d'argine per la sua altezza; 9° a essere posta nelle concavità e convessità dell'argine; 10° a essere posta in maggiore o minore larghezza del canale; 11° se l'altezza del canale ha più velocità nell'altezza della bocca o più tardità che altrove; 12° se il fondo ha globosità o concavità a riscontro d'essa bocca, o più alta o più bassa; 13° se l'acqua che passa per tal bocca piglia vento o no; 14° se l'acqua che cade fuor d'essa bocca cade in fra l'aria ovvero rinchiusa da un lato o da tutti, salvo la fronte; 15° se l'acqua che cade rinchiusa sarà grossa nel suo vaso, o sottile; 16° se l'acqua che cade, essendo rinchiusa, sarà lunga di caduta o breve; 17° se i lati del canale donde discende tale acqua sarà suoli o globulosi, o retti o curvi' (MS. F, fol. *9v*).

There is a similar note on waves in MS. I, fols. *87v*, *88r–v*, translated in E. MacCurdy, *The Notebooks of Leonardo da Vinci* (London, 1938), vol. I, pp. 85–6.

20. 'De' retrosi superficiali e di quelli creati in varie altezze dell'acqua; e di quelli che piglian tutta essa altezza, e de' mobili e delli stabili; de' lunghi e de' tondi; delli scambievoli di moto e di quelli che si dividono, e di quelli che si convertono in quelli dove si congiungono, e di que' che son misti coll'acqua incidente e refressa, che vanno aggirando essa acqua. Quali son que' retrosi che raggiran le cose lievi in superficie e non le sommergono; quali son quelli che le sommergono e raggiranle sopra il fondo e poi le lascian in esso fondo; quali son quelli che spiccan le cose del fondo e le regittano in

superficie dell' acqua; qua' son li retrosi obbliqui, quali son li diritti, qua' son li piani' (MS. F, fol. 2r).

21. A few examples of such lists are printed in Richter, *op. cit.*, vol. II, nos. 919–28 after C. Leic., fol. 15v, and C. Ar., fols. 35r–v, 45r, and 122r. There are longer such lists in C.A., fol. 74r–v.

22. J. R. D. Francis, *A Textbook of Fluid Mechanics* (London, 1958). The best introduction to these problems for laymen I have found is O. G. Sutton, *The Science of Flight* (Harmondsworth, 1955).

23. MS. E, fol. 8v.

24. 'Il fiume d'equale profondità, avrà tanto più di fuga nella minore larghezza, che nella maggiore, quanto la maggiore larghezza avanza la minore' (MS. A, fol. 57r). See also MS. A, fols. 23v and 57v. Other formulations of the principle of continuity (C. Leic., fols. 6v and 24r; C.A., fols. 80v, *b;* 80r, *b;* and 287r, *b*) are quoted in extenso in F. Arredi, 'Gli Studi,' etc., as quoted above, n. 4.

25. G. Bellincioni, 'Leonardo e il Trattato del Moto e Misura delle Acque,' in *Atti del Convegno di Studi Vinciani* (Florence, 1953), pp. 323–7. (New edition: *Studi Vinciani*, IV, 1954, pp. 89–95.)

26. 'Quanto più l'acqua correrà per la declinazione d'equale canale, tanto più fia potente la percussione da lei fatta nella sua opposizione. Perchè tutti li elementi, fuori del loro naturale sito, desiderano a esso sito ritornare, e massime foco, acqua e terra; e quanto esso ritornare fia fatto per linea più breve, tanto fia essa via più diritta, e quanto più diritta via fia, maggiore fia la percussione nella sua opposizione' (MS. C, fol. 26r).

27. 'Ogni parte d'acqua, infra l'altra acqua senza moto, diace di pari riposo con quella che nel suo livello situata fia. Qui la esperienza ne mostra che, se fussi un lago di grandissima larghezza, il quale in sè diacesse senza moto di vento d'entrata o d'uscita, che tu levassi una minima parte dell'altezza di quella argine che si trova dalla superficie dell'acqua in giù, tutta quell'-acqua, che si trova dal fine di detta tagliata argine in sù, passerà per essa tagliatura e non move o tirerà con seco fuori del lago alcuna parte di quella acqua, dove essa acqua mossa e partita diaceva. In questo caso, la natura, costretta dalla ragione della sua legge, che in lei infissamente vive—che tutte le parti di quella superficie dell'acque che senza alcuna entrata o uscita sostenute sono, equalmente dal centro del mondo situate sono. La dimostrazione, si è di sopra: diciamo che l'acqua del detto lago da argine sostenuta sia *n o a f*, e che

n m r a sia olio sopra a essa acqua sparso, e che essa tagliatura dell'argine, sia *m n*. Dico che tutto l'olio che si trova da *n* in su, passerà per essa rottura, senza muovere alcuna parte dell'acqua a lui sottoposta' (MS. C, fol. 23v).

28. 'Si vede chiaramente e si conosce che le acque che percuotono l'argine de' fiumi, fanno a similitudine delle balle percosse ne' muri, le quali si partono da quelli per angoli simili a quelli della percussione e vanno a battere le contraposte parete de' muri' (MS. A, fol. 63v).

29. MS. C, fols. 24v and 26r.

30. 'O mirabile giustizia di te, primo motore! Tu non ai voluto mancare a nessuna potenzia l'ordine e [e-]qualità de' sua neciessari effetti' (MS. A, fol. 24r).

31. 'Universalmente, tutte le cose desiderano mantenersi in sua natura, onde il corso dell'acqua che si move, ne cerca mantenere il [suo corso], secondo la potenza della sua cagione, e se trova contrastante opposizione, finisce la lunghezza del cominciato corso per movimenti circolari e retorti' (MS. A, fol. 60r). The Aristotelian source of the opening proposition is quoted by Leonardo in C.A., fol. 123r, *a:* 'Dice Aristotile che ogni cosa desidera mantenere la sua natura.'

32. 'Ogni movimento fatto da forza, conviene che faccia tal corso, quanto è la proporzione della cosa mossa con quella che move; e s'ella trova resistente opposizione, finirà la lunghezza del suo debito viaggio per circular moto o per altri vari saltamenti o balzi, i quali, computato il tempo e il viaggio, fia come se il corso fussi stato senza alcuna contraddizione' (MS. A, fol. 60v).

33. 'L'acqua, che per istretta bocca versa declinando con furia ne' tardi corsi de' gran pelaghi perchè nella maggior quantità è maggior potenza, e la maggior potenza fa resistenza alla minore, in questo caso, l'acqua sopravvenente al pelago e percotendo la sua tarda acqua, quella, sendo sostenuta dall'altra, non può dare loco, onde colla conveniente prestezza, a quella sopravvenente, non volendo attardare il suo corso, anzi, fatta la sua percussione, si volta indietro seguitando il primo movimento; con circolari retrosi finisce al fondo il suo desiderio, perchè in detti retrosi non trova se non è il moto di se medesima, colla quale s'accompagnan le volte l'una dentro all'altra, e in questa circulare revoluzione la via si fa più lunga e più continuata perchè non trova per contrasto se non se medesima e questo moto rode le rive consumate con deripazione e ruina d'esse' (MS. A, fol. 60r). See also C.A., fols. 354r, *e* and 361r, *b*.

34. 'Nota il moto del livello dell' acqua, il quale fa a uso de' capelli, che anno due moti, de' quali

l'uno attende al peso del vello, l'altro al linia-
mento delle volte; così l'acque a le sue volte
revertiginose, delle quali una parte attende al
inpeto del corso principale, l'altro attende al
moto incidente e reflesso' (Richter 389).

35. A more complex example of this interaction is
discussed on the drawing Windsor 12663r
(fig. 95): 'Il moto revertiginoso e di tre sorte,
cioè semplice, conposte, e decomposte; il moto
revertiginoso semplice e di tanto movimento
respecto all'altre due predette sorte; e il moto
conposto e in se due moti di varie velocità, cioè
un moto primo ch'ello move nel suo nascimento,
che è un moto in lunghezza chol moto univer-
sale del fiume o del pelago dove si genera, e
'l secondo moto e fatto infra giù e sù, e la terza
sorte à tre moti di varie velocità, cioè li 2
predetti del moto composto, e li se agiunge
un terzo che a tardezza mezzana infra 2 già
dette.' For the paleographic transcript of this
text, which I have ventured to normalize, cf.
K. Clark and C. Pedretti as cited above, note 5.
An even more complex description which
illustrates the cumulative effect of these inter-
actions on Leonardo's style is in MS. I, fol. 78v
and 78r: 'I retrosi son alcuna volta molti che
mettano in mezzo un gran corso d'acqua, e
quanto più s'appressano al fine del corso, più
son grandi: e si creano in superficie per l'acque
che to[r]nano indietro dopo la percussione
ch'esse fanno nel corso piu veloce, perche sendo
le fronti di tale acque percosse dal moto veloce,
essendo esse pigre, subito si trasmutano in
detta velocità, onde quella acqua che dirieto l'è
contingente e appiccata, è tirata per forza e
disvelta dall'altra, onde tutta si volterebbe
successivamente, l'una dirieto all'altra, con
tal velocità di moto, se non fussi che tal
corso primo non le può ricevere se già non
s'alzassino di sopra a essa, e questo non
potendo essere, è necessario che si voltino
indirieto e consumino in se medesimo tali
veloci moti, onde con varie circulazioni, dette
retrosi, si vanno consumando i principiati
impeti—e non stanno fermi, anzi, poi che
son generati così girando sono portati dall'im-
peto dell'acqua nella medesima figura: onde
vengono a fare 2 moti, l'uno fa in sè per la sua
revoluzione, l'altro fa seguitando il corso
dell'acqua che lo transporta, tanto che lo
disfa.'

36. E.g., MS. F, fol. 19r.

37. MS. A, fol. 61r. For a full translation, see
Heydenreich, *op. cit.*, I, pp. 146–7. For a further
analysis of this observation see Kenneth D.
Keele, 'Leonardo da Vinci's Physiology of the
Senses' in C. D. O'Malley (ed.), *Leonardo's*

Legacy (Berkeley and Los Angeles, 1969),
pp. 38–9.

38. 'L'impeto è molto più veloce che l'acqua,
perchè molte son le volte, che l'onda fugge il
loco della sua creazione e l'acqua non si move
del sito, a similitudine dell'onde fatte il maggio
nelle biade dal corso de' venti, che si vede
correre l'onde per le campagne, e le biade
non si mutano di lor sito' (MS. F, fol. 87v).

39. C. Leic., fol. 14v.

40. C.A., fol. 354v: 'L'onda dell'impeto alcuna volta
è immobile nella grandissima corrente dell'-
acqua, e alcuna volta è velocissima nell'acqua
immobile, cioè nelle superficie de' paludi.
Perchè una percussione sopra dell'acqua fa più
onde.'

41. MS. H, fols. 36v, 45r; MS. I, fol. 58r; C.A.,
fols. 124r, a; 175r, c, all quoted by F. Arredi,
'Gli Studi,' as quoted above, n. 4.

42. 'L'acqua, che correrà per canale d'eguale lati-
tudine e profondità, fia di più potente per-
cussione nello obbietto che si opporrà nel
traverso mezzo, che vicino alle sue argini. Se
metterai un legno per lo ritto in *f*, l'acqua
percossa in detta opposizione, risalterà poco
fuori della superficie dell'acqua, come appare
nella sperienza *s*; ma se metterai detto legno in
a, l'acqua si leverà assai in alto . . .' (MS. C,
fol. 28v).

43. 'L'acqua torbida fia di molta maggiore per-
cussione nella opposizione del suo corso, che
non fia l'acqua chiara' (MS. C, fol. 28r); see
also C.A., fol. 330v, b: 'Della materia intor-
bidatrice dell'acqua à il suo discenso tanto più
o men veloce, quanto ella è più o men grave.'

44. 'Opera e materia nuova, non più detta'.

a b divide il corso dell'acqua, cioè mezza ne
torna al loco dove la caduta sua percuote, e
mezza ne va innanzi. Ma quella che torna
indietro è tanto più che quella che va innanzi
quanto è l'aria che infra lei si inframmette in
forma di schiuma. Mai li moti revertiginosi
possono essere in contatto l'uno dell'altro, cioè li
moti che si voltano a un medesimo aspetto,
come la volta c d, e la volta p o, perchè quando
la parte di p o si comincia a sommergere colla
parte sua superiore o, ella s'incontrarebbe nella
parte del moto surgente della revoluzione c d,
e per questo si verebbono a scontrare in moti
contrari, per la qual cosa la revoluzione reverti-
ginosa si confonderebbe; ma questi tali moti
revertiginosi sono divisi dall'acqua media mista
colla schiuma che infra esse revertigine
s'inframette, come di sotto in n.m. si dimostra.

quali percussioni d'acque son quelle che non
penetrano le acque da lor percosse'.

45. I cannot stress enough that it is a mere selection
and that I have not even alluded to many other

very persistent preoccupations of Leonardo, e.g., the way one watercourse may influence the direction of another into which it issues, or the relation of speed and deposits. Other problems I have omitted because I failed to catch Leonardo's meaning.

46. Having translated this note in the text, I have ventured to retain it here in the paleographical transcription after K. Clark and C. Pedretti:

'Li moti delle chadute dellacque (*dentr*) poi chella e dentro assuo pelagho sono dj tre spetie (*de*) e acquestj / se ne agiugnie il quarto che e quel dellaria chessi somergie in sie [=insieme] chollacqua e cquesto e il p° inatto effia il p° / che sara djfinjto il 2° fia quello dessa aria somersa el 3° e quel cheffano esse acque refresse poiche / lan rēduta la inpremutata aria allaltra aria laquale poi chettale acqua essurta infigura dj grossi / bollorj acqujsta peso infrallaria e dj quella richade nella superfitie dellacqua penetrēdo (*q*) la insino al fōdo e (*que*) e esso fondo percote e chonsuma il 4° e il moto (*che*) revertiginoso fatto nella pelle del pelagho / dellacqua che ritorna indjrieto allocho della sua chaduta chome (*locho*) sito piu basso che ssinterpong/ha in fra lacqua refressa ellacqua incidēte . agivnjerasi il quīto moto detto moto rivellan/te (*e*) il quale e il moto cheffa lacqua refressa (*ch*) quandella riporta laria che collej si somerse alla su/perfitie dellacqa.

oveduto nelle perchussione delle nave lacqua sotto lacqua osservare piu integral/mente la revolutione delle sue inpressionj chellacha che chōfina chollaria ec / e quessto nascie perche lacqua infrallacqua nō pesa (*chome*) ma pesa lacqua / infrallaria . per la qual chosa . essa acqua che chessimove infrallacqua immobile / tanto a dj potentia quāto ella potentia dellinpeto acquella chongiůtali dal suo / motore il quale se (*stessa*) medesimo consuma cholle predette revolutionj.

ma la parte delacqua inpetu/osa chessitrova infrallaria ellal/tra acqua nō po osservare (*e*) chō / ta tēpo il deto inpeto perche la ponde/rosita la inpedjscie proibendole lagilita / effacilita del moto e per questo nō finjsscie la / intera revolutione.'

47. Cf. the allegorical drawing Windsor 12496 (Popham 125).

48. For some exquisite photographs and instructive diagrams, see Theodor Schwenk, *Sensitive Chaos, The Creation of Flowing Forms in Water and Air* (London, 1965); and also Francis, *op. cit.*, pl. 8.

49. There is a most interesting record of introspection in MS. A, fol. 58*v*, in which Leonardo tries to account for the sensation that water moves more rapidly than it does: 'Perchè il movimento dell'acqua, benchè sia più tardo che quello dell'omo, pare sempre più veloce. La ragione di questo si è, che se tu riguardi il movimento dell'acqua, l'occhio tuo non si puo fermare, ma fa a similitudine delle cose vedute nella tua ombra, quando cammini, che se l'occhio attende a comprendere la qualità dell'ombra, le festuche o altre cose che sono contenute da essa ombra, paiono di veloce moto, e parrà che quelle sieno molto più veloci a fuggire, di detta ombra, che l'ombra a camminare.'

50. Plato, *Timaeus, 79B*. I use the translation by R. G. Bury in the Loeb Classical Library. My attention was drawn to this passage and its implications for Leonardo studies by Sir Karl Popper.

51. MS. F, fol. 27*r* (Richter no. 939).

52. 'Ogni acqua, che per innondazione move la sua superficie per un verso, si move nel suo fondo per contrario corso. Questa ragione si prova in questa forma, cioè: noi vediamo al mare mandare le sue onde inverso la terra, e benchè l'onda che termina colla terra sia l'ultima delle compagne e sia sempre cavalcata e sommersa dalla penultima, non di meno la penultima non passa di là da l'ultima, anzi, si sommerge nel luogo dell'ultima, e sendo così sempre questo sommergimento in continuo moto, dove il mare confina con la terra, è necessario che dopo quello sia un contrario moto in sul fondo del mare, e tanto ne torna di sotto, inverso la cagione del suo movimento, quanto esso motore ne caccia da sè da la parte di sopra' (MS. A, fol. 57*v*). This is one of several passages indicating that Leonardo did not always distinguish clearly between wave motion and flow. It is interesting to note that, according to a recent handbook of oceanography, 'Certain phenomena that appear to be associated with breakers are not yet understood. The existence of undertow has not been satisfactorily explained, and is doubted by some observers' (H. U. Sverdrup, Martin W. Johnson, and R. H. Fleming, *The Oceans* (New York, 1942), p. 537).

53. Del frussi e reflusso del mare e sua varietà. Corre l'onda del fiume contro al suo avvenimento . . . El ritornar dell'onda alla riva . . . (C.A., fol. 281 *r, a*).

54. Aristotle, *Physics*, IV, viii, 215 a. For a full discussion of this theory and the debates on 'impetus' it engendered see A. Maier, *Zwei Grundprobleme der scholastischen Naturphilosophie* (Rome, 1951). I should like to thank Mrs. Anne Harrison for her expert help in revising this all too brief sketch of complex issues.

55. Much of the evidence is assembled in A. Uccelli, *I Libri del Volo di Leonardo da Vinci* (Milan, 1952), pp. 29–32. An additional passage dating from before 1495 is to be found in the Codex Madrid I, 190v.

56. '. . . Essendo adunque quest'aria sospinta, ella ne sospigne e caccia dell'altra e genera dopo sè circolari movimenti, de' quali il peso mosso in essa è sempre centro, a similitudine de' circoli fatti nell'acqua, che si fanno centro del loco percosso dalla pietra, e così, cacciando l'un circolo l'altro, l'aria ch'è dinnanzi al suo motore, tutta per quella linea è preparata a movimento, il quale tanto più cresce, quanto più se l'appressa il peso che la caccia: onde trovando esso peso men resistenza d'aria, con più velocità raddoppia il suo corso a similitudine della barca tirata per l'acqua, la quale si move con difficoltà nel primo moto, benchè il suo motore sia nella più potente forza, e quando essa acqua, con arcuate onde, comincia a pigliare moto, la barca seguitando esso moto, trova poca resistenza, onde si move con più facilità; similmente la ballotta, trovando poca resistenza, seguita il principiato corso, insino a tanto che, abbandonata alquanto dalla prima forza, comincia a debolire e declinare. Onde, mutato corso la preparata fuga fattale dinnanzi dalla fuggente aria, non le servono più, e quanto più declina, più trova varie resistenze d'aria e più si tarda, insino a tanto che ripigliando il moto naturale, si rifà di più velocità. Ora io concludo, per la ragione della ottava proporzione, che quella parte del moto che si trova tra la prima resistenza dell'aria e il principio della sua declinazione, sia di maggiore potenza, e questo è il mezzo del cammino, il quale è fatto per l'aria con retta e diritta linea. E perchè nessun loco può esser vacuo, il loco donde si parte la barca, si vuol richiudere e fa forza, a similitudine de l'osso delle ciliege dalle dita premuto, e però fa forza a preme e caccia la barca' (MS. A, fol. 43v). Mrs. Harrison has traced the end of this passage to Aristotle's *Meteorologica* I. 4, a source known to Leonardo but otherwise ignored.

57. C.A., fol. 168v, b, quoted by Uccelli, *op. cit.*, p. 32.

58. 'Questi 3 navigli, d'eguale larghezza, lunghezza e profondità, essendo mossi da egal potenzie, faran varie velocità di moti, imperocchè il naviglio che manda la sua parte più larga dinanzi è più [ve]loce ed è simile alla figura delli uccelli e de' pesci muggini; e questo tal naviglio apre da lato e dinanzi a sè molta quantità d'acqua, la qual poi colle sue revoluzioni strigne il naviglio dalli due terzi indrieto: e l contrario fa il naviglio *d c*, e l *d* [*=e*] *f* è

mezzano di moto in fra li due predetti' (MS. G, fol. 50v).

59. C. Leic., fol. 29v; see also C.A., fol. 176r, c.

60. Keele, *op. cit.* in note 12 above, pp. 82–3 (after Q. IV, fol. 11v).

61. Windsor 19119 v. cf. Martin Kemp, 'Dissection and Divinity in Leonardo's Late Anatomies', *Journal of the Warburg and Courtauld Institutes*, XXXV, 1972, p. 222.

62. MS. B, fol 50v. cf. Ivor B. Hart, *The World of Leonardo da Vinci* (London, 1961), pp. 304–5.

63. Ash., fol. 4r (Richter 390).

64. La forza è tutta per tutta se medesima, ed è tutta in ogni parte di sé. Forza è una virtù spirituale, una potenza invisibile, la quale è infusa, per accidental violenza, in tutti corpi stanti fori della naturale inclinazione.

Forza non è altro che una virtù spirituale, una potenza invisibile, (infusa) la quale è creata e infusa, per accidental violenza, da corpi sensibili nelli insensibili, dando a essi corpi similitudine di vita; la qual vita è di maravigliosa operazione, constringendo e stramutando di sito e di forma tutte le create cose. Corre con furia a sua disfazione, e vassi diversificando mediante le cagioni. Tardità la fa grande, e prestezza la fa debole. Vive per violenza, e more per libertà. (È atta a) Trasmuta e costringne(re) ogni corpo a mutazione di sito e di forma. Gran potenza le dà gran desiderio di morte. Sca(ch)ccia con furia ciò che s'oppone a sua ruina . . . abita ne' corpi stati fori de lor naturale corso e uso . . . (Ne)ssuna cosa sanza lei si move. (Ne)ssuno sono o voce sanza lei si sente. C. A. 302, a, Richter 1113B. For a related passage from MS. A, fol. 34r see Heydenreich, *op. cit.*, p. 119.

65. MS. A, fol. 55v (Richter 941).

66. It appears that Leonardo had improved on Aristotle's somewhat animistic version of this law by assuming that the varying density of the elements alone caused some to rise and some to seek the bottom, relying again on the 'force' of compression. For this important interpretation and its sources, see F. Arredi, 'Le Origini dell'Idrostatica' (quoted above, note 4), which appeared unfortunately in a very inaccessible periodical. On the page of C.A., fol. 123r, where Leonardo quotes Aristotle's law of maintenance, he also notes: 'La gravità e la forza desidera non essere, e però ciascuna con violenza si mantiene suo essere.'

67. See Kenneth D. Keele, 'Leonardo da Vinci's Physiology of the Senses' as quoted in note 37 above.

68. Or vedi la speranza e'l desiderio del repatriarsi e ritornare nel primo chaos fa a similitudine della farfalla al lume, e l'uomo che con continui

desideri sempre con festa aspetta la nuova primavera, sempre la nuova (e)state, sempre e' nuovi mesi, e nuovi anni, parendogli che le desiderate cose, venendo, sieno troppo tarde, e non s'avede che desidera la sua disfazione; ma questo desiderio è ne quella quintessenza, spirito degli elementi, che trovandosi rinchiusa pro anima dello umano corpo desidera sempre ritornare al suo mandatario; E vo' che sappi che questo medesimo desiderio è quella quintessenza, conpagnia della natura, e l'uomo è modello dello mondo. C.Ar. fol. 156v. Quoted after Richter 1162.

69. 'L'acqua che pel fiume si move, o ell'è chiamata, o ell'è cacciata, o ella si move da sè; s'ella è chiamata, o vo' dire addimandata, quale è esso addimandatore? s'ella è cacciata, che è quel che la caccia? s'ella si move da sè, ella mostra d'avere discorso, il che nelli corpi di continua mutazion di forma è impossibile avere discorso, perchè in tal corpi non è giudizio' (MS. K, fol. 101v).

70. 'L'acqua corrente, ha in sè infiniti moti, maggiori e minori che 'l suo corso principale. Questo si prova per le cose che si sostengano infra le 2 acque, le quali son di peso equale all'acqua, e mostra bene pell'acque chiare il vero moto dell'acqua che le conduce, perchè alcuna volta la caduta dell'onda inverso il fondo le porta con seco alla percussione di tale fondo e refretterebbe con seco alla superficie dell'acqua, se 1 corpo notante fussi sferico: ma ispesse volte nol riporta perchè e' sarà più largo o più stretto per un verso che per l'altro, e la sua inuniformità è percossa dal maggiore lato da una altra onda refressa, la qual va rivolgendo tal mobile il quale tanto si move, quanto ell'è portato, il qual moto è quando veloce e quando tardo, e quando si volta a destra e quando a sinistra, ora in su e ora in giù, rivoltandose e girando in se medesimo ora per un verso e ora per l'altro, obbidendo a tutti i sui motori, e nelle battaglie fatte da tal motori sempre ne va per preda del vincitore' (MS. G, fol. 93r).

71. 'La navication non è scientia, fatta che abbi perfectione perche se così fussi essi si salverebbono da ogni pericolo come fan li uccellij nelle fortune de venti, dell'aria co'venti e i pesci notanti, nelle fortune del mare e diluvii de fiumi, li quali non periscan.' (Windsor, 12666r.)

72. R. Giacomelli, 'La scienza dei venti di Leonardo da Vinci,' in *Atti del Convegno di Studi Vinciani* (Florence, 1953), pp. 374–400. (New edition: *Studi Vinciani* IV, 1954, pp. 140–66.)

73. MS. G, fol. 73v. See also MS. E, fol. 70v: 'L'aria si condensa dinanzi alli corpi che con velocità la penetrano, con tanto maggiore o minore densità, quanto la velocità fia di maggiore o minore furore.'

74. 'Libro, del moto che fa il foco penetrato all'acqua pel fondo della caldara e scorre in bollori alla superficie d'essa acqua per diverse vie, e li moti che fa l'acqua percossa dalla penetrazione d'esso foco. E con questa tale sperienzia potrai investigare li vapori caldi che esalan della terra e passan pell' acqua ritorcendosi perchè l'acqua impedisce il suo moto e poi essi vapori penetran pell'aria con più retto moto. E questo sperimento farai con un vaso quadrato di vetro, tenendo l'occhio tuo circa al mezzo d'una d'esse pariete e nell'acqua bollente con tardo moto potrai mettere alquanti grani di panico, perchè mediante il moto d'essi grani potrai speditamente conoscere il moto dell'acqua che con seco li porta, e di questa tale esperienza potrai investigare molti belli moti che accagiono dell'uno elemento penetra nell'altro' (MS. F, fol. 34v). There is another passage, MS. F, fol. 48r, of somewhat doubtful reading: 'Per fare pelgli [*sic*, perhaps belli] spettacoli d'acqua pannicolata, ponendo molti vari obietti in una corrente bassa eguale e veloce.' The same technique is described, without reference to its aesthetic effect, in C.A., fol. 126v. Prof. Pedretti informs me that the incorrect transcription of a note in the *Quaderni d'Anatomia* (IV., fol. 11v) has so far failed to explain the technique of Leonardo's glass model of the valve of the heart. The note reads as follows: 'fa questsa / prova dj / uetro e / moujci dentro / cise / lo a/cq' e panicho' (Make this trial in the glass [model] and have water and millet move into it). It is exactly the experiment described in MS. F. Prof. Pedretti also tells me that Leonardo's aesthetic intentions at the time of his experiments with 'aqua pannicolata' are shown by his notes and drawings concerning 'mistioni' (MS. F, fols. 42v, 55v, 56v, 73v, 95v; MS. K iii, fol. 115r; C.A., fols. 105v, a, 201v, a), a sort of plastic material imitating semi-precious stones—a frozen image of the movements of liquids: 'uetro pannjchulato damme inventionato' (Windsor, 12667v).

75. 'De Anima. Il moto della terra contro alla terra ricalcando quella, poco li move le parte per cosse.' 'L'acqua percossa dall'acqua, fa circuli dintorno al loco percosso; per lunga distanza la voce infra l'aria; più lunga infra 'l foco; più la mente infra l'universo: ma perchè l'è finita, non si astende infra lo infinito' (MS. H, fol. 67r). Cf. A. Marinoni, 'Leonardo as a Writer', in *Leonardo's Legacy* as cited in note 37 above, p. 61.

76. J. Gantner, *Leonardos Visionen von der Sintflut und vom Untergang der Welt* (Bern, 1958).

77. Cod. Urb., fols. 33*v*–34*r* (McMahon no. 93).

78. Gantner, *op. cit.*, p. 200.

79. Vasari-Milanesi, IV, pp. 376 ff.

80. K. Clark, *Landscape into Art* (London, 1949).

81. Windsor, 12665*v* (Richter 608).

LEONARDO: THE GROTESQUE HEADS

1. There are approximately one hundred such drawings by and after Leonardo in various collections, about half of them in the Royal Library at Windsor Castle. This is the only body of this material which has been fully catalogued and illustrated, in Kenneth Clark, *The Drawings of Leonardo da Vinci in the Collection of his Majesty the King at Windsor Castle* (London, 1935; second edition, revised with the assistance of Carlo Pedretti, London, 1968). There are representative selections in H. Bodmer, *Leonardo* (Klassiker der Kunst) (Stuttgart, 1931) and in A. E. Popham, *The Drawings of Leonardo da Vinci* (London, 1946). The list in Bernard Berenson, *The Drawings of the Florentine Painters* (2nd edition, Chicago, 1938) is professedly incomplete. There is a large collection of reproductions in the Witt Library of the Courtauld Institute of Art in London, and I should like here to repeat my thanks to Professor Peter Murray for making them available to me while he was Witt Librarian. A good many grotesques were photographed in the nineteenth century by Braun and illustrated in early books on Leonardo. There is little unanimity as yet about questions of attribution and dating, which can not be resolved in this chapter. In his monograph of 1946, for instance, A. E. Popham expressed doubts about a number of drawings of this kind at Chatsworth which he acknowledged as authentic in his *Catalogue of Italian Drawings in the Department of Prints and Drawings in the British Museum*, 1950. An important drawing in the Vienna Albertina was dismissed as a copy by A. Stix and L. Fröhlich-Bum, in their Catalogue, vol. III, no. 228, and in J. Schönbrunner and J. Meder, *Handzeichnungen alter Meister aus der Albertina*, vol. V, no. 590, but restored to Leonardo by Otto Kurz in *Old Master Drawings*, XII, 1937/8, p. 32. Some of the dubious drawings from various collections are illustrated in *Mostra di Leonardo* (Novara, 1939).

2. The best bibliographical survey of these early reproductions after Verga's *Bibliografia Vinciana* is to be found in W. R. Juynboll, *Het komische genre in de italiaansche Schilderkunst* (Leiden, 1934), pp. 54–67.

3. Published in Ratisbon by the nephew of Joachim Sandrart, the writer and painter.

4. There are 58 heads in *Recueil de testes de caractère et de charges dessinées par Léonard de Vinci florentin et gravées par le C. de C.* [Comte de Caylus] (Paris, 1730).

5. K. F. Flögel, *Geschichte des Grotesk-Komischen* (1788), ed. Max Bauer (Munich, 1914), provides a great number of horrifying examples.

6. The general vogue of Northern humorous imagery in the Florence of Leonardo's youth was one of the problems that fascinated A. Warburg after he had found the inventory of Careggi. Cf. A. Warburg, *Gesammelte Schriften* (Berlin, 1932), esp. p. 211.

7. Hind, *Early Italian Engraving* (London, 1938), II, 143. The affinity to Leonardo's types is so striking that the possibility should not be excluded that the engraver had got hold of one of Leonardo's drawings, such as our fig. 113. For the flower in the woman's bosom see the drawing at Chatsworth (fig. 152).

8. Cf. W. R. Juynboll, *loc. cit.*, for the earlier literature. After that, L. Baldass, 'Gotik und Renaissance im Werke des Quinten Metsys', *Jahrbuch der kunsthistorischen Sammlungen in Wien*, N.F. VII, 1933, p. 146 f.; and Max J. Friedländer, 'Quentin Massys as a Painter of Genre Pictures', *The Burlington Magazine*, May 1947.

9. It was from this great collector that the Count of Caylus obtained the models for his series (see above Note 4).

10. Vasari-Milanesi IV, p. 26.

11. Berenson, *op. cit.*, vol. II, catalogue 1930, p. 117, under 1050, only mentions this as a 'strong suspicion'.

12. It is only D. Merezhkowski (*Leonardo da Vinci*, Leipzig, 1903) who makes Leonardo 'caricature' Savonarola. The drawing in the Albertina (Fig. 126) is certainly a type, not a portrait.

 The specific mechanism that makes a *caricatura* in the original, Seicento meaning of the term is discussed in a chapter on 'The Principles of Caricature' by E. Kris and myself in E. Kris, *Psychoanalytic Explorations in Art* (New York, 1952), where also a bibliography is given.

13. '*Die echten Blätter zeichnen sich durch köstlichen, zündenden Humor, wie durch vollendete anato-*

mische Durchbildung . . . aus. Keines von ihnen enthält eine Figur, welche den Beschauer durch einen Ausdruck von Niedrigkeit und Albernheit abstösst, und nicht durch irgend eine Eigenschaft unsere Sympathie zu erwecken vermöchte.' Paul Müller-Walde, *Leonardo da Vinci* (Munich, 1889), p. 49.

14. E. Müntz, *Léonard de Vinci* (Paris, 1899), p. 256.

15. E. Wind in *The Listener*, 15th May 1952, speaks of 'Darwinism *avant la lettre.*'

16. H. Klaiber, 'Leonardo da Vinci's Stellung in der Geschichte der Physiognomik und Mimik', *Repertorium für Kunstwissenschaft*, 1905.

17. On occasion of the publication of a drawing, *L'Arte*, xxv, 1922, p. 6.

18. E. Hildebrandt, *Leonardo da Vinci* (Berlin, 1927), p. 317.

19. W. Suida, *Leonardo und sein Kreis* (Munich, 1929), p. 99.

20. L. H. Heydenreich, 'Leonardo da Vinci als Klassiker der Kunst', *Kritische Berichte zur Kunstgeschichtlichen Literatur*, III/IV, 1930/32, p. 174, and the same author's *Leonardo* (Berlin, 1943), pp. 189 f.

21. Cf. H. Klaiber, *loc. cit.* and, for the eighteenth century, E. Kris, 'Die Charakterköpfe des F.X. Messerschmidt' in *Jahrbuch der kunsthistorischen Sammlungen in Wien*, N.F. VI, 1932, see also W. R. Juynboll, *loc. cit.*

22. Pomponius Gauricus, *De Sculptura* (1504), ed. A. Chastel and R. Klein (Geneva, 1969), Chapter III.

23. The comparative lack of expression in the majority of Leonardo's types becomes particularly apparent if one compares them with such eighteenth-century imitations and re-interpretations as *Characaturas by Leonardo da Vinci from Drawings by Winceslaus Hollar out of the Portland Museum* (London, 1786). These versions show an infusion of the spirit of Hogarth and Rowlandson.

23a. Dr. I. Grafe has drawn my attention to the similarity of this passage to Alberti's *De Pictura*, Section 35 (ed. Grayson, p. 72).

24. P. Giovio, 'Dialogus de Viris Litteris Illustribus' in Tiraboschi, *Storia della Letteratura Italiana* (Florence, 18 12),VII, p. 1680. See also p. 119 below and Figs. 227–8.

25. ed. Grayson, Section 55, p. 96.

26. *Historia Naturalis*, xxxv, 89.

27. S. Freud, *Eine Kindheitserinnerung des Leonardo da Vinci* (Vienna, 1910).

28. It can be shown that Freud's image of Leonardo owed more to D. Merezhkowski's biographical novel than to historical research. (Cf. now my review article in *The New York Review of Books*, IV, 1, February 11, 1965, and my paper

on 'Freud's Aesthetics', *Encounter*, January 1966). It is well known by now that Freud was misled by the translation of *nibbio* as 'vulture' instead of 'kite' in Marie Herzfeld's anthology of Leonardo's notes. Had he been even a mediocre historian rather than a great psychologist he would surely not have sought the key to the story about the 'nibbio' in Egyptian myths about vultures but rather in the meaning attached to the kite in the *Fiori di Virtù*, a collection of fables which Leonardo copied out and where the bird signifies envy.

29. I quote from the first edition, 1935, Appendix B.

30. Kenneth Clark, *Leonardo da Vinci* (Cambridge, 1939), pp. 69 f.

31. *Loc. cit.*, p. 101.

32. Similarly M. Johnson 'Leonardo's Fantastic Drawings' in *The Burlington Magazine*, 1942, pp. 141 and 192 f.

33. 'Leonardo's Method for Working out Compositions', *Norm and Form* (London, 1966).

34. See also *Cod. Atl.* 102r, 175r, 206v, 358v.

35. Especially between Windsor 12447 and 12486.

36. They have been restored to their original context through the painstaking research of Carlo Pedretti, *Leonardo da Vinci, Fragments at Windsor Castle from the Codex Atlanticus* (London, 1957); supplemented in *Raccolta Vinciana*, XIX, 1962, pp. 278–82.

37. Carlo Pedretti, 'A new grotesque after Leonardo', *Raccolta Vinciana*, XIX, pp. 283–6. His find neatly confirmed the hypothesis I put forward in the original version of this study.

38. *Mostra di Leonardo* (Novara, 1939), p. 224.

39. e.g. Trivulzio 30r, Windsor 12471, 12475a, 12556, 12586r, 12650v (see also figs. 131, 137).

40. Windsor 12453; 12463; 12468; 12491c; g; 12493a; 12582; S. A. Strong, *Reproductions of Drawings by Old Masters . . . at Chatsworth* (London, 1902) pl. 28a, b; Codice Atlantico, fol. 266r, Ashb. 2037, 10v, and Louvre, Vallardi Collection, *Leonardo Mostra*, 1939, p. 175, are further examples.

41. Cf. L. Baldass, as quoted above, Note 8.

42. In their seemingly compulsive character these physiognomic variations are only surpassed by Leonardo's abstract 'doodles' known as the *Ludi Geometrici*, which cover pages after pages of the Codice Atlantico. These, too, must have their *rationale* in the search for a visual formula which allows its possessors to create diverse equivalents at will and offer another important cue to the workings of Leonardo's mind.

43. Here, as in other instances mentioned, Leonardo seized on an existing tradition. For the idea that every painter paints himself cf. my article 'Botticelli's Mythologies', in *Symbolic Images*. (London 1972), p. 77 and Note

177. For the psychological background of Leonardo's remark cf. E. Kris, *Psychoanalytic Explorations in Art* (New York, 1952), p. 113. It needs no psychological specialist, however, to suspect that Leonardo's remark about falling in love with one's own type is characteristic of what is called 'narcissism'.

44. Illustrated in my *Norm and Form*, fig. 52. The medal was cast to commemorate Cosimo's elevation to the title of *Pater Patriae* after his death. The 'Roman type' selected for his portrayal contrasts with the realistic figure of the old man as he appears in Benozzo Gozzoli's fresco in the Medici chapel. It accords well with the reverse of the medal, which is also an adaptation of Roman reverses. The similarity of Leonardo's favourite type with this Roman profile in Florentine guise accounts for the resemblance of Windsor 12458 to Cosimo, noted by Clark. See now also Hans Ost, *Leonardo-Studien* (Berlin, 1975), pp. 67f.

45. L. Planiscig, *'Leonardos Porträte und Aristoteles'* in *Festschrift für Julius Schlosser* (Vienna, 1927).

46. Similar coin-like heads appear in the Codice Atlantico fol. 324r (not by Leonardo?) and an obvious copy of a coin in the Leonardesque sketchbook attributed to Francesco di Simon in the *British Museum Catalogue*, 57r.

47. L. Beltrami, *'Il volto di Leonardo' Per il IV Centenario della morte di Leonardo da Vinci* (Bergamo, 1919), pp. 75 ff.

48. E. Möller, *'Wie sah Leonardo aus?'*, *Belvedere*, 1926.

49. G. Nicodemi, *'Il volto di Leonardo'*, *Mostra di Leonardo da Vinci in Milano* (Novara, 1939), p. 9.

50. G. Castelfranco, in *Mostra Didattica Leonardesca*, 1952, Section C; and Nicodemi, *loc. cit.*

51. G. Castelfranco, *loc. cit.*, Section XXIV.

52. *Op. cit.*, vol. II, p. 260.

53. *Loc. cit.*, p. 99. Popham, *loc. cit.*, p. 104 calls it a 'gentle' caricature of a Roman general.

54. O. H. Giglioli, *Leonardo* (Florence, 1944).

55. *Loc. cit.*

56. This is also the interpretation now favoured by Kenneth Clark in 'Leonardo and the Antique', *Leonardo's Legacy*, ed. C. D. O'Malley (Berkeley and Los Angeles, 1969), p. 6.

57. Sixten Ringbom, *Icon to Narrative* (Åbo, 1965).

58. See also the drawing of two heads, published by A. Rosenberg, *Old Master Drawings*, March 1939, pl. 60, and illustrated in Tolnay, *op. cit.*, p. 325, 8a.

59. It is copied and adapted in a genre painting attributed to Massys by M. J. Friedländer, *loc. cit.*

60. Transcribed by Richter, *loc. cit.*, vol. II, p. 340, no. 1355.

61. Richter, vol. II, p. 86, no. 797. Referred to by Heydenreich in *Kritische Berichte, loc. cit.*

62. I quote here from the transcript in Richter, *loc. cit.*, vol. II, pp. 292–308, which gives the most accessible conspectus of these inventions. I have also taken the liberty of putting the 'title' or solution of the riddle at the end, the method Leonardo adopted in Arundel 263, which best brings out the character of the prophecies.

63. The (rightly famous) remark of Leonardo's where he refuses to make known his device for sinking ships because of the evil nature of man (Leic. 22b; Richter 1114), must be confronted with such instructions as Cod. B. fol. 69v. *'Da gitare venemo in polvere sulle galee'* (how to throw poison powder onto galleys) to gain an inkling of the tensions that prompted the servant of a Cesare Borgia to buy and liberate cage birds (as Plutarch tells of Pythagoras). For these tensions cf. M. Johnson, *loc. cit.*

64. See my study quoted above, Note 33.

65. For the importance attached by the Renaissance to the 'power of art' over the passions see my *Icones Symbolicae*, now reprinted in *Symbolic Images* (London, 1972), p. 174. One suspects that Leonardo's interest in music may have been connected with this tradition.

66. Kenneth Clark, *Landscape into Art* (London, 1949), p. 47.

BOSCH: THE EARLIEST DESCRIPTION OF THE TRIPTYCH

1. Ludwig Pastor, 'Die Reise des Kardinals Luigi d'Aragona durch Deutschland, die Niederlande, Frankreich und Oberitalien, 1517–1518; beschrieben von Antonio de Beatis' (Freiburg i.B., 1905). (*Erläuterungen und Ergänzungen zu Janssens Geschichte des deutschen Volkes*, iv, 4.) I gratefully remember a series of lectures by Professor Ellis Waterhouse on the patronage of Charles V in which he drew much on this

source and also mentioned the description in question, without, however, drawing the same conclusion.

2. *Loc. cit.*, p. 117.

3. *Loc. cit.*, p. 143.

4. Veddimo anche el palazzo di Monsignor di Nassau, quale è situato in parte montuosa, benchè lui è in piano vicino alla piazza di quello del Re Catholico. Dicto palazzo è assai

grande et bello per lo modo todescho … In quello sono belissime picture, et trale altre uno Hercule con Dehyanira nudi di bona statura, et la historia di Paris con le tre dee perfectissimamente lavorate. Ce son poi alcune tavole de diverse bizzerrie, dove se contrafanno mari, aeri, boschi, campagne et molte altre cose, tali che escono da una cozza marina, altri che cacano grue, donne et homini et bianchi et negri de diversi acti et modi, ucelli, animali de ogni sorte et con molta naturalità, cose tanto piacevoli et fantastiche che ad quelli che non ne hanno cognitione in nullo modo se li potriano ben descrivere. *Loc. cit.*, pp. 64, 116.

5. For documentation see Charles de Tolnay, *Hieronymus Bosch* (Baden Baden, 1965), pp. 360–3. I have reviewed the English edition in the *New York Review of Books*, 23 February 1967, pp. 3–4.

6. First noticed by Dollmayr, cf. de Tolnay, *op. cit.*, *loc. cit.*

7. de Tolnay, *op. cit.*, pp. 391 (no. 15), 321.

8. *Journal of the Warburg and Courtauld Institutes*, XXX, 1967, p. 152.

9. de Tolnay, *op. cit.*, pp. 407 f.

10. E. Münch, *Geschichte des Hauses Nassau-Oranien*, iii (Aachen and Leipzig, 1833), pp. 162–219, deals with Henry III.

11. *Jan Gossaert, genaamd Mabuse*, Catalogue of an Exhibition at the Groeningenmuseum, Brugge, 1965, by H. Pauwels *et al.* I am indebted for this idea to Professor Kurz.

12. Felix Rachfahl, *Wilhelm von Oranien und der Niederländische Aufstand* (Halle a.S., 1906), vol. II, p. 108, a reference likewise due to Professor Kurz.

13. *Loc. cit.*, pp. 116–17. We learn from Dürer's travel diary in the Netherlands (27 August 1520), that he also saw this bed in the house of the Count of Nassau 'in which fifty people might lie'. It apparently impressed him more than the picture by Bosch, for though he mentions the 'good painting' by Master Hugo (van der Goes) in the chapel, was shown 'all the precious things in the house everywhere' and admired the view from the window, there is no reference to our painting.

14. E. Münch, *op. cit.*, p. 214.

15. By Lampsonius on H. Cock's portrait engraving of 1572, possibly inspired by Felipe de Guevara's reference to the *genre* of *grilli* in connexion with Bosch; for this text see de Tolnay, *op. cit.*, p. 401.

16. G. K. Nagler, *Künstler-Lexikon* (Stuttgart, 1835 ff.).

17. For the references, cf. O. Kurz, quoted in note 8 above, p. 154. Despite the evidence de Tolnay still prefers his earlier interpretation.

18. de Tolnay, *op. cit.*, pp. 403–4, the padre speaks of 'the vanishing taste of strawberries … and its fragrance which one can hardly smell ere it passes.'

19. Published by R. Klibansky in Ernst Cassirer, *Individuum und Kosmos in der Philosophie der Renaissance*, *Studien der Bibliothek Warburg* (Leipzig, 1927). I am indebted to Mr. J. B. Trapp for drawing my attention to this analogy.

20. I am greatly indebted to Prof. Xavier de Salas, Director of the Prado, who kindly confirmed this observation and sent a photograph of this detail.

BOSCH: AS IT WAS IN THE DAYS OF NOE

1. For a bibliography up to 1965, see Charles de Tolnay, *Hieronymus Bosch*, English edition (Baden Baden, 1966), pp. 360–3.

2. Tolnay, *op. cit.*, pp. 403–4.

3. *Early Netherlandish Painting* (Cambridge, Mass., 1953), p. 357.

4. Anna Spychalska-Boczkowska, 'Material for the iconography of Hieronymus Bosch's Triptych *The Garden of Delights*', *Studia Muzealne* (Poznán, 1966).

5. See above, pp. 3–6.

6. Migne, *Patrologia Latina* (henceforward abbreviated as P.L.), cxiii, col. 105. So also Rabanus Maurus, *P.L.*, cvii, col. 513.

7. *P.L.*, cxcviii, col. 1082: '*Disperdam eos cum terra, id est cum fertilitate terrae. Tradunt quoque vigorem terrae, et fecunditatem longe inferiorem esse post diluvium, quam ante,*

unde esus carnium homini concessus est, cum antea fructibus terrae victitaret.' The motif of vegetarianism of man before the Flood was not, in all likelihood, prompted by the Biblical passage which is here explained, but by Genesis ix, 3, where God says to Noah after the Flood that 'every moving thing that liveth shall be meat for you'. In discussing the iconography of Bosch's Madrid *Epiphany* in C. S. Singleton (editor), *Interpretation: Theory and Practice* (Baltimore, 1969), I have had occasion to comment on the relevance of the *Historia Scholastica* for Bosch and to point out that the copy of the 1485 edition of that much printed work in the Paris Bibliothèque Nationale comes from the charterhouse of Bois le Duc, Bosch's hometown.

8. St. Augustine, *De Civitate Dei*, *loc. cit.*, xv,

23, cautiously presents the pros and cons of this interpretation. The *Historia Scholastica* (*loc. cit.*, 1081), equally cautiously concedes another possibility: 'potuit etiam esse, ut incubi daemones genuissent gigantes'.

9. *loc. cit.*, xv, 22. In this interpretation the progeny of Seth represents and foreshadows the City of God while Cain's progeny stands for the terrestrial city. The *Historia Scholastica* is again more straightforward: '*filii Dei*, id est Seth, religiosi, *filias hominum* id est de stirpe Cain'.

10. G. K. Hunter, 'Othello and Colour Prejudice', *Proceedings of the British Academy*, liii, 1967, pp. 147–8. Admittedly the author quotes no text from Bosch's age in support of this theory.

11. The belief had little theological sanction, since Cain's descendants must all have perished in the flood. Hence Isaac de la Peyrère argued in 1656 that the Negroes belong to a pre-Adamite race related to Cain (cf. T. F. Gossett, *Race, The History of an Idea in America*, Dallas, 1963, p. 15). But it could also be argued that the curse on Ham for mocking Noah was a renewal or continuation of the curse on Cain (cf. Hunter, *loc. cit.*).

12. The belief in 'antediluvian' monsters of gigantic size is again foreshadowed by St. Augustine, *op. cit.*, xv, 9, who refers to a find he had witnessed of an enormous human molar which must have belonged to a giant before the Flood. But speculations about gigantic antediluvian animals clashed with the Biblical dimensions of Noah's ark, which made it hard enough to accommodate even all the animals of normal size. For these discussions see Don Cameron Allen, *The Legend of Noah* (Urbana, 1949). The development of palaeontology had largely to evade or avoid this problem. Cf. Othenio Abel, *Vorzeitliche Tierreste im deutschen Mythus, Brauchtum und Volksglauben* (Jena, 1939), and W. N. Edwards, *The Early History of Palaeontology* (London, 1967).

13. *Hist. Schol.*, Lib. Genesis xxxi; Migne, *P.L.*, cxcviii, col. 1081: 'Methodius causam diluvii, hominum scilicet peccata, diffusius exsequitur dicens, quia quingentesimo anno primæ chiliadis, id est post primam chiliadem, filii Cain abutebantur uxoribus fratrum suorum nimiis fornicationibus. Sexcentesimo vero anno mulieres in vesania versæ supergressæ viris abutebantur. Mortuo Adam, Seth separavit cognationem suam a cognatione Cain, quæ redierat ad natale solum. Nam et pater vivens prohibuerat ne commiscerentur, et habitavit Seth in quodam monte proximo paradiso. Cain habitavit in campo, ubi fratrem occiderat.

Quingentesimo anno secundæ chiliadis exarserunt homines in alterutrum coeuntes. Septingentesimo anno secundæ chiliadis filii Seth concupierunt filias Cain, et inde orti sunt gigantes. Et incœpta tertia chiliade inundavit diluvium'. One might speculate on the date here assigned to the beginning of mankind's deterioration—the year 1500 after the creation —and the probable date of the painting about 1500 years after the Salvation, but unless this parallelism could be documented from contemporary prognostications it is better regarded as a coincidence.

14. Tolnay, *op. cit.*, p. 397. ('Lost Works by Hieronymus Bosch', no. 8); W. Fraenger, *Die Hochzeit zu Kana: ein Dokument semitischer Gnosis bei Hieronymus Bosch* (Berlin, 1950), p. 97.

15. H. Zimmermann, 'Das Inventar der Prager Kunst und Schatzkammer vom 6. Dezember 1621', *Jahrbuch der kunsthistorischen Sammlungen in Wien*, xxv, 1905, p. xlvii, no. 1287, 'Das unzüchtige leben vor der sündfluth (Cop.) . . . vielleicht A.A.18, Historia mit nacketen leuten, sicut erat in diebus Noë. 1288, Zween altarflüegel, wie die Welt erschaffen'. I am indebted for this reference to Professor Otto Kurz.

16. W. Fraenger, *Das Tausendjährige Reich* (Coburg, 1947), English as *The Millennium of H. Bosch* (London, 1952). His most redoubtable opponent is D. Bax, *Beschrijving en poging tot verklaring van het Tuin der Onkuisheiddrieluik van J. Bosch* (Amsterdam, 1956).

17. This important commentary is to be found in many large editions of the Bible around 1500.

18. *P.L.*, cvii, col. 1079: 'Neque enim quia haec agebant, sed quia his se totos dedendo Dei judicia contemnebant, aqua vel igne perierunt'.

19. The verses under the print read:

Ut quondam tellus rapidis cum mersa procellis
Aequoris insanis convulsaque fluctibus atque
Per medias undas delata est Arca Profundi
Mortales turpi frangebant saecula luxu
Laxantes scelerum passim et constanter
 habenas
Laetaque ad instructas carpentes gaudia
 mensas.

For the drawing cf. *Prisma der Bijbelse Kunst* (Exhib., Prinsenhof, Delft, 1952), p. 43.

20. See note 7 above.

21. See note 16 above.

22. *Jewish Antiquities*, i, 70–71.

23. *P.L.*, cxcviii, col. 1079: 'et quia (Tubal) audierat Adam prophetasse de duobus judiciis, ne periret ars inventa, scripsit eam in duabus columnis, in qualibet totam, ut dicit Josephus, una marmorea, altera latericia, quarum altera

non diluetur diluvio, altera non solveretur incendio'.

24. See Paul E. Beichner, 'The Medieval Representative of Music, Jubal or Tubalcain?', *Texts and Studies in the History of Medieval Education*, ii (Notre-Dame, Indiana, 1954).

25. Rudolf von Ems, *Weltchronik*, ed. Gustav Ehrismann (Berlin, 1915):

> Nu begunde sere
> Ie mere und ie mere
> Wahsin das lút, sin wart vil,
> Alle zit und alle zil
> Leite spate unde frú
> Ir zal mit kraft wahsende zů.
> 'Súnde und súntlicher sin
> Begunde wahsen ouh an in,
> Mit kúnstlichir liste kraft
> W̊hs ouh ir liste meisterschaft
> An manegir kunst mit wisheit.
> 'Nu hat Adam in vor geseit
> Das al dú welt můste zergan
> Mit wazzir und ouh ende han
> Mit fúre: *fúr* die forhte
> Ir kunst mit vlize worhte
> Z̊w súle, der einú ziggelin
> Was und dú ander steinin
> Von marmil, hertir danne ein glas.
> 'Swas kunst von in do fundin was
> Und irdaht, die scribin sie
> An dise selbin súle . . .
> (verses 671–92).

Needless to say I do not suggest that this German text was Bosch's immediate source, but it represents a tradition of rhymed world histories which could only be studied in detail by comparing many unpublished manuscript sources.

26. *P.L.*, xiv, col. 387: 'Itaque caro causa fuit corrumpendae etiam animae quae velut origo et locus est quidam voluptatis, ex qua velut a fonte prorumpunt concupiscentiarum mala-

rumque passionum flumina . . .' An interesting suggestion was made by Nicolas Calas in 1949 in a brief article on the Triptych in *Life* that St. Augustine's *Commentaries to the Psalms* offer further clues to the imagery. The lines from Psalm CXLVIII 'praise the Lord from the earth, ye dragons, and all deeps' are discussed at some length and may throw some further light on the panel depicting hell. The relevance of this source is also stressed by Elena Callas, 'Bosch's 'Garden of Delights' a theological Rebus', *The Art Journal*, XXIX/2, 1969/70, pp. 184–99.

27. Nicholas de Lyra comments on 'Quoniam ipse dixit' . . . 'sicut enim simplici voluntate omnia creavit de nihilo : ita potest in nihilum redigere'.

28. It was with this fragment that W. Fraenger connected the inventory entry mentioned above, in *Die Hochzeit zu Kana* (Berlin, 1950).

29. Otto Kurz, 'Four Tapestries after Hieronymus Bosch', *Journal of the Warburg and Courtauld Institutes*, XXX, 1967. Some evidence for this cutting can even be discerned on the small illustration of his pl. 15a, but in making the comparison for our purpose of reconstructing the amount of painting now missing in the centre of the outer wings not only the reversal of the image in the tapestry must be considered, but also the reversal of the wings when they are closed. It is the motifs on the outer wings adjoining the columns on the tapestry that have to be scrutinized and these show indeed evidence of considerable trimming.

30. The plate in Tolnay, *loc. cit.*, is misleading.

31. In two of Bosch's triptychs, the *Hay Wain* and the Madrid *Epiphany*, the inner wings are framed, but the outsides join up to form a continuous painting.

32. For an important critical development of this interpretation see Bo Lindberg, 'The Fire next Time', *Journal of the Warburg and Courtauld Institutes*, XXXV, 1972, pp. 187–99.

FROM THE REVIVAL OF LETTERS TO THE REFORM OF THE ARTS: NICCOLÒ NICCOLI AND FILIPPO BRUNELLESCHI

* This paper is based on a lecture originally given at the New York Institute of Fine Art in December 1962.

1. *Vorlesungen über die Philosophie der Geschichte* (ed. E. Gans), (Berlin, 1840), pp. 493–6. I have referred to this problem in my inaugural lecture on 'Art and Scholarship' (1957), now reprinted in *Meditations on a Hobby Horse* (London, 1963), pp. 106–19, and more fully in my Deneke Lecture *In Search of Cultural History* (Oxford, 1969).

2. *Architectural Principles in the Age of Humanism*, 2nd ed. (London, 1952).

3. Augusto Campana, 'The Origin of the Word "Humanist"', *Journal of the Warburg and Courtauld Institutes*, IX, 1946, pp. 60–73; P. O. Kristeller, *Studies in Renaissance Thought and Letters* (Rome, 1956), esp. p. 574.

4. Charles Singer, E. J. Holmyard *et al.*, *A History of Technology*, II (Oxford, 1956); III (Oxford, 1957).

5. *The Works of John Ruskin*, ed. E. T. Cook and

A. Wedderburn (London, 1904), XI, p. 69 (*Stones of Venice*, III, ch. I).

6. Hans Baron, *The Crisis of the Early Italian Renaissance* (Princeton, N.J., 1955), and bibliography on p. 444.

7. Giuseppe Zippel, *Nicolò Niccoli* (Florence, 1890). For a sympathetic appraisal of Niccoli's position, see E. Müntz, *Les précurseurs de la Renaissance* (Paris, 1882), and now also George Holmes, *The Florentine Enlightenment* (London, 1969), which draws on the same material as this chapter.

8. Vespasiano da Bisticci, *Vite di Uomini Illustri*, ed. P. d'Ancona and E. Aeschlimann (Milan, 1951), pp. 442–3.

9. *Ed. cit.*, p. 440.

10. For Bruni's dialogues see below. Niccoli is also introduced in the dialogues by Poggio Bracciolini, *An seni uxor sit ducenda, De Nobilitate* and *De infelicitate principum*, in Lorenzo Valla, *De voluptate* and in Giovanni Aretino Medico, *De nobilitate legum aut Medicinae* (first published by E. Garin, Florence, 1947).

11. The most accessible edition (and Italian translation) is in E. Garin, *Prosatori Latini del Quattrocento* (Milan, 1952), pp. 44–99.

12. *Ed. cit.*, pp. 68–70.

13. *Ed. cit.*, p. 74.

14. *Ed. cit.*, pp. 52–6.

15. *Ed. cit.*, p. 60.

16. H. Baron, *op. cit.*, pp. 200–17.

17. *Ed. cit.*, p. 94.

18. For four of them, see below, for the fifth, by Lorenzo di Marco de' Benvenuti, see Hans Baron, *op. cit.*, pp. 409–16. In addition there are Francesco Filelfo's many attacks.

19. *Invettiva contro a cierti caluniatori di Dante, etc.*, in Giovanni da Prato, *Il Paradiso degli Alberti*, ed. A. Wesselofsky, vol. I, pt. 2 (Bologna, 1867), pp. 303–16.

20. Guarino Veronese, *Epistolario*, ed. R. Sabbadini (Venice, 1915), I, pp. 33–46.

21. *Ed. cit.*, p. 36.

22. *Ed. cit.*, p. 37.

23. *Ed. cit.*, p. 38.

24. *Leonardo Bruni Oratio in Nebulonem Maledicum* in G. Zippel, *Niccolò Niccoli* (Florence, 1890), pp. 75–91.

25. *Ed. cit.*, p. 77.

26. *Ed. cit.*, p. 78.

27. *Ed. cit.*, pp. 84–5.

28. B. L. Ullman, *The Humanism of Coluccio Salutati* (Padua, 1963), pp. 108–12.

29. *Op. cit.*, pt. III.

30. *Op. cit.*, esp. pp. 289–90; 2nd ed. (Princeton, 1966), pp. 322–3.

31. Lauro Martines, *The Social World of the Florentine Humanists, 1390–1460* (London, 1963), pp. 161–3.

32. B. L. Ullman, *The Origin and Development of Humanistic Script* (Rome, 1960), pp. 70–1, where more passages on diphthongs are quoted.

33. *Op. cit.*, pp. 25 and 53.

34. *Ed. cit.*, p. 435.

35. *Ed. cit.*, p. 438.

36. This anonymous attack was published by Wesselofsky together with *Il Paradiso degli Alberti*, *ed. cit.*, vol. I, pt. II, pp. 321–30, but does not form part of it.

37. *Ed. cit.*, p. 327.

38. As quoted above note 32.

39. *Op. cit.*, pp. 13–14.

40. *Op. cit.*, p. 18 and fig. 8.

41. *Op. cit.*, pp. 24–5.

42. *Op. cit.*, pp. 86–7.

43. *Italian Illuminated Manuscripts from 1400–1550*, Catalogue of an Exhibition held in the Bodleian Library (Oxford, 1948).

44. MS. Can. Pat. Lat. 138.

45. MS. Can. Pat. Lat. 105.

46. Hans Tietze, 'Romanische Kunst und Renaissance', *Vorträge der Bibliothek Warburg 1926–27* (Berlin, 1930). The point is also discussed *inter alia* by E. Panofsky, *Renaissance and Renaissances in Western Art* (Stockholm, 1960), p. 40, and recently by Eugenio Luporini, *Brunelleschi* (Milan, 1964), esp. notes 31 and 33.

47. 'Similmente la scrittura non sarebbe bella se non quando le lettere sue proportionali in figura et in quantità et in sito et in ordine et in tutti i modi de' uisibili colle quali si congregano con esse tutti le parti diuerse ... *Lorenzo Ghiberti's Denkwürdigkeiten* (I Commentarii), ed. J. v. Schlosser (Berlin, 1912), MS. fol. 25 v. I am indebted for this reference to Mrs. K. Baxandall.

48. Antonio Manetti (attrib.), *Vita di Ser Brunellesco*, ed. E. Toesca (Florence, 1927), 'E nel guardar le scolture, come quello che aveva buono occhio ancora mentale, et avveduto in tutte le cose, vide il modo del murare degli antichi et le loro simetrie, et parvegli conoscere un certo ordine di membri e d'ossa molto evidentemente. ... Fece pensiero di ritrovare el modo de' murari eccellenti e di grand'artificio degli antichi, e le loro proporzioni musicali ...'

49. See above, especially E. Luporini, note *cit*.

50. *Ed. cit.*, p. 441.

51. *Ed. cit.*, pp. 39–40. 'Quis sibi quominus risu dirumpatur abstineat, cum ille ut etiam de architectura rationes explicare credatur, lacertos exerens, antiqua probat aedificia, moenia recenset, iacentium ruinas urbium et "semirutos" fornices, diligenter edisserit quot disiecta gradibus theatra, quot per areas columnae aut

stratae iaceant aut stantes exurgant, quot pedibus basis pateat quot (obeliscorum) vertex emineat. Quantis mortalium pectora tenebris obducuntur!'

52. For an (abbreviated) edition and translation into Italian see E. Garin, *Prosatori Latini del Quattrocento*, pp. 8–36.

53. *Op. cit.*, esp. pp. 81–5; for the question of date B. Ullman, *Salutati*, p. 33, and Baron, 2nd ed., pp. 484–7.

54. 'Quod autem haec urbs romanos habuerit auctores, urgentissimis colligitur coniecturis, stante siquidem fama, quae fit obscurior annis, urbem florentinam opus fuisse romanum: sunt in hac civitate Capitolium, et iuxta Capitolium Forum; est Parlasium sive Circus, est et locus qui Thermae dicitur, est et regio Parionis, est et locus quem Capaciam vocant, est et templum olim Martis insigne quem gentilitas romani generis volebat auctorem; et templum non graeco non tusco more factum, sed plane romano.

'Unum adiungam, licet nunc non extet, aliud originis nostrae signum, quod usque ad tertiam partem quarti decimi saeculi post incarnationem mediatoris Dei et hominum Jesu Christi apud Pontem qui Vetus dicitur, erat equestris statua Martis, quam in memoriam Romani generis iste populus reservabat, quam una cum pontibus tribus rapuit vis aquarum, annis iam completis pridie Nonas Novembrias septuaginta; quam quidem vivunt adhuc plurimi qui viderunt. Restant adhuc arcus aquaeductusque vestigia, more parentum nostrorum, qui talis fabricae machinamentis dulces aquas ad usum omnium deducebant. Quae cum omnia romanae sint res, romana nomina romanique moris imitatio, quis audeat dicere, tam celebris famae stante praesidio, rerum talium auctores alios fuisse quam Romanos? Extant adhuc rotundae turres et portarum monimenta, quae nunc Episcopatui connexa sunt, quae qui Romam viderit non videbit solum, sed iurabit esse romana, non solum qualia sunt Romae moenia, lateria coctilique materia, sed et forma' (*ed. cit.*, pp. 18–20).

55. 'Vedesi questo tempio di singulare belleza e in forma di fabrica antichissima al costume e al modo romano; il quale tritamente raguardato e pensato, si giudicherà per ciascuno non che in Italia ma in tutta cristianità essere opera più notabilissima e singulare. Raguardisi le colonne che dentro vi sono tutte uniforme, colli architravi di finissimi marmi sostenenti con grandissima arte e ingegno tanta graveza quanto è la volta, che di sotto aparisce rendendo il pavimento più ampio e legiadro. Raguardisi i pilastri colle pareti sostenenti la volta di sopra,

colli anditi egregiamente fabricati infra l'una volta e l'altra. Raguardisi il dentro e di fuori tritamente, e giudicherassi architettura utile, dilettevole e perpetua e soluta e perfetta in ogni glorioso e felicissimo secolo' (*ed. cit.*, vol. III, pp. 232–3).

56. *Giovanni Rucellai ed il suo Zibaldone*, ed. A. Perosa (London, 1960), p. 61.

57. For a calendar of dates and documents see Cornelius von Fabriczy, *Filippo Brunelleschi* (Stuttgart, 1892), pp. 609–17, and the same author's 'Il palazzo nuovo della Parte guelfa', *Bullettino dell'Associazione per la difesa di Firenze antica*, IV, June 1904, pp. 39–49.

58. Fabriczy, *Brunelleschi*, p. 559.

59. Gene A. Brucker, *Florentine Politics and Society, 1343–1378* (Princeton, N.J., 1962), pp. 99–100.

60. Fabriczy, *Brunelleschi*, p. 292.

61. H. Baron, *op. cit.*, p. 612, n. 18.

62. A. Chastel, *L'Art Italien* (Paris, 1956), I, p. 191. It appears, however, that this date, which is sometimes found in the literature, is based only on the negative evidence mentioned by Fabriczy in the article quoted under note 57: in the *Protocolli notarili delle provvisioni dei Capitani e Consuli della Parte* of 1418–26 there is a reference under 17th September 1422 to the construction of the palace and to the *Operai* previously appointed to supervise this venture. Since this appointment is not recorded in the volume concerned Fabriczy concluded that it must have been referred to in an earlier (and lost) volume. So far, therefore, we have no means of knowing when the new palace was begun nor can we tell when Brunelleschi was called in.

63. G. Marchini, 'Il Palazzo Datini a Prato', *Bolletino d'Arte*, XLVI, July to September 1961, pp. 216–18.

64. E. H. Gombrich, 'Norma e Forma', *Filosofia*, XIV, July 1963. Now published in English in *Norm and Form* (London, 1966).

65. *Decamerone*, *Giornata VI, Novella 5*.

66. E. H. Gombrich, 'Visual Discovery through Art', *Arts Magazine*, XL, I, November 1965. Now in James Hogg (ed.), *Psychology and the Visual Arts* (Harmondsworth, 1969).

67. 'Quid igitur, si pictor quispiam, cum magnam se habere eius artis scientiam profiteretur, theatrum aliquod pingendum conduceret, deinde magna expectatione hominum facta, qui alterum Apellen aut Zeuxin temporibus suis natum esse crederent, picturae eius aperirentur, liniamentis distortis atque ridicule admodum pictae, nonne is dignus esset quem omnes deriderent?' *Ed. cit.*, p. 72.

68. For a full bibliography see Luporini, *Brunelleschi*, n. 63.

69. E. H. Gombrich, 'The "What" and the "How": Perspective Representation and the phenomenal World' in R. Rudner and I. Scheffler, *Logic and Art, Essays in Honor of Nelson Goodman* (New York, 1972), pp. 129–49.

70. E. H. Gombrich, *Art and Illusion* (New York and London, 1960), chaps. VIII and IX.

71. E. H. Gombrich, 'The Renaissance Concept of Artistic Progress and its Consequences', *Actes du XVII Congrès International d'histoire de l'art*, now reprinted in *Norm and Form* (London, 1966).

THE LEAVEN OF CRITICISM IN RENAISSANCE ART

1. Julius Schlosser Magnino, *La Letteratura Artistica* (Florence, 1956).

2. Michael Baxandall, *Giotto and the Orators* (Oxford, 1971).

3. For this approach, based on the philosophy of K. R. Popper, see my *Art and Illusion* (New York and London, 1960), and 'Visual Discovery through Art,' *The Arts Magazine*, Nov. 1965, reprinted in J. Hogg (ed.), *Psychology and the Visual Arts* (Harmondsworth, 1969), and pp. 35ff. and 109 of this volume.

4. A contribution to the XVIIth International Congress of Art History, Amsterdam, 1952, now reprinted in my *Norm and Form* (London, 1966).

5. Cyril Mango, 'Antique Statuary and the Byzantine Beholder,' *Dumbarton Oaks Papers*, XVII, 1963.

6. 'There is nothing he could not have portrayed so as to deceive the eye.' *Decamerone*, Giornata VI, Novella 5.

7. J. Huizinga, 'Renaissance en Realisme,' *Verzamelde Werken*, IV (Haarlem, 1949), pp. 276 ff.

8. C. Backvis, in *Atti del X Congresso Internazionale delle Scienze Storiche*, Rome, Sept. 4–11, 1955, pp. 536–8. His debating point came out more clearly in the discussion than in the printed version.

9. *Underweysung der Messung* (Nuremberg, 1525), fol. Aib. Quoted after K. Lange and F. Fuhse, *Dürers schriftlicher Nachlass* (Halle a.S., 1893), p. 180. Unless otherwise stated the translations in this study are my own. I have frequently sacrificed readability to accuracy.

10. *Ibid.*, p. 254.

11. *Ibid.*, pp. 342–3. 12. *Ibid.*, p. 288.

13. *Ibid.*, p. 339. 14. *Ibid.*, p. 311.

15. *Ibid.*, p. 316. 16. *Ibid.*, p. 304.

17. *Ibid.*, pp. 229, 289. 18. *Ibid.*, p. 305.

19. S. L. Alpers, '*Ekphrasis* and Aesthetic Attitudes in Vasari's *Lives*,' *Journal of the Warburg and Courtauld Institutes*, XXIII, 1960).

20. Giorgio Vasari, *Le vite de' più eccellenti Pittori, Scultori e Architettori*, ed. G. Milanesi (Florence, 1878–85), I, p. 648.

21. *Ibid.*, II, pp. 563–4.

22. For the bibliography of this problem see E. Panofsky, *Early Netherlandish Painting* (Cambridge, Mass., 1953), I, p. 418.

23. Jakob Burckhardt, 'Die Sammler,' *Beiträge zur Kunstgeschichte von Italien, Gesamtausgabe*, XII (Berlin, 1930), pp. 316, 317.

24. Vespasiano da Bisticci, *Vite di Uomini Illustri*, ed. Paolo d'Ancona and Erhard Aeschlimann (Milan, 1951), p. 209.

25. *Vite*, VII, p. 686.

26. For an important discussion of this problem see James Ackerman in James Ackerman and Rhys Carpenter, *Art and Archaeology* (Englewood Cliffs, 1963), pp. 171 ff. See also my review article 'Evolution in the Arts,' *The British Journal of Aesthetics*, vol. IV, no. 3, July, 1964.

27. *Vite*, III, pp. 683, 690.

28. For Michelangelo's letter of complaint of May, 1518, against Signorelli as a defaulting creditor see G. Milanesi, *Le Lettere di Michelangelo Buonarroti* (Florence, 1875), no. CCCLIV.

29. *Vite*, VII, p. 135.

30. For a brief discussion of these passages see Schlosser, *La Letteratura Artistica*, p. 82.

31. *Vite*, II, p. 413.

32. *Ibid.*, III, pp. 567–8.

33. *Ibid.*, III, pp. 586–7.

34. P. Giovio's biographies are printed in Tiraboschi, *Storia della Letteratura Italiana* (Florence, 1712), VI, p. 116.

35. *Vite*, IV, p. 11.

36. *Cod. Urb.*, ed. A. Philip McMahon (Princeton, 1956), fol. 33v, no. 89.

37. A. Manetti, *Vita di Filippo di Ser Brunellesco*, ed. E. Toesca (Florence, 1926). A translation is in Elizabeth G. Holt, *A Documentary History of Art* (New York, 1957), I, pp. 171–2.

38. Manetti, *Vita di Brunellesco*, p. 16.

39. Quintilian *Inst. Orat. II.* xiii. 10. The identification of Myron's statue in Roman copies only dates from the eighteenth century.

40. For the history of this statue see John Pope-Hennessy, *Italian High Renaissance and Baroque Sculpture* (London, 1963), Catalogue Volume, pp. 63 f.

41. *The Life of Benvenuto Cellini*, trans. Robert H. Hobart Cust (London, 1927), II, pp. 300–2. I have used this translation.

42. *Vite*, VII, p. 680.

43. W. Kallab, *Vasaristudien* (Vienna, 1908).

44. An allusion to the criticism Apelles is reported by Pliny to have made of Protogenes; see p. 17 above.

45. The *Aphrodite anadyomene* by Apelles.

46. Karl Frey, *Der literarische Nachlass Giorgio Vasaris* (Munich, 1923), I, pp. 220–1.

47. *Ibid.*, p. 222.

48. For this concept see Leonardo's *Trattato della Pittura*, ed. cit., f. 13 and 13v.

49. See Paola Barocchi, *Vasari Pittore* (Milan, 1964).

50. *Vite*, VII, pp. 691–2.

51. *Ibid.*, VII, pp. 669–70.

52. *Ibid.*, VII, pp. 665–6.

53. *Ibid.*, IV, p. 376. For a quotation and discussion of this passage see my paper 'Mannerism: The Historiographic Background,' a contribution to the XXth Congress of the History of Art, New York, 1961, now reprinted in *Norm and Form*.

54. *Vite*, VII, p. 657.

55. Pope-Hennessy, *Italian High Renaissance and Baroque Sculpture*, 1963, Catalogue Volume, pp. 82–3.

56. Letter of June 13, 1579, quoted *ibid.*

57. *Vite*, V, p. 284.

58. Marco Boschini, *Le Ricche Minere della Pittura Veneziana* (Venice, 1674), 2d ed., fol. b4–b5.

59. *Vite*, VII, p. 447.

60. Memini virum excellentem ingenio et virtute *Albertum Durerum* pictorem dicere, se iuvenem floridas et maxime varias picturas amasse, seque admiratorem suorum operum valde laetatum esse, contemplantem hanc varietatem in sua aliqua pictura. Postea se senem coepisse intueri naturam, et illius nativam faciem intueri conatum esse, eamque simplicitatem tunc intellexisse summum artis decus esse. Quam cum non prorsus adsequi posset, dicebat se iam non esse admiratorem operum suorum ut olim, sed saepe gemere intuentem suas tabulas, ac cogitantem de infirmitate sua. Letter to Georg von Anhalt, Dec. 17, 1546, in *Philippi Melancthonis Opera*, ed. C. G. Bretschneider (Halle, 1839), VI, p. 322.

61. For a general formulation of this principle see K. R. Popper, *Of Clouds and Clocks*, The Arthur Holly Compton Memorial Lecture (St. Louis, 1966), reprinted in his *Objective Knowledge* (Oxford, 1972).

62. For the fresh problems raised by the application of perspective and the consequent impairment of the compositional pattern see i.a. Otto Pächt, 'Zur deutschen Bildauffassung der Spätgotik und Renaissance,' (originally presented to Fritz Saxl in 1937, *Alte und neue Kunst*, I, 1952), 2, where our fig. 220 is discussed from this point of view; R. W. Valentiner, 'Donatello and the Medieval Front Plane Relief,' *The Art Quarterly*, II, 1939, and in *Studies of Renaissance Sculpture* (London, 1950); my book *The Story of Art* (London, 1950), especially pp. 190–1, and 200–1. For a more detailed and very subtle discussion see John White, *The Birth and Rebirth of Pictorial Space* (London, 1957). For the problem of reconciling conflicting demands see also my papers on 'Raphael's Madonna della Sedia' and 'Norm and Form,' the title essay of the volume cited above. The lecture to the Humanities Seminar at The Johns Hopkins University on which this chapter is based was intended as an introduction to the discussion, in two subsequent lectures, of various examples of such problems and their solutions.

63. For a discussion of this ideal see Craig Hugh Smyth, *Mannerism and Maniera* (New York, 1962), p. 9 and n. 50, giving further literature.

THE PRIDE OF APELLES: VIVES, DÜRER AND BRUEGEL

1. Joannis Ludovici Vivis Valentini *Opera Omnia*, Tomus I (Valencia, 1782), pp. 391–4.

2. It is not mentioned among the 10271 items of Mathias Mende, *Dürer-Bibliographie* (Wiesbaden, 1971) and neither is the only reference in print to this dialogue in connection with Dürer, to which Otto Kurz has kindly drawn my attention, M. de L. (Marques de Lozoya) 'Juan Luis Vives y Alberto Durero', *Archivo Español de Arte*, XIV (1940/41), pp. 42–3.

3. Juan Estelrich, *Vives, Exposition organisée à la Bibliothèque Nationale*, Paris, Janvier–Mars 1941, p. 90.

4. As Marques de Lozoya assumed in the article quoted in note 2.

5. I quote from the translation published by F. Watson under the title *Tudor School Boy Life* (London, 1908), pp. 210–5.

6. *Historia Naturalis* XXXV, 85.

7. Ludwig Münz, *Pieter Bruegel Zeichnungen* (London, 1962), cat. no. 126.

8. Georg Habich, *Die deutschen Medailleurs des XVI. Jahrhunderts* (Halle a.d.S., 1916), p. 82.

9. Heinrich Roettinger, *Erhard Schön und Niklas Stör (Studien zur deutschen Kunstgeschichte 229)* (Strassburg, 1925), no. 280. Henry Meier, 'The aged Dürer, A question of editions', *Bulletin of the New York Public Library* 32 (1928), pp. 490–2.

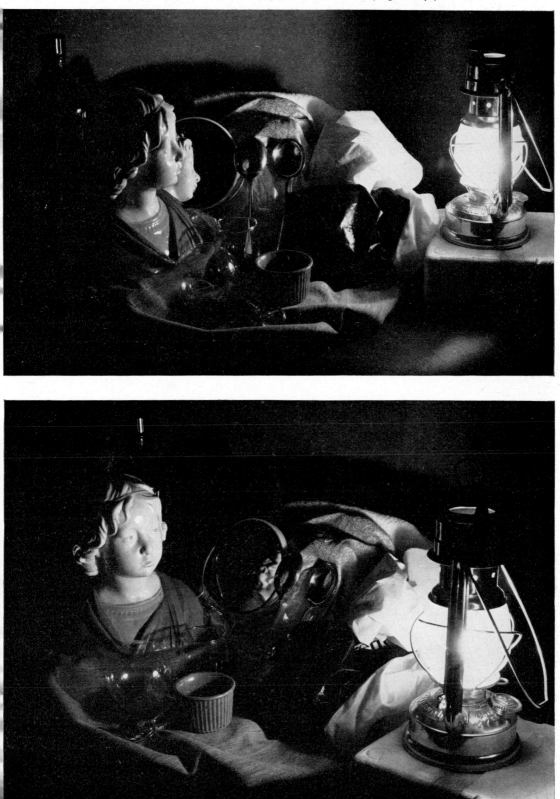

1–2. *Illumination and Reflection:* The light of a lamp falling on variously textured objects.—
The same, photographed from another position to show the effect of curvature on the shift of reflections.
Photos S. G. Parker-Ross, The Warburg Institute

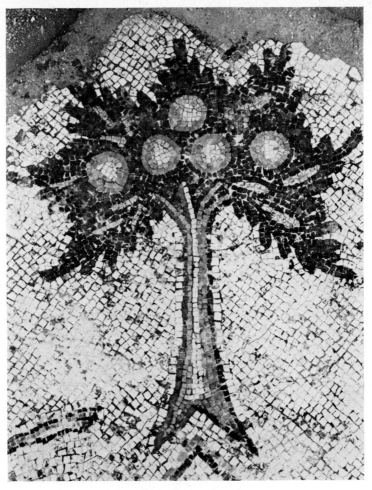

3. *Fruit tree*. Mosaic from Caesarea, Israel. Late sixth century A.D.

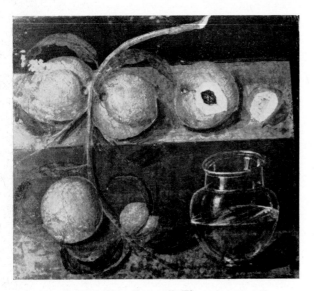

4. *Still life* from Pompeii. First century A.D.
Naples, Museo Nazionale

5. *Still life* from Pompeii. First century A.D.
Naples, Museo Nazionale

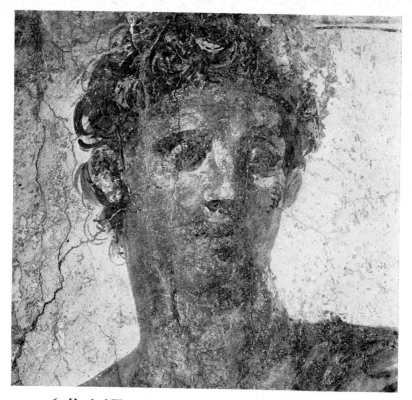

6. *Head of Theseus*. Detail of a painting from Herculaneum.
First century A.D. Naples, Museo Nazionale

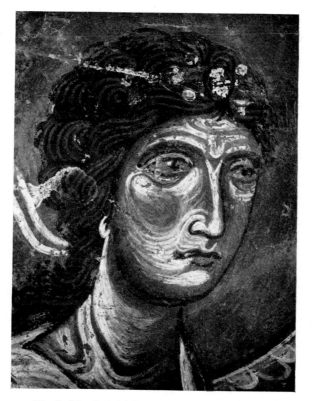

7. *Head of St. Gabriel*. Detail from the murals of Pskov.
Before 1156

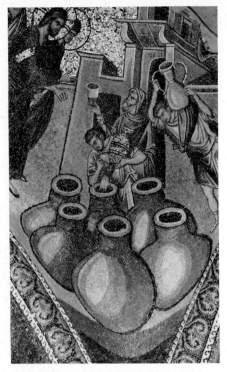

8. Detail of the *Marriage of Cana*.
Mosaic, about 1320, from the Outer
Narthex of the Kariye Djami, Istanbul

9. *The twelve Apostles*. Icon, about 1300. Moscow,
Museum of Fine Art

10. *Traveller and Magician* (?). Mural from the House of the Dioscuri. First century A.D.
Naples, Museo Nazionale

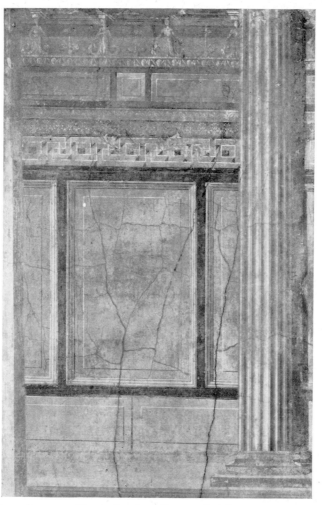

11. Roman wall-painting from Boscoreale. First century B.C.
New York, Metropolitan Museum of Art

12. Trompe-l'œil panel
from the Casa dei Vettii,
Pompeii. First century A.D.

13. *Cupboard*. Detail from the
St. Lawrence mosaic.
Fifth century A.D. Ravenna,
Mausoleum of Galla Placidia

14. *Cupboard*. Detail from the Ezra
miniature in the Codex Amiatinus.
Early eighth century. Florence,
Biblioteca Laurenziana

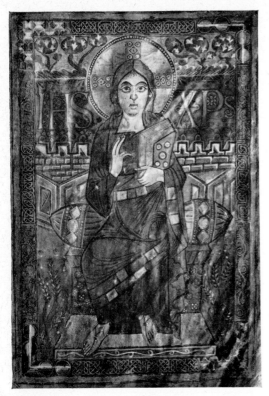

15. *Christ enthroned.*
From the Godescalc Gospels. 781–783. Paris,
Bibliothèque Nationale, Nouv. acqu. Lat. 1203,
fol. 3a

16. *The Heavenly Jerusalem.* Detail.
From a Gospel Book from St.-Médard, Soissons.
Early ninth century. Paris, Bibliothèque Nationale,
Cod. Lat. 8850, fol. 1r

17. Detail of *Rebekah at the Well*,
from the Vienna Genesis.
Sixth century. Vienna,
Nationalbibliothek, Codex Vindob.
theol. Graec. 31, fol. 7

18. *Hannah's Prayer*, from the Paris Psalter. Byzantine,
tenth century. Paris, Bibliothèque Nationale, Cod. Graec. 139

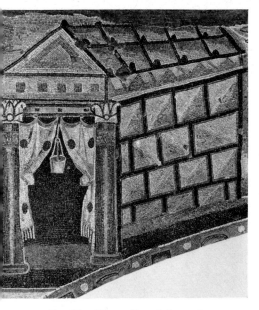

19. *Dwelling House*. Detail from the Triumphal Arch mosaic of Santa Maria Maggiore, Rome. Fifth century.

20. Page from a prayer-book of Otto III. Mainz, eleventh century. Pommersfelden, Codex 2540

22. *The consecration of a Church*. Detail. From an English Pontifical, about 1020. Rouen, Bibliothèque, MS. A27, fol. 2v

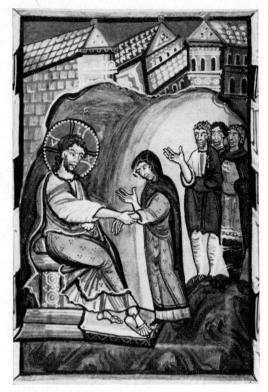

23. *Christt and St. Peter's Mother-in-law.*
From a Cologne MS., first half of the
eleventh century. Darmstadt, Library,
MS. 1640, fol. 77r

24. *The Lamb of the Apocalypse and the Symbols
of the Evangelists.* From the Sacramentary of
Bishop Sigebert. 1022–1036. Berlin (East),
Deutsche Staatsbibliothek, Cod. Theol. Lat. 2, fol. 8

25. Mosaic from Antioch. Second century A.D.

26. Architectural detail from an *Annunciation*. German, second half of tenth century, Würzburg, Universitätsbibliothek

27. Meander from the upper border of a mural. First century B.C. Pompeii, Villa dei Misteri

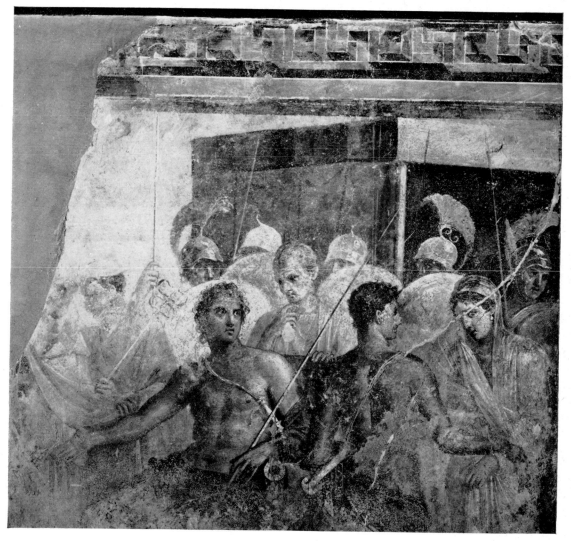

28. *Achilles releasing Briseis*. Mural from the House of the Tragic Poet, Pompeii. First century A.D. Naples, Museo Nazionale

29. Meander from the mosaics of the Mausoleum of Galla Placidia, Ravenna.
Fifth century A.D.

30. Meander from the tapestry of St. Michael. German,
second half of twelfth century. Halberstadt, Cathedral

31. Meander from a mural. Tenth century. Oberzell, Reichenau, Church of St. George

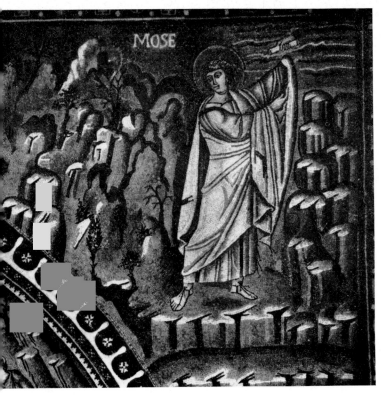

32. *Moses on Mount Sinai*. Mosaic. About 550 A.D. Ravenna, S. Vitale

33. *Landscape mural* from Boscoreale. First century B.C. New York, Metropolitan Museum of Art

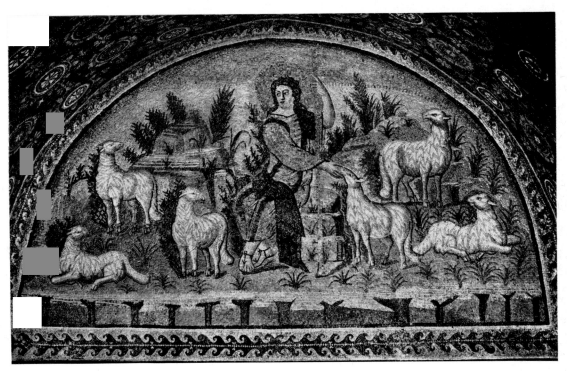

34. *The Good Shepherd*. Fifth century A.D. Mosaic from the Mausoleum of Galla Placidia, Ravenna

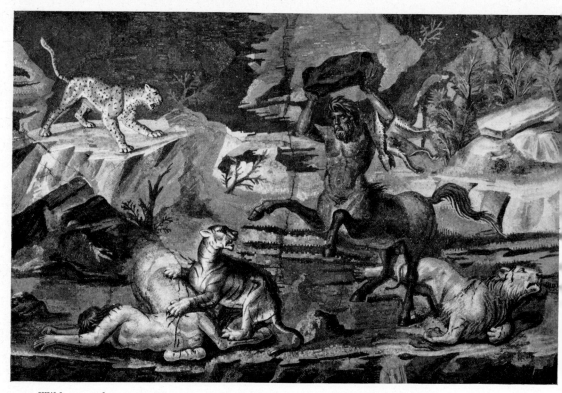

35. *Wild cats and centaurs*. First or second century A.D. Mosaic from the Villa Hadriana. Berlin, Museum

36. Detail of a Pompeian wall decoration.
First century A.D. Naples, Museo Nazionale

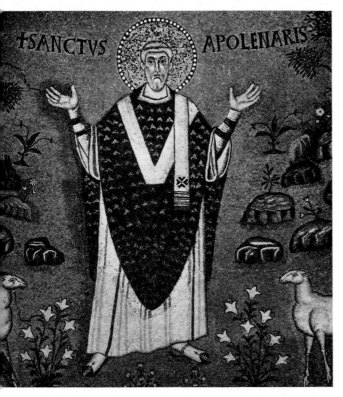

37. St. *Apollinaris*, Apse mosaic. Sixth century. Ravenna, S. Apollinare in Classe

38. Detail from the *Flight into Egypt*. Mosaic. About 1320. Kariye Djami, Istanbul

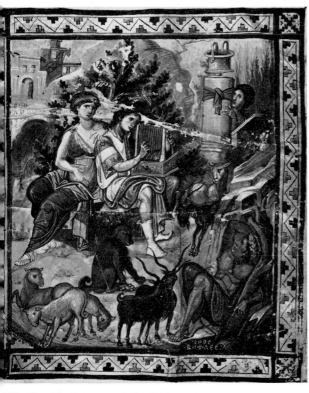

The *David* miniature of the Paris Psalter. Tenth century. Paris, Bibliothèque Nationale, Cod. Graec. 139

40. St. *John the Baptist*. Cretan icon, about 1600. Recklinghausen, Ikonen-Museum

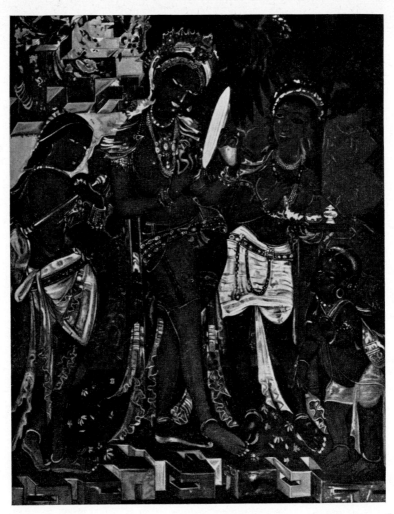

41. *Princess at her toilet in a landscape.* Fifth century A.D. Mural,
Ajanta, Cave 17

42. Meander from a ceiling. Sixth century A.D.
Ajanta, Maharastra Cave I.

43. *Head of the Buddha.* Fifth century A.D.
From a mural at Ajanta, Cave IX

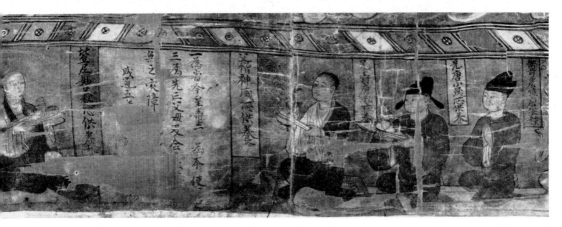

44. Detail from *Four Bodhisattvas*. Painting, dated 864, from Tun-huang, Western China. London, British Museum

45. *Landscape with an iron pagoda.* Japan, eleventh or twelfth century. Osaka, Fujita collection

46. Attributed to Kuo Hsi (eleventh century): *Landscape.* Chicago, Art Institute, Kate S. Buckingham Collection

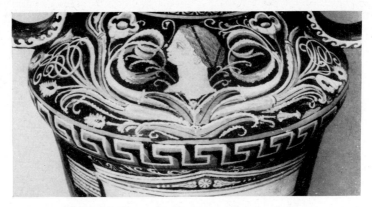

47. Detail of a South Italian vase. Fourth century B.C.
Copenhagen, National Museum, Inv. No. 3408

48. *The Death of Pentheus.* Mural in the House of the Vettii, Pompeii. First century A.D.

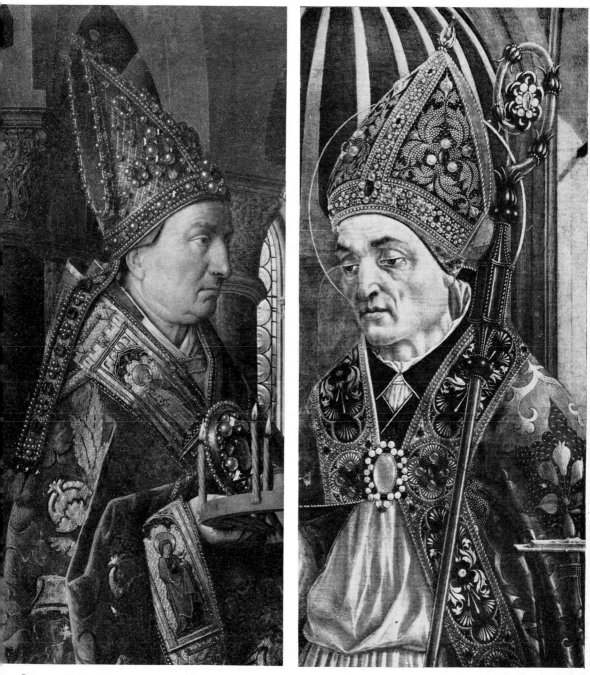

49. Jan van Eyck: *St. Donatian*. Detail of Fig. 51

50. Domenico Veneziano: *St. Zenobius*. Detail of Fig. 52

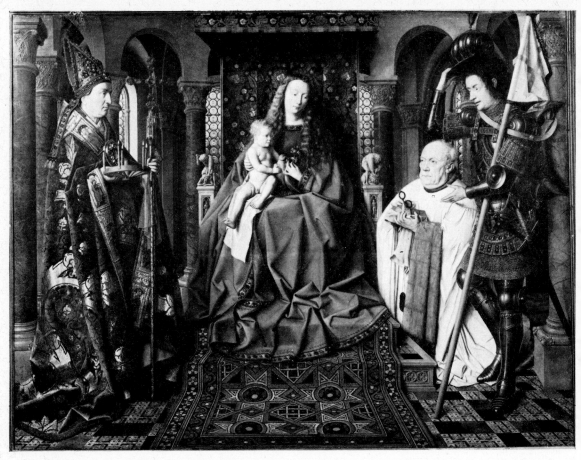

51. Jan van Eyck: *Madonna and Child with St. Donatian, St. George and the Canon van der Paele*. 1436.
Bruges, Museum

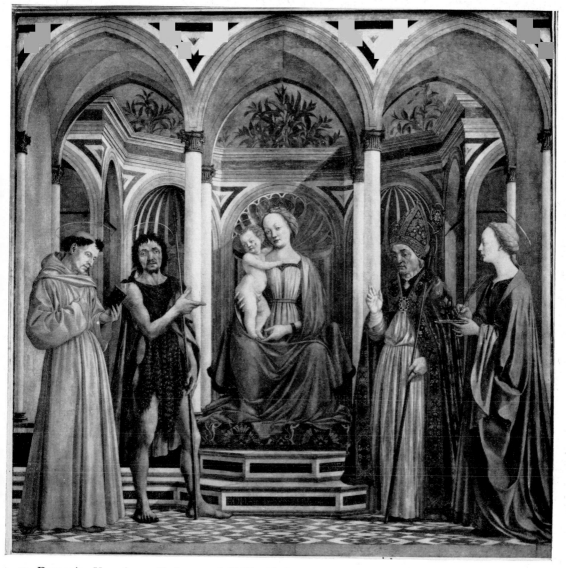

52. Domenico Veneziano: *Madonna and Child with Saints Francis, John the Baptist, Zenobius and Lucy.*
About 1445. Florence, Uffizi

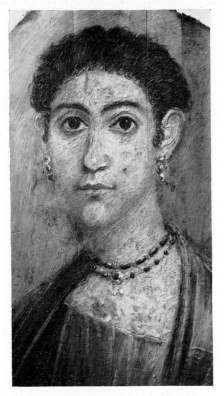

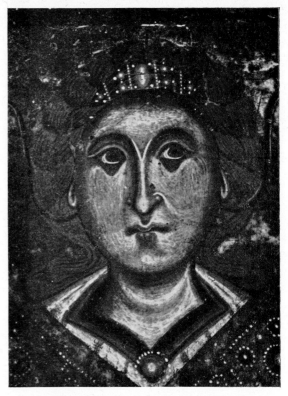

53. Graeco-Egyptian portrait
from Hawara. Second century A.D.
London, British Museum

54. Tuscan master: *Head of St. Michael*.
Thirteenth century. Vico l'Abate

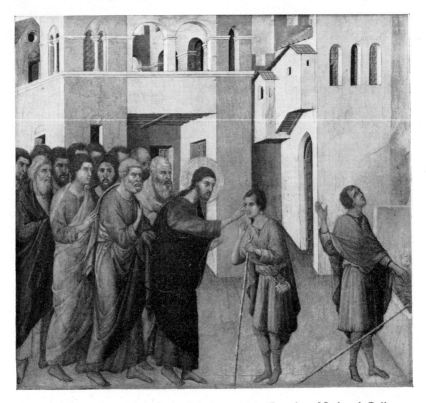

55. Duccio: *The Healing of the Blind*. 1308–11. London, National Gallery

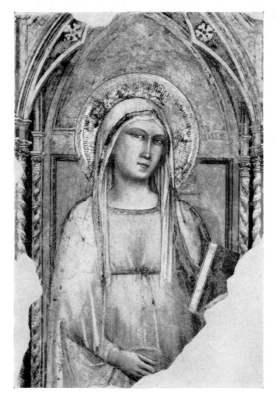

56. Taddeo Gaddi: *Madonna del Parto*.
About 1350. From S. Francesco di Paola,
Florence

57. Tuscan master: *Standing Evangelist*.
Drawing, about 1430. London,
British Museum

58. Lorenzo di Bicci (1350–1427):
Madonna Enthroned. Sinopia of fresco
from Via Aretina, Florence

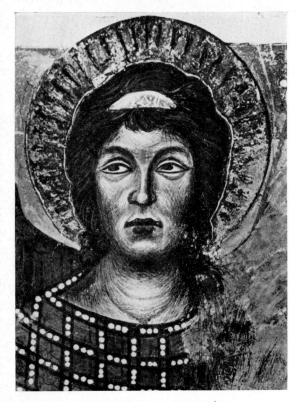

59. Attributed to Cimabue: *Angel*. About 1290.
Assisi, S. Francesco

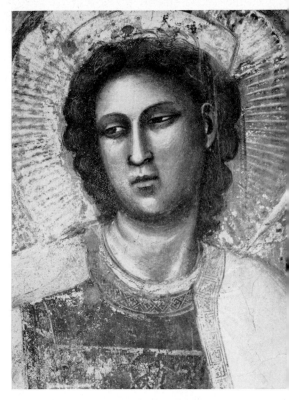

60. Giotto: *Head of the Virgin*. Detail from
The Last Judgement. About 1306. Padua,
Arena Chapel

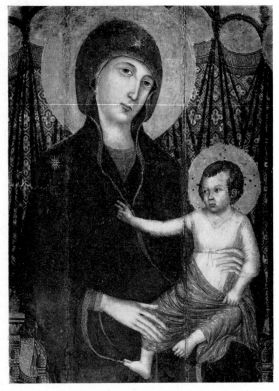

61. Duccio: *Madonna Rucellai*. Detail. After 1285.
Florence, Uffizi

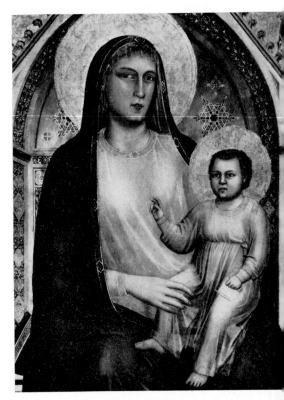

62. Giotto: *Ognissanti Madonna*. Detail.
About 1305–10. Florence, Uffizi

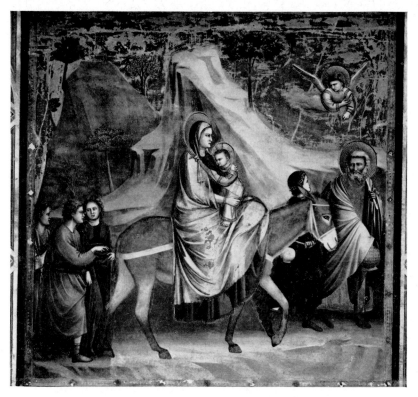

63. Giotto: *The Flight into Egypt*. About 1306. Padua, Arena Chapel

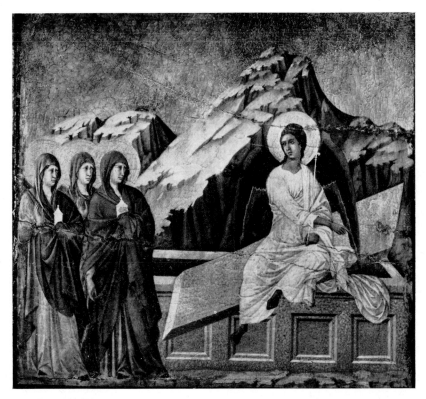

64. Duccio: *The Three Maries at the Tomb*. 1308–11. Siena, Opera del Duomo

65. Agnolo Gaddi: *The Evangelist Mark*. About 1390.
Florence, S. Croce

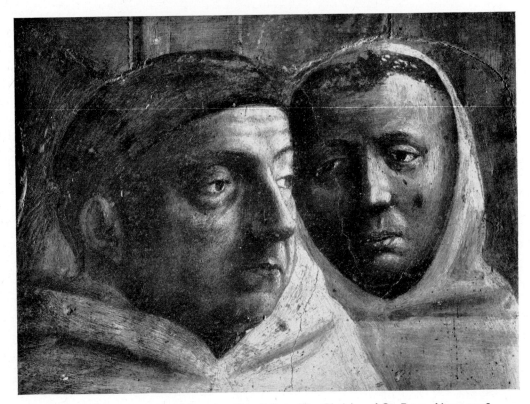

66a. Masaccio: *Heads of Bystanders*. Detail from *The Chairing of St. Peter*. About 1428.
Florence, S. Maria del Carmine, Brancacci Chapel

66b. Masaccio: *St. Peter healing the Sick with his shadow* (detail). 1425–7.
Florence, S. Maria del Carmine, Brancacci Chapel

67. Michele and Giovanni Spagnolo: Marquetry from choir stalls. Second half of the fifteenth century.
Pisa, Cathedral

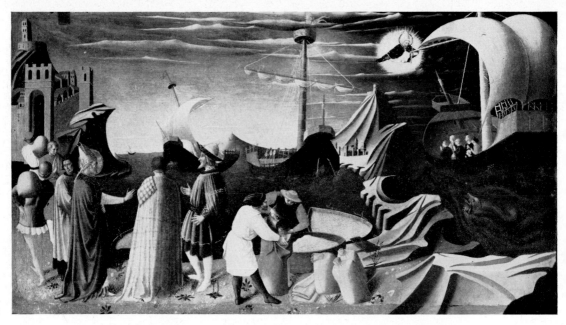

68. Fra Angelico: *Scenes from the Life of St. Nicholas.* 1437. Rome, Vatican Gallery

69. Melchior Broederlam: *The Annunciation and the Visitation.*
About 1400. Dijon, Musée des Beaux-Arts

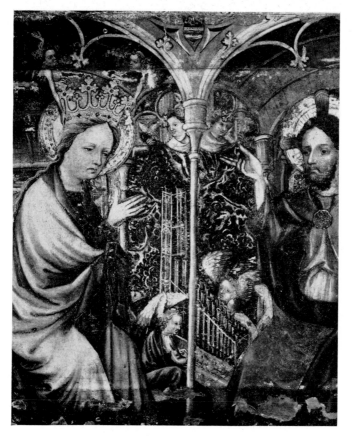

70. Brabantine master: *The Coronation of the Virgin.*
About 1400. Brussels, Musée Royal

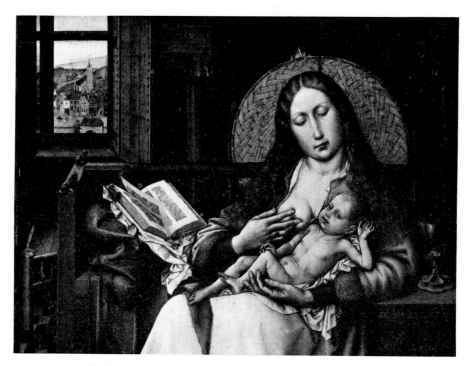

71. Robert Campin: *Virgin and Child before a Firescreen.* Detail.
Before 1430. London, National Gallery

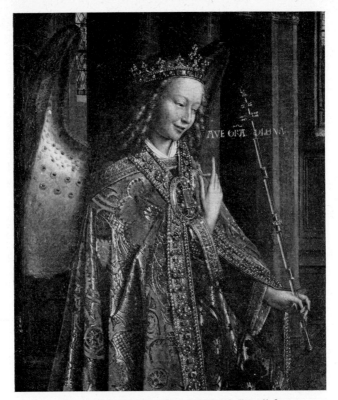

72. Jan van Eyck: *The Angel Gabriel*. Detail from
The Annunciation. About 1434. Washington,
National Gallery of Art, Mellon Collection

73. Jan van Eyck: Detail from the Ghent Altar. 1432.
Ghent, St. Bavo

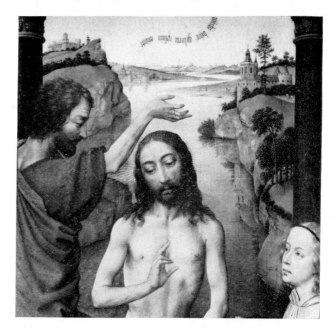

74. Melchior Broederlam:
Detail from the *Visitation* (Fig. 69).
About 1400. Dijon, Musée
des Beaux-Arts

75. Rogier van der Weyden: Detail from
The Baptism of Christ. Probably after 1450.
Berlin-Dahlem, Staatliche Museen

76. Leonardo da Vinci: Detail from *Ginevra de' Benci*. 1474.
Washington, National Gallery of Art

77. Leonardo da Vinci: *Landscape*. Drawing, 1473. Florence, Uffizi

78. Jan van Eyck: *The Stigmatization of St. Francis*. About 1438. Philadelphia,
Museum of Art, Johnson Collection

79. Leonardo da Vinci: *Rocks*. Drawing, about 1494.
Windsor, Royal Library, 12395

80. Leonardo da Vinci: *Mountain range*. Drawing, 1511. Windsor, Royal Library, 12410

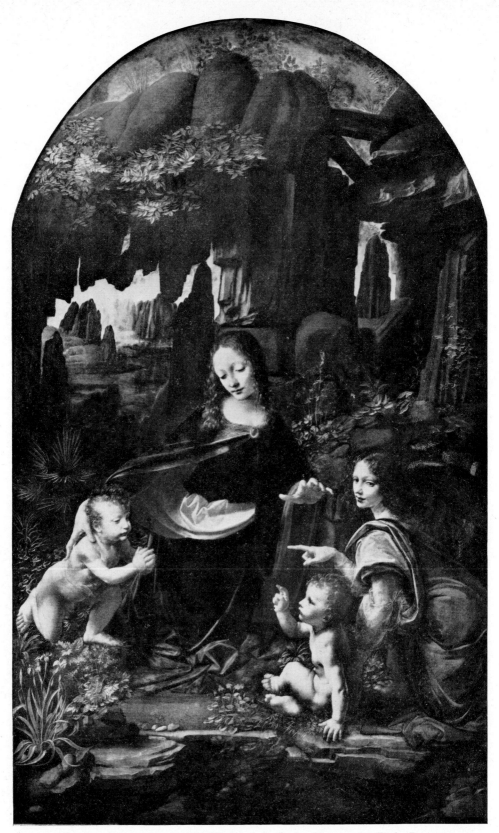

81. Leonardo da Vinci: *The Virgin of the Rocks*. About 1482. Paris, Louvre

82. *Impact of water on water.* 1507–9. Windsor, Royal Library, 12660*v*

LEONARDO DA VINCI

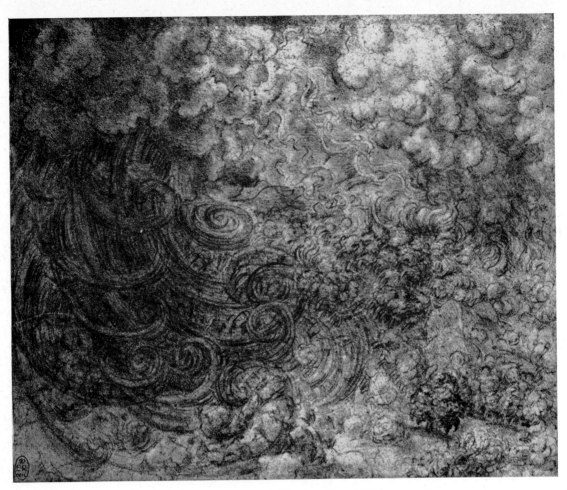

83. *Deluge*. About 1512–16. Windsor, Royal Library, 12384

84. *Sketch of a waterfall*. About 1492. Paris, MS. A, fol. 59v

LEONARDO DA VINCI

85. *Sketch of a waterfall.* About 1507–10. Windsor, Royal Library, 12659r

86. *Movement of water.* About 1501–9. Paris, MS. F, fol. 20v

87. *Movement of water.* About 1490. Paris, MS. C, fol. 26r

LEONARDO DA VINCI

88. *Movement of water*. About 1492. Paris, MS. A, fol. 24v

89. *Movement of
About 1508–9. I
MS. F, fol. 9

90. *Diagram of oil on water.* About 1508–9. Paris, MS. C, fol. 23v

91. *Diagram of rebound of water.* About 1492. Paris, MS. A, fol. 63v

93. *Diagram of the law of rebound.* About 1492. Paris, MS. A, fol. 24r

92. *Diagram of erosion by water.* About 1508–9. Paris, MS. C, fol. 23v

94. *Vortices of water turning back.* About 1492. Paris, MS. A, fol. 60v

LEONARDO DA VINCI

95. *Waterfall and corkscrew waves.* About 1507–10. Windsor, Royal Library, 12663r

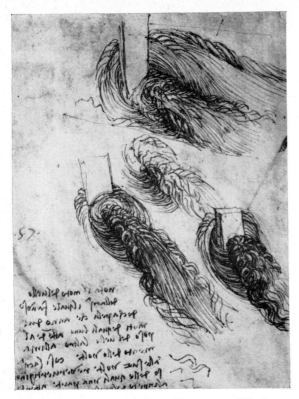

96. *Curls and waves of water*. About 1513. Windsor,
Royal Library, 12579r

97. *Diagram of eddies*. About 1493–4. Paris,
MS. H, fol. 64 (16n)

LEONARDO DA VINCI

98. Modern representation of flow behind
cylinder

99. Photograph of movement of water

100. Representation of the theory of the tides. 1516–17. Codex Atlanticus, fol. 281r.*a*

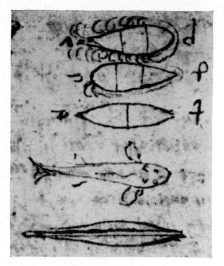

101. *Shapes of fishes and boats.* 1510–15.
Paris, MS. G, fol. 50v

103. *Elasticity of drapery.*
About 1492. Paris, MS. A,
fol. 4r

102. *A spring lock.* About 1500.
Codex Atlanticus, fol. 56v.b

LEONARDO DA VINCI

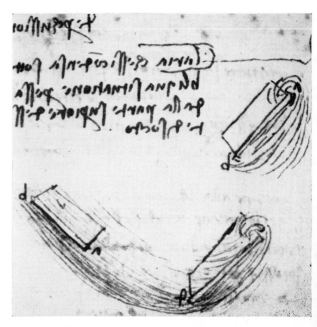

104. *Compression of air under bird's wings.*
1513–14. Paris, MS. E, fol. 47v

105. *Diagram of the compressibility of air.* 1513–14.
Paris, MS. E, fol. 70v

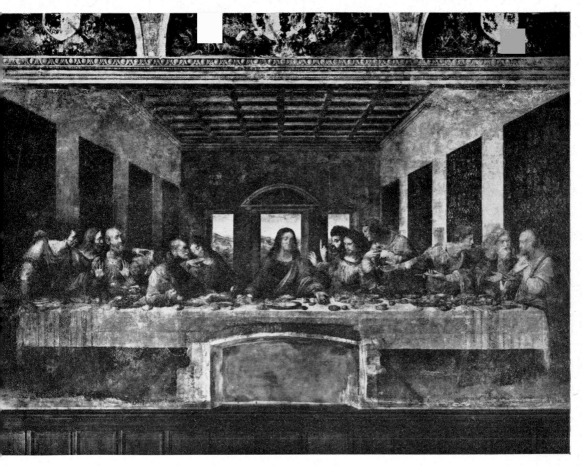

106. Leonardo da Vinci: *The Last Supper*. 1497. Milan, S. Maria delle Grazie

107. Leonardo da Vinci: *Deluge*. About 1512–16. Windsor, Royal Library, 12378

108. Michelangelo: *The Deluge*. Ceiling fresco, 1508–12. Rome, Vatican, Sistine Chapel

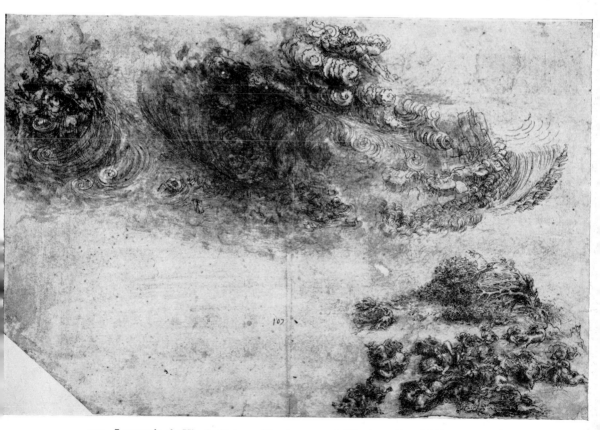

109. Leonardo da Vinci: *Deluge*. About 1512–16. Windsor, Royal Library, 12376

110. Giulio Romano: *Sala dei Giganti*. 1532. Mantua, Palazzo del Te

111. *Grotesque couple.* Florentine engraving,
about 1465–80. London, British Museum

113. *Grotesque couple.* About 1485.
Windsor, Royal Library, 12453r

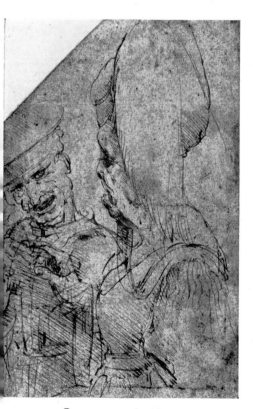

112. *Grotesque couple.* About 1490.
Windsor, Royal Library, 12449 (detail)

114. *Old woman.* 1490–3. London, Victoria and Albert
Museum, Codex Forster III, fol. 72r

DRAWINGS BY LEONARDO (Figs. 112-114)

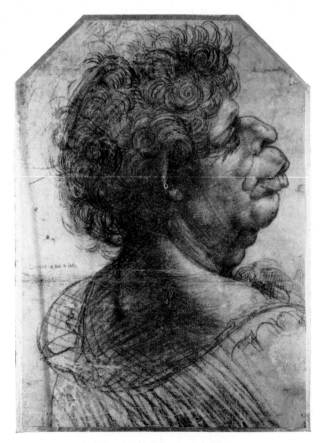

115. Scribbled heads. 1489. Milan, Castello Sforzesco, Codice Trivulziano

116. 'Scaramuccia'. 1503–4. Oxford,
Christ Church Library

DRAWINGS BY LEONARDO

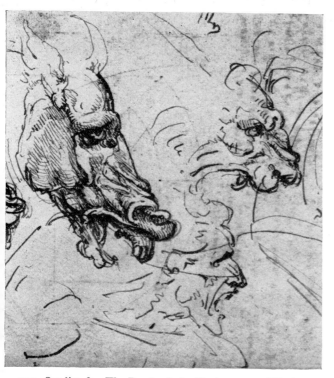

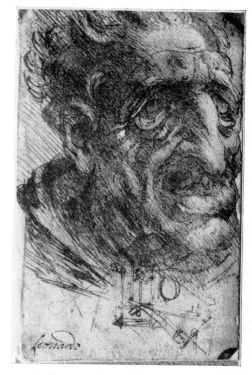

117. Studies for *The Battle of Anghiari*. 1503–4. Windsor, Royal Library, 12326r (detail)

118. *Grotesque head*. About 1495. Venice, Accademia

DRAWINGS BY LEONARDO

119. Bernardino Luini(?): *Salome with the head of St. John the Baptist*. About 1525. Vienna, Kunsthistorisches Museum

120. *Profile of a beautiful youth.* 1478–80.
Windsor, Royal Library, 12276*r* (detail)

121. *Profile of a beautiful youth.* About 1513.
Windsor, Royal Library, 19093*r* (detail)

DRAWINGS BY LEONARDO

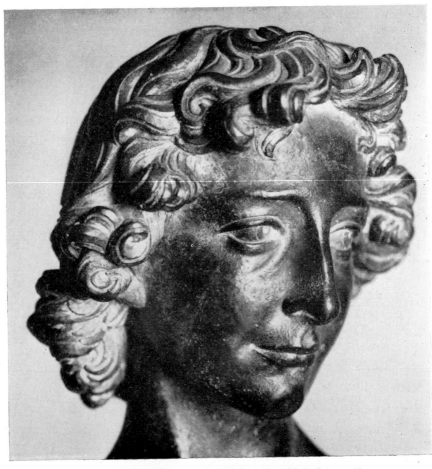

122. Andrea del Verrocchio: *Head of David.* Before 1478.
Florence, Museo Nazionale

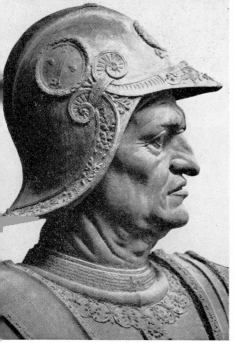

123. Andrea del Verrocchio:
Head of Colleoni. About 1488. Venice,
Campo SS. Giovanni e Paolo

124. Leonardo: *Profile of a warrior*. Detail. About 1480.
London, British Museum

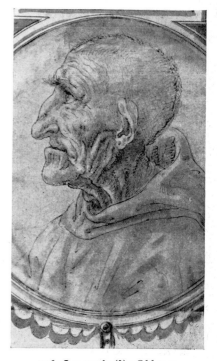

125. Leonardo: *Two profiles*. 1478. Florence, Uffizi

126. Leonardo (?): *Old man,*
sometimes called Savonarola.
Detail of a drawing. Vienna,
Albertina

129. *Profile doodle.* About 1508, Windsor,
Royal Library, 12586v (detail)

130. *Profile.* About 1505-8. Codice Atlantico,
fol. 224v (detail)

131. *Nutcracker profile.* About 1487. Codice
Atlantico, fol. 266r (detail)

132. *Profile doodle.* About 1500-5. Codice
Atlantico, fol. 299r (detail)

127. *Profile* on a sheet of geometrical drawings. 1508-13.
Windsor, Royal Library, 19121v (detail)

129

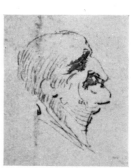

130

128. *Profile* on a sheet of architectural
drawings. About 1517. London,
British Museum, Codex Arundel 263,
fol. 270v (detail)

131

132

133. *Profile.* About 1478. Codice
Atlantico, fol. 320v (detail)

134. *Man and dragon-fly.* About
1489. Paris, Codex Ashburnham
2037, fol. 10v

135. *Omo salvatico.* About 1500.
Codice Atlantico, fol. 194r (detail)

136. Francesco Melzi: Copy of
Fig. 135. Amsterdam, Rijksmuseum

137. *Profile head of a lion.* About
1508. Windsor, Royal Library,
12586r (detail)

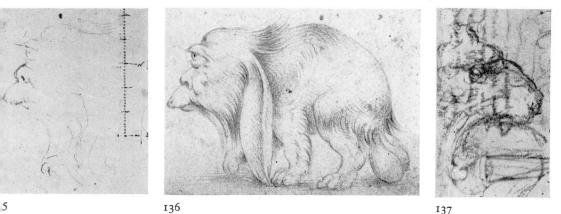

5 136 137

DRAWINGS BY LEONARDO (Figs. 127-135, 137, 138) AND AFTER LEONARDO (Fig. 136)

138. *Profiles* on a sheet of geometrical drawings. About 1510. Windsor, Royal Library, 12669r (detail)

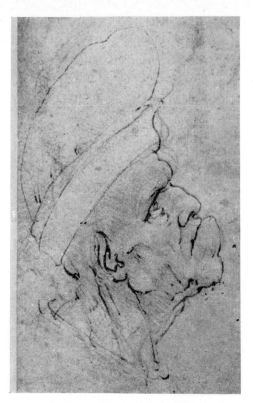

141. After Leonardo:
Profile. Vienna, Albertina

139. *Profile*. About 1485.
Windsor, Royal Library,
12462r

140. *Profile*, overdrawn by another hand.
About 1480. Windsor, Royal Library, 12448

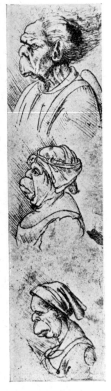

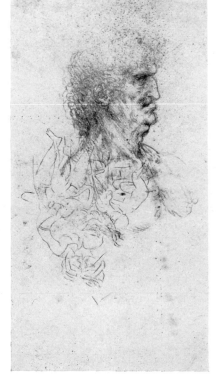

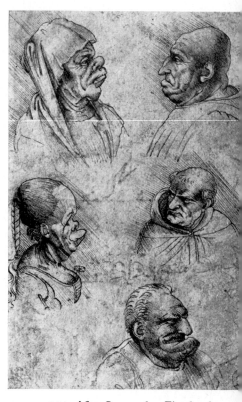

142. After Leonardo
Three profiles. Paris,
Louvre, Vallardi
Collection

143. *Profile*. About 1505. London,
British Museum

144. After Leonardo: *Five heads*.
Venice, Accademia

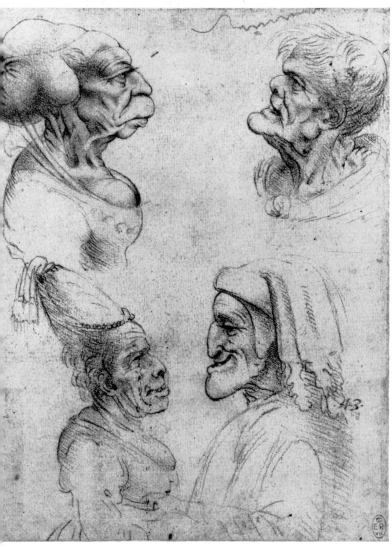

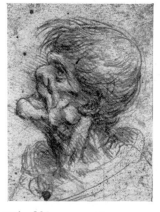

146. *Old woman.* About 1492.
Hamburg, Kunsthalle

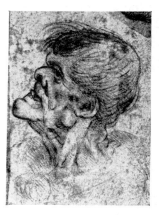

147. After Leonardo:
Old woman. Milan,
Ambrosiana

145. Francesco Melzi (?): *Four heads.* Copies after Leonardo. Windsor,
Royal Library, 12493

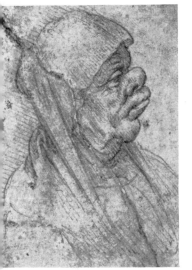

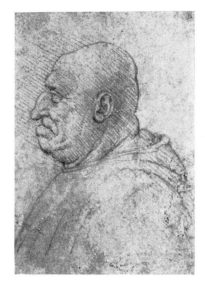

148-9. Leonardo (?):
Two heads. London,
British Museum

DRAWINGS BY LEONARDO
(Fig. 146) AND
AFTER LEONARDO (?)
(Figs. 145, 147-149)

150. *Half-length profile* on a sheet of geometrical and other studies. About 1490. Windsor, Royal Library, 12283r (detail)

151. *Half-length profile* on a sheet of mechanical and figure studies. About 1505. Windsor, Royal Library, 12328r (detail)

DRAWINGS BY LEONARDO

152. Leonardo (?): *Old woman*. Chatsworth,
Devonshire Collection

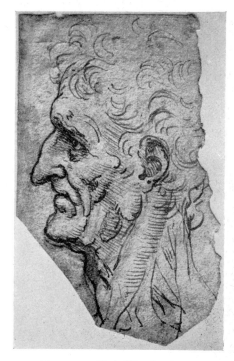

153. Francesco Melzi(?) after Leonardo:
Old man. Windsor, Royal Library, 12475*a*

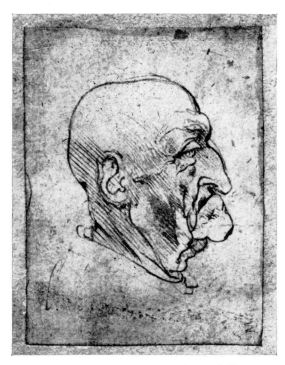

154. After Leonardo(?): *Old man*. Milan,
Ambrosiana

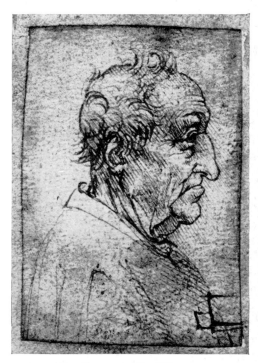

155. After Leonardo(?): *Old man*. Milan,
Ambrosiana

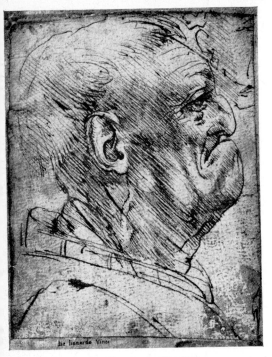

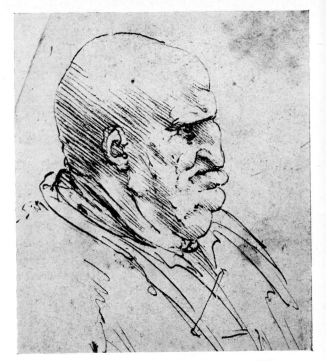

156. After Leonardo (?): *Old man.*
Milan, Ambrosiana

157. *Old man.* About 1495. Windsor, Royal Library,
12489r (detail)

DRAWINGS BY LEONARDO
(Figs. 157-160) AND AFTER
LEONARDO (Fig. 156)

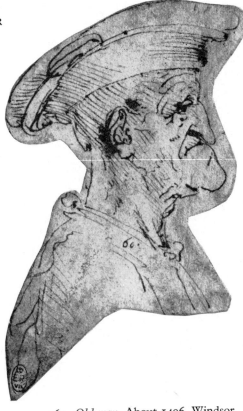

158. *Old man.* About 1481–90.
Windsor, Royal Library, 12454

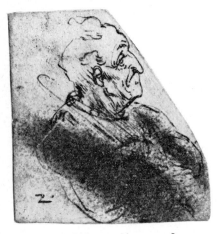

159. *Old man.* About 1478.
Windsor, Royal Library, 12464

160. *Old man.* About 1496. Windsor,
Royal Library, 12475r

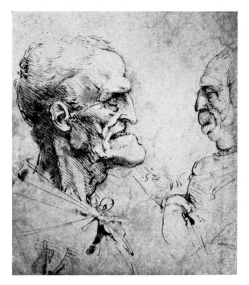

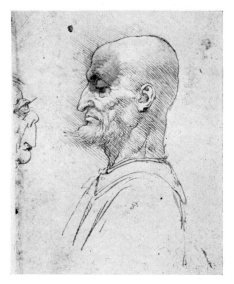

161. *Two old men.* About 1490. Windsor,
Royal Library, 12490

162. *Two old men.* About 1492. Windsor,
Royal Library, 12555*v* (detail)

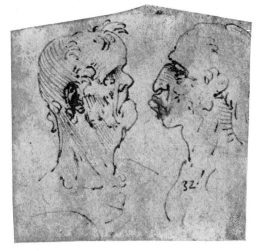

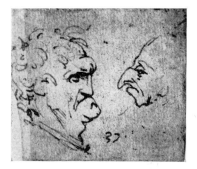

164. *Two old men.* About
1487–90. Windsor,
Royal Library, 12474

163. *Two old men.* About 1485.
Windsor, Royal Library, 12463

DRAWINGS BY LEONARDO

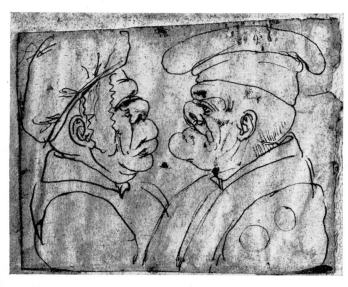

165. Leonardo(?): *Two old men.*
Milan, Ambrosiana

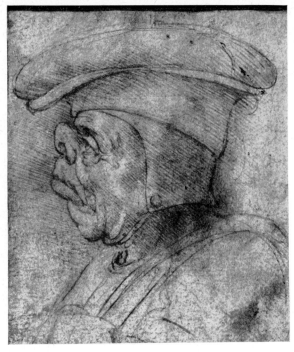

166 Leonardo (?): *Old man*. Milan, Ambrosiana

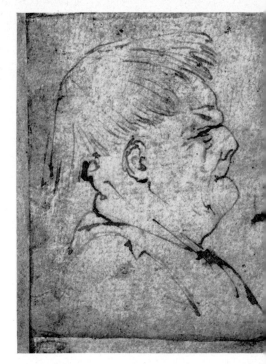

167. Leonardo (?): *Old man*. Milan, Ambrosiana
181. *An Apostle*. About 1490–7. Windsor,
Royal Library, 12548

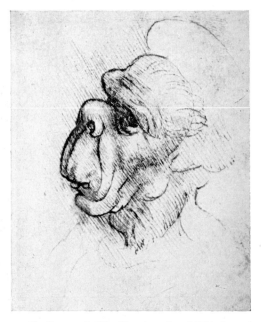

168. Leonardo(?): *Grotesque head*. Windsor,
Royal Library, 12491 (detail)

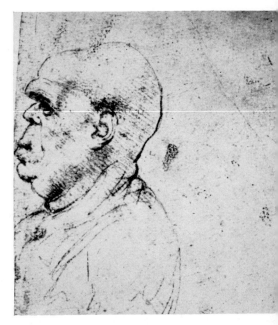

169. Leonardo: *Old man*. About 1500,
Rome, Biblioteca Corsini

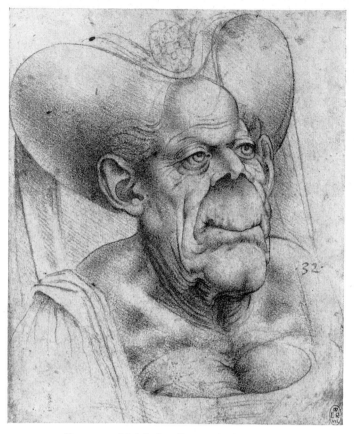

170. Francesco Melzi after Leonardo (of about 1492):
Grotesque head. Windsor, Royal Library, 12492

171. John Tenniel: *The Duchess holding the Baby, with Alice,
the Cook and the Cheshire Cat*, from the illustrations
to Lewis Carroll's *Alice's Adventures in Wonderland*,
London, 1865

172. Leonardo: *Old man*. About 1508 ? Windsor, Royal Library, 12642v (detail)
173. Aes of Galba. London, British Museum
174. Sestertius of Nero. London, British Museum
175. Leonardo: *Young man*. About 1505. Windsor, Royal Library, 12328v (detail)

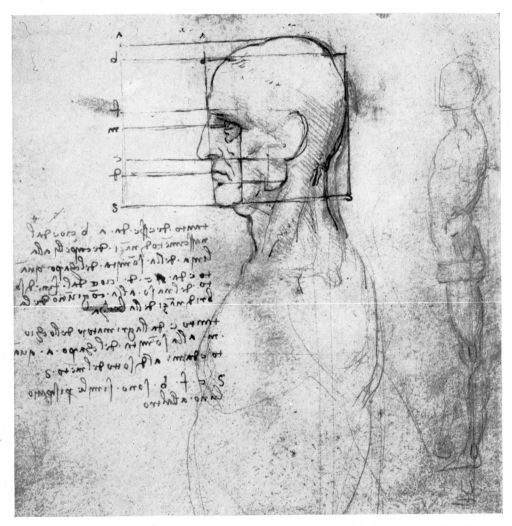

176. Leonardo: *Proportion head*. About 1488. Windsor, Royal Library, 12601 (detail)

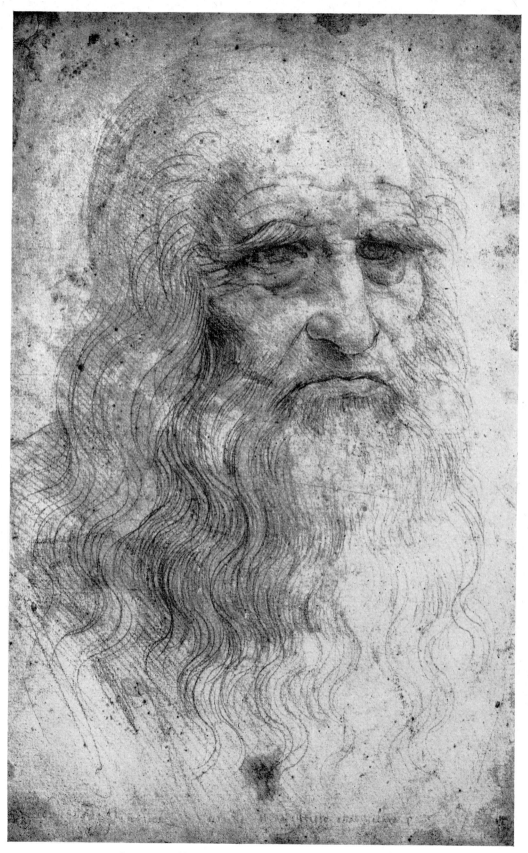

177. Leonardo: '*Self-Portrait*'. About 1512. Turin, Royal Library

178. *Seated old man.* 1510–13. Windsor,
Royal Library, 12579*r* (detail)

179. *Old man.* After 1513.
Windsor, Royal Library,
12488 (detail)

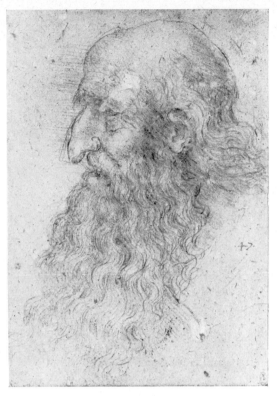

180. *Old man.* After 1513. Windsor,
Royal Library, 12500

DRAWINGS BY LEONARDO

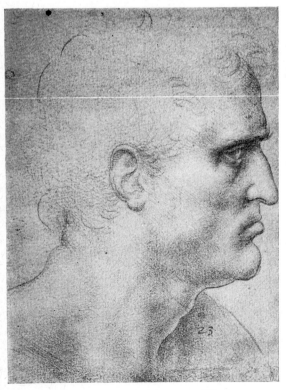

181. *An Apostle.* About 1490–7. Windsor,
Royal Library, 12548

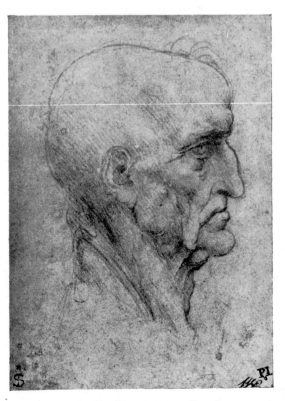

182. *Profile.* About 1490–7. London,
British Museum

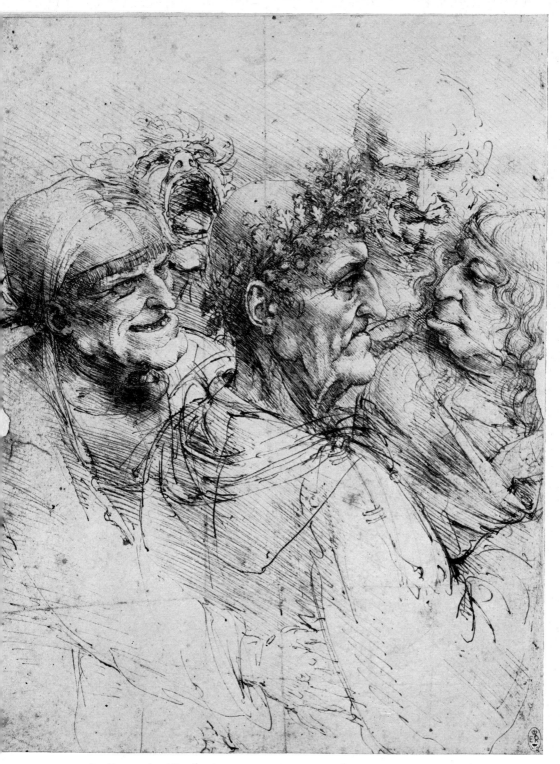

183. Leonardo: *Five heads*. About 1494. Windsor, Royal Library, 12495*r*

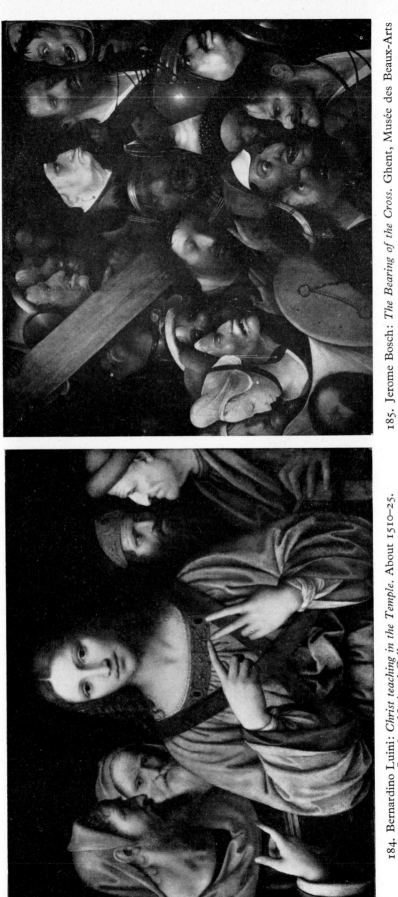

184. Bernardino Luini: *Christ teaching in the Temple.* About 1510–25. London, National Gallery

185. Jerome Bosch: *The Bearing of the Cross.* Ghent, Musée des Beaux-Arts

JEROME BOSCH'S 'GARDEN OF EARTHLY DELIGHTS' (Figs. 186-203)

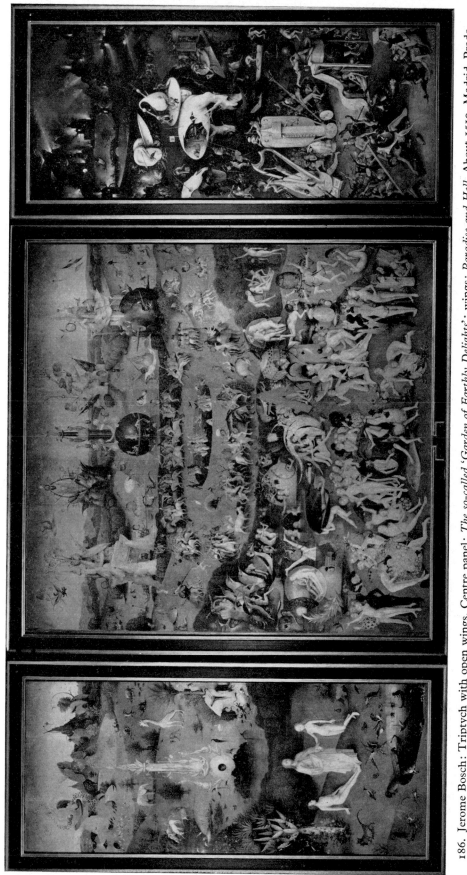

186. Jerome Bosch: Triptych with open wings. Centre panel: *The so-called 'Garden of Earthly Delights'*; wings: *Paradise and Hell*. About 1510. Madrid, Prado

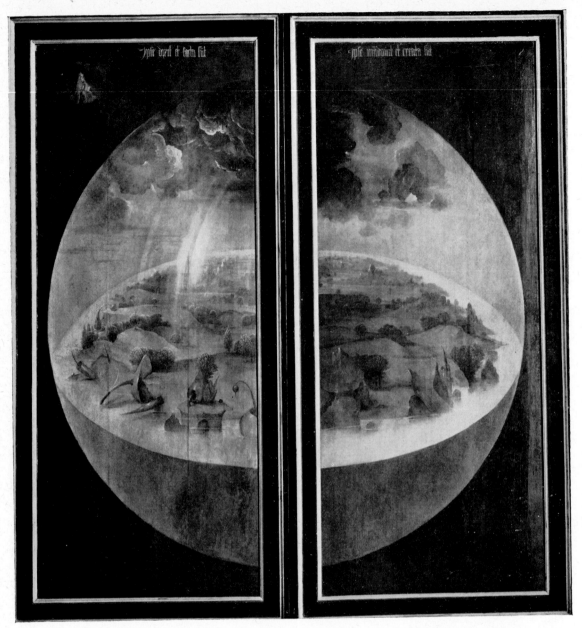

187. The closed wings of the triptych (Fig. 186): *The Recession of the Flood*. Grisaille

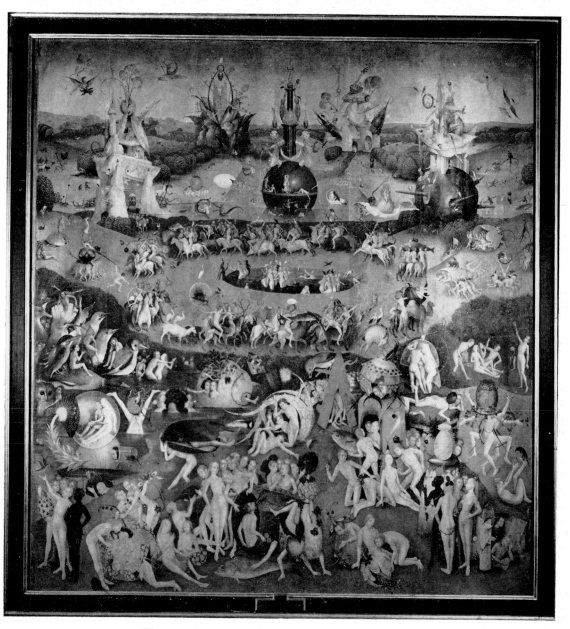

188. *The so-called 'Garden of Earthly Delights'*. Detail of Fig. 186

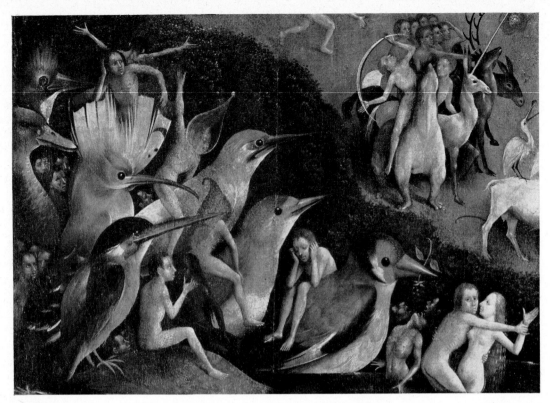

189. *Gigantic birds*. Detail from Fig. 188

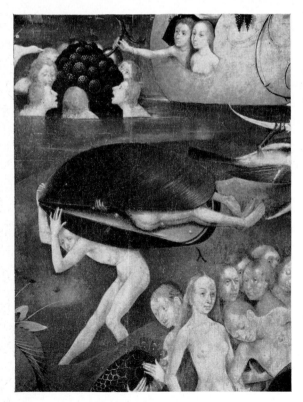

190. *Pair in an oyster; giant grape.*
Detail from Fig. 188

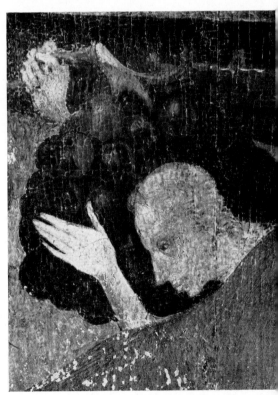

191. *Grape consisting of human heads.*
Detail from Fig. 188

192. *The fiend on his stool.* Detail from the Hell wing
(Fig. 186)

193. Jerome Bosch: *Grotesques.* Drawing. Vienna, Albertina

194. *Tree-man and ramshackle boats.* Detail from the Hell wing (Fig. 186)

195. *Fantastic structure.* Detail from Fig. 188

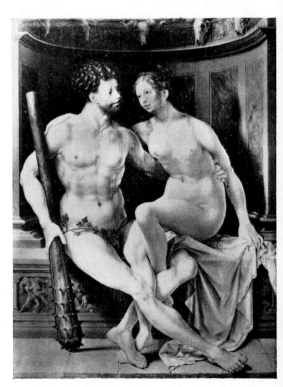

196. *Fortune and Wisdom.* From Bovillus, *Liber de Sapiente*, 1510

197. Jan Gossaert ('Mabuse'): *Hercules and Deianeira.* 1517. Birmingham, Barber Institute

198. *Man biting into strawberry, black and white women, man beside glass pillar.* Detail from Fig. 188

199. *Crowd around giant strawberry.*
Detail from Fig. 188

200. *Flying figures.* Detail from Fig. 188

201. *The Fountain in Paradise.*
Detail from the Paradise wing (Fig. 186)

202. Jerome Bosch (?):
After the Deluge. Grisaille.
Rotterdam, Museum Boymans-
Van Beuningen

203. J. Sadeler (d. 1600) after D. Barendsz (d. 1592): *Sicut autem erat in diebus Noe.*
Engraving

204. Coluccio Salutati's script, from a Seneca MS.
Before 1375. London, British Museum,
Add. 11987, fol. 12

205. Poggio Bracciolini's script from Salutati's
De Verecundia. 1402–03. Florence,
Biblioteca Laurenziana, Strozz. 96, fol. 22*v*

206. MS. of Lactantius Firmianus. Florentine,
1458. Oxford, Bodleian Library,
Canonici Pat. Lat. 138, fol. 2*r*

207. MS. of St. Gregory, *Dialogues*.
North Italian, first half of the twelfth century.
Oxford, Bodleian Library, Can. Pat. Lat. 105,
fol. 3*v*

208. The Baptistery, Florence. Twelfth century

209. The Baptistery, Florence, towards the high altar

210. The Baptistery, Florence. Opposite view

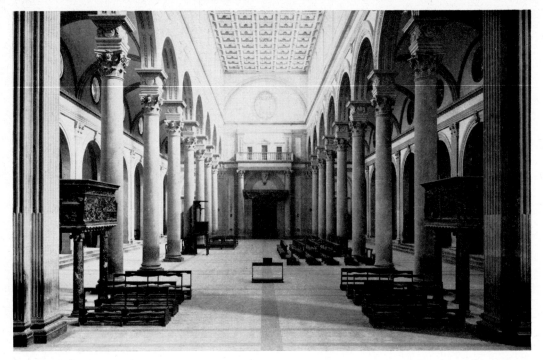

211. San Lorenzo, Florence. Begun 1418

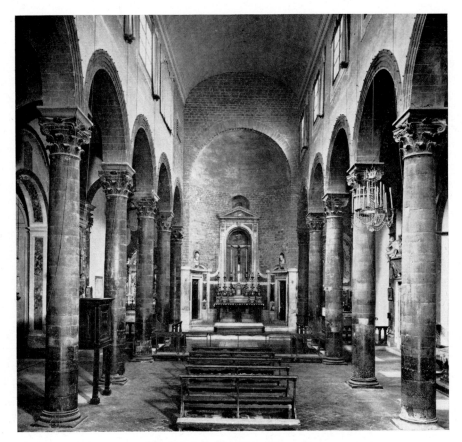

212. SS. Apostoli, Florence. Eleventh century

213. Cappella Pazzi, about 1430. Florence, S. Croce

214. G. P. Pannini: *The Interior of the Pantheon in Rome (before restoration)*. Detail.
About 1740. Washington, National Gallery of Art, Samuel H. Kress Collection

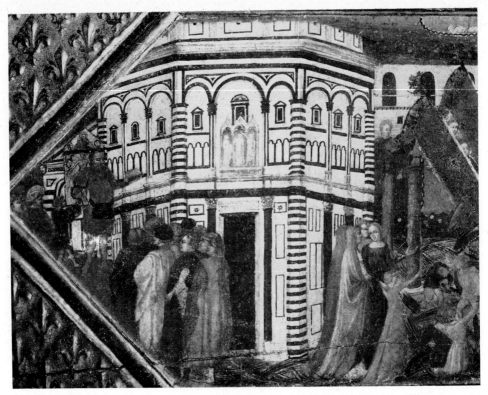

215. *The Baptistery*. Detail of a Florentine cassone painting, about 1430. Florence, Museo Nazionale

216. *The City of Florence*. Detail of a fresco in the Bigallo, Florence, 1352

217. *The Florentines feeding the Sienese.* About 1340. From the Biadaiolo MS. Florence, Biblioteca Laurenziana, Cod. Laurenziano Tempiano No. 3, fol. 58c

218. Window, Palazzo Medici Riccardi, Florence. About 1450

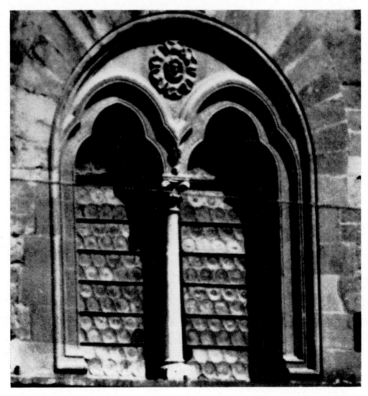

219. Window, Palazzo del Podesta, Florence. Fourteenth century

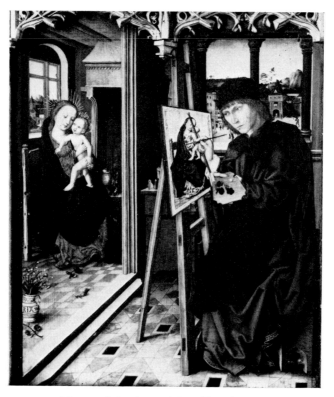

220. Master of the Augustinian Altarpiece of 1487:
St. Luke Painting the Madonna. 1487. Nuremberg,
Germanisches Nationalmuseum

221. Andrea Mantegna: *Christ in Limbo.*
Engraving, late fifteenth century

222. Master A. G. (Albrecht Glockenton ?):
Christ in Limbo. Engraving, late fifteenth century

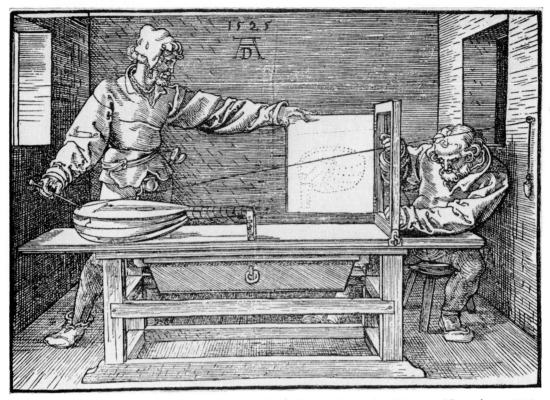

223. Albrecht Dürer: *Instruction in Perspective*. From Unterweisung der Messung, Nuremberg, 1525

224. Albrecht Dürer: *Proportion Study
for a figure of Adam*. 1504. Vienna, Albertina

225. Luca Signorelli: *The Fall of the Damned.* 1499–1506. Orvieto, Cathedral

226. Michelangelo: *The Last Judgement.* 1534–41.
Rome, Vatican, Sistine Chapel

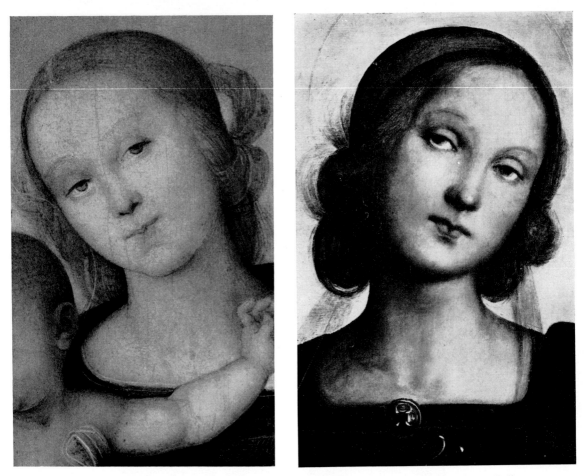

227-8. Perugino: *Head of the Virgin*, from an altarpiece. About 1480. London, National Gallery.—
Head of St. Apollonia, from an altarpiece. About 1500. Bologna, Pinacoteca

229. Filippo Brunelleschi: *The Sacrifice of Isaac.*
1401-3. Florence, Museo Nazionale

230. Lorenzo Ghiberti: *The Sacrifice of Isaac.*
1401-3. Florence, Museo Nazionale

231. After Myron: *Discobolus.*
Fifth century B.C. Munich, Glyptothek

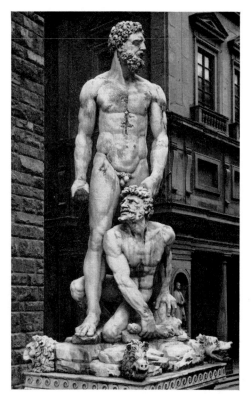

232. Baccio Bandinelli: *Hercules and Cacus.*
1534. Florence, Piazza della Signoria

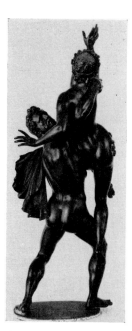

233. Giovanni da Bologna: *A Rape.*
Small bronze. 1579. Naples,
Museo di Capodimonte

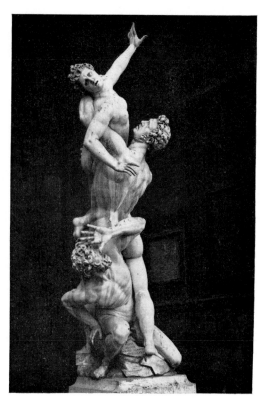

234. Giovanni da Bologna:
The Rape of the Sabine Women. Marble.
1583. Florence, Loggia dei Lanzi

235. Giorgio Vasari: *The Martyrdom of St. Sigismund*. Drawing, about 1550. Lille, Musée Wicar

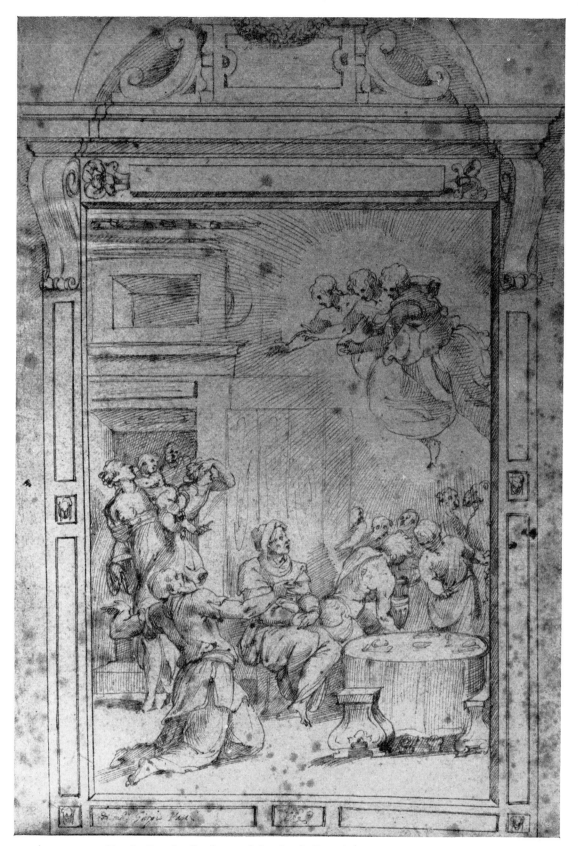

236. Giorgio Vasari: *Abraham and the Angels*. Drawing, 1539. Lille, Musée Wicar

237. Pieter Bruegel the Elder: *The Painter and the Buyer*. Drawing,
about 1565. Vienna, Albertina

238. Matthes Gebel: *Portrait of Albrecht Dürer*.
Bronze medal, 1527. London, British Museum

239. Attributed to Erhard Schön:
Portrait of Albrecht Dürer. Woodcut, 1528.
London, British Museum

BIBLIOGRAPHICAL NOTE

SOURCES OF PHOTOGRAPHS

INDEX

Bibliographical Note

Details of those papers in this volume previously published are as follows:

LIGHT, FORM AND TEXTURE IN XVTH CENTURY PAINTING. *The Journal of the Royal Society of Arts*, No. 5099, Vol. CXII, October 1964, pp. 826–49. Also reprinted in W. Eugene Kleinbauer (ed.), *Modern Perspectives in Western Art History* (New York etc., 1971), pp. 271–84.

THE FORM OF MOVEMENT IN WATER AND AIR. C. D. O'Malley (ed.), *Leonardo's Legacy* (Berkeley and Los Angeles, University of California Press, 1969), pp. 171–204.

LEONARDO'S GROTESQUE HEADS. Achille Marazza (ed.), *Leonardo, Saggi e Ricerche* (Rome, Istituto Poligrafico dello Stato, 1954), pp. 199–219.

THE EARLIEST DESCRIPTION OF BOSCH'S 'GARDEN OF EARTHLY DELIGHT'. *Journal of the Warburg and Courtauld Institutes*, vol. XXX, 1967, pp. 403–6.

'AS IT WAS IN THE DAYS OF NOE'. *Journal of the Warburg and Courtauld Institutes*, XXXII, 1969, pp. 162–70, under the title quoted on p. 83.

FROM THE REVIVAL OF LETTERS TO THE REFORM OF THE ARTS. Douglas Fraser *et al.* (ed.), *Essays in the History of Art Presented to Rudolf Wittkower* (London, Phaidon Press, 1967), pp. 71–82.

THE LEAVEN OF CRITICISM IN RENAISSANCE ART. S. Singleton (ed.), *Art, Science and History in the Renaissance* (Baltimore, Johns Hopkins Press, 1967), pp. 3–42.

VIVES, DÜRER AND BRUEGEL. J. Bruyn *et al.* (ed.), *Album Amicorum J. G. van Gelder* (The Hague, Martinus Nijhoff, 1973), pp. 132–4.

Sources of Photographs

Berlin, W. Steinkopf: Fig. 75

Brussels, A. C. L.: Figs. 50, 70, 73

Chicago, Art Institute: Fig. 47

Florence, Alinari: Figs. 6, 10, 13, 27, 28, 32, 37, 49, 51, 60, 61, 62, 63, 64, 208, 209, 210, 211, 213, 216, 232

Florence, Brogi: Fig. 67

Florence, Soprintendenza alle Gallerie: Fig. 234

Lille, Gérondal: Figs. 235, 236

London, British Museum: Figs. 21, 45, 57, 148, 149, 173, 174, 182, 204, 221, 222

London, Courtauld Institute of Art: Fig. 152

London, Sir Ernst Gombrich: Fig. 12

London, John Webb, FRPS, Brompton Studios: Fig. 56

Madrid, Museo del Prado: Fig. 191

Marburg: Photo Marburg: Figs. 20, 31

Naples, Soprintendenza alle Gallerie: Fig. 233

New York, Metropolitan Museum of Art, Rogers Fund 1903: Figs. 11, 33

Recklinghausen, Photo Wiemann: Fig. 40

Rome, Anderson: Figs. 34, 118, 144, 147, 154, 155, 156, 165, 166, 167, 177, 225, 228

Rome, German Archaeological Institute: Figs. 4, 29, 36

Rome, Musei Vaticani: 68

Washington, D.C., Dumbarton Oaks, Byzantine Institute: Fig. 8

Other Sources

p. 3: after E. J. Sullivan, *Line*, London, 1922

Fig. 3: after Meyer Schapiro and Michael Avi-Yonah, *Israel—Ancient Mosaics*, Unesco World Series, New York, 1960

Fig. 19: after J. Wilpert, *Die römischen Mosaiken und Malereien*, vol. 3, Freiburg im Breisgau, 1917

Fig. 25: after Richard Stilwell, *Antioch on the Orontes*, iii, Princeton, 1941

Figs. 41–43: after G. Yazdani et al., *Ajanta*, Oxford, 1930–55, vols. IV, II, III

Fig. 46: after Otto Fischer, *Die Kunst Indiens, Chinas und Japans*, Berlin, 1928

Fig. 54: after C. L. Ragghianti, *Pittura del Dugento a Firenze*, Florence, n.d.

Fig. 59: after Eve Borsook, *The Mural Painters of Italy*, London, 1960

Fig. 65: after B. Berenson, *Italian Pictures of the Renaissance, Florentine School*, vol. 1. London, 1963

Fig. 99: after L. Rosenhead, *Laminar Boundary Layers*, Oxford, 1963

INDEX

247